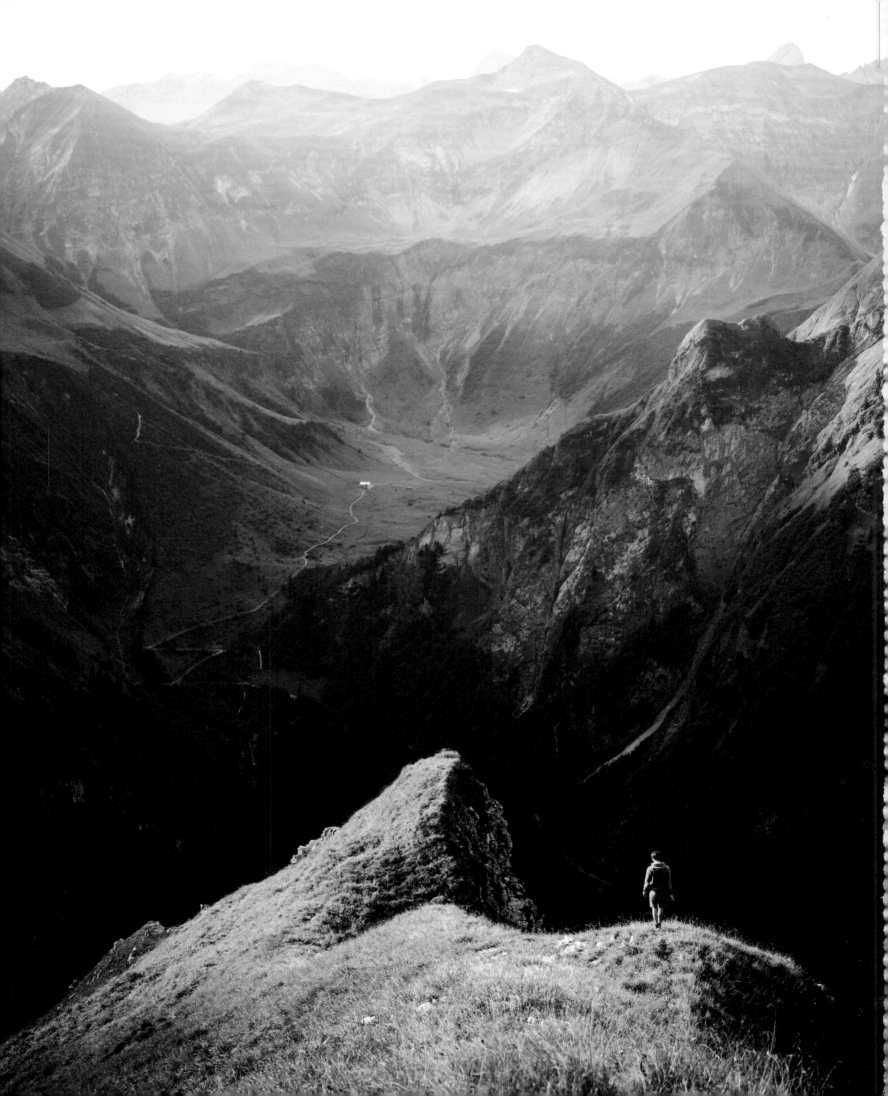

THE HIDDEN TRACKS

Wanderlust off the Beaten Path
explored by Cam Honan

gestalten

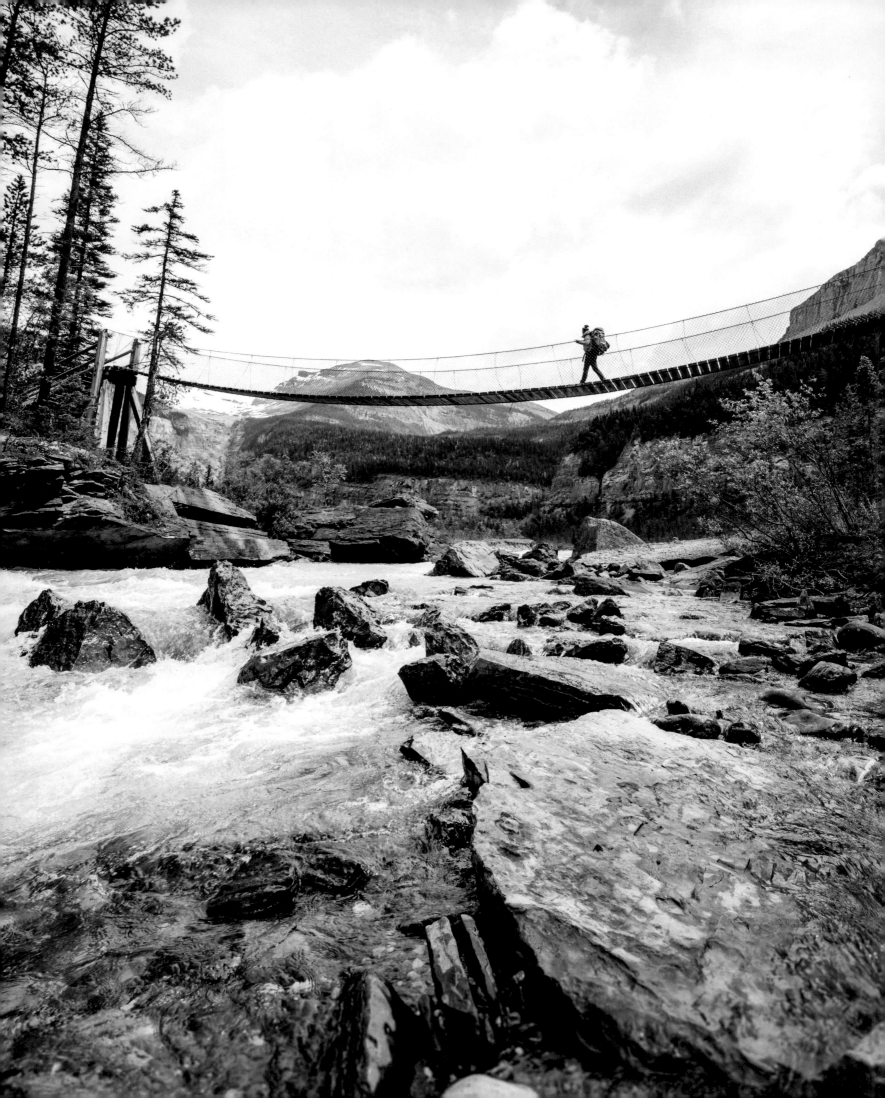

A NATURAL PROGRESSION

From Stranger to Guest to Family

When many people first head out into the wilderness, they feel like a stranger in a strange land. Out of their comfort zone. Odd sounds, weird smells, too hot, too cold, too wet, too much. The first time may prove to be the last.

For those that persevere—and in so doing learn to accept the natural world on its own terms—a transformation can take place. Slowly but surely you settle into the conditions that were once a catalyst for fear and anxiety. As experience accumulates, worries and doubts begin to fade. And with this heightened sense of connection comes a magnified feeling of responsibility, an unwritten duty of care with Mother Nature. Spending time in the wilderness goes from being an occasional footnote to a fundamental part of your life. The stranger has evolved into a regular guest.

In the third and final stage of this natural progression, the guest becomes a family member. Regardless of season or environment, a sense of belonging permeates your outdoor excursions. From a tangible perspective, wildlife seems less skittish in your presence (or you in theirs) and navigating obstacles such as river fords, desert crossings, and snowbound terrain becomes a matter of course. No drama, no need to second guess; you know what needs to be done and you do it. That's not to say that you never make mistakes, but it does mean that when errors invariably happen, you look at them as learning experiences rather than negatives or reasons not to return. From an intangible perspective, feelings of separation have disappeared, replaced instead by a sense of union with your surroundings.

You have come home, and in so doing have realized that your spirit never really left. Our connection with the natural world is innate. So while it may seem like Mother Nature is teaching us, I've long suspected she is simply sending us reminders—providing the key so that we can unlock a part of ourselves that has always been there.

By Cam Honan

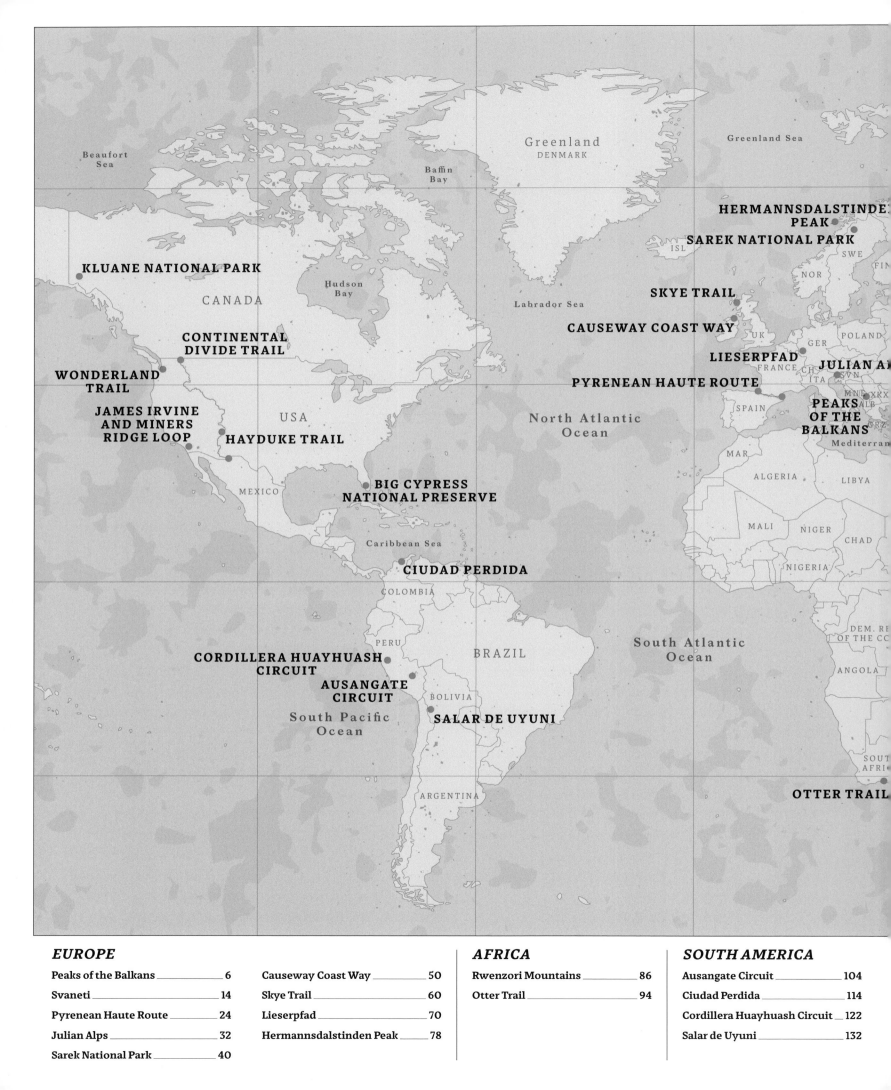

KLUANE NATIONAL PARK

HERMANNSDALSTINDEN PEAK

SAREK NATIONAL PARK

SKYE TRAIL

CONTINENTAL DIVIDE TRAIL

CAUSEWAY COAST WAY

WONDERLAND TRAIL

LIESERPFAD

JULIAN A...

PYRENEAN HAUTE ROUTE

JAMES IRVINE AND MINERS RIDGE LOOP

HAYDUKE TRAIL

PEAKS OF THE BALKANS

BIG CYPRESS NATIONAL PRESERVE

CIUDAD PERDIDA

CORDILLERA HUAYHUASH CIRCUIT

AUSANGATE CIRCUIT

SALAR DE UYUNI

OTTER TRAIL

Arctic Ocean

Kara Sea

Barents Sea

Laptev Sea

RUSSIA

OLKHON ISLAND

Sea of
Ohotsk

**KAMCHATKA
PENINSULA**

KAZAKHSTAN

MONGOLIA

SVANETI

KHONGORYN ELS

GEORGIA

CHINA

North Pacific Ocean

IRAQ

IRAN

TIBET

TIGER LEAPING GORGE

NPL

BHT

JPN

SAUDI
ARABIA

SNOWMAN TREK

INDIA

YEMEN

Arabian Sea

Bay of
Bengal

Philippine
Sea

ETHIOPIA

PHILIPPINES

DA
KENYA

WENZORI MOUNTAINS

INDONESIA

Indian Ocean

Coral
Sea

AUSTRALIA

Tasman
Sea

**AROUND
THE MOUNTAIN
CIRCUIT**

**MOUNT ANNE
CIRCUIT**

NZL

DUSKY TRACK

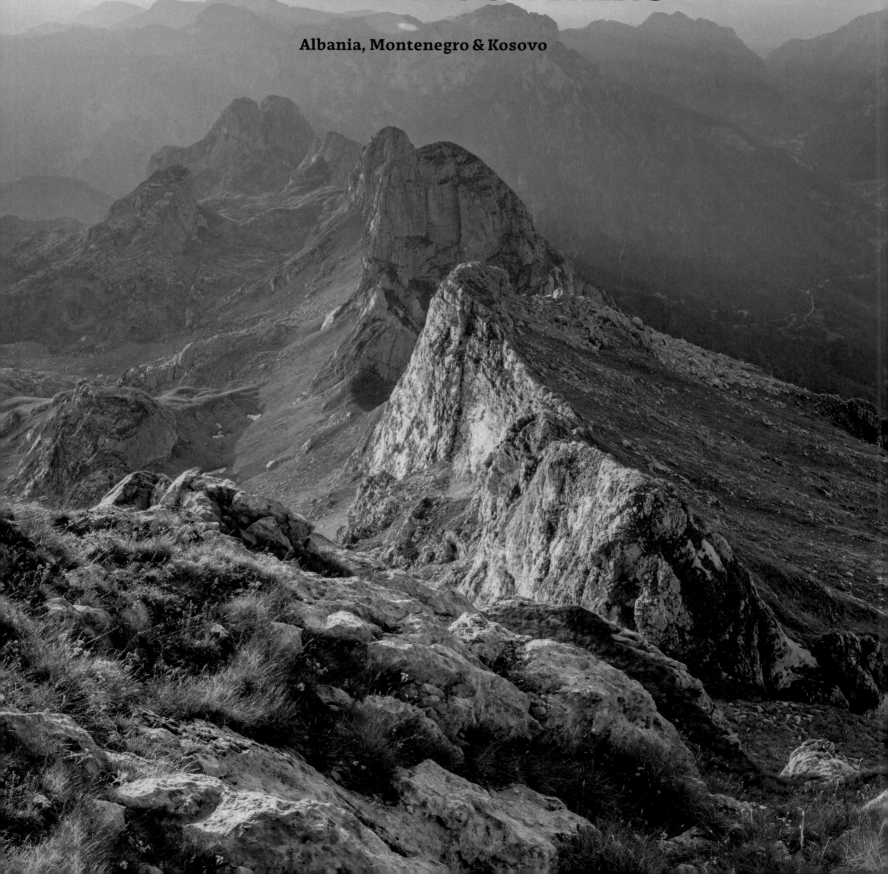

PEAKS OF THE BALKANS

THE MYSTERIOUS ACCURSED MOUNTAINS

Albania, Montenegro & Kosovo

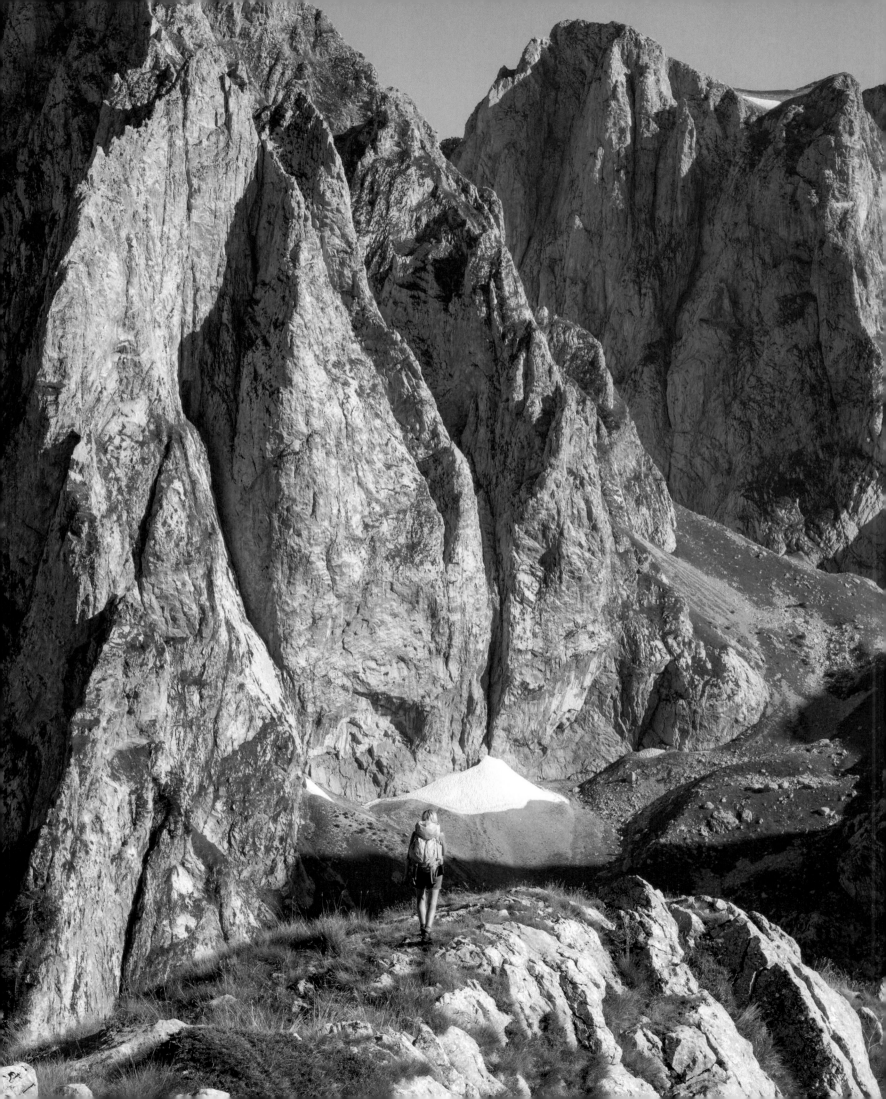

Above: Remote border crossing from Montenegro into Albania.
Left: High passes among nearly impenetrable granite peaks.

For hikers of a superstitious bent, the prospect of trekking through the Balkans' Accursed Mountains may evoke more than a little trepidation. And up until fairly recently, this nervousness would have been wholly justified, due to the fact that the region was one of the most dangerous in the world. However, over the past couple of decades the Balkans have undergone an incredible transformation, and what was once a no-go zone is now an inviting place for tourists, including backpackers eager to experience its long-hidden wonders.

The Peaks of the Balkans trail is a 192 km (119 mi) loop hike that passes through the beautiful and rugged borderlands of Albania, Montenegro, and Kosovo. The circuit consists of 10 stages, takes between 9 and 12 days to finish, and is roughly evenly distributed between each of the three countries. The trek was established in 2012 through a joint effort of the German development corporation GIZ and local and national action groups. The worthy goals of the project are to foster a sense of cross-border unity, assist in protecting the region's flora and fauna, and help local inhabitants create a sustainable form of eco-friendly income.

There are multiple potential starting and finishing options for the Peaks of the Balkans, including Theth (Albania), Plav (Montenegro), and Rekë e Allagës (Kosovo). Generally well marked and easy to follow, the route links together ancient mountain villages by way of unpaved forestry roads ▶

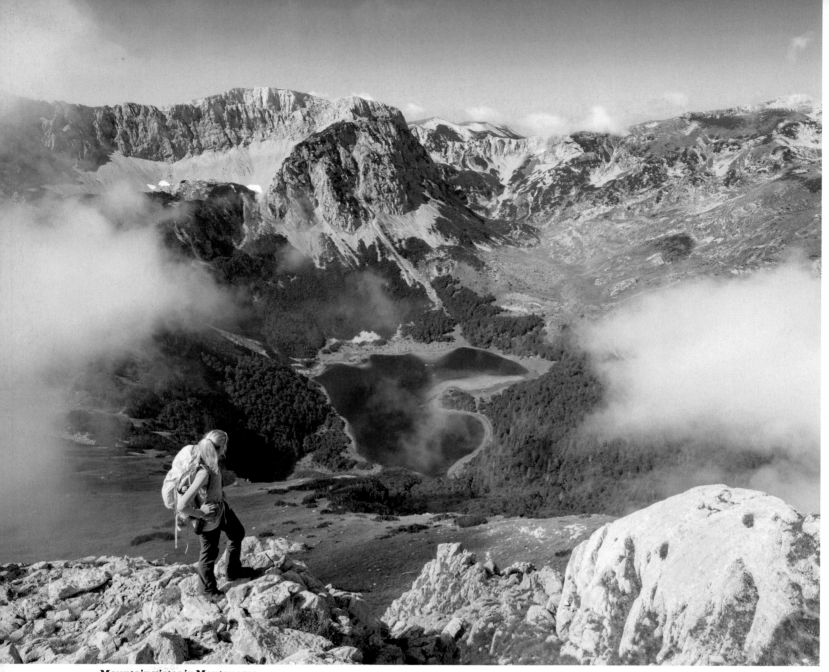

Mountain vistas in Montenegro.

Making friends with locals in remote villages.

and pathways that have been used for centuries by shepherds and traders alike. The trail is still more of a concept than an established track, so you have the freedom to take alternative routes along the way, including the highly recommended and considerably more scenic second-stage alternate over Prosllopit Pass. Given the remote nature of certain sections of the Peaks of the Balkans trail, it is generally recommended to hire a guide. Those who wish to go independently should be experienced navigators, equipped for changeable alpine conditions, and ideally know a few words of the local languages in order to communicate with village folk along the way.

What makes the Peaks of the Balkans truly unique is not the lush green valleys, flower-laden alpine meadows, or the scenic high mountain passes through which it traverses.

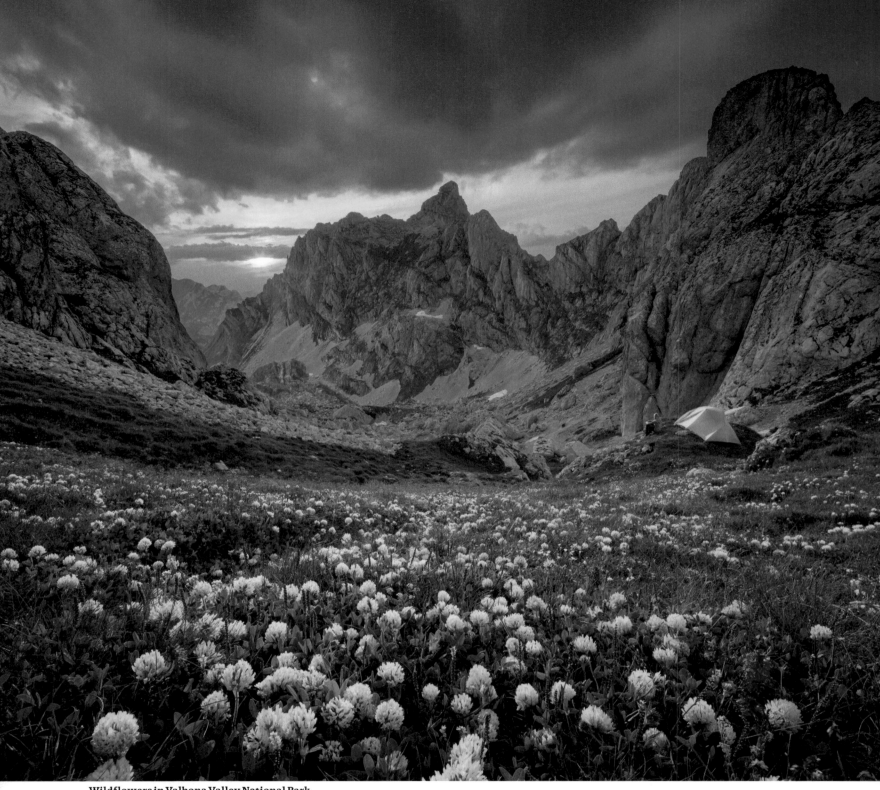

Wildflowers in Valbona Valley National Park.

Nor is it the ancient forests of beech, oak, and pine trees, or the exposed rocky ridges it negotiates. While all of these natural wonders make for an already stunning trail, what leaves the most indelible impression is the historical and cultural context of the experience.

During the trek you will encounter regular reminders of the region's war-torn past in the form of abandoned guard towers, cemeteries, and concrete-domed pillboxes located on top of lonely mountain passes. More than 100,000 of these small bunkers can be found throughout the picturesque Albanian countryside, all of which were built at the behest of Communist dictator Enver Hoxha between the 1960s and 1980s. The juxtaposition between natural beauty and sobering history is striking.

Situated among the affecting vestiges of history are isolated mountain settlements in which pastoral life continues on much as it has for centuries. Thanks to the advent and growth of the Peaks of the Balkans trail, ▶

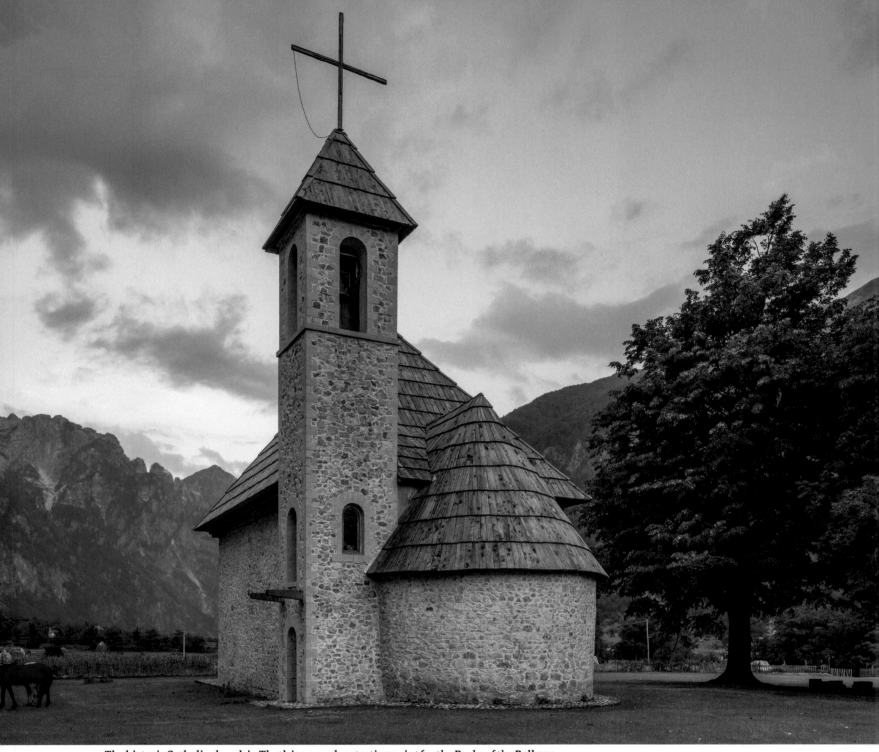

The historic Catholic church in Theth is a popular starting point for the Peaks of the Balkans.

some locals have converted rooms in their homes to accommodate hikers, a good supplement to their seasonal income from farming and shepherding. The lodgings are simple and spotless, and in light of an authentic, welcoming experience with your hosts, Wi-Fi and modern amenities will not be missed. Overnight stays generally include hearty meals of homegrown produce, such as cured meats, bread, cheese, yogurt, and vegetables. This will likely be washed down by generous servings of the local firewater rakija, a power-packed fruit brandy found throughout the region. Treating travelers as honored guests rather than transitory

strangers is nothing new to the peoples of the Accursed Mountains. Hospitality has always been an integral part of local culture, such that it was codified into traditional Albanian law (*Kanun*). The Peaks of the Balkans trail takes hikers on an undulating multiday circuit around one of Europe's most remote and dazzling ranges. In its own way, this border-crossing trail is helping to unite a region that had been fractured for a long time. It is a 192 km (119 mi) long testament to the fact that the Balkans, and the resilient people that call it home, are once again open for business. ◆

GOOD TO KNOW

About the Trail
/ <u>DISTANCE</u> 192 km (119 mi)
/ <u>ELEVATION GAIN</u> 9,800 m (32,152 ft)
/ <u>DURATION</u> 9 to 12 days
/ <u>LEVEL</u> Moderate

Start / Finish
The Peaks of the Balkans is a loop hike that can be started and finished in various locations, including Theth (Albania), Plav (Montenegro), and Rekë e Allagës (Kosovo).

Highest Point
The border between Dobërdol, Albania, and Milishevc, Kosovo (2,290 m [7,513 ft])

Lowest Point
Çerem, Albania (670 m [2,198 ft])

Season
Late May to early October. Wildflowers are at their peak in June, August is the warmest month, and autumn colors begin in early October, a month that also traditionally heralds the first snowfall.

Accommodation
Camping is possible, but most hikers use homestay accommodation in villages along the route. The cost usually includes dinner, breakfast, and a packed lunch.

FLORA & FAUNA

Balkan Lynx The Accursed Mountains are home to the Balkan lynx, an endangered subspecies of the Eurasian lynx. With an estimated population of between 30 and 40 (as of 2018), the Balkan lynx is one of the rarest cats in the world. Strict carnivores that feed primarily on deer and other hoofed animals, they measure up to 110 cm in length and 70 cm in height, and are the third-largest predator in Europe after the brown bear and wolf.

HELPFUL HINTS

Cross-Border Permits The Peaks of the Balkans trail crosses backwards and forwards between Albania, Montenegro, and Kosovo. Before beginning the trail, aspiring thru-hikers will need to obtain a cross-border permit. Whether walking independently or with an organized group, the most hassle-free way of doing this is online via a reputable local tour operator.

BACKGROUND

The Accursed Mountains The Peaks of the Balkans trek mostly takes place in the evocatively named Prokletije (accursed, in English) mountains. There are multiple stories as to how they received their colorful moniker. According to one legend, the devil himself came up from Hades to wreak havoc for a day of mischief and mayhem. A more interesting legend relates the story of two brothers and a beautiful fairy they found in the mountain forest. When posed the question as to which one of the siblings she preferred, the fairy said that she liked one for his looks and the other for his bravery. Upon hearing the verdict, the so-called brave one murdered his handsome brother and then took the fairy home to meet his mother. Understandably enraged after hearing the news of her deceased offspring, Mom promptly cursed the fairy, her surviving son, and the mountains for the rest of eternity.

Albanian Riviera There is no better way to finish the Peaks of the Balkans circuit than with a celebratory trip to the Albanian Riviera that lures weary hikers with its turquoise waters, pristine beaches, and picturesque seaside villages.

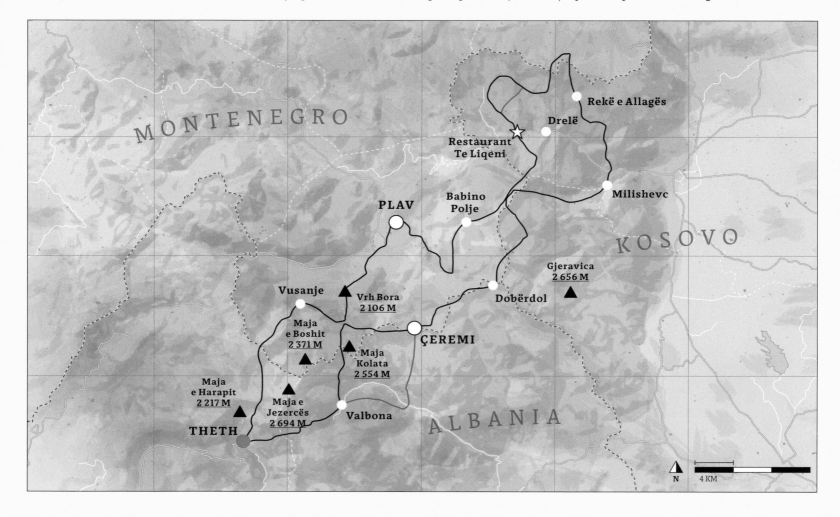

SVANETI

HIDDEN VALLEYS & ANCIENT STONE TOWERS

Georgia

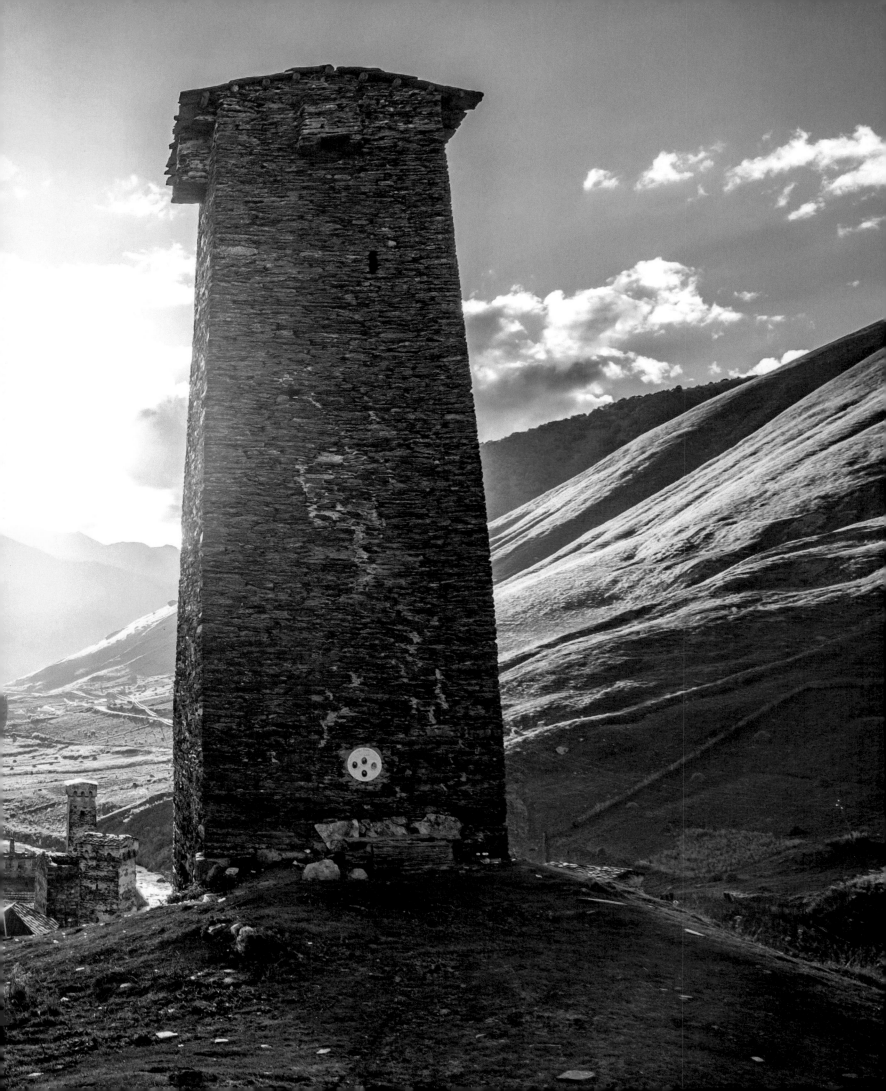

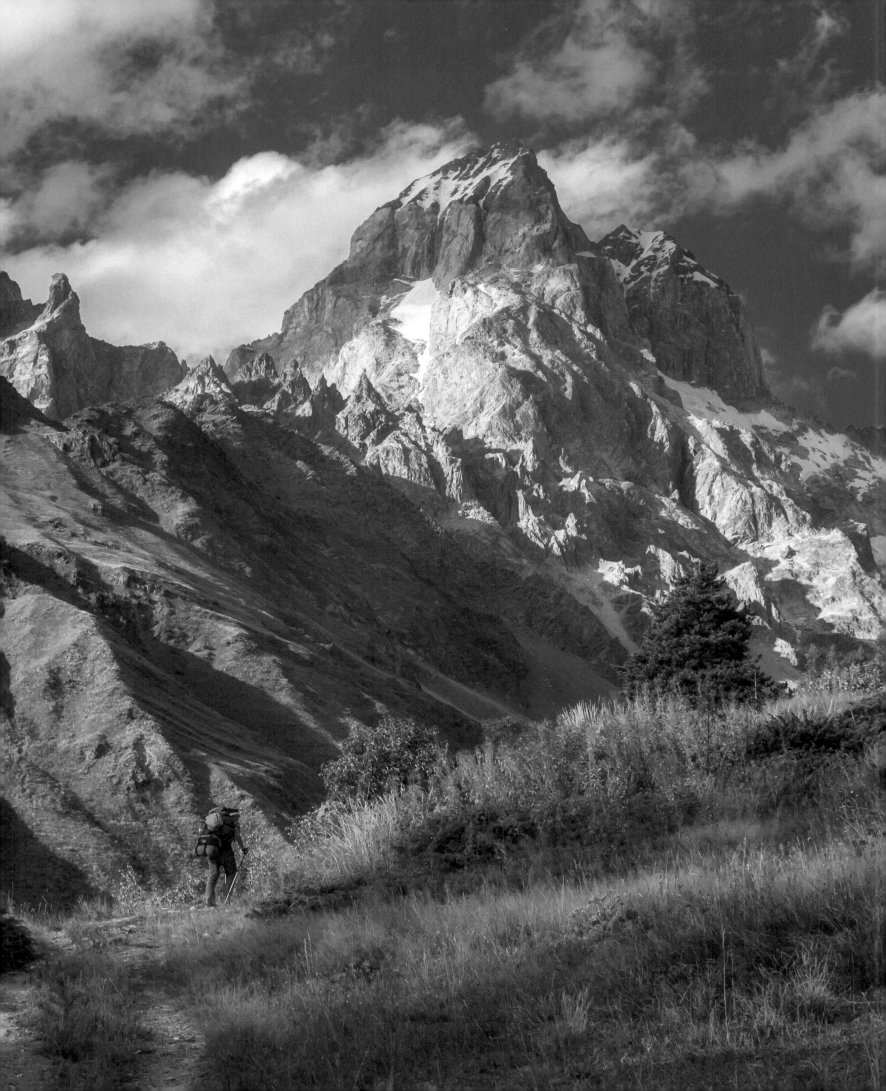

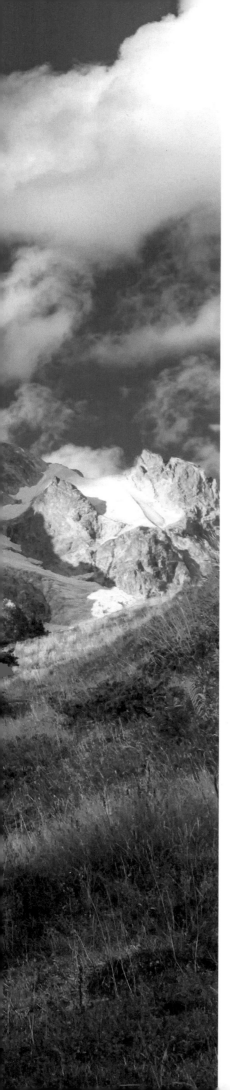

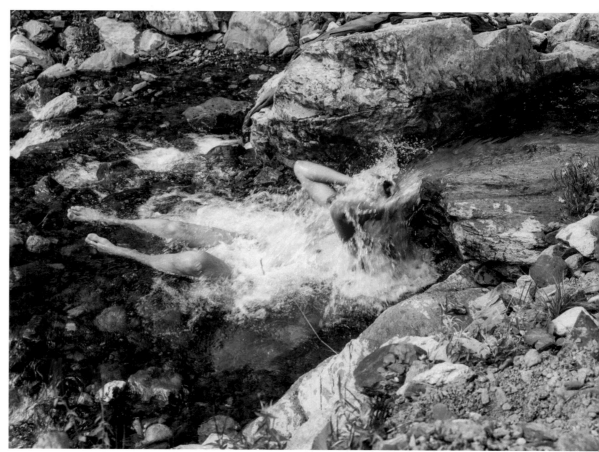

Left: The trek can be extended by an additional day, by hiking from Mazeri to Mestia via the beautiful Guli pass and Ushba mountain.
Above: Cooling off in a mountain stream along the way.

S vaneti is a high and remote mountain region in northwestern Georgia. Part of the Caucasus range that extends between the Black and Caspian Seas, it is home to the Svans, a fiercely independent people famous for their polyphonic singing and blood feuding. Until the early part of this century, Svaneti had remained largely isolated from the outside world, but in recent years, increasingly more visitors have come to the area, drawn in by a combination of its singular culture and history, and some of the most pristine mountainous landscapes in Eurasia.

The trek between Mestia and Ushguli encapsulates all of the varied elements that make the Svaneti region unique. Measuring 57 km (35.4 mi) and normally completed in four days, it is an accessible, relatively easy trail that winds its way through craggy peaks, alpine meadows, and picturesque valleys. These valleys house ancient villages renowned for their *koshki,* World Heritage-listed stone towers that date back to between the ninth and thirteenth centuries. Built for defense against invaders—and occasionally neighbors with whom the occupants were feuding—these slate-capped citadels typically measure 20 to 25 m (65 to 82 ft) in height. During troubled times in the lowlands, the *koshki* would also act as repositories for jewels, icons, and manuscripts that had been laboriously transported up to Svaneti's isolated valleys. It was a role that the villagers took very seriously, and for centuries Svaneti was considered a bulwark of early Georgian culture. There are more than 200 *koshki* still remaining in the region, and wandering through these storied towers is a highlight of any journey to Svaneti.

Although it is possible to camp along the entire Mestia to Ushguli trek, it is recommended to stay in village guesthouses. Run by local families, these ▶

The trail winds through remote ancient villages and lush green hills.

stopovers present a wonderful opportunity to experience traditional Georgian hospitality. The accommodation is by no means luxurious, but the guesthouses are clean and cozy, with huge servings of local cuisine not to be missed by hungry hikers. Foremost among the culinary offerings is the ubiquitous *khachapuri* (cheese-filled bread). Usually mixed with other ingredients such as eggs, meat, potatoes, and / or beans, *khachapuri* holds an important place in Georgian culinary culture, to the point that its price is often used as a barometer of inflation in different areas of the country.

Hopefully you will have the chance to hear traditional folk music when overnighting in Svaneti's villages. Georgia is known for its rich polyphonic vocal traditions dating back to ancient times. Styles of polyphony can vary from region to region, with the people of Svaneti known for

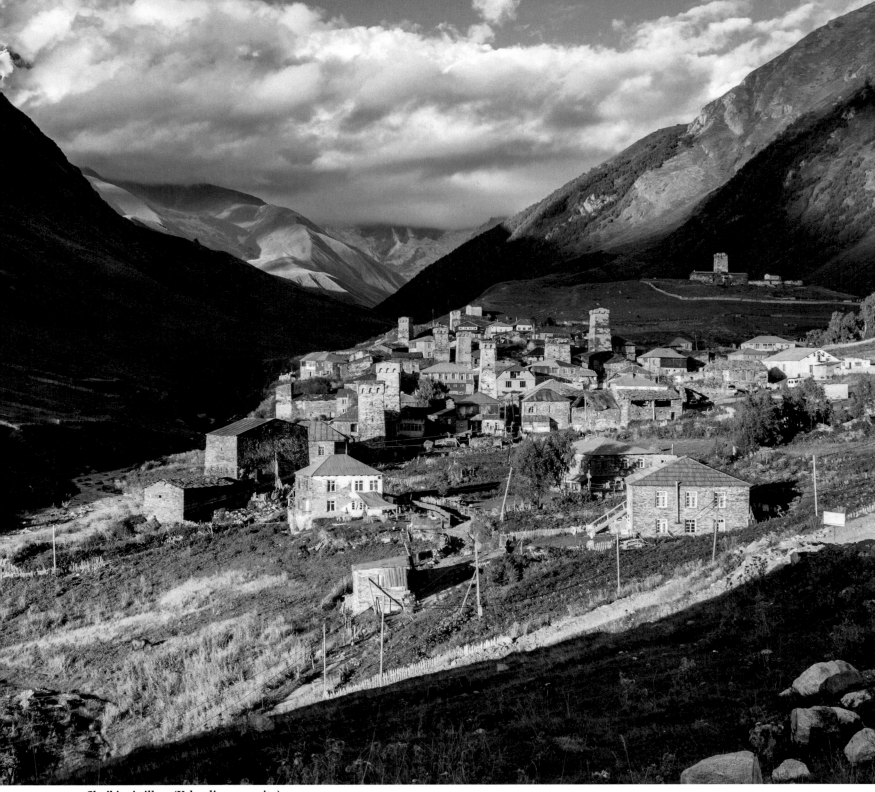

Chvibiani village (Ushguli community).

their primeval three-part singing with pentatonic harmonies. The songs are usually sung in their native tongue of Svan, an unwritten, consonant-heavy language; due to the region's remoteness, it has retained many archaic features that have been lost in other Kartvelian languages. Often accompanying the sonorous vocals are traditional Svan stringed instruments called *changi,* resembling an ancient wooden harp, and *chuniri,* resembling a three-stringed lute that is played with a bow. When

listening to the ancient musical ensemble after a hearty meal and a *chacha* (Georgian pomace brandy), or three, it is easy to forget time completely—quite characteristic of the whole journey through Svaneti, as if stealing away into the twelfth century. In the words of Richard Bærug, co-author of *Europe's Unknown Fairytale Land:* "Svaneti is a living ethnographic museum. Nowhere else can you find a place that carries on the customs and rituals of the European Middle Ages." ▶

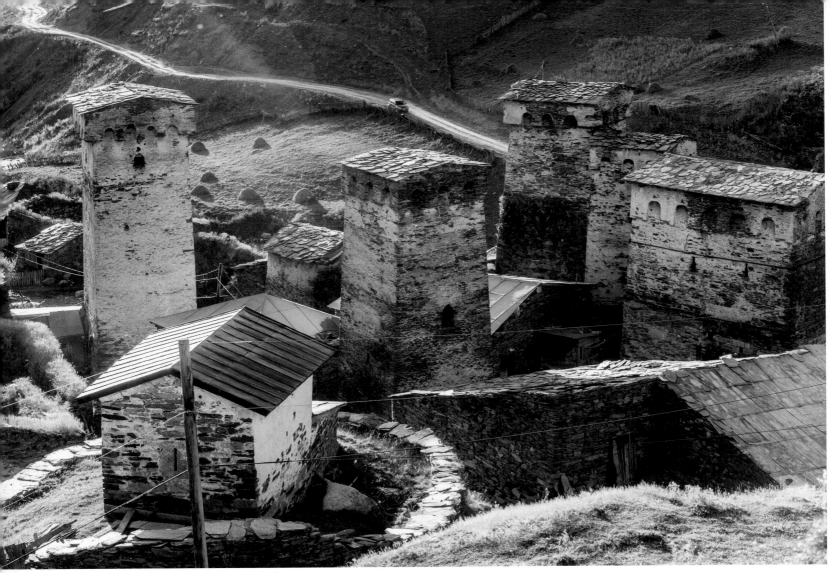

Chazhashi village (Ushguli community).

Below: Sheep enjoying the tasty minerals of the tower walls.
Right: Lardaad Glacier.

"Svaneti is a living ethnographic museum. Nowhere else can you find a place that carries on the customs and rituals of the European Middle Ages."

–RICHARD BÆRUG, CO-AUTHOR OF *EUROPE'S UNKNOWN FAIRYTALE LAND*

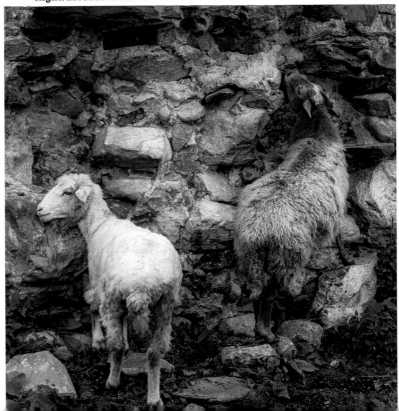

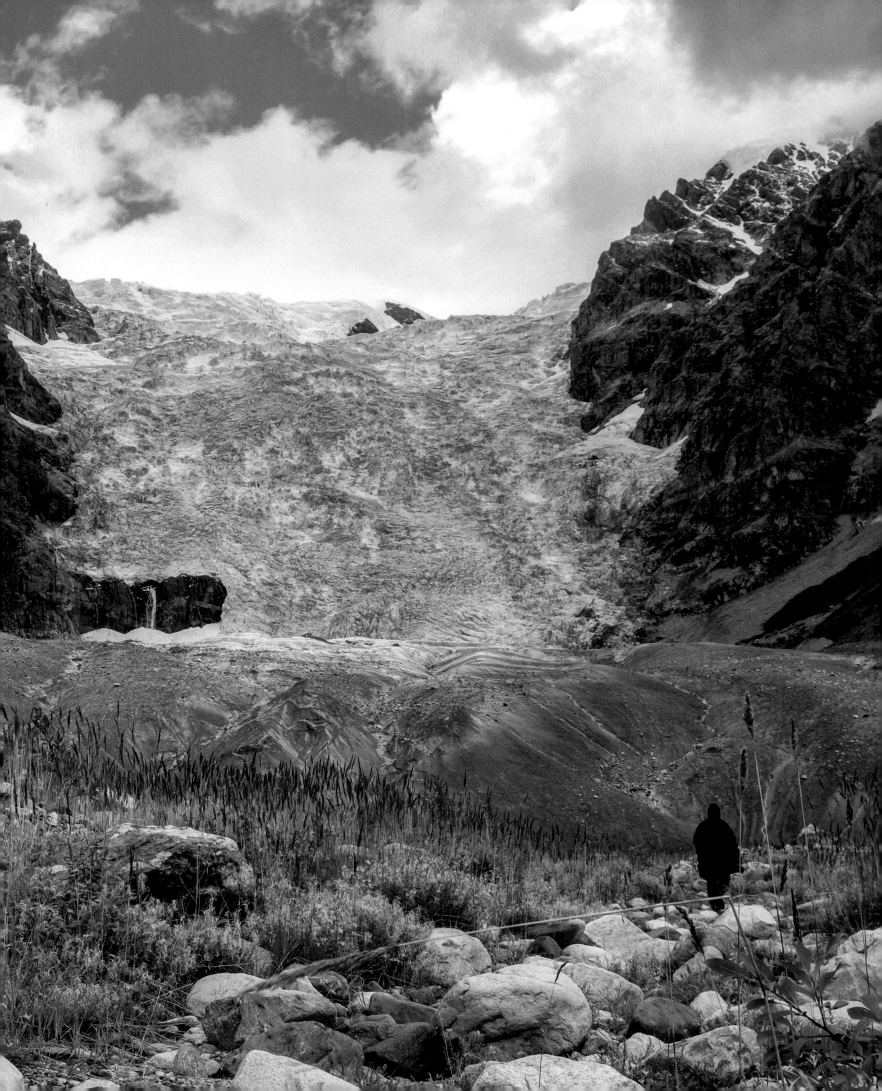

Despite retaining much of its cultural integrity, Svaneti has slowly but surely begun to modernize since the turn of the millennium. Roads have been improved, even the most remote of villages now have electricity, and the government has tried to promote the mountain enclave as the "Switzerland of the Caucasus." Not surprisingly, there have been challenges. But the proud inhabitants of the Svaneti region have a long history of surviving and adapting, and there is little doubt that they will fight to preserve their cherished traditions in the face of ever-encroaching modernity. ◆

The trek between Mestia and Ushguli is an accessible, relatively easy trail that winds its way through craggy peaks, alpine meadows, and picturesque valleys.

Morning light sweeping over Svaneti's mountains.

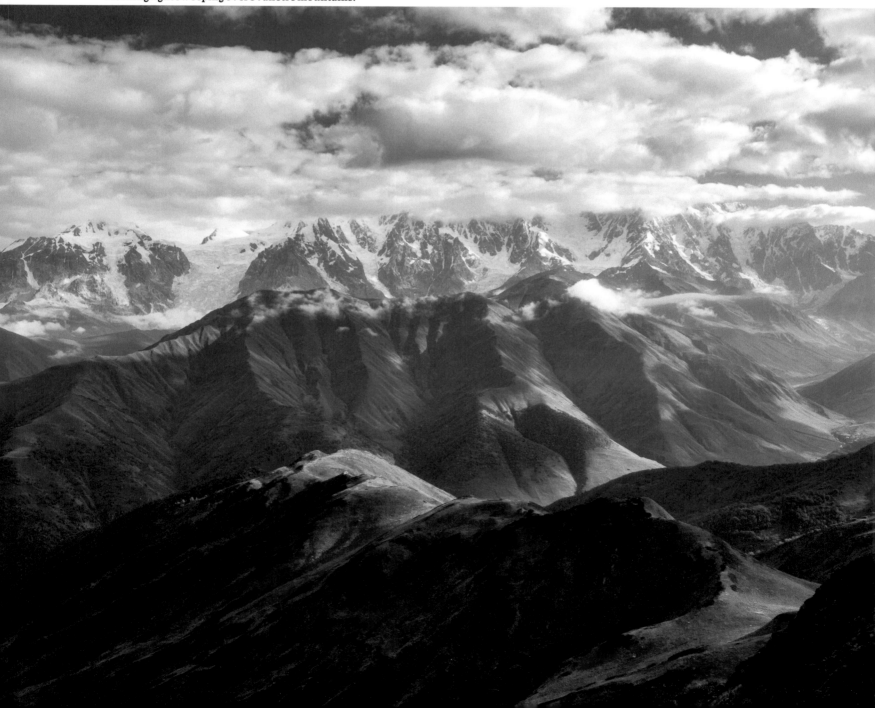

GOOD TO KNOW

About the Trail
/ <u>DISTANCE</u> 57 km (35.4 mi)
/ <u>DURATION</u> 4 days
/ <u>LEVEL</u> Easy

Start / Finish
⚐ Mestia
⚐ Ushguli

Highest Point
2,737 m (8,980 ft)

Lowest Point
1,411 m (4,629 ft)

Season
May to October

Accommodation
It is possible to either camp, stay in villages, or combine the two.

Resupply
Food is available at the guesthouses in the villages. Unless you are camping, it is not necessary to carry more than a day's worth of food at any one time.

Water
The water in all of the villages is fine to drink from the tap. When taking water from the streams along the way, it is recommended that you purify it.

HELPFUL HINTS

Cash is King Be sure to leave Mestia with enough cash to cover all of your meals and accommodation for the entire trek, as there are no ATM machines in any of the mountain villages.

Travel Lightly Thanks to guesthouse accommodations and hearty meals available in all of the medieval villages along the way, hikers can choose to leave behind their tents and stoves and travel lightly between Mestia and Ushguli.

BACKGROUND

Georgian Music in Outer Space
One of the most beloved songs in Georgia is called "Chakrulo," a drinking tune about preparing for battle and resistance against oppression. In 1977, "Chakrulo" was one of only 27 musical compositions from around the world included on a golden phonograph record that was taken into space on the Voyager spacecraft. In addition to the selected songs, the Voyager Golden Record contains a variety of images, natural sounds, and spoken greetings selected to portray the diversity of life and culture on Earth. As of 2018, both Voyager 1 and 2 have been operating for over 40 years, and are currently more than 40 billion km (24.9 billion mi) away from Earth.

FLORA & FAUNA

Spring in Svaneti The month of June in the Svaneti region sees the snow melting and the wildflowers blooming. The alpine meadows become ablaze with a kaleidoscope of yellow, purple, pink, white, and blue. Buttercups, cowslips, sunflowers, and rhododendrons are just some of the various types of flowers you can spot at this time. Overall, Georgia has approximately 4,200 wildflowering plant species and 8,500 spore-bearing species, making it one of the most botanically diverse nations on Earth.

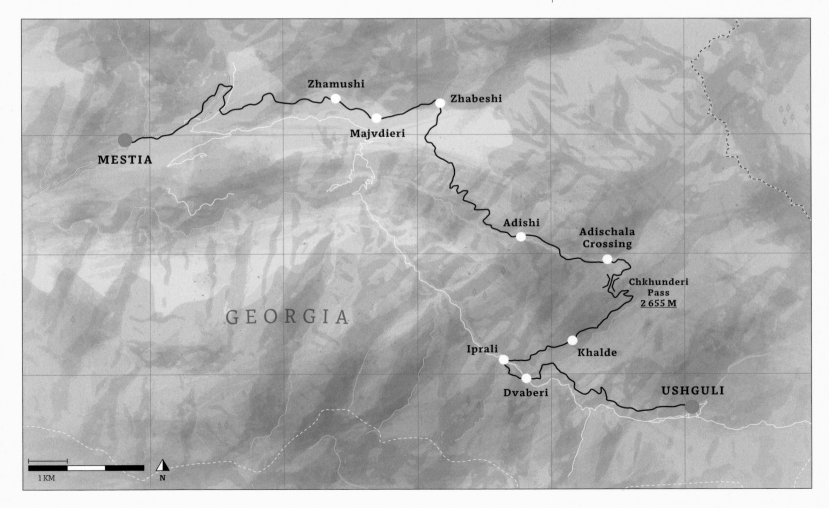

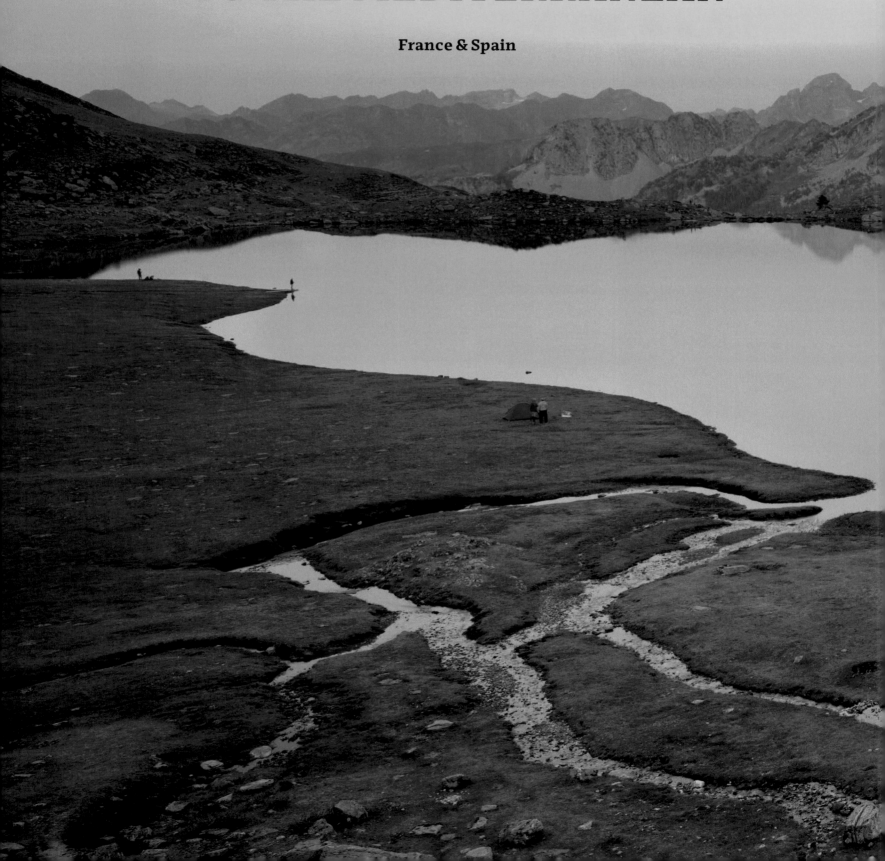

PYRENEAN HAUTE ROUTE

FROM THE ATLANTIC TO THE MEDITERRANEAN

France & Spain

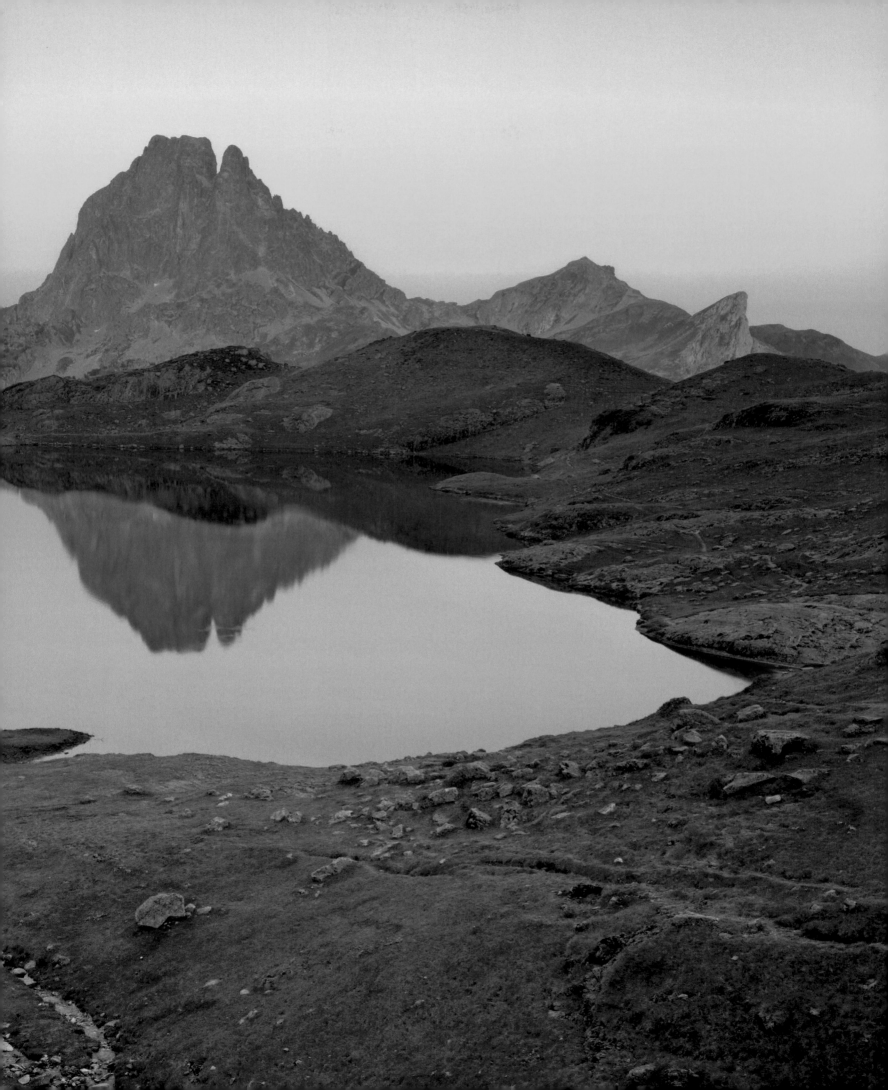

The Pyrenean Haute Route (or HRP for Haute Randonnée Pyrénéenne) is an 800 km (497 mi) traverse of one of Europe's most beautiful mountain ranges. Stretching from the Atlantic Ocean to the Mediterranean Sea, it crisscrosses the natural boundary between Spain and France, and remains close to this watershed throughout most of its undulating course. Often overlooked by outdoor enthusiasts in favor of the Alps, the Pyrenees are wilder, less crowded, and more affordable than their famous neighbors to the northeast. An ideal destination for hikers in search of gorgeous mountain scenery and more solitude, they offer an off-the-beaten-track feel that is hard to come by in other parts of Western Europe.

The HRP is one of three coast-to-coast routes that cross the Pyrenees. The other two are the GR10 in France and the GR11 in Spain, both of which are well-defined, established trails that stay on their respective sides of the border. (Note: all three routes also pass through the

Sempervivum tectorum (common houseleeks) flourish on rocky soil in sunny, dry conditions.

Horses graze in the meadows below Pic d'Ansabère (2,377 m [7,799 ft]).

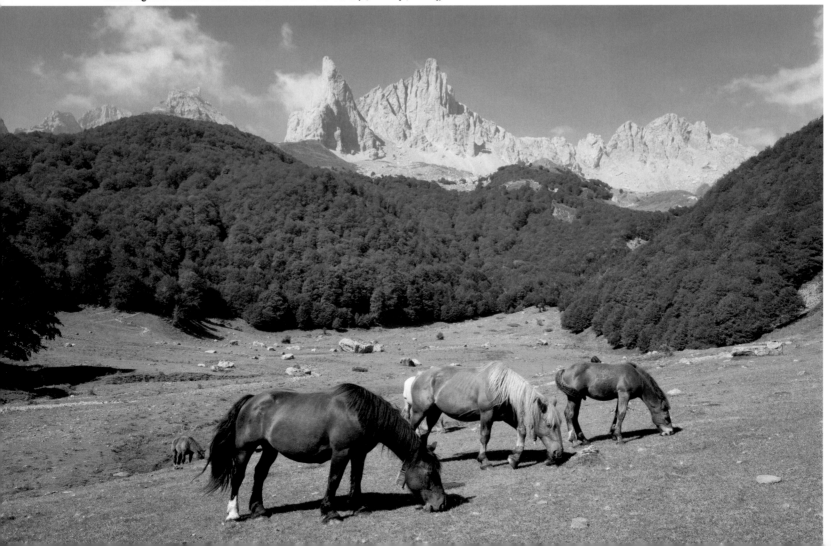

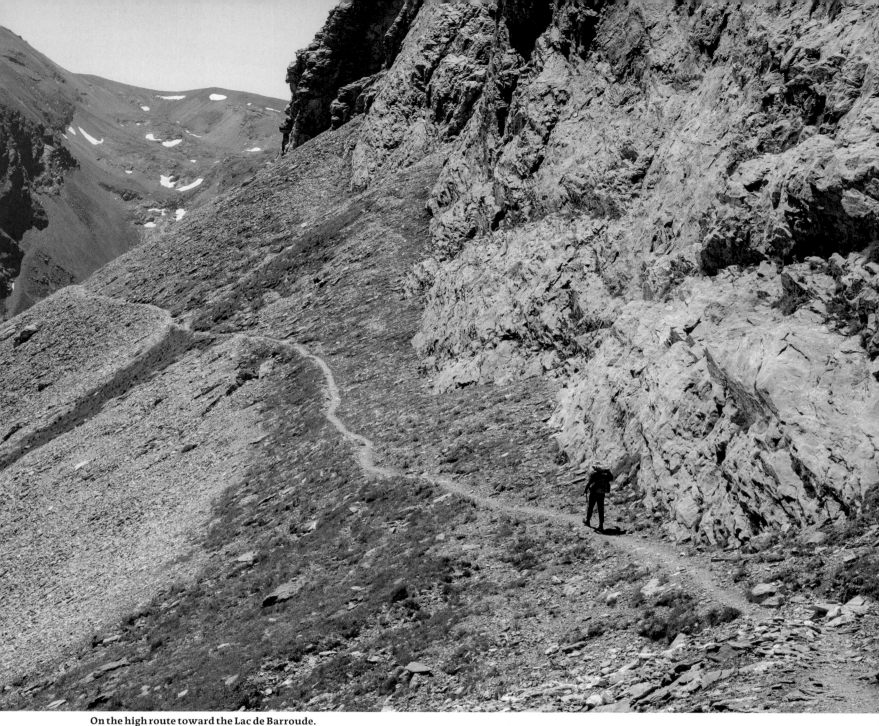

On the high route toward the Lac de Barroude.

principality of Andorra.) Unlike the other range-spanning treks, the HRP—which is split into 45 daily stages—is sometimes trailless and largely unmarked. Further differentiating the HRP is the fact that it tends to stay high on the range's crest, whereas the GR10 and GR11 constantly vacillate between alpine landscapes and low-lying valleys. While all three routes pass through spectacular environs, the HRP is the most challenging of the trio and is best suited to fit and experienced backpackers with good navigation skills. The GR10 and GR11 (particularly the former) are more accessible to hikers with varied levels of experience, and, due to the fact that each of their daily stages finish at a small town or village, represent better alternatives for those wanting more in the way of creature comforts while on a long-distance hiking holiday.

One of the first things that comes to mind when describing the HRP is its diversity of landscapes, cultures, cuisines, flora, fauna, and languages. Every day brings something different, and the only apparent constant is that of change. In regard to the natural scenery, the hike is bookended by delightful seaside towns, with a myriad of rocky granite peaks, sapphire-blue lakes, flower-laden meadows, and sweeping glacial cirques lying in between. The magnificent central part of the range encapsulates all of these different natural elements, so for those who are short on time, it's an excellent option for a section hike of the HRP. ▶

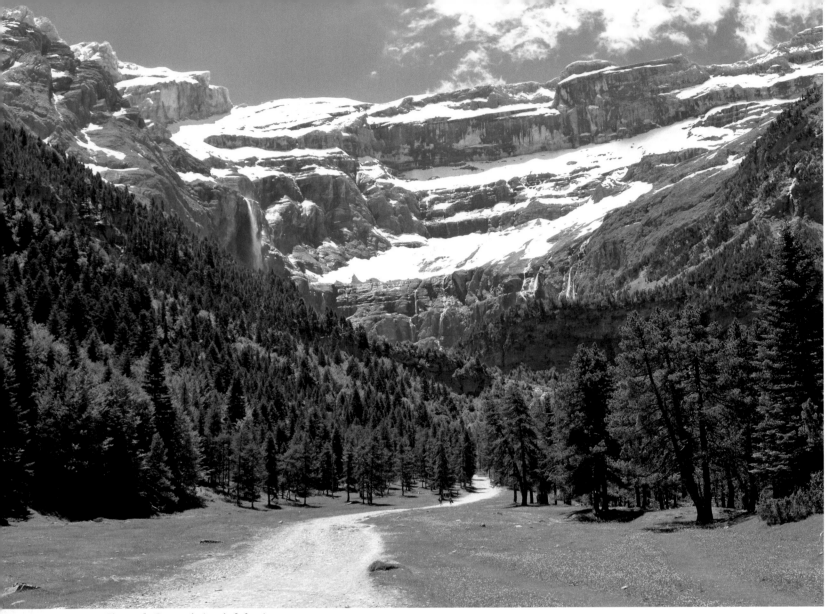

Cirque de Gavarnie (see info box).

What makes the HRP such a challenging proposition is its combination of rugged terrain and frequent changes in altitude and weather. Because much of it is above the tree line, hikers are more exposed to the elements than on the GR10 and GR11, and therefore need to be constantly monitoring changes in conditions. Frequent and affordable mountain refuges along its course mitigate the weather challenges, and are very welcome sanctuaries when Mother Nature flexes her meteorological muscles. For many thru-hikers overnighting at these refuges and sharing a meal and conversation with fellow trekkers, represents an integral part of the Pyrenees experience. However, it should be noted that during the summer months, these huts are often full and almost always noisy; therefore it is strongly recommended that all HRP hikers bring their own shelter. Not only does a tent give you a greater degree of flexibility accommodation-wise, it also gifts you the freedom to soak up ▶

**Right: Sunset on the rocky crest.
Below: A curious lizard along
the Pyrenean Haute Route.**

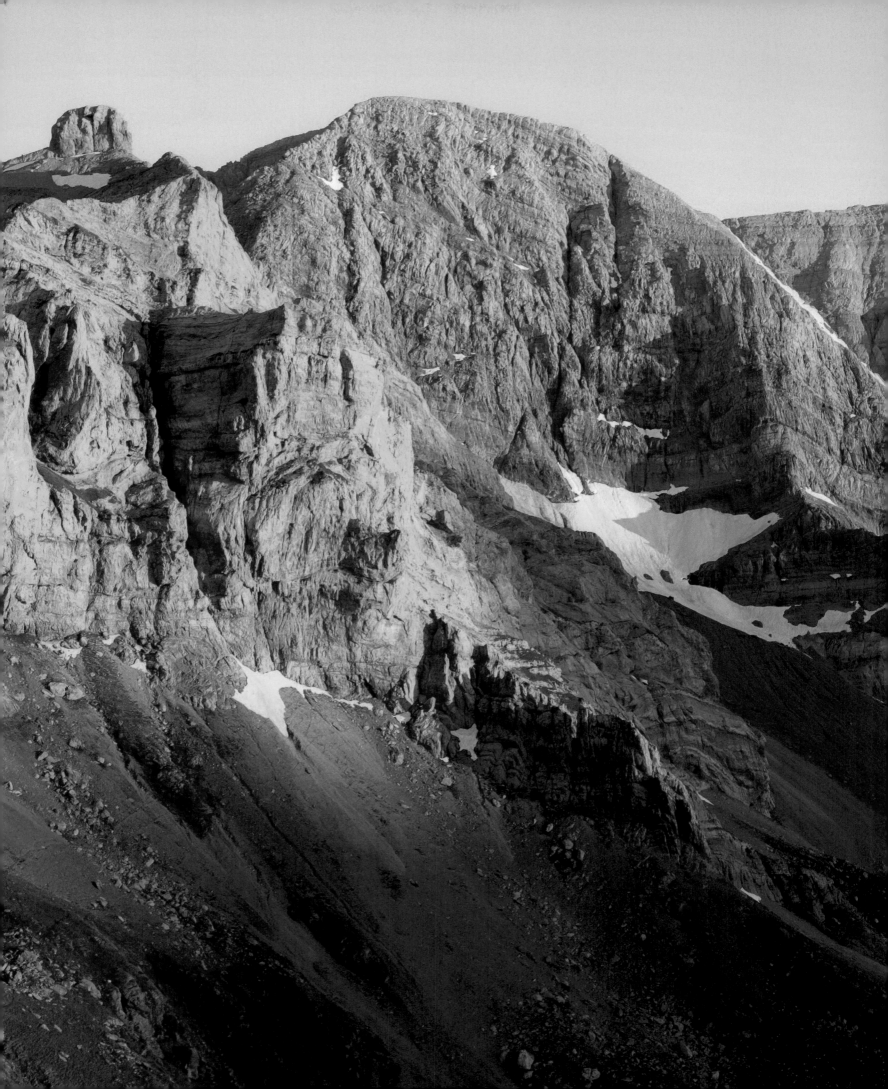

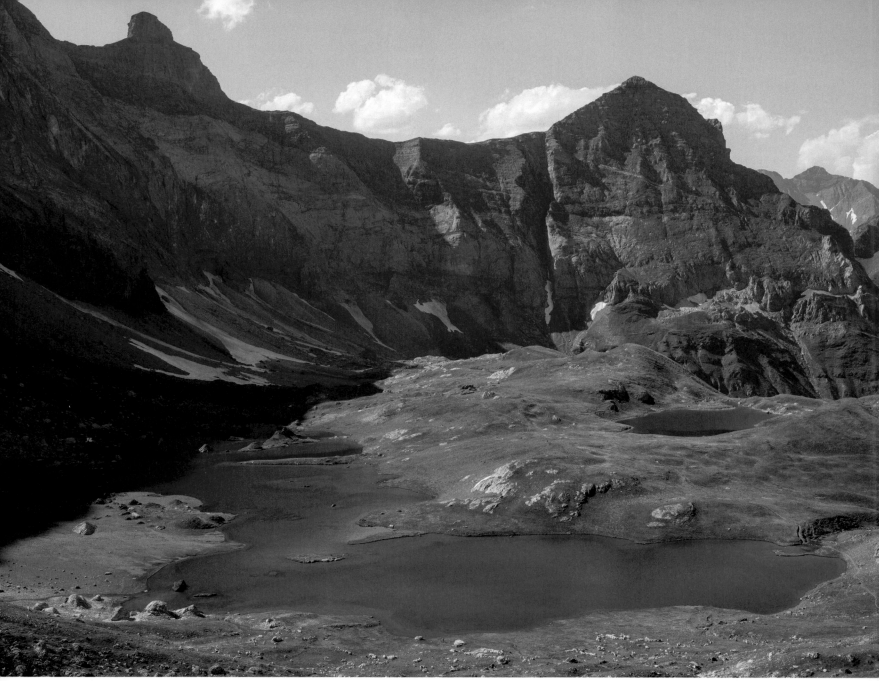

Lac de Barroude.

a beautiful Pyrenean sunrise and sunset from a secluded mountain perch whenever you choose to do so.

The huts are by no means the only opportunity for social and cultural interaction during the trek. Although not to the same degree as the GR10 and GR11, the HRP also passes through or stays close by to various mountain villages throughout its length. One of the most interesting is Zugarramurdi (population: 225), which is accessed via a 7 km (4.2 mi) side trip from the Col de Nablarlatz (Stage 2). Zugarramurdi is a picturesque Basque village known for being the setting of witchcraft accusations in the early 1600s. According to legend, much of the occult activity took place in local caves, and irrespective of the veracity of the claims, a number of Zugarramurdi's residents were subsequently tried and burnt at the stake by the Spanish Inquisition. In more

recent times, the village has embraced its dark and tumultuous past in the form of the Dia de la Bruja (Day of the Witch) festival, which is celebrated around the time of the summer solstice each year.

Aside from its unique combination of natural, historical, and cultural elements, the Pyrenean Haute Route may well be—along with the GR10 and GR11—the only long-distance hike in the world where you can start with a dip in the ocean and finish with a swim in the sea. What lies between immersing yourself in these vast bodies of water is a multi-week invitation to experience an iconic range and the diverse peoples who have called it home for centuries. All that's required to accept the invitation is an open mind, an adventurous spirit, and a decent level of conditioning and backpacking experience. ◆

GOOD TO KNOW

About the Trail
/ <u>DISTANCE</u> 800 km (497 mi) approx.
/ <u>DURATION</u> 45 days
/ <u>LEVEL</u> Challenging

Start / Finish
⚲ Hendaye
⚲ Banyuls-sur-Mer

Highest Point
Col de Literole (2,983 m [9,787 ft])

Lowest Point
Atlantic Ocean and
Mediterranean Sea (0 m [0 ft])

Season
Mid-June to September

Accommodation
A wide range of accommodation is available,
including regularly spaced huts in the
mountains, and *gîte d'étapes* and hotels in the
villages. Bivouacking—setting up your shelter
late in the day and setting off again early the
next morning—is possible throughout the route.

BACKGROUND

The Colosseum of Nature One of the
scenic highlights of the Pyrenean Haute
Route is the spectacular Cirque de Gavarnie,
a huge limestone amphitheater described
by famed author Victor Hugo in 1843 as
the "the Colosseum of nature." Measuring
approximately 6.5 km (4 mi) wide and 1,500 m
(4,921 ft) high, the cirque is located 4 km
(2.5 mi) south of the village of Gavarnie, where
you can find accommodation and supplies.

Culinary Heritage Apart from enjoying
the pristine mountain scenery, don't miss
savoring the local culinary specialties. One
of them, *Tomme des Pyrénées,* should be on
the "must sample" list of every cheese-loving
hiker. Made from either pasteurized or
unpasteurized cow's milk, this rustic cheese
is usually wrapped in distinctive black wax
paper and can be found throughout the
Basque country.

HELPFUL HINTS

Resupply In all the villages along the HRP,
you can buy basic staples such as pasta,
bread, sausage, cheese, yogurt, cereals,
canned tuna, and chocolate. Provisions can
also sometimes be purchased at the staffed
mountain huts, all of which serve hearty
and reasonably priced meals.

Water The villages along the route have
fountains or pumps from which potable
water can be obtained. While in the
mountains, it is recommended to treat
any water taken downstream of human
settlement, grazing animals, or agriculture.

FLORA & FAUNA

Pyrenean Brown Bear (*Ursus arctos***)**
The Pyrenees were once home to a thriving
population of brown bears, the last of
which was said to have been killed in
the early 1990s. Since then, periodic
attempts have been made to reintroduce
the species into the range using bears
from Slovenia. As of 2017, there were
thought to be around 30 brown bears in
the Pyrenees. The repopulation program
of the French government continues
to be strongly protested by farmers on both
sides of the Franco-Spanish border, who
blame the bears for the deaths of hundreds
of their sheep.

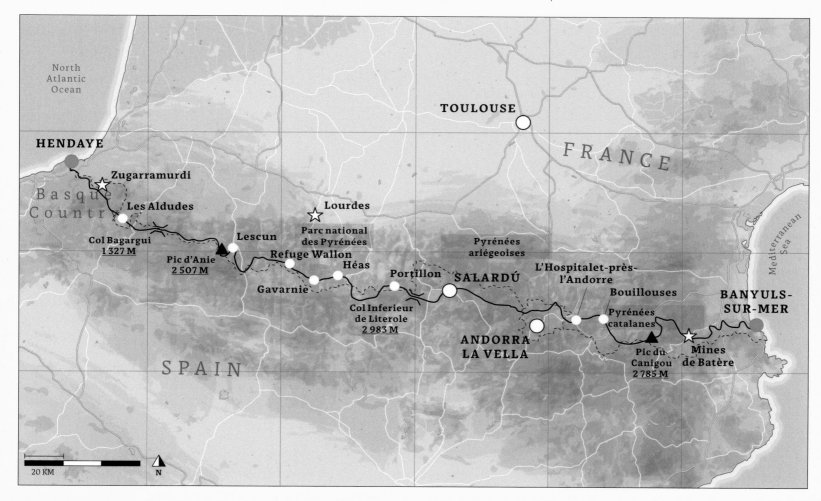

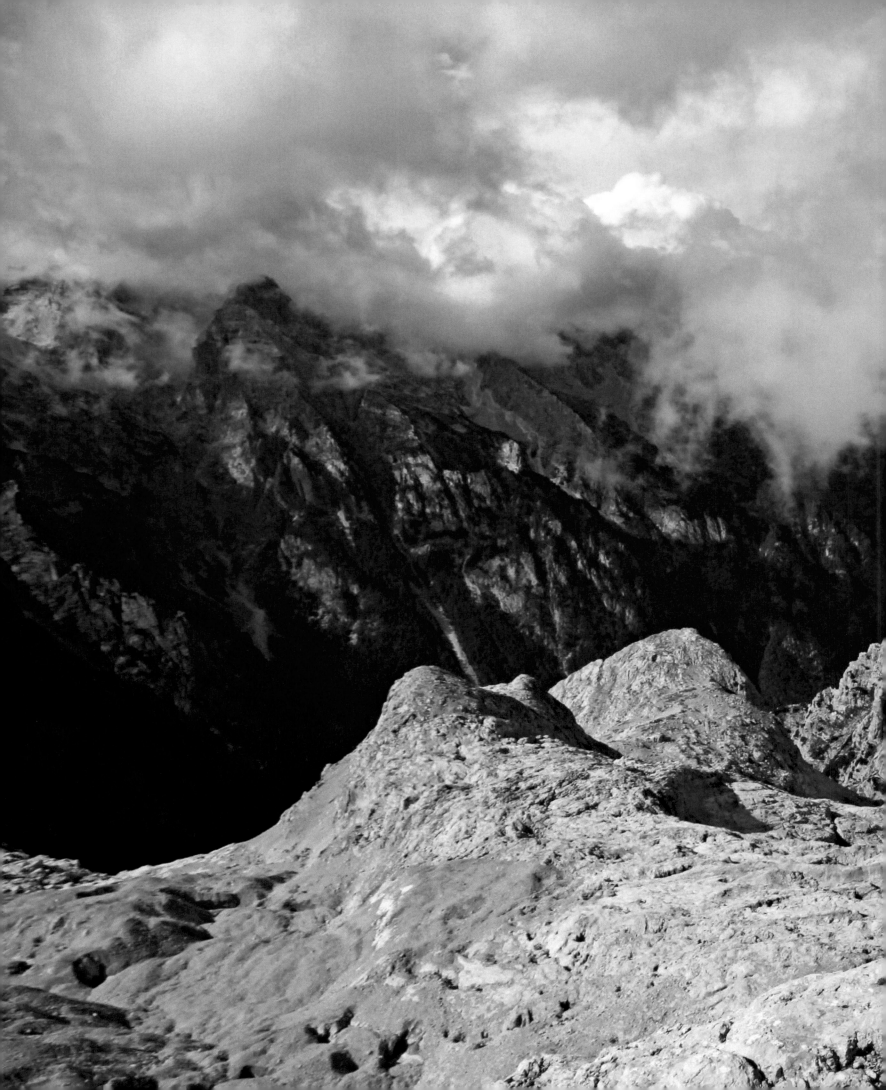

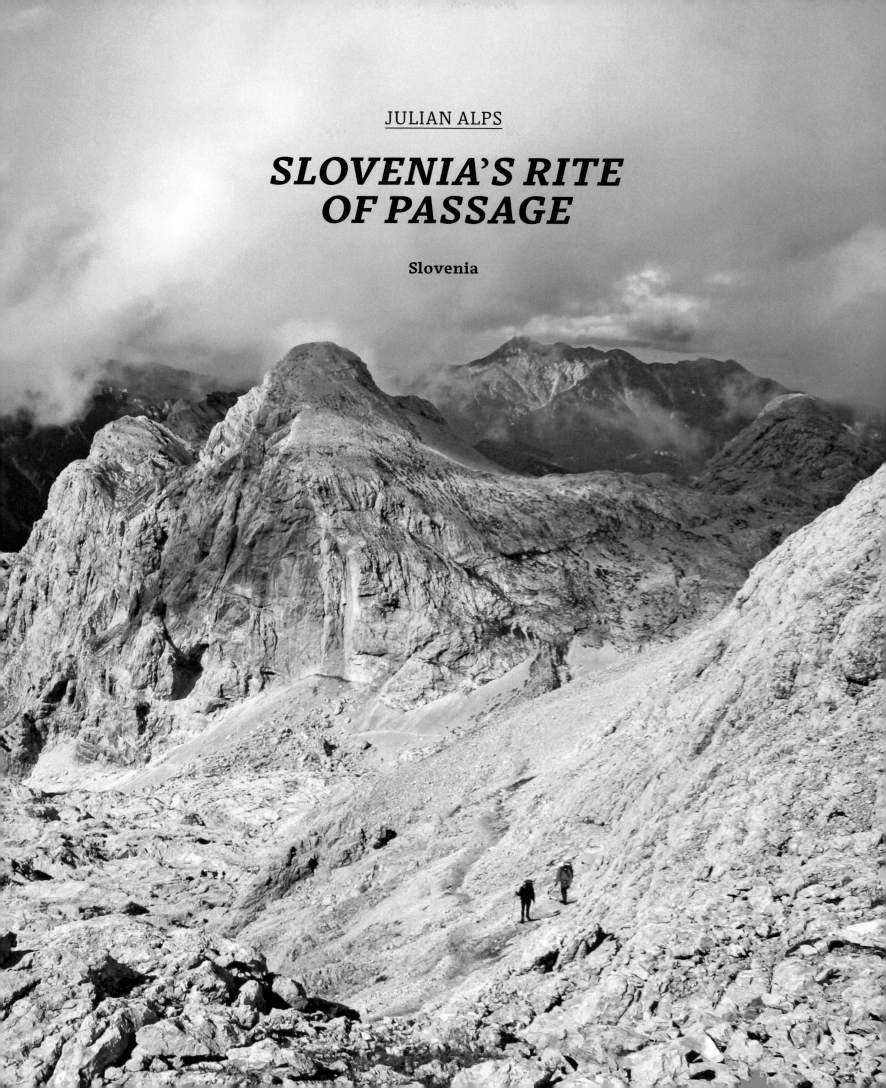

JULIAN ALPS

SLOVENIA'S RITE OF PASSAGE

Slovenia

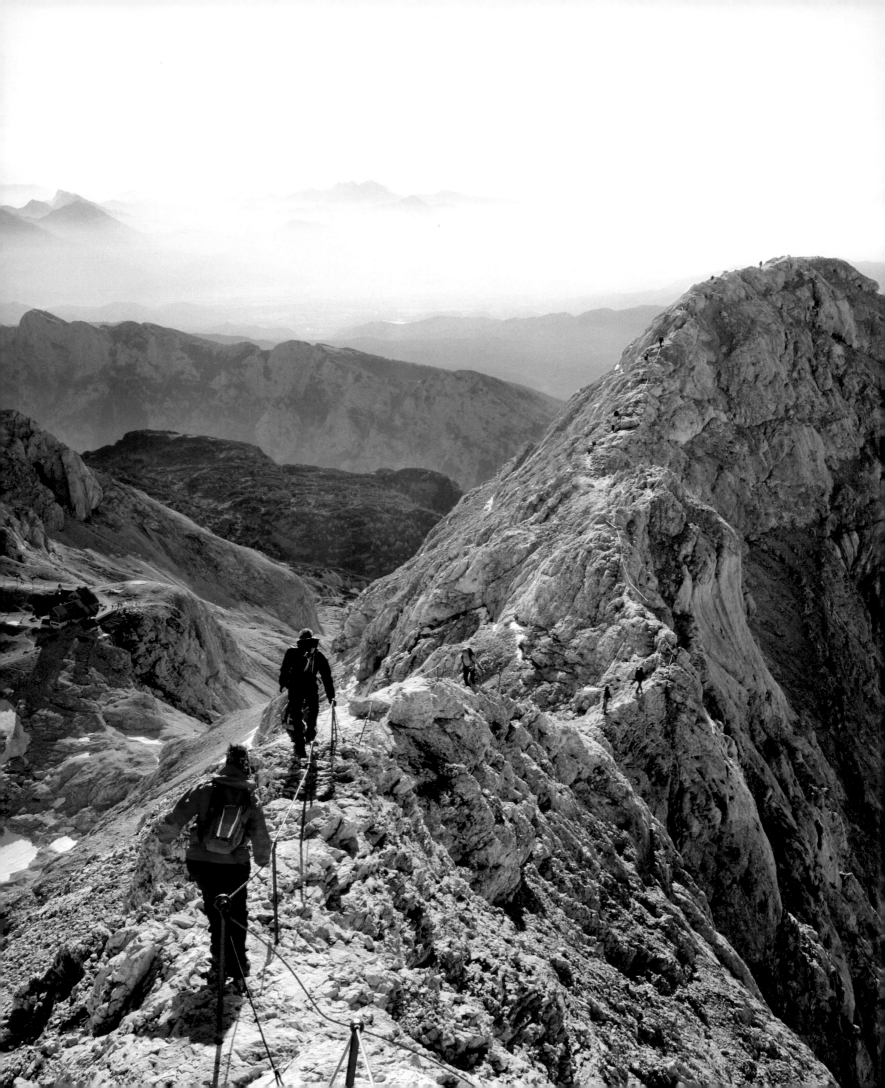

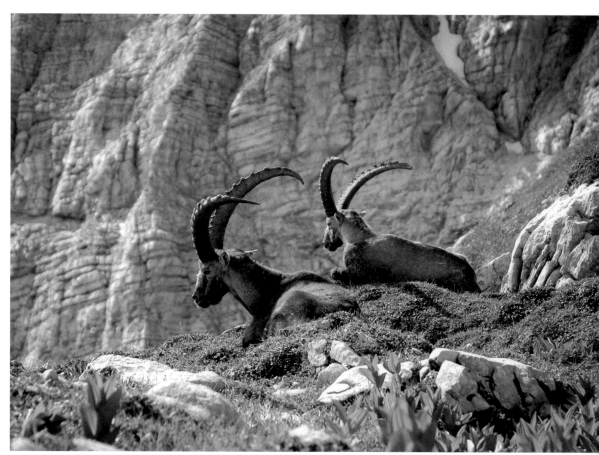

Left: Hikers climbing along the ridge of Mount Triglav.
Above: Ibex surveying their mountain home.

M ount Triglav (2,864 m [9,396 ft]) is Slovenia's highest mountain and preeminent national symbol. Its image is depicted on the country's flag, such is its importance in the hearts and minds of its citizens. Former president Milan Kučan once said that it was the duty of all Slovenians to climb it at least once during their lifetime. Of the multiple routes that lead to its pyramid-shaped summit, possibly the most scenic is via the legendary Seven Lakes Valley, a place known for its karst topography, magical chamois folklore, and, of course, a collection of picture-perfect lakes.

The namesake and centerpiece of Slovenia's only national park (est. 1981), Mount Triglav is located in the eastern part of the Julian Alps, a range that extends from northeastern Italy to Slovenia. A mixture of limestone peaks, alpine meadows, and glacier-carved valleys, the Julian Alps are not as high or well known as their alpine cousins to the west, but are just as beautiful and far less crowded. Dotted with welcoming mountain huts and laced with a myriad of trail options, the area was made to be explored and experienced on foot.

The featured trail is a horseshoe-shaped route located on the southern side of Mount Triglav: the Southern Triglav Horseshoe (STH), to assign it a name. It ascends to the summit via the Seven Lakes Valley, and subsequently descends via Voje Valley. In terms of difficulty, it is a trail that can be done by a fit hiker with a reasonable amount of experience and a good head for heights. The STH is normally completed in either two long or three shorter days, and although climbing experience is not a requirement, ▶

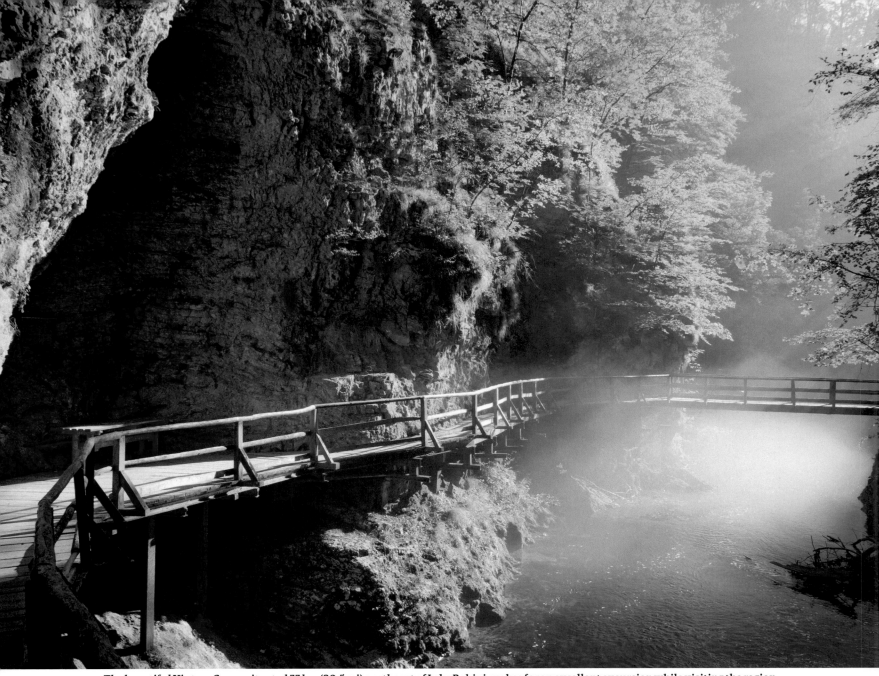

The beautiful Vintgar Gorge, situated 33 km (20.5 mi) northeast of Lake Bohinj, makes for an excellent excursion while visiting the region.

Peričnik Falls, a highlight of Triglav National Park.

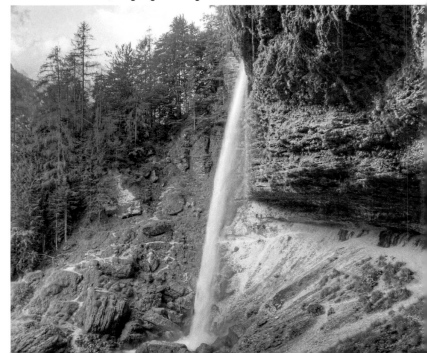

Former president Milan Kučan once said that it was the duty of all Slovenians to climb Mount Triglav at least once during their lifetime.

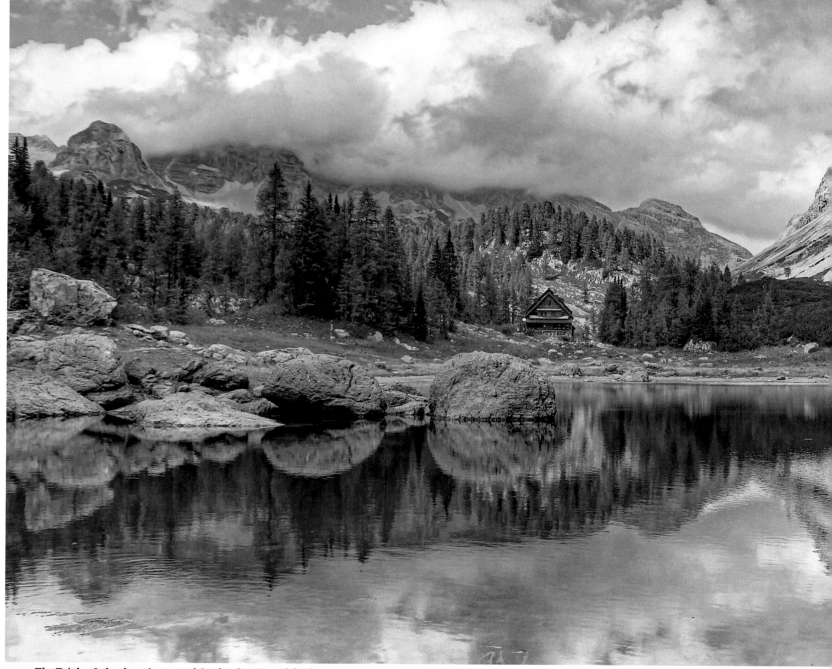

The Triglav Lakes hut sits at an altitude of 1,683 m (5,521 ft).

it is recommended that all hikers wear helmets on the trail's steep scrambling sections due to a chance of rocks being dislodged by hikers above.

The Southern Triglav Horseshoe begins at Koča pri Savici, located 4 km (2.5 mi) by road from Lake Bohinj. The path gradually climbs through peaceful beech forest, and later becomes steep and more challenging as it approaches the Seven Lakes Valley. This area is famed as the location of one of Slovenia's most beloved fairytales. The story of Zlatorog (Goldhorn) is a fable of love, treasure, and, ultimately, tragedy. The protagonists are a young and desperate hunter from Trenta Valley and Zlatorog, a nearly indestructible white chamois buck with golden horns. After being wounded by the young hunter's gunshot, Zlatorog is revived thanks to the magical flower petals that

grew out of his spilt blood. Understandably enraged, he subsequently charges the boy, who had been giving chase along a narrow ledge. The boy is blinded by the sun's reflection off the white chamois's golden horns, and falls from the cliff to his death.

Back to the trail. A stop for lunch is in order among the limestone crags and shimmering blue waterholes of the Seven Lakes Valley, before continuing on to Tržaška koča na Doliču (Dolič hut: 2,151 m [7,057 ft]). Overnight accommodation can be procured here. Triglav National Park's atmospheric refuges boast hearty food, red wine, and, more often than not, an international cast of diners. Sitting down and enjoying a meal and conversation with other trekkers can be as much a part of hiking in Slovenia's Julian Alps as the spectacular mountain scenery itself. ▶

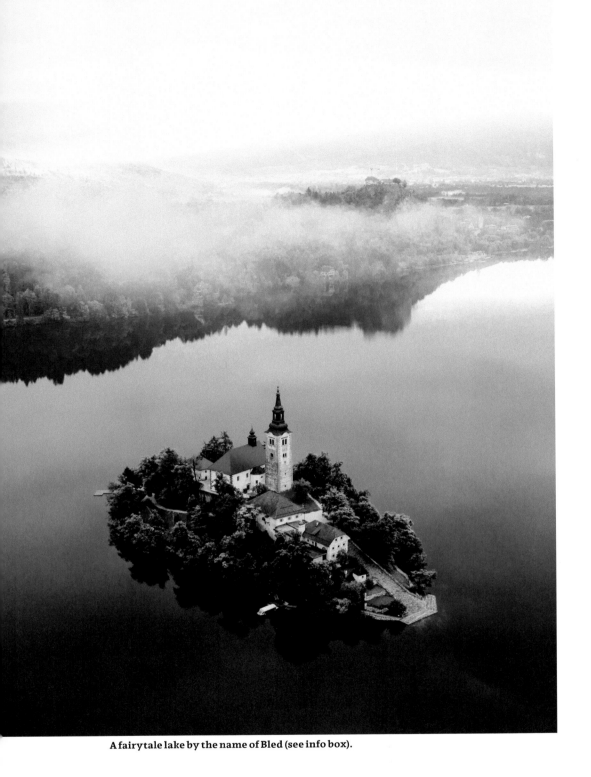

A fairytale lake by the name of Bled (see info box).

Mount Triglav is much more than a mountain to the Slovenian people. Since the early years of the twentieth century, it has been a symbol of hope and resistance.

The following morning sees an early start, and a final two- to three-hour push to the summit. Along the way, expect to negotiate precarious ledges and cliffs with the aid of metal ladders, holds, and cables—collectively known as *via ferrata* (iron path). The views are magnificent upon reaching the summit, a veritable wonderland of jagged rocky towers and ice-age sculpted valleys stretching out in all directions. For those hikers who wish to truly embrace the moment in traditional Slovenian style, a lighthearted birching (or spanking) of the bottom is customary. Often accompanied by cheers, clapping, and songs from local summiteers, this jovial (and maybe a tad kinky) tradition dates back decades. Its origins may be murky, but it certainly makes for a unique celebration on top of one of Europe's beloved peaks.

Mount Triglav is much more than a mountain to the Slovenian people. Since the early years of the twentieth century, when the Julian Alps were the site of some of the First World War's bloodiest battles, Triglav has been a symbol of hope and resistance. By following the Slovenian rite of passage in summiting it, you will gain a window into the culture of this small but fiercely independent alpine nation. ◆

About the Trail
/ <u>DISTANCE</u> 33 km (20.5 mi)
/ <u>DURATION</u> 2 to 3 days
/ <u>LEVEL</u> Moderate to challenging

Start / Finish
⚲ Koča pri Savici
⚲ Stara Fužina

Highest Point
Mount Triglav (2,864 m [9,396 ft])

Lowest Point
Stara Fužina (546 m [1,791 ft])

Season
Mid-June to end of September

Conditions
Afternoon and evening thunderstorms are common in July and August. Try to avoid hiking on the high and exposed parts of the mountain at these times of day during summer.

Accommodation
Mountain huts. Book well in advance during the main trekking season.

HELPFUL HINTS

A Side Trip to Lake Bled Lake Bled is the most famous attraction in Slovenia, and is less than a 40-minute drive to the Koča pri Savici trailhead. Bled is one of those enchanting places that ticks all of the fairytale boxes: dramatic mountain setting, medieval cliff-top castle, and an impossibly picturesque island in the middle of its cobalt-blue waters. From a hiking perspective, there is a mellow 6 km (3.7 mi) trail around its circumference. But for the best lake views, climb the 634 m (2,080 ft) Straža hill, which rises above its southeastern shore.

FLORA & FAUNA

Green Slovenia Slovenia is the third most forested country in Europe (after Finland and Sweden). 40 percent of its total area is covered by mountains, and in 2016, it was recognized as one of the five greenest countries in the world by researchers at Yale and Columbia universities and the World Economic Forum.

BACKGROUND

Historical Aljaž Tower Situated on the summit of Mount Triglav is a rocket-shaped tower by the name of Aljaž. Dating back to 1895, Aljaž had a practical function, acting as an emergency shelter and triangulation point on Slovenia's highest peak. From a cultural and historical point of view, it has long been considered an important symbol of Slovenian nationhood. During the Communist era, when Slovenia was part of the former Yugoslavia, it was painted red, with authorities placing a red star on top. However, shortly before the fall of the Soviet Union, the star was removed and the tower restored to its original metallic gray—as it still appears to this day.

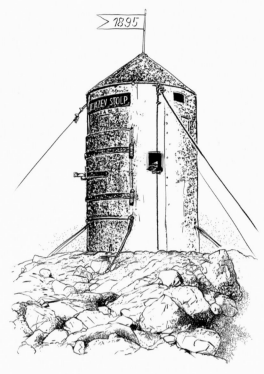

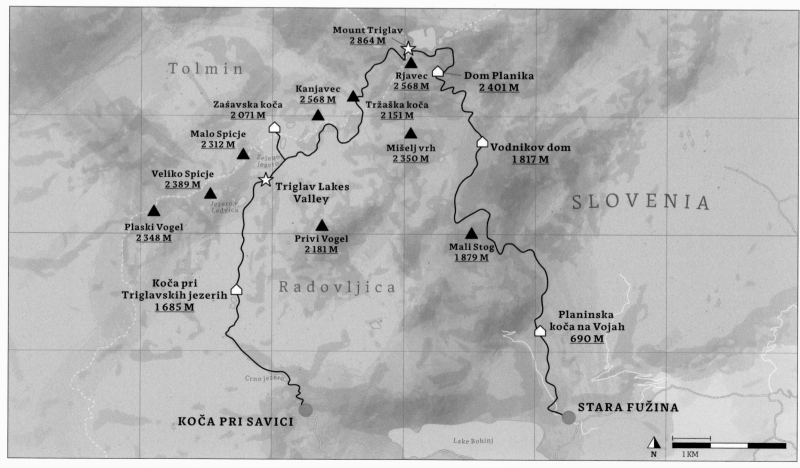

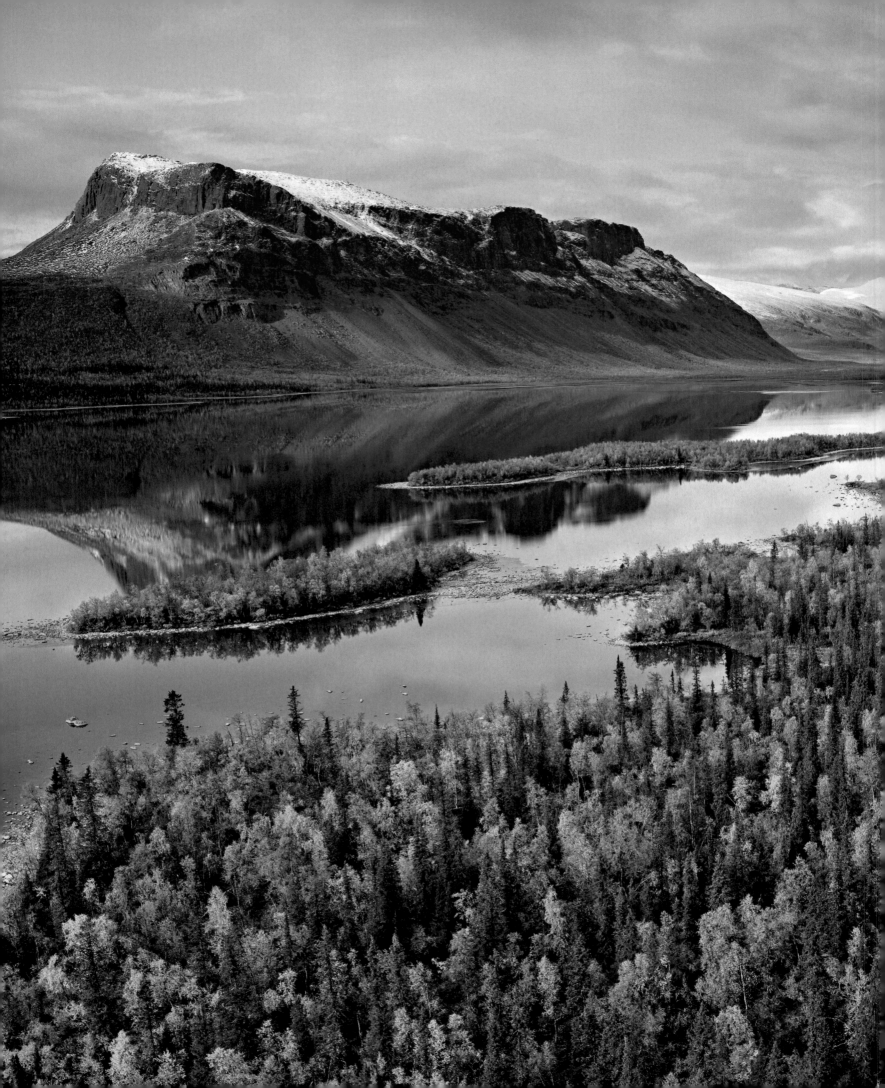

SAREK NATIONAL PARK

EUROPE'S LAST GREAT WILDERNESS

Sweden

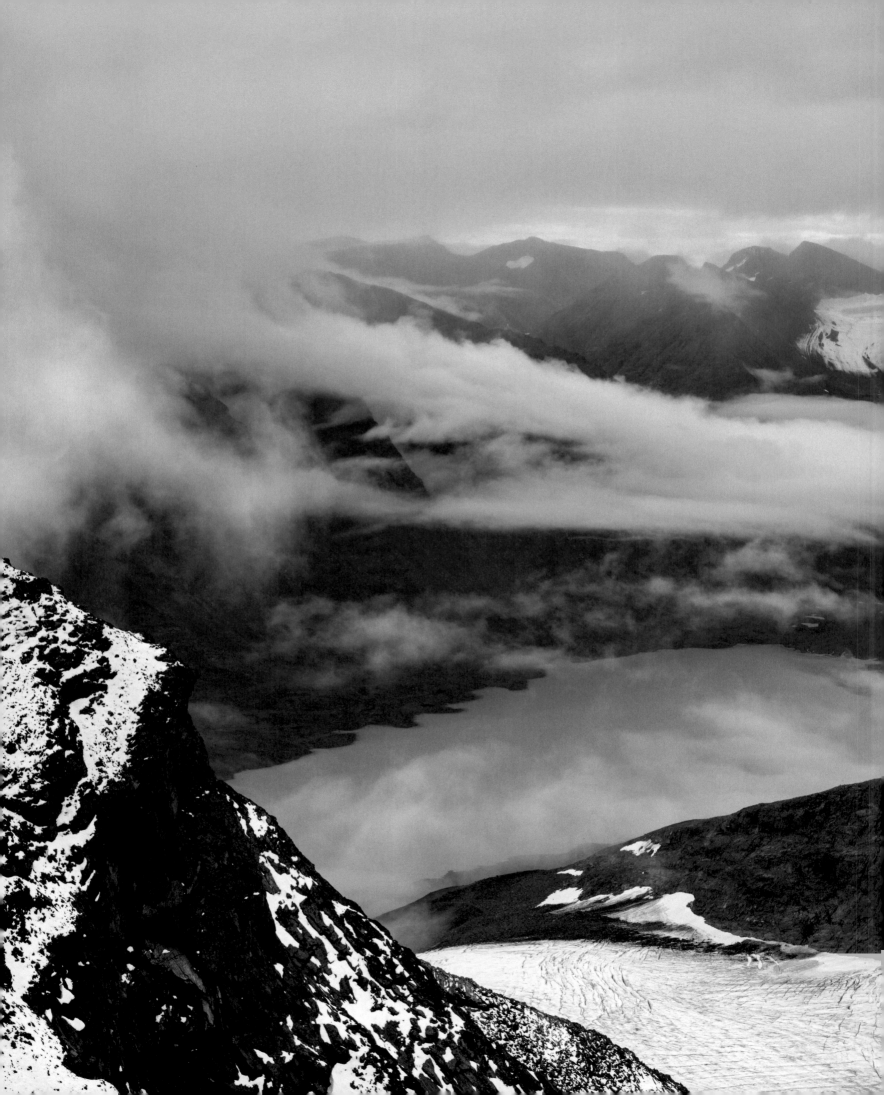

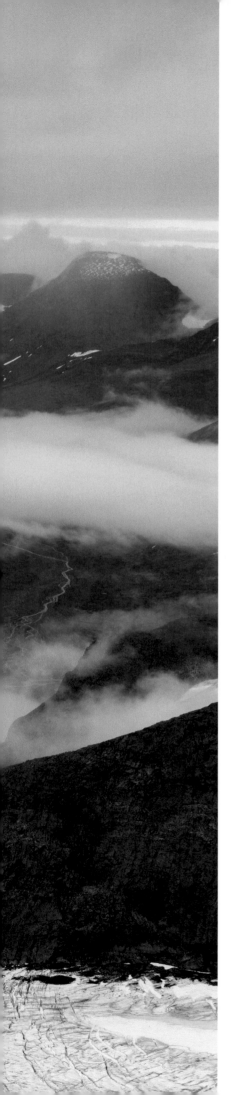

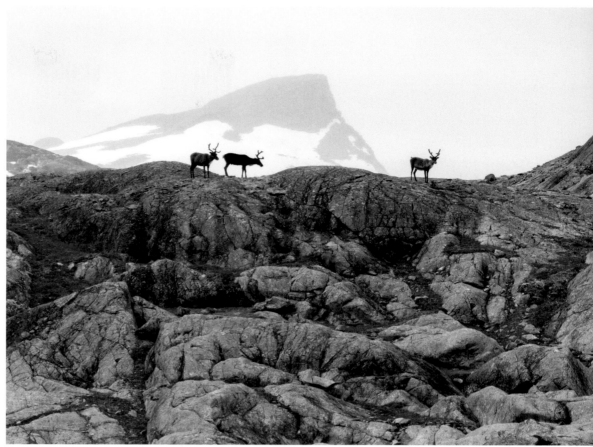

Left: View from Vuojnestjåhkkå overlooking Bierikjavrre.
Above: Reindeer and rocky passes.

The remote location of Sarek National Park, combined with its rugged and trailless terrain, makes it an off-the-beaten-track destination for experienced climbers, cross-country skiers, and hikers. Located in Swedish Lapland, Sarek's pristine landscape boasts more than 100 glaciers, six of the country's thirteen highest peaks, and an array of wildlife, including bears, wolves, lynx, and moose. With no tourist infrastructure and almost no paths or signs, Sarek is to Swedes what Alaska is to Americans—a raw, untamed land where dreams of outdoor adventures await.

The featured route begins in Akkastugorna in the east and finishes at the Saltoluokta Lodge in the west. Both trailheads are accessed via short boat rides from Ritsem and Kebnats, respectively. In the space of 109 km (68 mi), the route passes through alpine tundra and glaciated valleys, offering spectacular views of surrounding snowy peaks standing sentinel-like on either side of the low-lying areas. During the trek, hikers will ford freezing-cold rivers, trudge their way through long stretches of soggy terrain, and traverse wide-open spaces, which, for millennia, have acted as migratory paths for herds of reindeer in search of foraging grounds.

Reindeer have long been a source of livelihood for Sarek's original inhabitants, the semi-nomadic Sami people. With a population that is spread across northern Scandinavia and the Kola Peninsula of Russia, ▶

the Sami traditionally lived in *siidat,* small communities in which members worked together—hunting, fishing, and tending their reindeer herds—for the economic benefit of the whole group. It was not until 1977 that they were recognized by the Swedish government as an indigenous group and minority people, with rights to the territory encompassing Sarek National Park. It was at that time that the Sami communities of Sirkas, Jåhkågaskka, and Tuorpons were officially granted permission to pasture their herds within park boundaries.

Reindeer are commonly sighted in Sarek during the hiking season, but they are by no means the only large mammals found within the park. The area is also home to brown bears, lynx, wolverine, and Europe's largest species of moose (see info box). The best place to spot wildlife

Breakfast in Sarek.

Clear morning skies in one of Sweden's rainiest places.

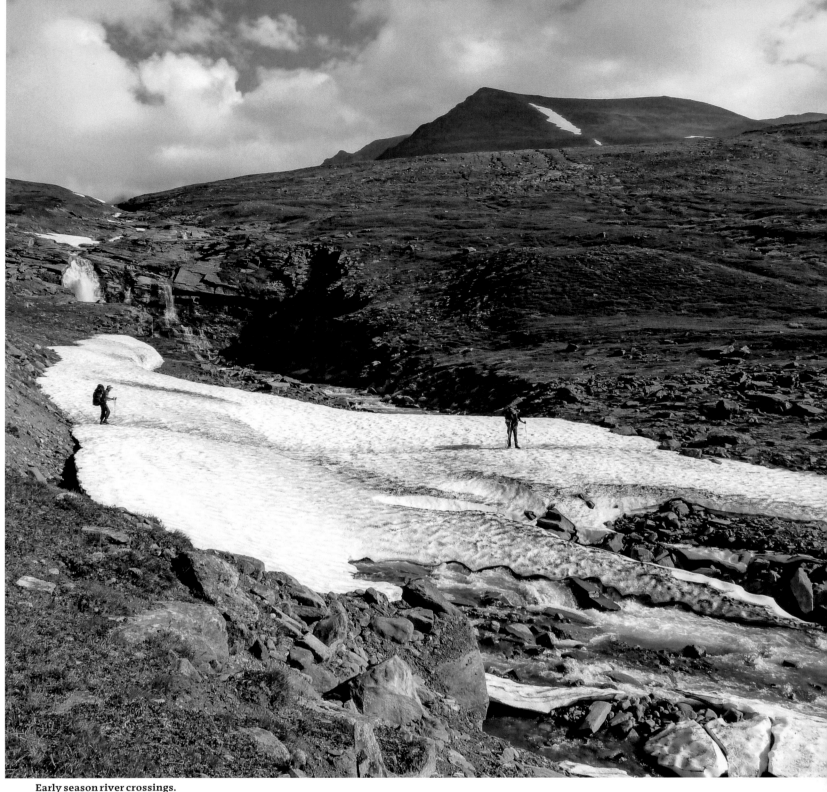

Early season river crossings.

is in the lush Rapa Valley, from where hikers can make a side trip up to Snávvávágge and Låddebákte peak (1,537 m [5,042 ft]) to behold breathtaking views of the forested valley below, as well as a mesmerizing tapestry of watercourses snaking its way off to the distant horizon.

Due to the changeable, unpredictable nature of meteorological conditions in Sarek, there are no guarantees as to how many of these beautiful features will be visible. With its reputation as being one of the rainiest places in all of Sweden, the park is not a place you want to be without good backcountry skills or the right attire and equipment (e. g. storm-worthy tent, quality rain gear, GPS/topographic maps and compass), especially given the rugged terrain and the dearth of shelters. Sarek is not called Europe's "last great wilderness" for nothing, and for those unprepared, it can be unforgiving.

This pure arctic outback is one of the largest and last remaining places on Earth where the traditional way ▶

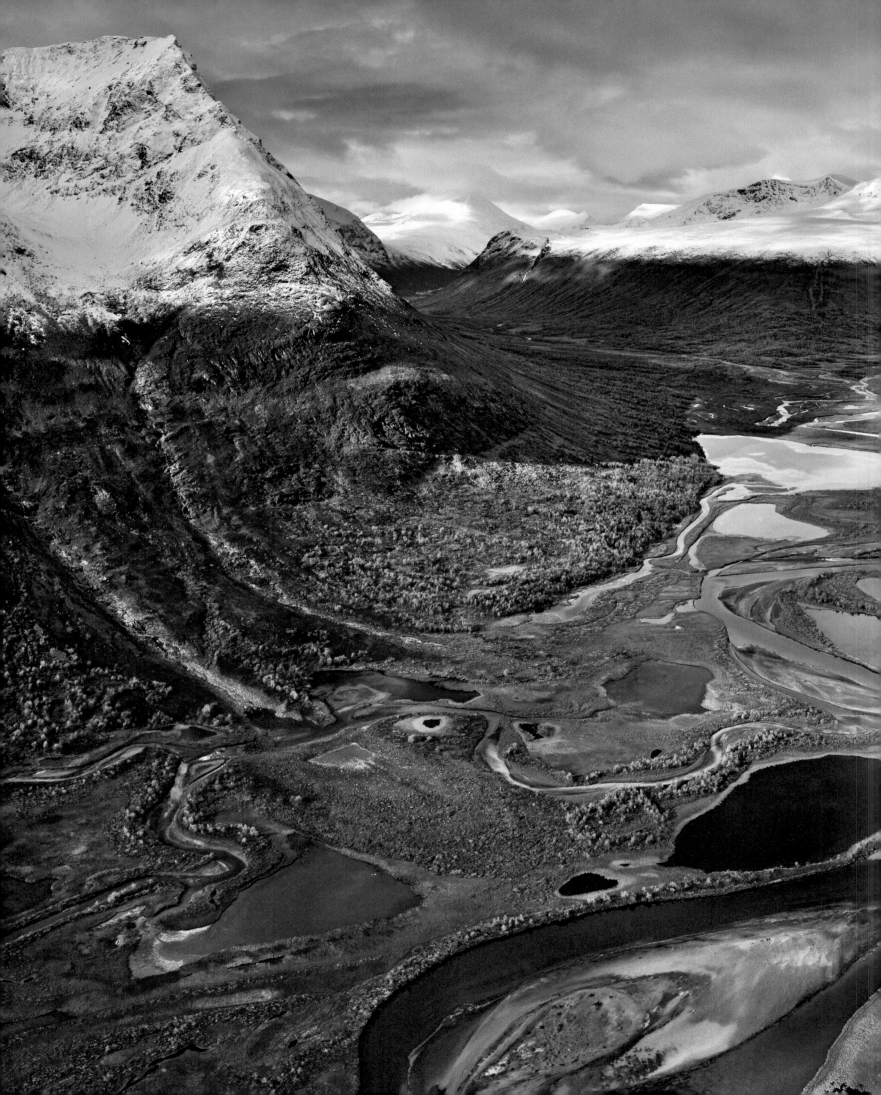

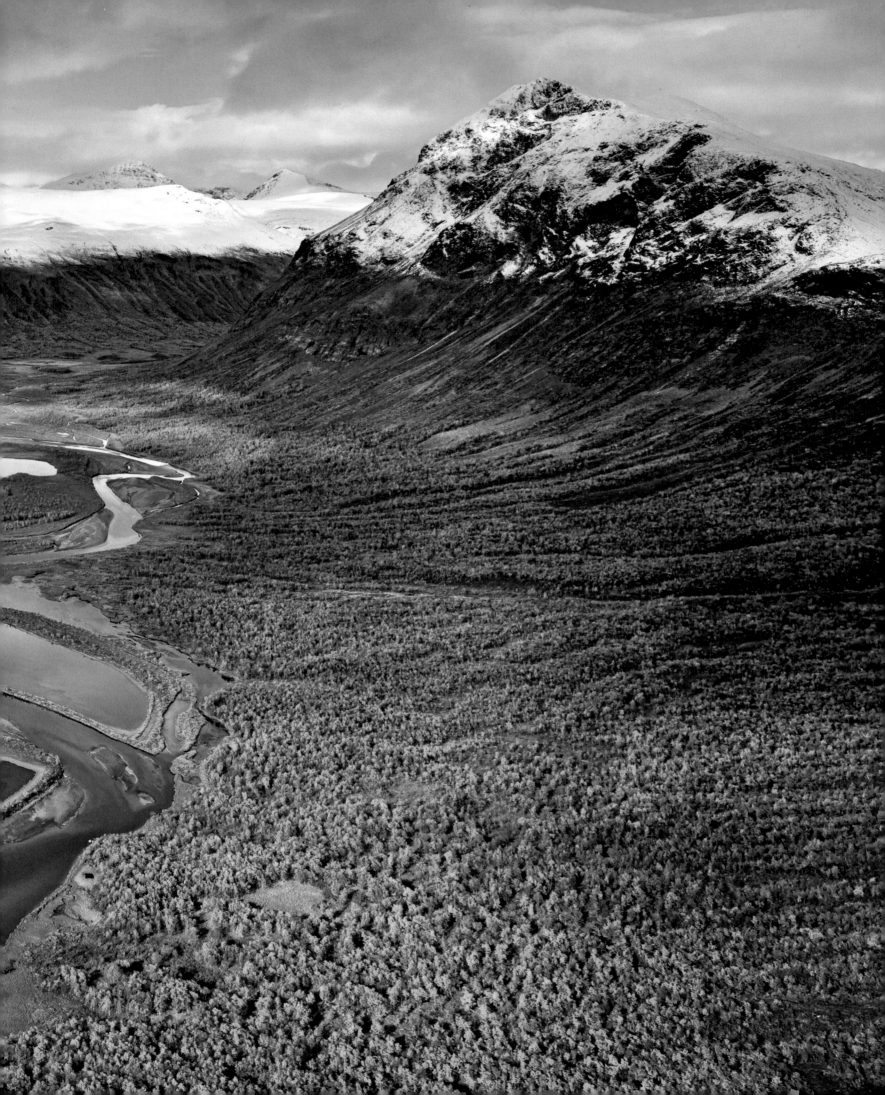

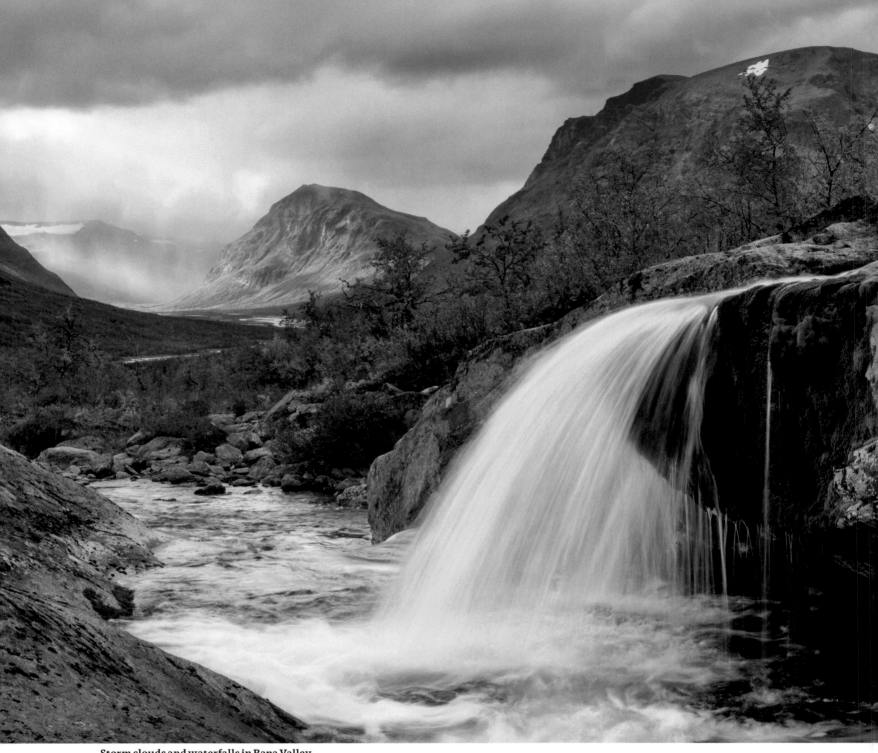

Storm clouds and waterfalls in Rapa Valley.

of life is still based on the seasonal migration of livestock. When you find yourself following one of the reindeer's ancient migratory paths during the hike (they can make for a welcome respite from the often boggy tundra), take a moment to appreciate that you are taking part in one of the world's most amazing natural phenomena with each footstep. And if you are fortunate enough to encounter a herd of these characterful and hardy quadrupeds, be sure to give them a wide berth as they make their way to their summer pastures, just as their ancestors have done for thousands of years before them. ◆

With no tourist infrastructure and almost no paths or signs, Sarek is to Swedes what Alaska is to Americans—a raw, untamed land where dreams of outdoor adventures await.

GOOD TO KNOW

About the Trail
/ DISTANCE 109 km (68 mi)
/ DURATION 5 to 7 days
/ LEVEL Challenging

Start / Finish
⚲ Akkastugorna
⚲ Saltoluokta Lodge

Season
Late June to September

Conditions
Sarek is known as one of the stormiest areas in Sweden. The unpredictable weather, combined with the lack of shelters and trailless nature of the terrain, means that it is not a place you want to be without sufficiently warm layers and proper rain gear. As one of Sweden's most famous proverbs says: "Det finns inget dåligt väder, bara dåliga kläder" (There is no bad weather, there are only bad clothes).

Resupply
All supplies should be brought from Gällivare or Kiruna.

FLORA & FAUNA

The Giant Moose of Sarek Sarek National Park is home to Europe's largest moose. Officially protected from the yearly

hunting season, moose in this area grow bigger than their relatives in other parts of Sweden, as well as in Norway, Finland, Russia, and Poland. Females weigh in between 200 kg (441 lb) and 360 kg (794 lb), while males range from 380 kg (838 lb) to a whopping 850 kg (1874 lb). Fun fact: Sweden has more moose per square kilometer than any other country in the world, with a total population of around 400,000.

Cloudberries Native to the upper regions of the northern hemisphere, cloudberries (*Rubus chamaemorus*) can be found in the bogs and tundra of Sarek National Park. They usually flower in June after the snowmelt, and then ripen into juicy amber-colored berries in July and early August. Considered an endangered species, the berry is in high demand in culinary circles and serves as the regional symbol of Lapland.

HELPFUL HINTS

Kungsleden For those who want to experience similar arctic landscapes to those found in Sarek but aren't sure they possess the necessary skills, the Kungsleden (King's Way) is an excellent alternative. Beginning in the nearby village of Abisko, this classic trail stretches 440 km (270 mi) from north to south, and boasts a well-maintained path and regular mountain huts throughout its duration, where meals and lodging can be arranged.

BACKGROUND

Europe's First National Parks
The Yellowstone region of Wyoming, Montana, and Idaho was declared the world's first national park by the U.S. government in 1872. Inspired by this landmark conservation decision, Swedish explorer Adolf Erik Nordenskiöld proposed an equivalent type of protection for his own country's abundant wilderness areas in 1880. Almost three decades later, in 1909, the proposition was finally adopted, and Sarek and eight other natural areas in Sweden were declared Europe's first national parks. The other ones were Abisko, Garphyttan, Gotska Sandön, Hamra, Pieljekaise, Stora Sjöfallet, Sånfjället, and Ängsö. Overall, there are 28 national parks in Sweden today.

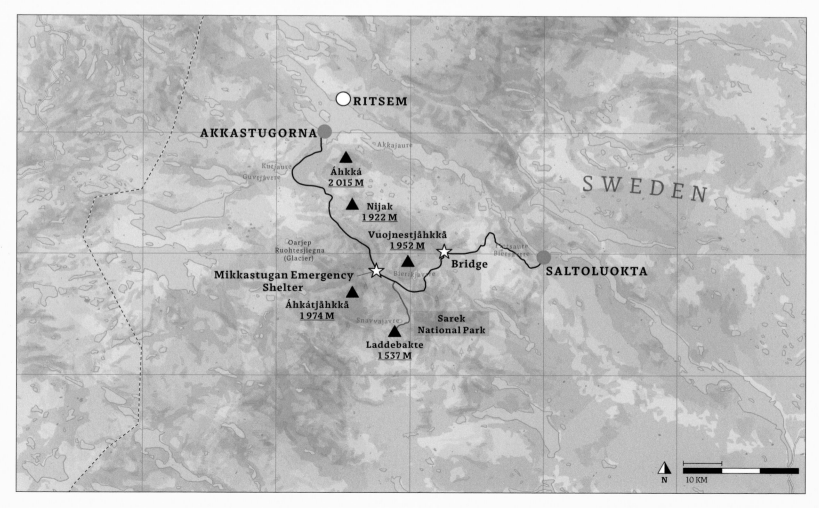

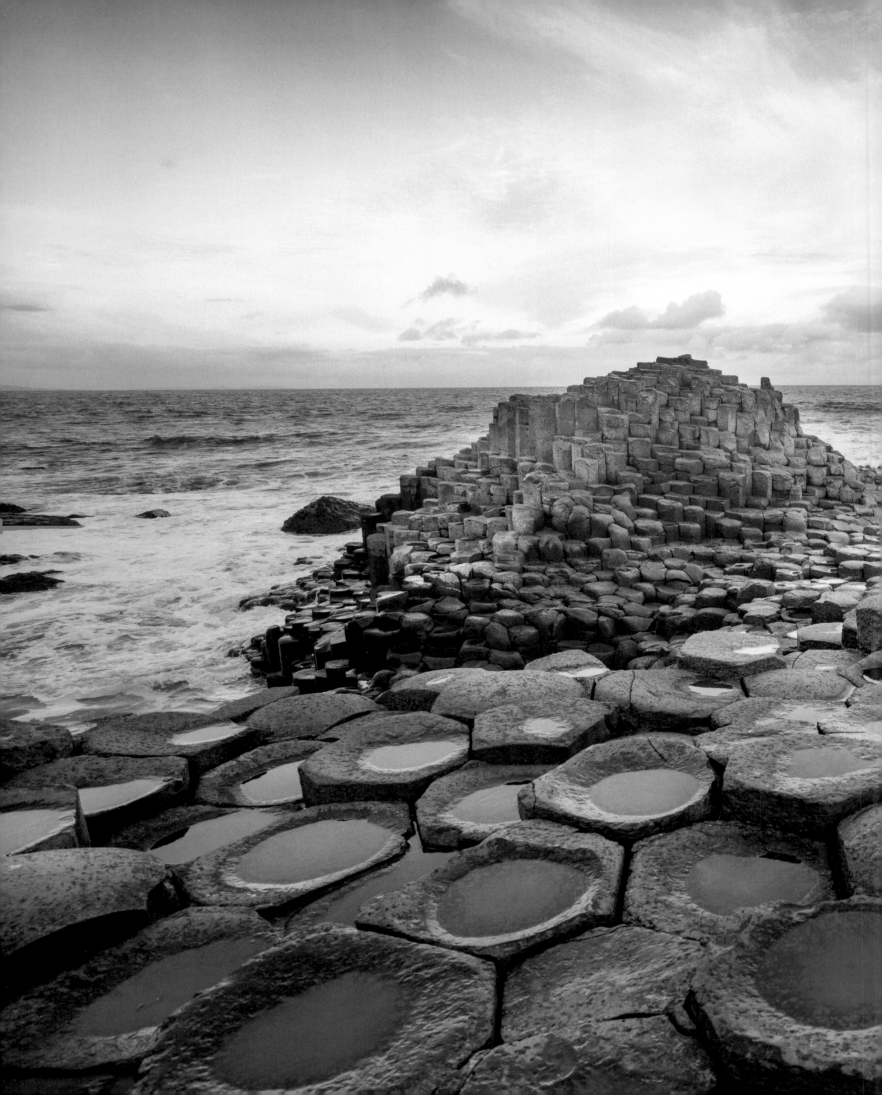

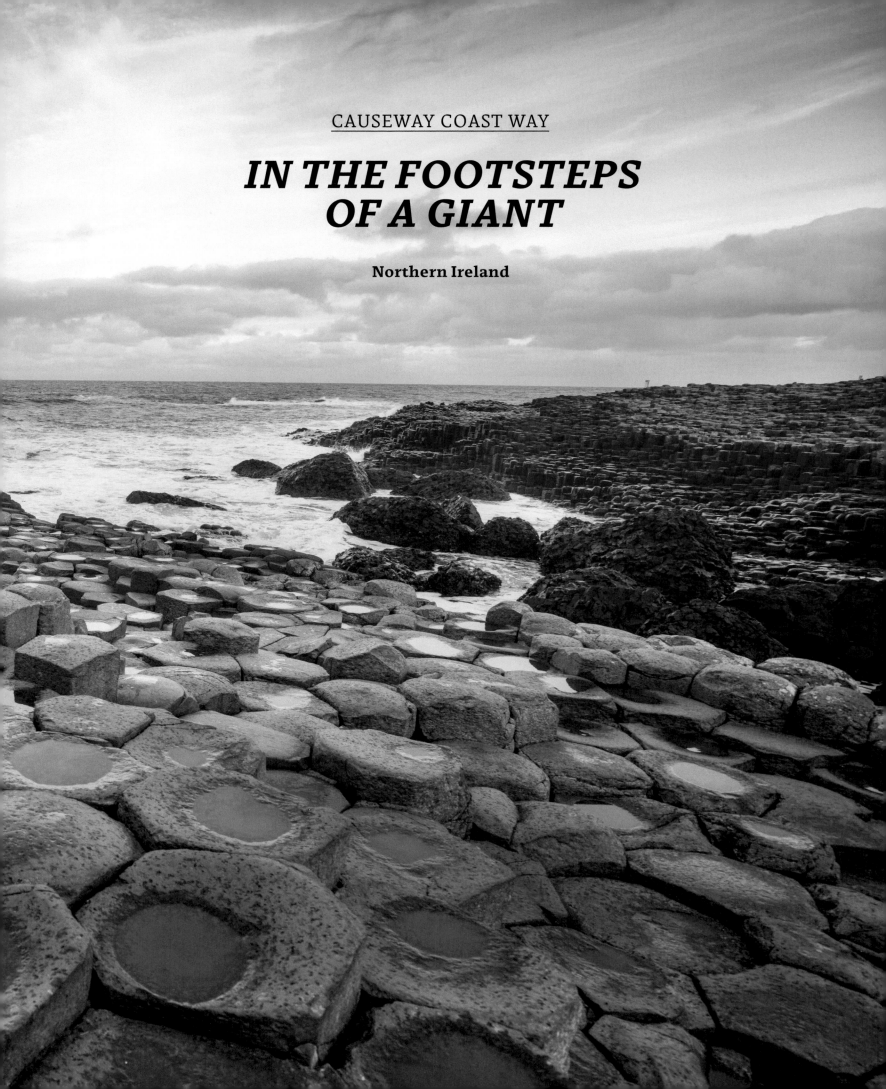

IN THE FOOTSTEPS OF A GIANT

Northern Ireland

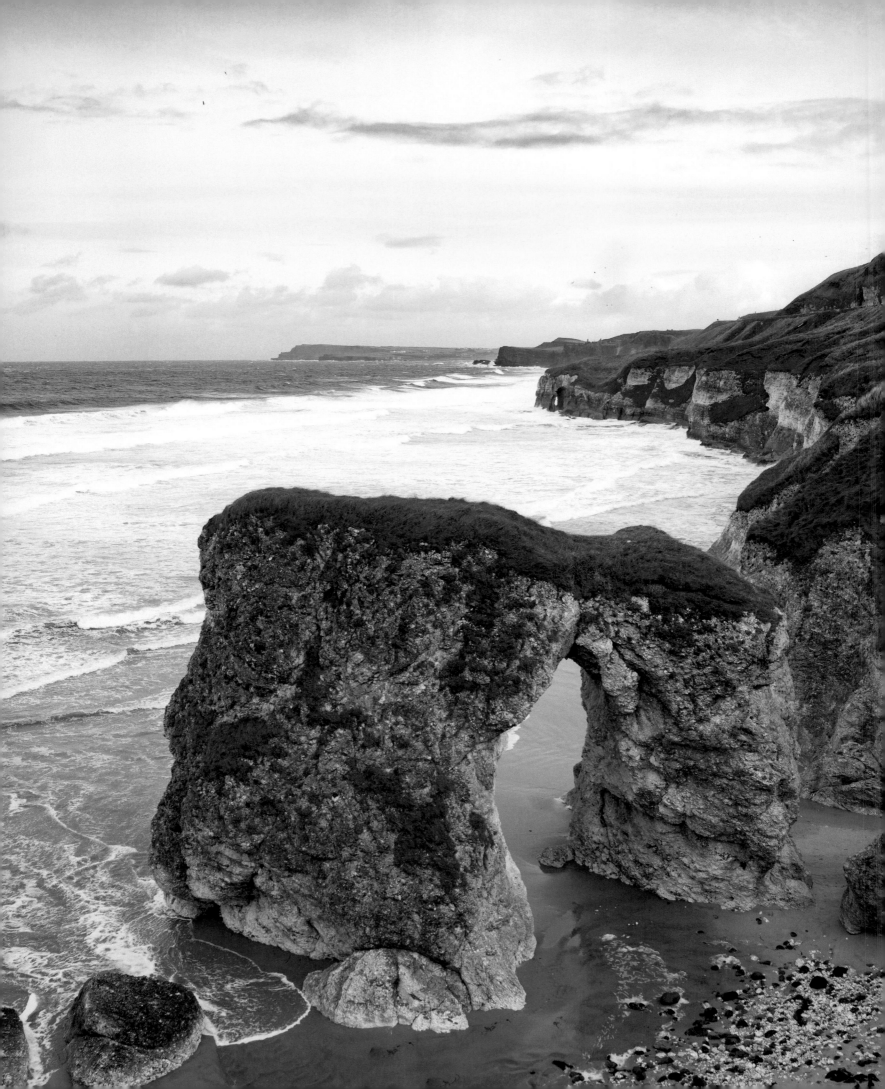

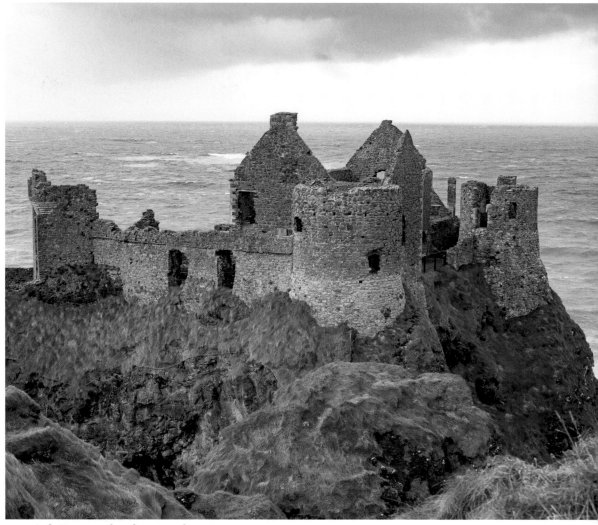

Left: Wave-sculpted stone arch.
Above: Dunluce Castle.

Part of what makes the Causeway Coast Path so special are the lesser-known marvels: the secluded beaches, the emerald green fields, the dramatic seascapes, and the rugged basalt cliffs.

The Causeway Coast of Northern Ireland is renowned as one of the world's most incredible coastlines. It is a place of myths and legends, dramatic cliffs and windswept beaches, charming villages and historic landmarks. And there is no better way to experience its wonders, both natural and man-made, than by hiking the Causeway Coast Way (CCW).

Stretching some 51 km (31.5 mi) between the towns of Ballycastle and Portstewart, the CCW is a well-signed trail with a mellow gradient (the highest point is only 140 m [459 ft] above sea level), making it suitable for hikers of all ages and abilities. It is possible to do the trek at any time of year, though the shoulder seasons of spring and autumn arguably offer the best balance of weather, lower prices, and smaller crowds. ▶

53

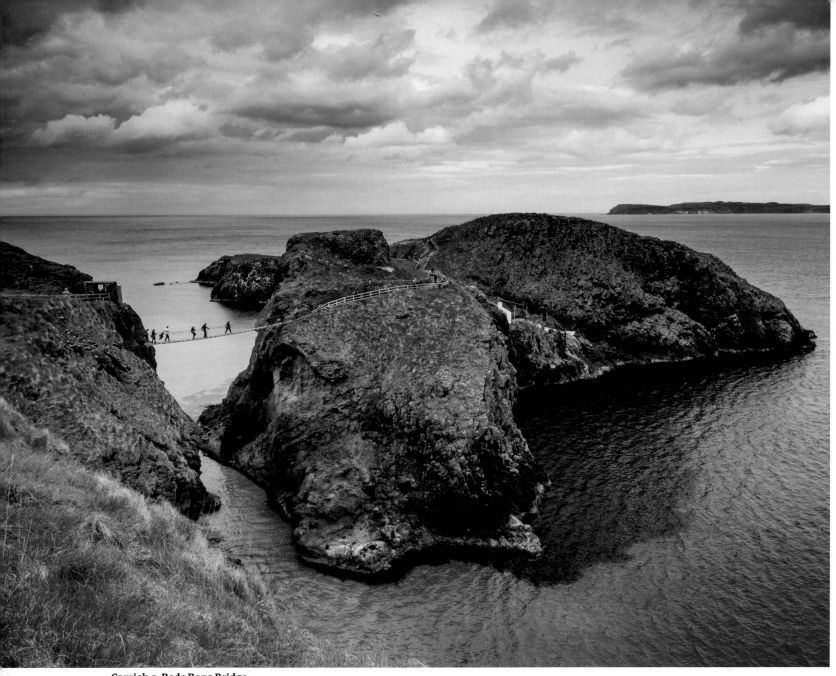

Carrick-a-Rede Rope Bridge.

Inquisitive locals.

As much a walk through time as it is a coast-hugging pathway, two of the most notable historic features encountered on the CCW are Dunluce Castle and Old Bushmills Distillery. The former dates back to the fourteenth century, and is stunningly situated on a rocky outcrop overlooking the North Atlantic. One of Northern Ireland's most famous landmarks, its image appeared on the inner sleeve of Led Zeppelin's iconic *Houses of the Holy* album; it is also said to have been the inspiration for Cair Paravel castle in C. S. Lewis's *The Chronicles of Narnia*. The distillery is not quite as old as the castle, but for hikers in search of a more literal "taste" of local culture, it makes for a short and satisfying detour from the trail. Bushmills is said to be the world's oldest whiskey distillery, with a history dating back to 1608. It's a great place to while away

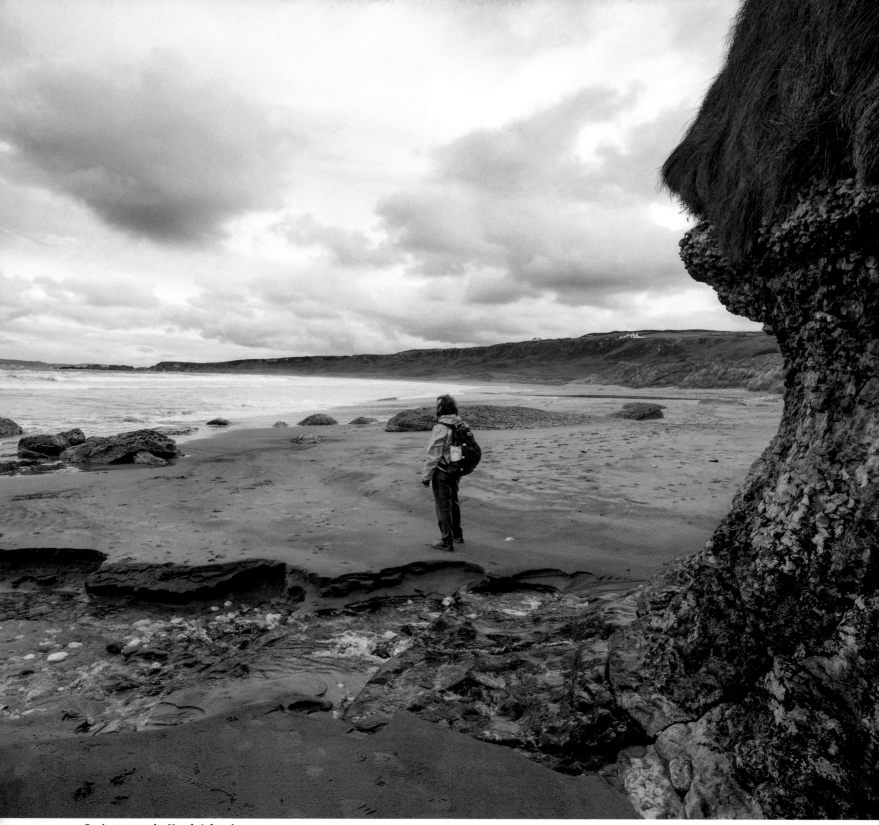

Gazing out at the North Atlantic.

a few hours, and if you decide to take the rest of the day off after sampling some of the establishment's finest malts, there are plenty of accommodation options available in the surrounding village.

Though the man-made highlights are undeniably memorable, it is the Giant's Causeway that is the standout of the CCW. Situated only 3 km (1.8 mi) from Bushmills village, this World Heritage-listed site consists of 40,000 interlocking basalt columns that resulted from an ancient volcanic eruption an estimated 50 to 60 million years ago. It's an amazing sight to behold at any time of day, but if you have the opportunity to witness it at sunrise or sunset, you are in for a special treat. The columns glow in the soft morning and late-afternoon light, and, when combined ▶

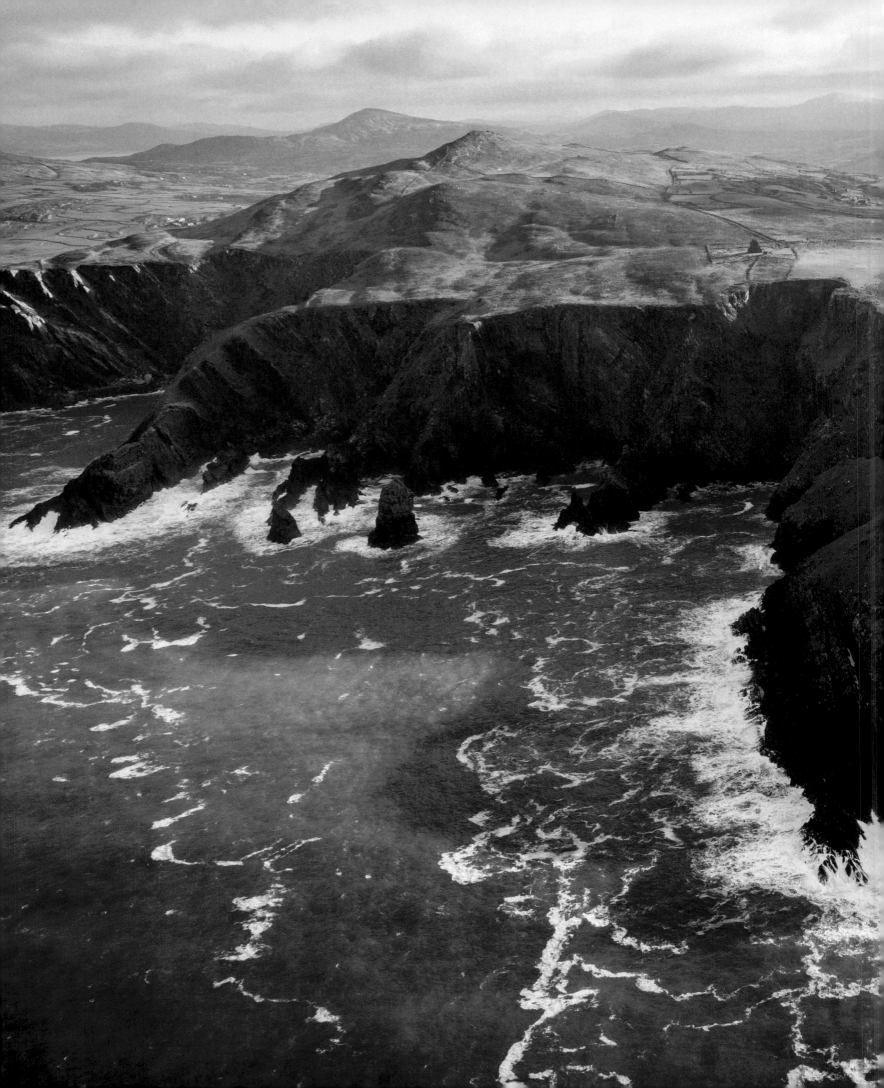

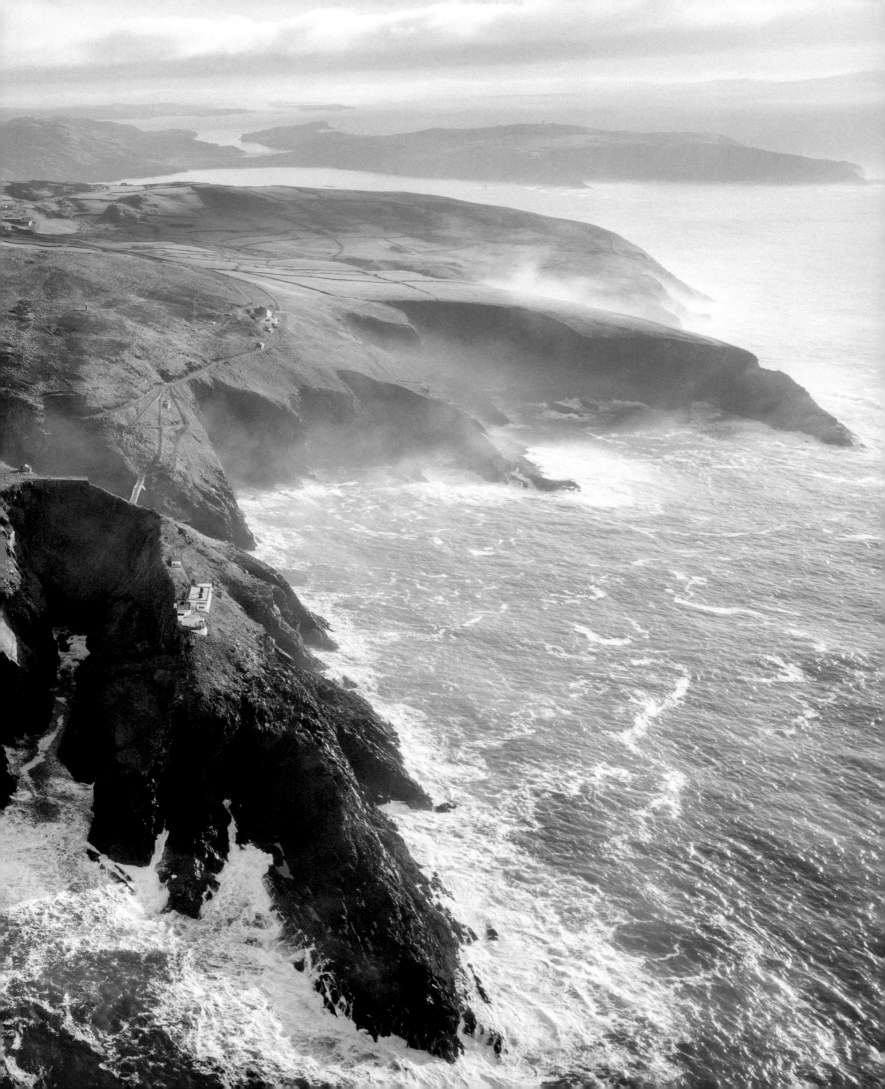

The Causeway Coast is a place of myths and legends, dramatic cliffs and windswept beaches, charming villages and historic landmarks.

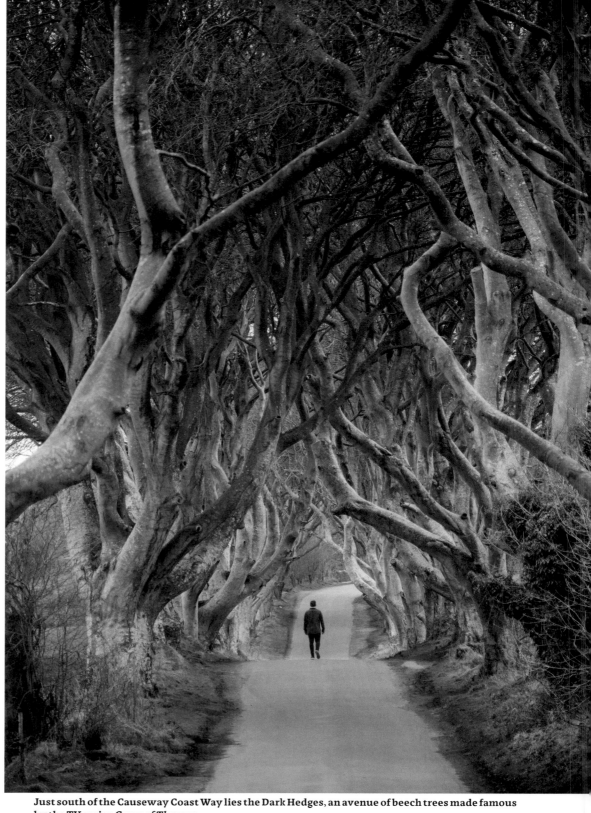

Just south of the Causeway Coast Way lies the Dark Hedges, an avenue of beech trees made famous by the TV series *Game of Thrones*.

with the crashing waves and crimson-orange hues of the sky, the spectacle is one as utterly unique as it is unforgettable.

In the space of a mere two days and 51 km (31.5 mi) of hiking, the Causeway Coast Way passes by some of Northern Ireland's most notable tourist attractions. However, if truth be told, most of these can be accessed by motorized transport. What makes this trail so special are the many lesser-known marvels that lie between the widely acclaimed highlights: the secluded beaches, the emerald green fields, the dramatic seascapes, and the rugged basalt cliffs. As with the whiskey, each vista is to be experienced at a leisurely pace, one that encourages short, savoring sips as opposed to big, hasty gulps. ◆

GOOD TO KNOW

About the Trail
/ <u>DISTANCE</u> 51 km (31.5 mi)
/ <u>DURATION</u> 2 to 3 days
/ <u>LEVEL</u> Easy

Start / Finish
⚑ Ballycastle
⚑ Portstewart

Season
The trail can be done at any time of year, though spring and autumn are ideal. During these seasons, daytime temperatures usually hover between 14 °C and 18 °C (57 °F and 64 °F), and the weather is generally a little drier and more settled. If you want to avoid the crowds, steer clear of school holidays in July and August.

Accommodation
Plenty of bed and breakfasts and guesthouses in the villages along the trail.

Highlights
The Giant's Causeway, Dunluce Castle, Carrick-a-Rede Rope Bridge, and Old Bushmills Distillery.

Shelter from the Storm
Irrespective of when you hike the Causeway Coast Way, inclement conditions are possible. Good wet-weather gear, such as a lightweight rain jacket and rain pants is essential. That

being said, if a big storm front does happen to rumble through, hikers can take solace in the fact that a warm and dry pub is never too far away.

HELPFUL HINTS

Footwear Opt for trail-running shoes over traditional hiking boots. The former are lighter, more breathable and comfortable, quicker to dry, and, if you buy a pair with a solid heel counter, offer just as much ankle

support. Remember that due to the ample accommodation and resupply options available in the villages, the Causeway Coast Way is one trail where you can afford to travel light; there is no need to carry a tent, sleeping bag, or much in the way of food and water.

BACKGROUND

The Giant's Causeway–What's in a Name? Long recognized as one of Earth's natural wonders, the Giant's Causeway was designated a World Heritage site by UNESCO in 1986. According to scientists, the basalt columns for which it is famed were created by a volcanic eruption some 50 to 60 million years ago. Over the past two centuries, the site's geology has played an important role in the study of volcanology. However, the Giant's Causeway received its colorful name due to its mythology rather than its geology. According to legend, it was created by Irish giant Finn McCool as a means of crossing the North Channel to face his rival, the fearsome Scottish giant Benandonner.

Carrick-a-Rede Rope Bridge Located near the town of Ballintoy, the Carrick-a-Rede bridge was first erected by salmon fishermen in 1755. Spanning 20 m (65.6 ft) and suspended almost 30 m (98.4 ft) above the rocks and water below, the nerve-wracking bridge links the mainland to the tiny rock island of Carrickarede.

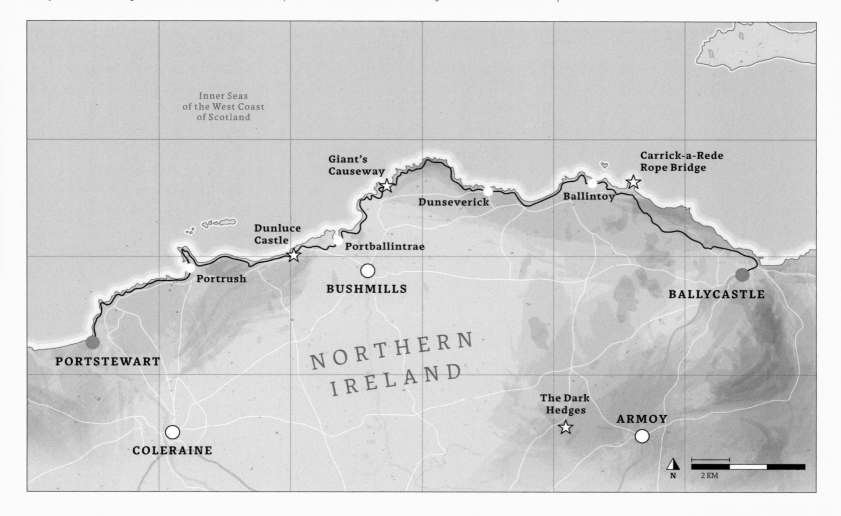

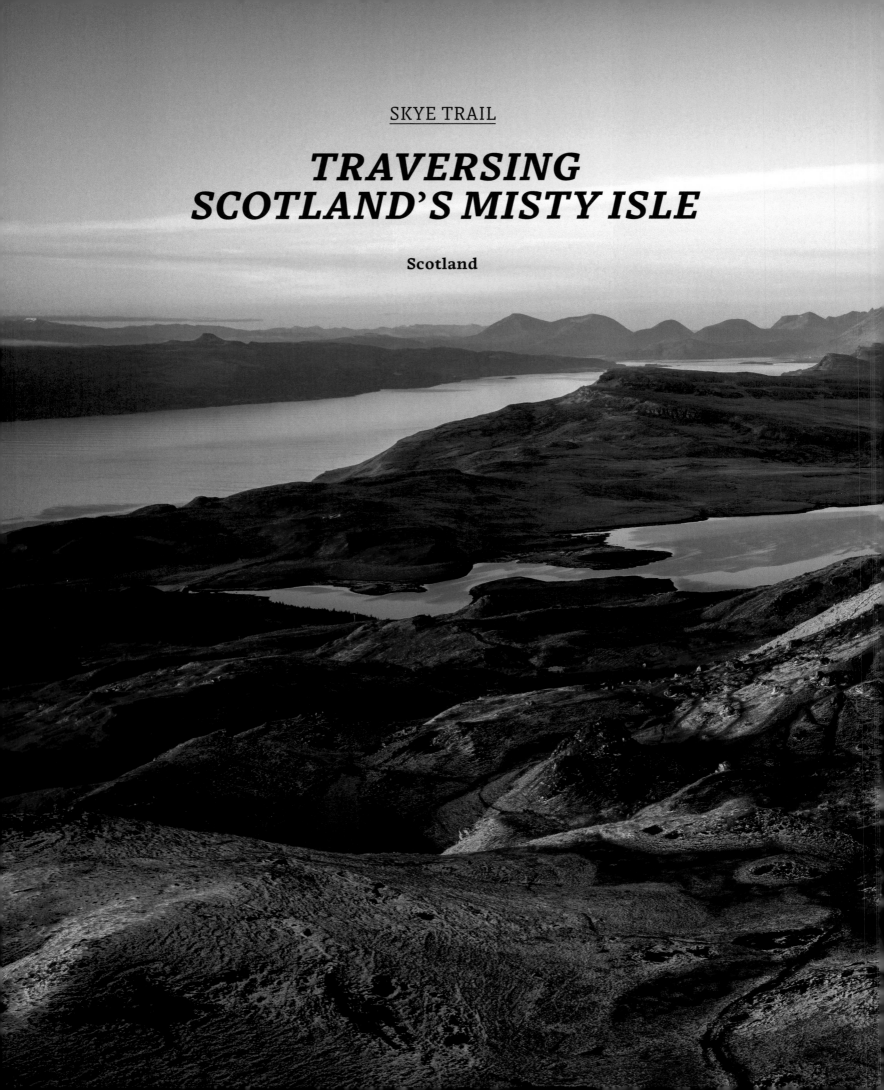

SKYE TRAIL

TRAVERSING SCOTLAND'S MISTY ISLE

Scotland

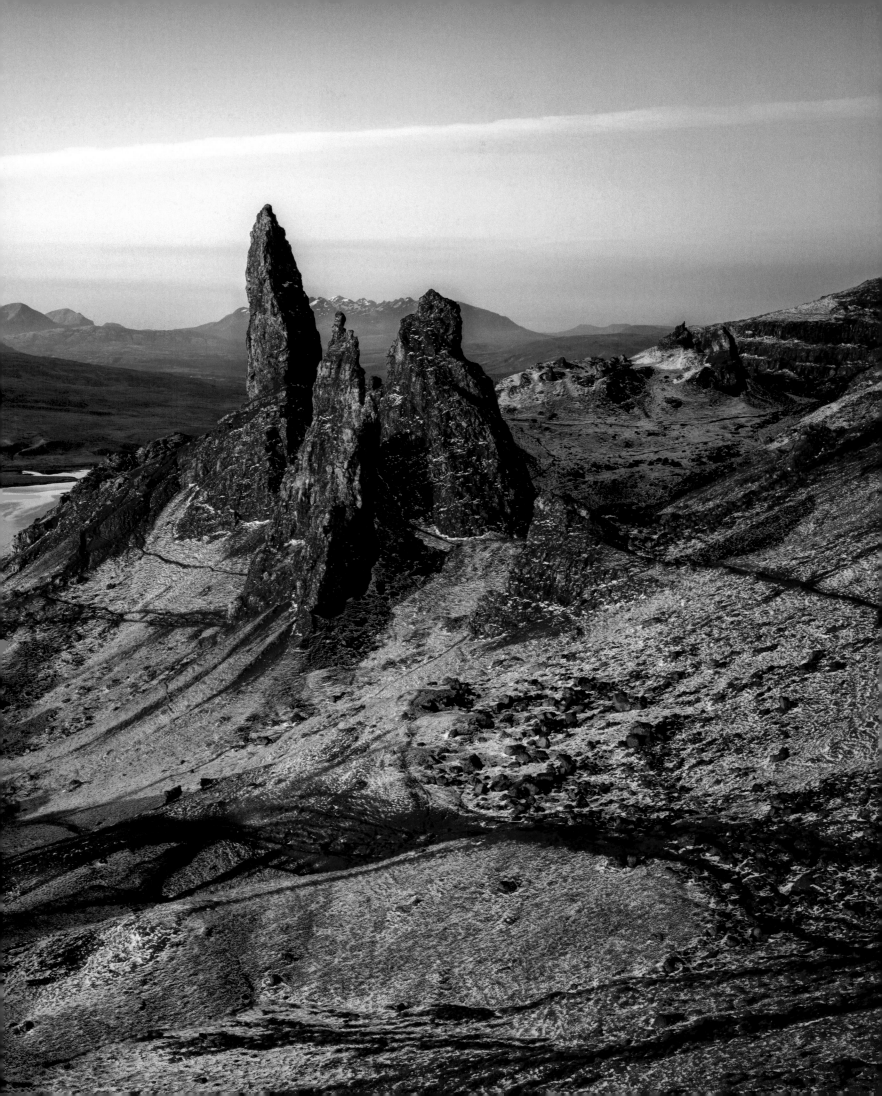

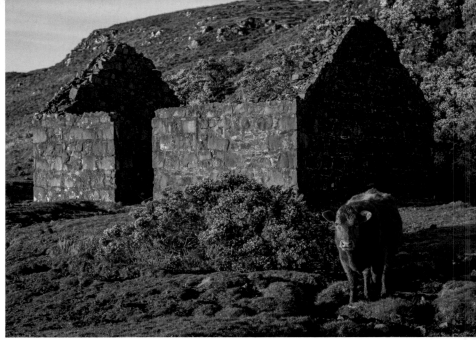

Skye is an island steeped in legend and natural beauty. Mythical tales of fairies and giants are woven together with stories of dramatic mountain ranges and coastlines. It is a place that engages and inspires all who visit, and for those with a wayfaring disposition, there is a trail spanning its length that encapsulates all of the many wonders for which it is renowned.

The Skye Trail extends 128 km (80 mi) from Broadford in the south to Rubha Hunish in the north. It is unmarked, often remote, and best suited to fit and experienced ramblers. The route follows a diverse course along rugged coasts and exposed mountain ridges, passing through storied glens and deserted villages with tragic histories. It is a highland tour de force from start to finish, and according to Cameron McNeish, award-winning outdoors writer and one of the most respected backpacking authorities in Britain,

"Any argument that says this is not the most astonishing landscape in Britain is surely indefensible."

Most hikers take about seven days to complete the Skye Trail. Although the hike can be done in either direction, it is recommended to head northward, thereby potentially gifting yourself a grand finale in the form of Trotternish Ridge and

Above: A four-legged visitor in the deserted village of Boreraig.
Below: Portree, the capital of the Isle of Skye and a great place to kick back mid-hike.

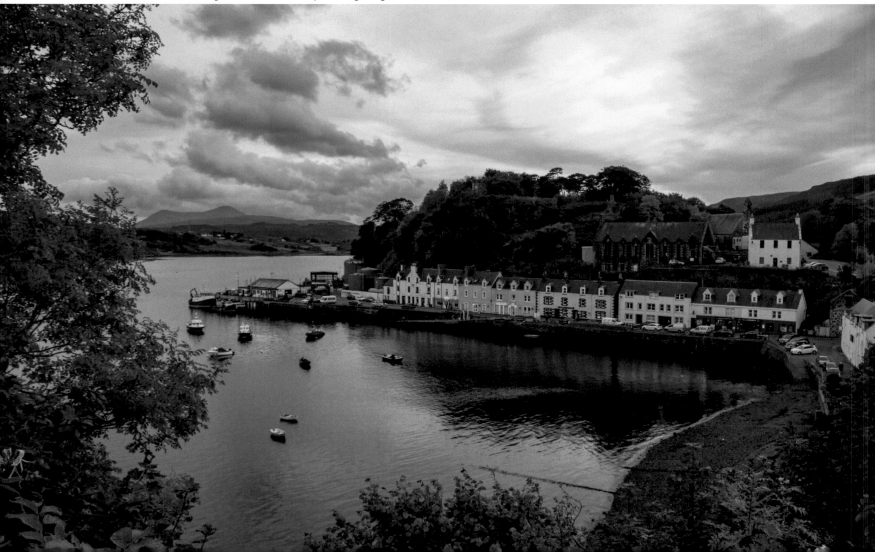

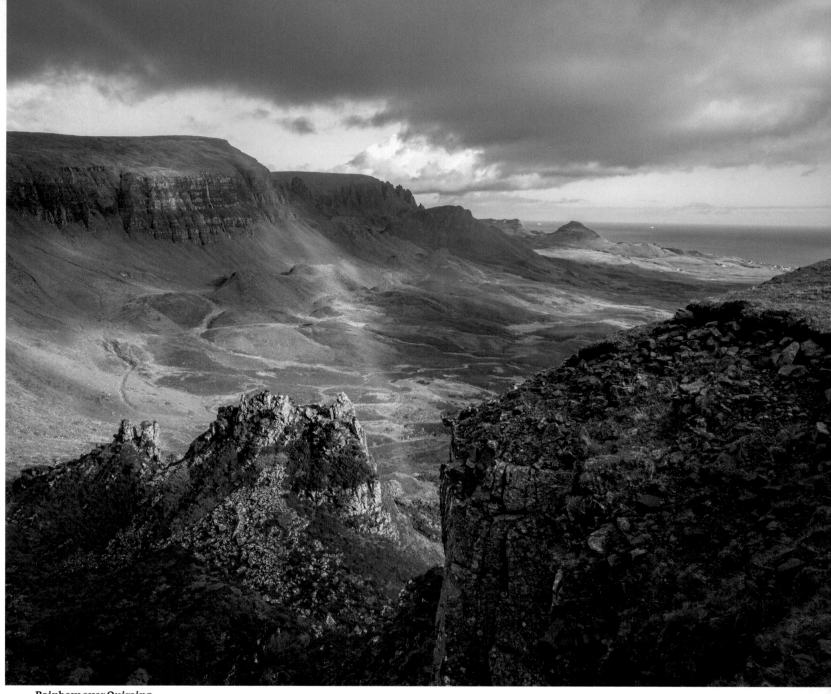

Rainbow over Quiraing.

the spectacular headland of Rubha Hunish. The operative word is "potentially," because there are no guarantees that you will actually reach Skye's landmarks in clear weather. The island is notorious for its inclement conditions, and its name is said to derive from the Norse word *Skuyö,* or "isle of cloud;" an etymological heads-up if ever there was one.

Not long after departing the southern trailhead of Broadford, the Skye Trail passes through the haunting village of Boreraig. One of the most well-preserved relics from the Highland Clearances of the eighteenth and nineteenth centuries, Boreraig was abandoned in 1852, when landowners forcibly removed its tenants in favor of more profitable sheep farmers. Walking among the burnt and surprisingly intact ruins makes for a somber reminder of one of the darkest periods in Scottish history, during which thousands of evicted Highlanders fled and relocated to places as far off as Australia and New Zealand. ▶

63

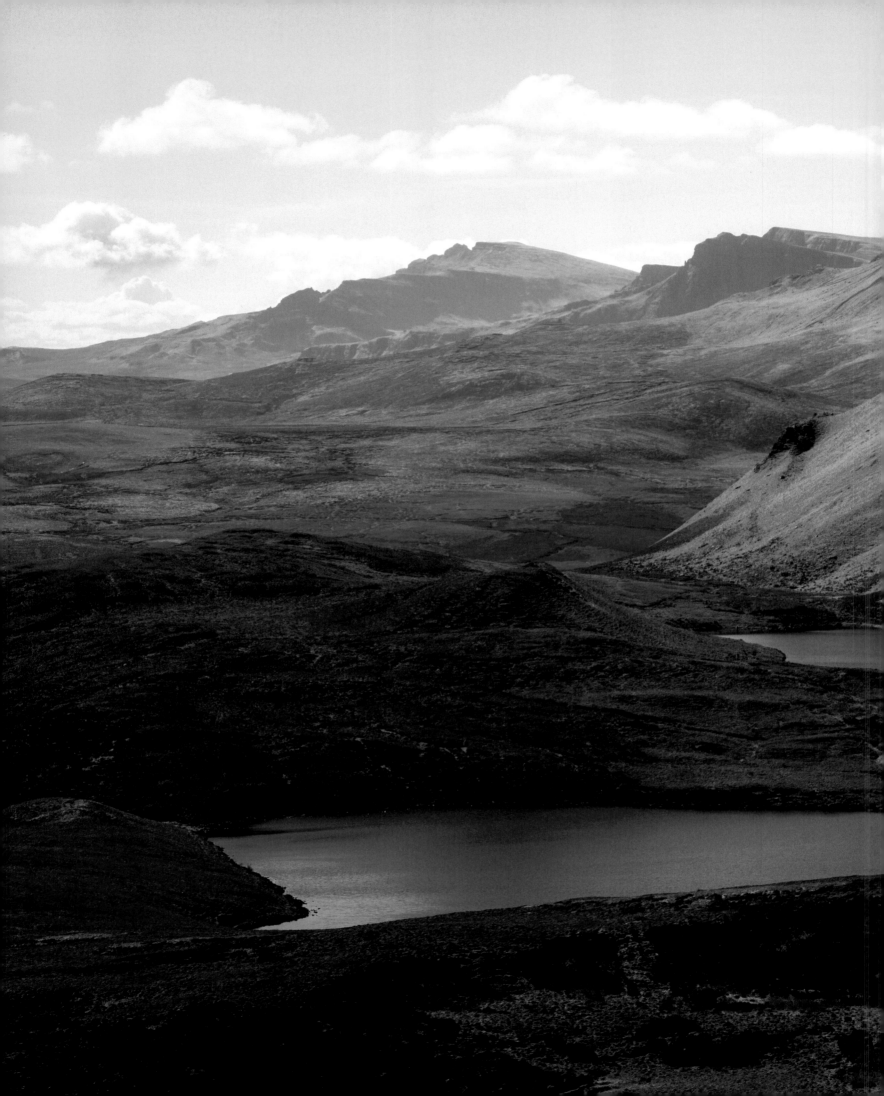

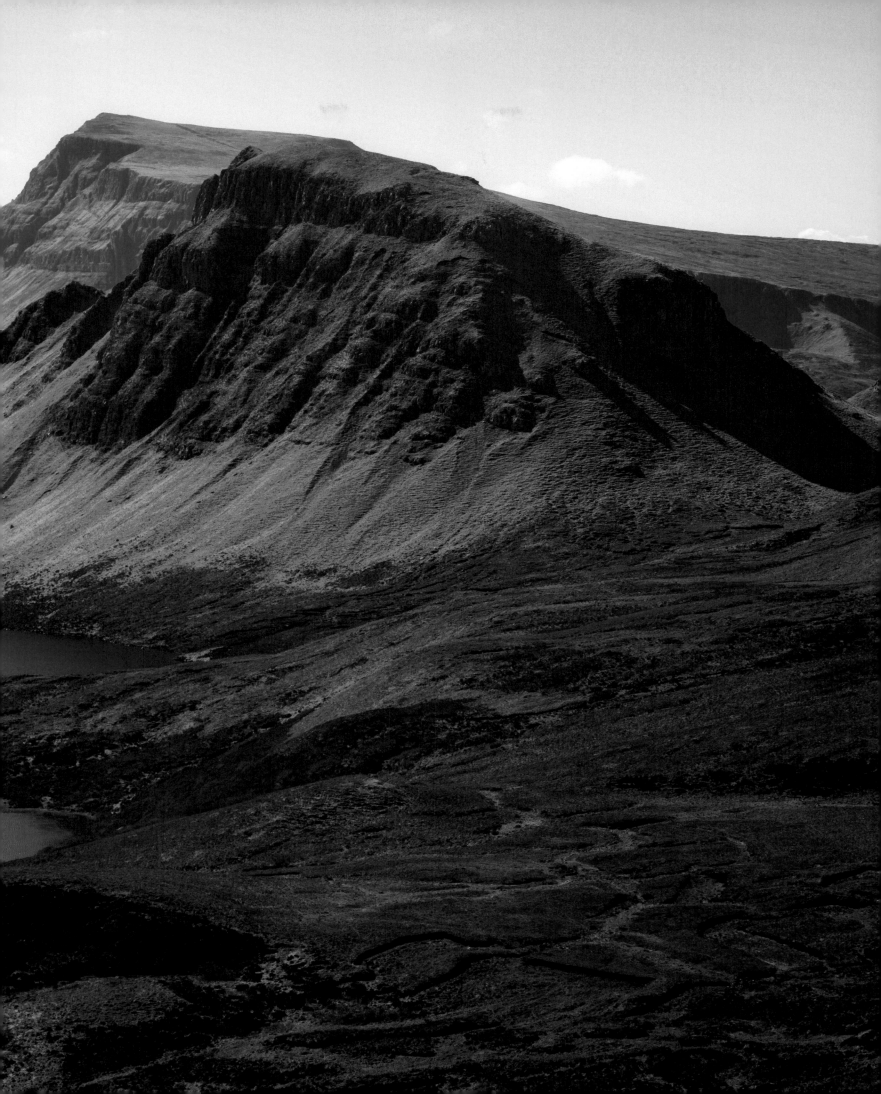

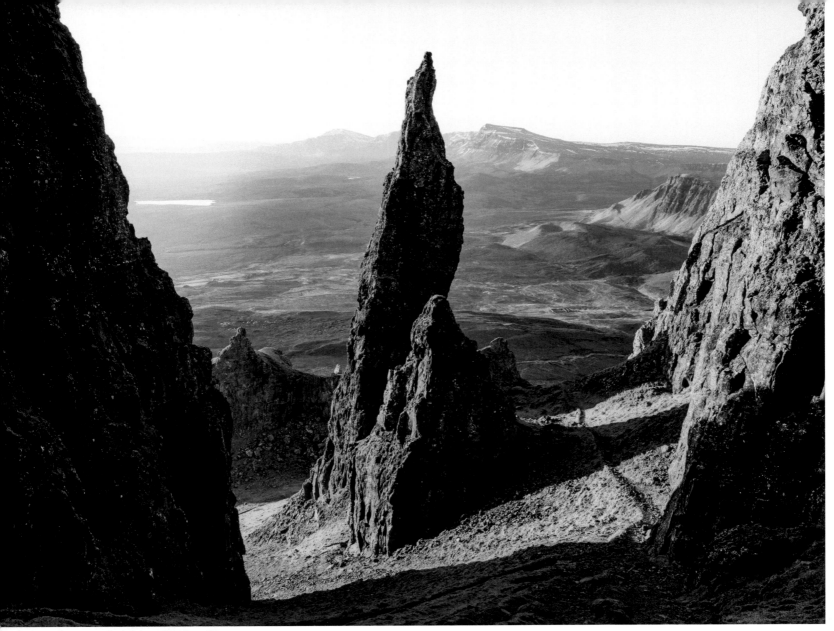

Sunrise at Old Man of Storr.

Below: Fairy Pools at the foot of the Cuillin mountains.
Right: Side trip to the legendary Neist Point Lighthouse
on the Isle of Skye's west coast.

Leaving Boreraig, the Skye Trail continues along the undulating coast, skirting Loch Eishort and Loch Slapin before eventually arriving at Elgol. From this tiny seaside village, history and literary buffs can make a two-hour side trip to Bonnie Prince Charlie's cave; in 1746, the elusive prince took refuge here on his final night in Skye before escaping. Even more impressive is the short out-and-back boat ride from Elgol to Loch Coruisk, one of Scotland's most beautiful lakes. In addition to inspiring writers and painters like Walter Scott, J. M. W. Turner, and Sidney Richard Percy, Loch Coruisk is home to the Kelpie, a shape-shifting water horse of Celtic mythology. Keep an eye out while you're visiting!

Heading north from Elgol, the Skye Trail passes in the shadows of the dramatic Cuillin range before reaching picturesque Glen Sligachan. Located in this deep and boggy glacial valley is the venerable Sligachan Hotel. ▶

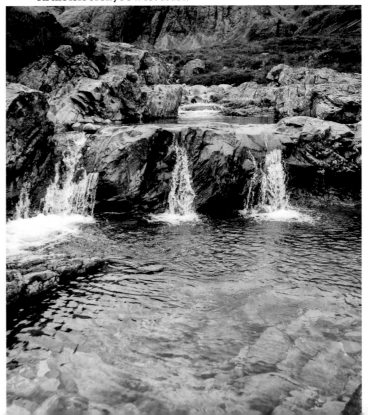

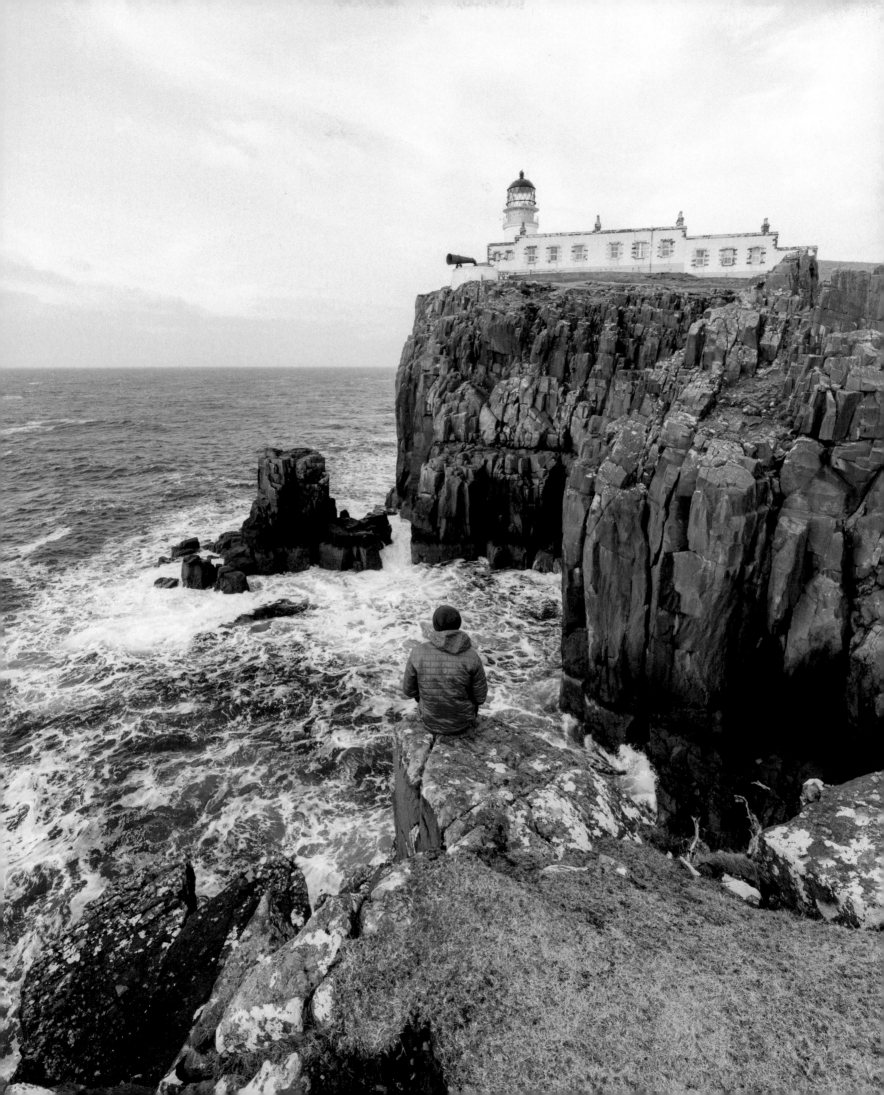

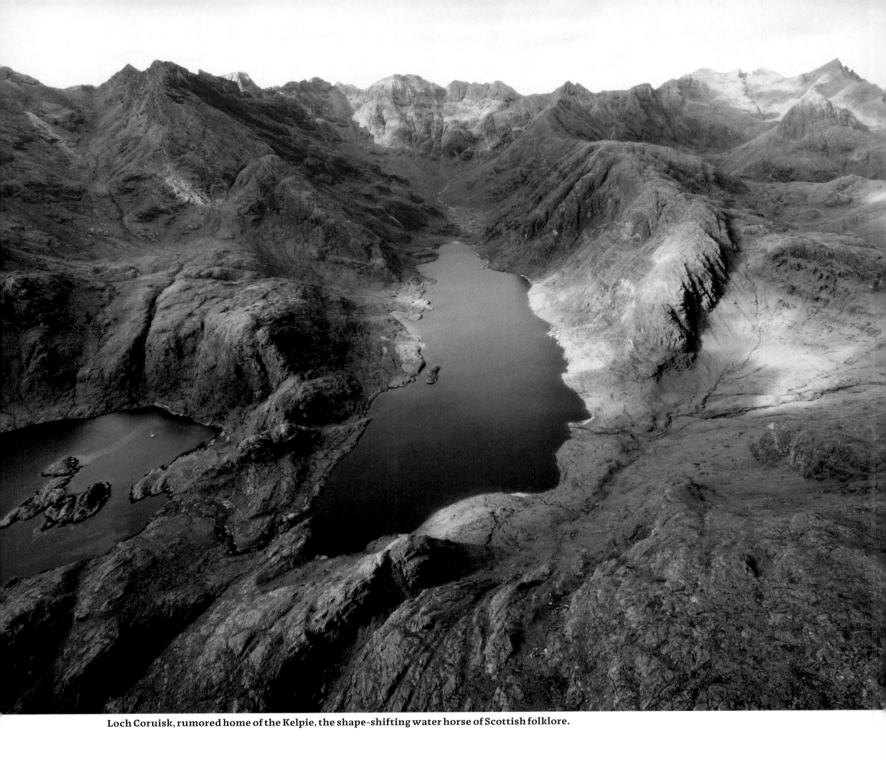

Loch Coruisk, rumored home of the Kelpie, the shape-shifting water horse of Scottish folklore.

Established in 1830, it has provided a welcome sanctuary for generations of weary, rain-soaked hikers and climbers. It's a great place to replenish and recharge over a hot meal washed down by an ale or two. Sligachan is but one of many atmospheric locations along the Skye Trail. Others include the beautifully situated Flodigarry Hotel or Skye's largest town of Portree (population: 4,150). The latter boasts a number of accommodation options, and is an ideal place to resupply before beginning the final stage of your journey, thanks to its position at the approximate halfway mark of the trail.

A big finish, whether it be in a book, a movie, or at the conclusion of this multiday hike on a very wet Scottish island, leaves a lasting impression. As aforementioned, heading north on the Skye Trail culminates with the Trotternish Ridge and Rubha Hunish. The ridge consists of an otherworldly 36 km (22.4 mi) traverse that includes multiple summits, jaw-dropping views, and the chance to observe golden and sea eagles winging their way around the skies above. Rubha Hunish epitomizes the perfect end to a long ramble—a magical headland from which hikers can soak in one final sunset over the chilly waters of the North Sea. And if your timing is just right, you might spot some playful dolphins or a passing pod of whales waving their goodbyes. ◆

GOOD TO KNOW

About the Trail
/ <u>DISTANCE</u> 128 km (80 mi)
/ <u>DURATION</u> 7 days
/ <u>LEVEL</u> Moderate to challenging

Start / Finish
⚑ Broadford
⚑ Rubha Hunish

Season
May to September

Conditions
Even by Scottish standards, which raise the bar, the Isle of Skye is a wet place. Regardless of when you hike, strong winds, precipitation, and foggy conditions are likely. A good rain jacket and a storm-worthy tent are essential.

Accommodation
Most Skye Trail hikers take a hybrid approach, combining camping with overnight stays in villages or bothies (free mountain huts) along the way.

HELPFUL HINTS

Layering in Cold and Wet Weather
If you are hiking in cold, wet, and windy weather for an extended period of time, it's not so much a question of staying 100 percent dry (which is nearly impossible) as it is of maintaining a reasonable level of comfort while out on the trail. When hiking the Skye Trail, opt for multiple light layers of clothing that dry relatively quickly and retain warmth when wet. For example: a merino wool base layer, a fleece and/or synthetic fiber garment as insulation layer/s, and a rain jacket with a durable water repellent (DWR) coating as an outer layer.

FLORA & FAUNA

Sea Eagle The Isle of Skye is the best place to spot Britain's largest bird of prey, the sea eagle (also known as the white-tailed eagle). Measuring up to 0.95 m (3.1 ft) in length and with a wingspan of 2.4 m (8 ft), the sea eagle was hunted into extinction in the United Kingdom by the early 1900s, but was reintroduced to Scotland in 1975 from Norway. Since that time, the bird—the fourth-largest eagle in the world—has made a successful recovery. As of 2016, there were 106 pairs, with experts predicting a rise to 221 pairs by 2025.

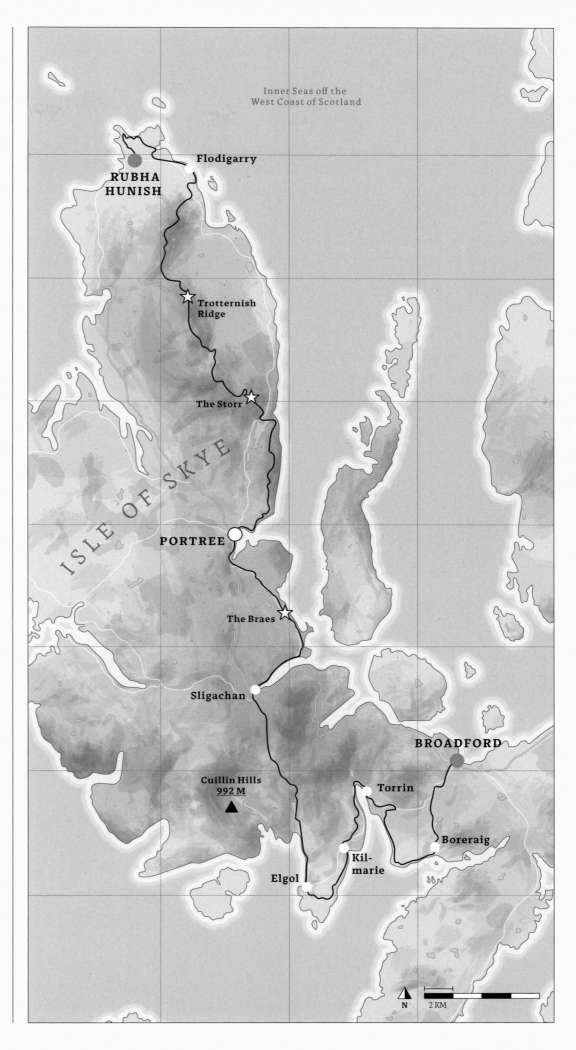

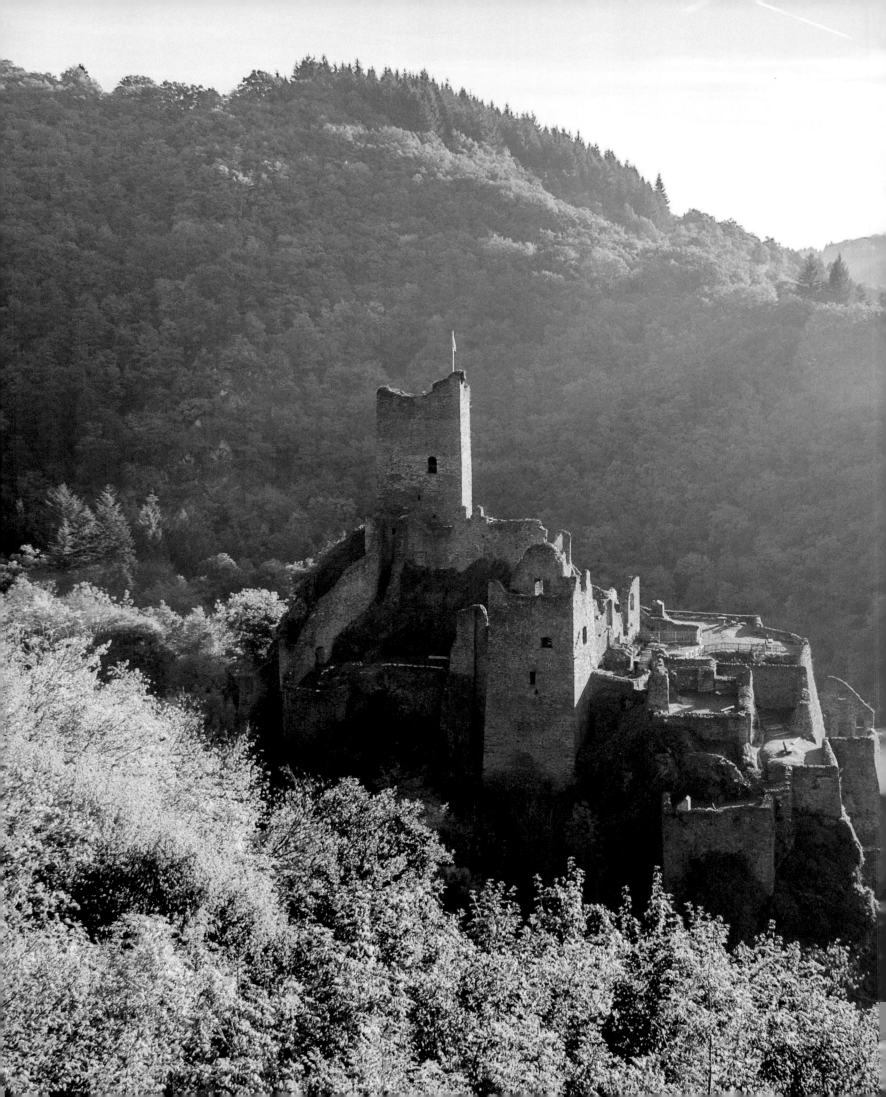

LIESERPFAD

EIFEL'S HIDDEN GEM

Germany

Walking among the peaceful wooded landscape, one cannot help but be amazed that despite the Lieserpfad's easily accessible location in western Germany, it is anything but a crowded trail.

The Lieserpfad is a gorgeous 74 km (46 mi) trail that follows the length of the Lieser waterway, from a spring near Boxberg to its confluence with the majestic Moselle river. Along the way, expect to encounter medieval castles, enchanting forests, a volcanic landscape dotted with lakes, and, for the finish, a picturesque wine village where you can celebrate with a glass or two of Riesling.

Located in the region of Eifel, a low-lying mountain range in western Germany and eastern Belgium, the Lieserpfad is usually completed in a leisurely four days. The trail is well marked and maintained, with minimal daily elevation gain and loss, making it an ideal option for hikers of all levels of fitness and experience. There are periodic benches and three-sided shelters along the path where you can rest, and at the end of each stage, you'll find multiple accommodations and culinary options from which to choose.

The Lieserpfad runs north to south and is divided into four manageable sections. Beginning at Boxberg, the first stage consists of a relaxing 15 km (9.3 mi) stretch of trail, notable for the legendary Hilgerath church and the *dreesen* (mineral springs) of Neichener and Rengener. These sources of carbonated H_2O are volcanic in origin, and although locals swear by their alimentative properties, most visitors find the water's sour taste far from palatable. The day's finishing point is the spa town of Daun, where you can visit the Eifel-Vulkanmuseum to get an excellent overview of the region's fascinating geological history.

A tranquil forest trail between Manderscheid and Wittlich.

The 18 km (11.2 mi) second stage begins with a bang—or at least a volcanic explosion that happened 20,000 years ago. What remained was the Gemündener Maar, a more than 300 m (984 ft) wide by 38 m (125 ft) deep lake a mere 1.5 km (0.9 mi) south of Daun. With clear blue water and towering beech trees all around, the Gemündener Maar is one of a group of circular crater hollows in the volcanic Eifel region collectively known as the "Eyes of the Eifel." From natural wonders

to man-made marvels, the other highlight of the second stage are the magnificent vistas of the Manderscheid castles (see info box) as seen from the rocky paths near day's end.

The third stage to the historical town of Wittlich is the longest—and arguably most picturesque—section of the Lieserpfad. Measuring 23 km (14.3 mi) in length, it crisscrosses the river on charming wooden bridges and offers many beautiful lookouts at regular intervals. Walking among the peaceful wooded landscape, one cannot ▶

73

A view over the valley.

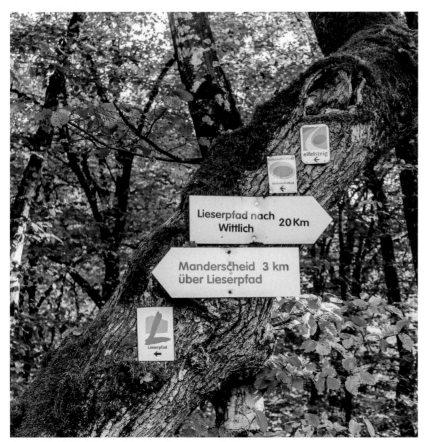

It's difficult to get lost on the Lieserpfad!

Below: Mosses and mushrooms everywhere.
Right: There are plenty of benches and shelters
to be found along the trail.

Soaking up the solitude.

help but be amazed that despite the Lieserpfad's easily accessible location in western Germany, it is anything but a crowded trail. Often it is just you, the forest, and a serpentine river winding its way south. The solitude is a leveling force, and this trail brings an opportunity to disconnect from the hustle and bustle of city life.

The fourth and final stage of the Lieserpfad extends across the Wittlicher valley, passing sandstone cliffs and the excavation site of a Roman villa, before eventually arriving in the small village of Lieser. Located on the Moselle river in the region of the same name, Lieser is one of Germany's most famous winemaking municipalities, producing some of the country's best Rieslings. As you contentedly sip a well-earned glass over a meal at one of the village restaurants, you can reflect on the beautiful 74 km (46 mi) journey you have just completed: a pilgrimage of the Lieser from its source to its mouth, and one of Germany's true hidden gems. ◆

GOOD TO KNOW

About the Trail
/ <u>DISTANCE</u> 74 km (46 mi)
/ <u>DURATION</u> 4 days
/ <u>LEVEL</u> Moderate

Start / Finish
⚲ Boxberg
⚲ Lieser

Highest Point
Boxberg (586 m [1,923 ft])

Lowest Point
Lieser (109 m [358 ft])

Season
Year round. It is most scenic during spring and autumn, but also great during summer.

Conditions
The trail is well marked and maintained throughout its course. During periods of heavy rain, the wooden bridges over the Lieser can be slippery, so take extra care.

Accommodation
Hotels and guesthouses. Wild camping is prohibited in Germany. There is one official campsite located close to the village of Manderscheid at the end of the second stage.

HELPFUL HINTS

Steep Slopes The Lieserpfad finishes in the Moselle wine region. Internationally renowned for the quality of its Rieslings, Moselle is also known for having the steepest vineyard slopes on the planet. The most precipitous gradient of all is found at Bremmer Calmont Vineyard near the village of Bremm, where slopes have been measured at a 65-degree incline.

BACKGROUND

Castles of Manderscheid Perched above the serpentine Lieser and boasting gorgeous views of the surrounding forested volcanic landscape, the upper castle of Oberburg (est. 973) and the lower castle of Niederburg (est. 1173) are open daily during the summer months for tours. If you happen to be there during the last week of August, you can attend the annual Historical Burgenfest celebration, a medieval festival that includes jousting tournaments, sword fights, and a historical artisans' market.

BOXBERG

Hilgerath Church

Daun

Gemündener Maar

GERMANY

MANDERSCHEID

Manderscheid Castles

Mosel Wine Region

WITTLICH

LIESER

2 KM

N

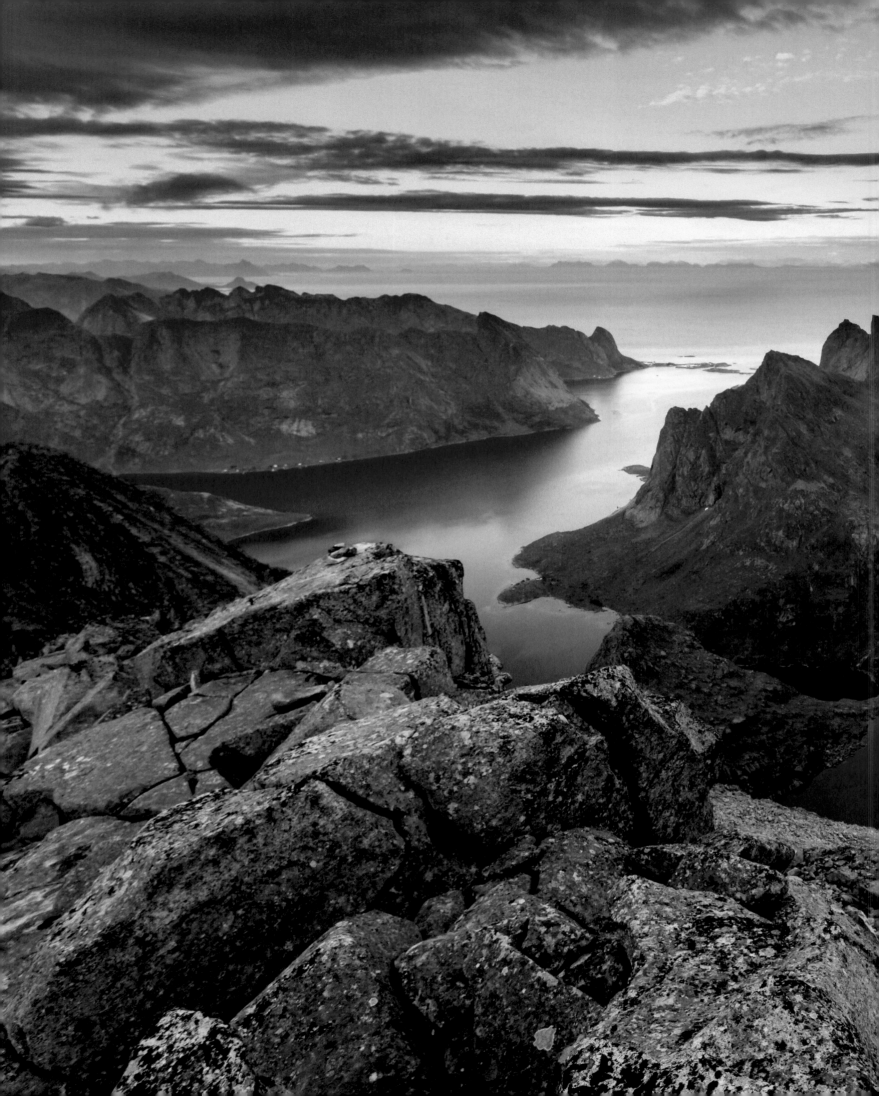

HERMANNSDALSTINDEN PEAK

REACHING FOR THE LOFOTEN SKY

Norway

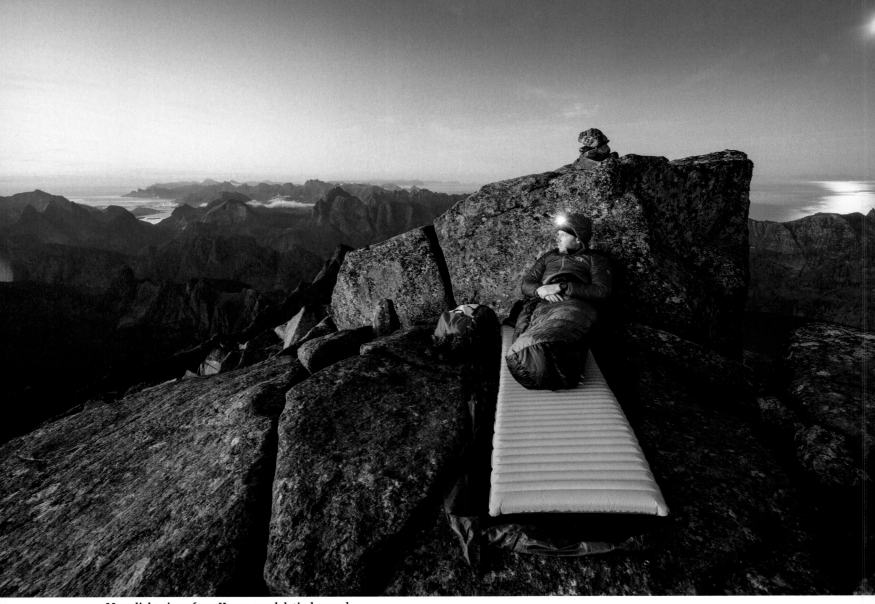

Moonlight views from Hermannsdalstinden peak.

Just off the coast of northern Norway in the Arctic Circle lies a legendary archipelago by the name of Lofoten. A combination of deep fjords, windswept beaches, jagged peaks, and picture-postcard villages, its staggering beauty has long been celebrated in art and literature. In more recent times, it has been put on the map through every second landscape photographer's social media account. While its unparalleled beauty is by no means a secret, there is still a way to escape most of the crowds and experience Lofoten's wonders in comparative solitude: grab a backpack, map, some warm clothes, and good wet-weather gear, and head for the hills on an overnight hiking excursion.

Long before it became a mecca for nature-loving tourists, Lofoten played an important role in Norway's fishing industry. For more than a millennium, it has been at the center of the country's lucrative cod fisheries, particularly during the colder

Preparing for a scenic evening meal.

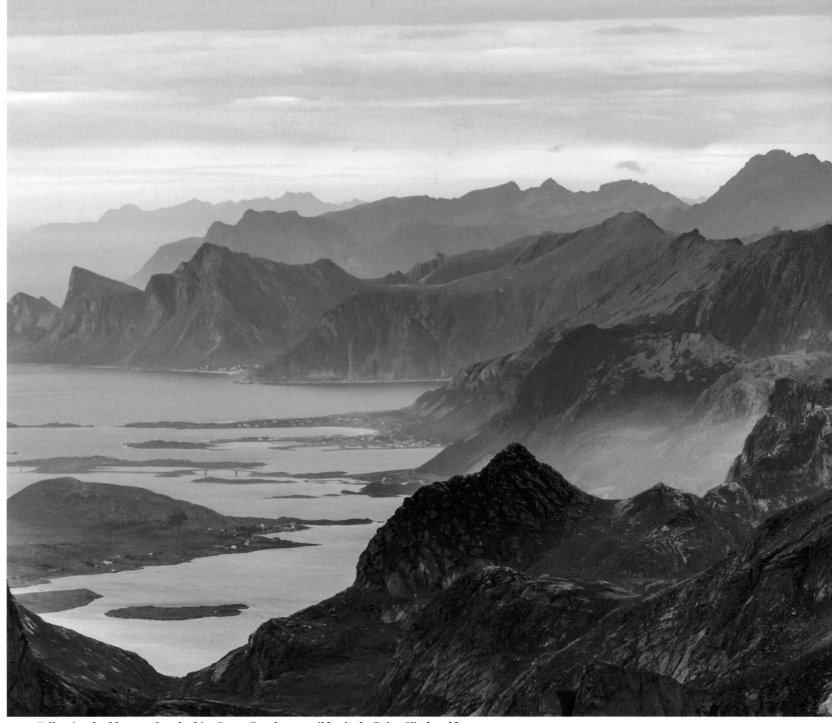

Following double page: Overlooking Bunes Beach, accessible via the Reine-Vindstad ferry.
Above: Lofoten's ragged coastline.

months, when cod migrate south from the Barents Sea to spawn in the warmer waters of the islands. Thanks in part to these same Gulf Stream currents and the relatively mild oceanic climate they help to regulate, Lofoten has become a popular winter destination for two-legged visitors as well, who flock to the archipelago to witness the spectacular aurora borealis, or northern lights, during the darkest days of the year.

In regards to hiking, there is something to suit all levels of fitness and experience. The islands contain a myriad of options, ranging from family-friendly coastal jaunts to rugged mountain treks. The out-and-back hike

from Sørvågen to the summit of Hermannsdalstinden lies firmly within the latter category. Although relatively short in distance, its challenging character is due both to the exacting nature of the terrain and to the sideways rain and strong winds that are not uncommon to the region.

The path begins in the village of Sørvågen and is not difficult to follow in clear weather. Along the route there are plenty of natural landmarks, such as lakes and distinctive peaks that act as reference points for orientation. Still, the going is rarely easy, with steep, muddy, and exposed conditions being par for the topographical course. During certain sections, scrambling is required, including the ▶

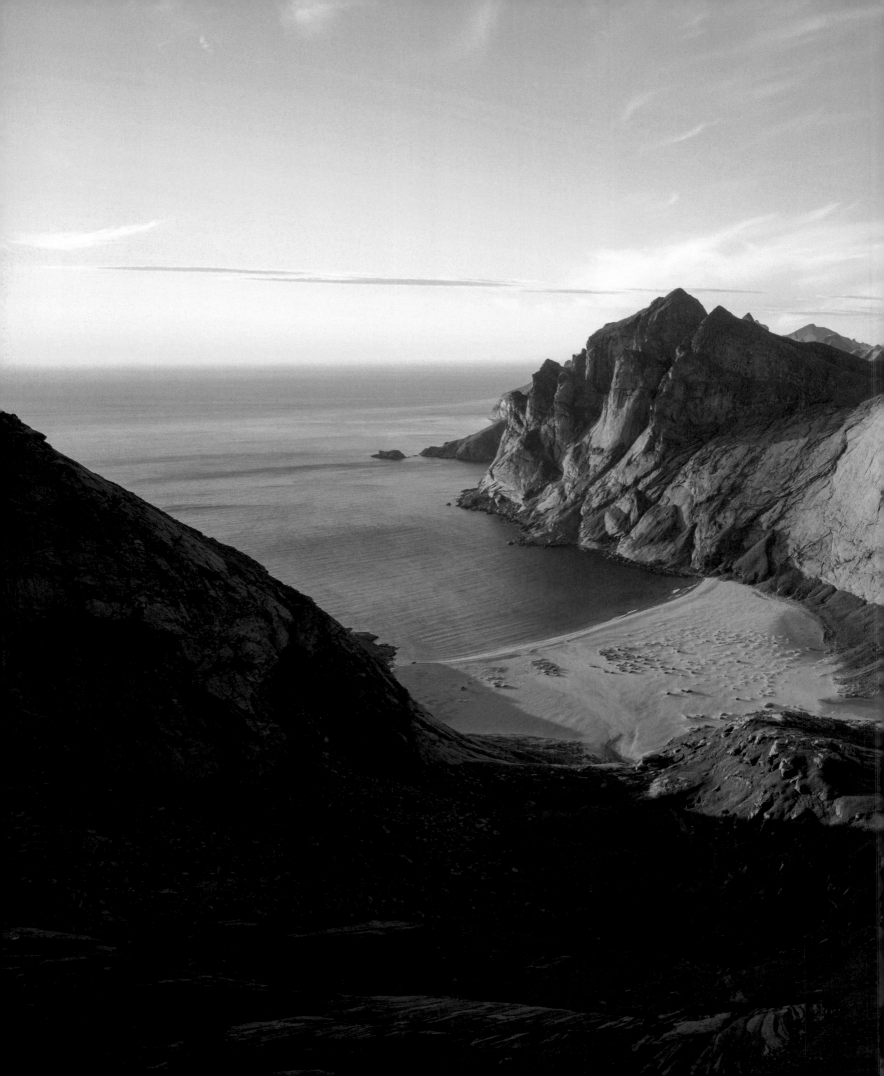

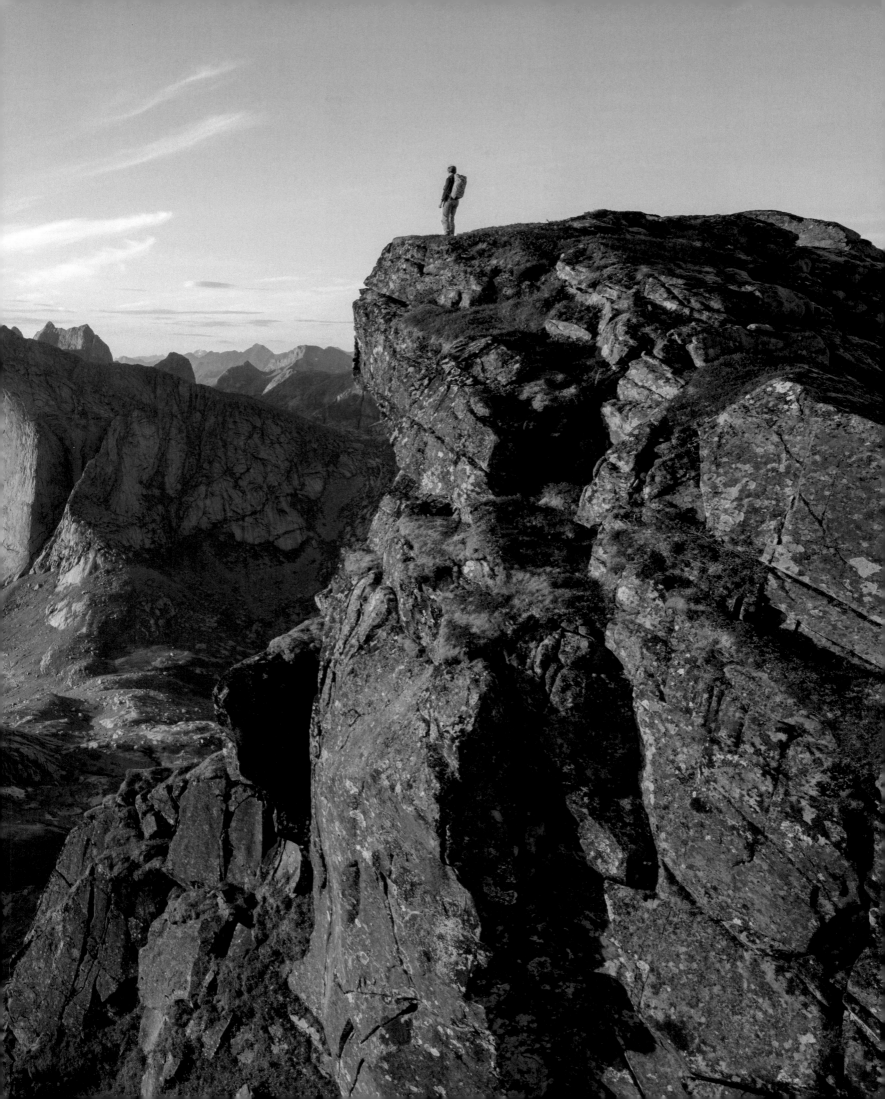

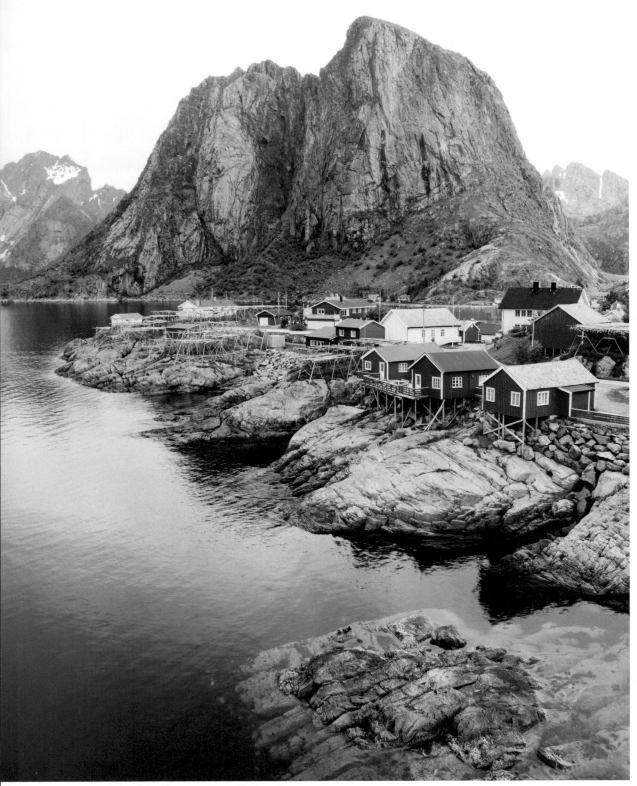

The islands contain a myriad of hiking options, ranging from family-friendly coastal jaunts to rugged mountain treks.

Side trip to Hamnøy, one of Lofoten's most picturesque fishing villages.

highly recommended to overnight along the way if you have the time, inclination, and a storm-worthy shelter. There are excellent campsites overlooking Tennesvatnet lake, near Munkebu hut, a two-and-a-half to three-hour walk from Sørvågen. From a meteorological perspective, this approach will improve your chances of catching clear views; you can make an early start the following day, thereby reaching the summit of Hermannsdalstinden during the morning hours, when visibility is often at its best. From an intangible perspective, you also give yourself the gift of sleeping under Lofoten's night sky. If your timing is just right and the weather gods are amenable, be sure to spend as many moments as you can outside your shelter. Look up toward the infinite heavens, and then lower your gaze to the equally ethereal moonlit peaks and lakes surrounding you on all sides.

The Lofoten islands may be one of those places whose reputation precedes it, but whatever the expectation, it will rarely disappoint those with a love for the outdoors.　◆

final push to the summit, in which hikers can expect to negotiate loose rock and boulders. Upon reaching the top, you will be greeted with one of the most stunning views imaginable. In every direction, there are glacier-sculpted fjords, granite pinnacles, sheer cliffs, and hidden coves and islets. In fine weather, it is a panorama you will never forget.

Although it is possible to do the return hike from Sørvågen to Hermannsdalstinden in one long day, it is

GOOD TO KNOW

About the Trail
/ <u>DISTANCE</u> 18 km (11.2 mi)
/ <u>DURATION</u> 7 to 11 hours
/ <u>LEVEL</u> Moderate

Start / Finish
⚑ Sørvågen (out and back)

Season
June to September

Conditions
Despite lying on a similar latitude to places such as Alaska and Greenland, the Lofoten islands experience a relatively mild oceanic climate. Average winter and summer temperatures are 1 °C (33.8 °F) and 13 °C (55.4 °F), respectively.

Alternate Route
A shorter and steeper alternative to the Sørvågen route begins at Forsfjord, which is accessed via the Vindstad/Bunes ferry from the village of Reine. From the Forsfjord pier, hike steeply up to the shores of Tennesvatnet lake, and from there head southwest to link up with the Sørvågen trail at Hill 448.

Across the Lofoten Islands
If you are looking for something longer than the hike to Hermannsdalstinden peak, consider a 160 km trek across the entire archipelago. Beginning in the hamlet of Delp on the island of Austvågøya and finishing near the village of Å in Moskenes, the "long crossing" consists of more than 18,386 m (60,322 ft) of combined elevation gain and loss, and takes 11 days, on average, to complete.

BACKGROUND

Mokstraumen Situated off the Lofoten archipelago is a singular system of tidal eddies and whirlpools known as the Moskstraumen (or maelstrom). Over the centuries, this hydrological phenomenon has been featured in classic literary tales, including Jules Verne's *Twenty Thousand Leagues Under the Sea* and Edgar Allan Poe's short story *A Descent into the Maelström*. What sets Lofoten's legendary Moskstraumen apart from most other whirlpools is its strength—it's the second strongest of its kind in the world—and the fact that it occurs in open sea, rather than in a river or strait.

HELPFUL HINTS

Northern Lights For those interested in combining hiking and witnessing the aurora borealis in Lofoten, the best chance comes in the month of September. Though the days are shorter and the weather more unpredictable than in July and August, the payoff comes in the form of fewer tourists, autumn colors, and the chance to see Mother Nature's light show from one of the most spectacular viewpoints.

Arriving in the Lofotens Perhaps the most memorable way to begin your Lofoten adventure is via a three-hour ferry ride from Bodø to Moskenes. Approaching the islands by sea, the peninsula's jagged profile gradually transforms from a distant speck on the horizon to one of the most breathtaking collections of deep fjords and towering rocky peaks imaginable.

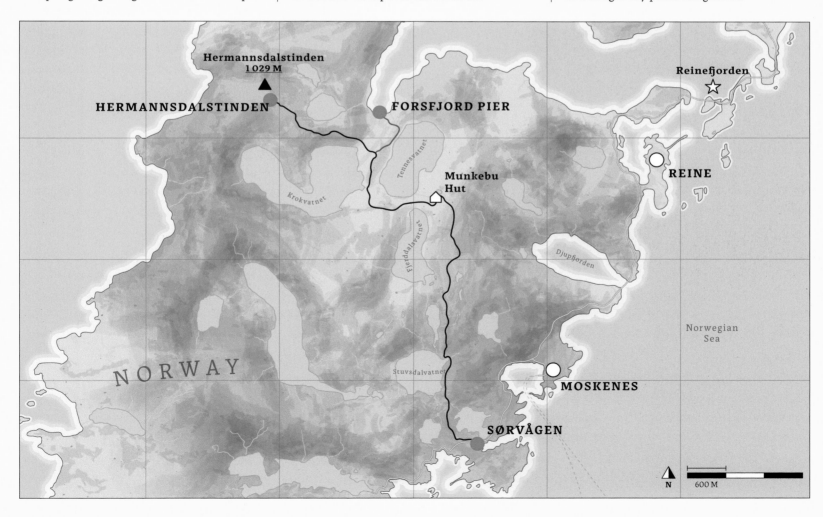

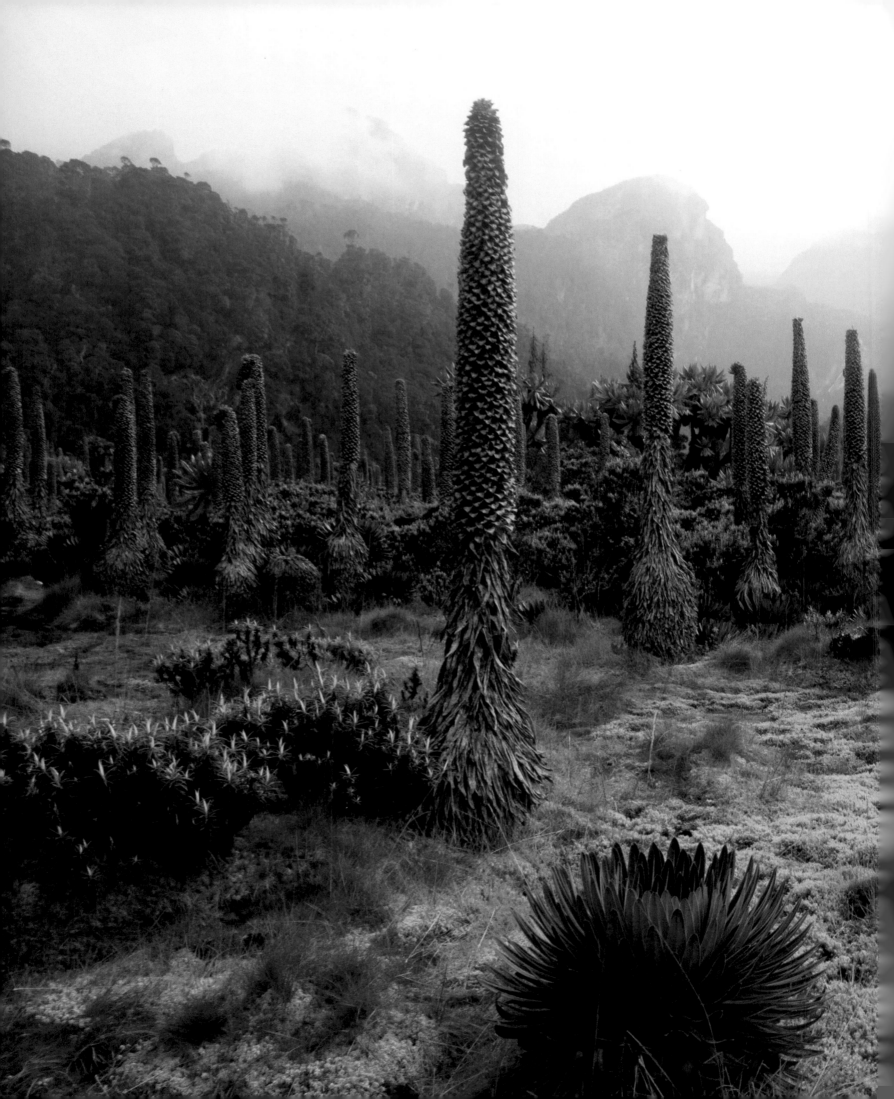

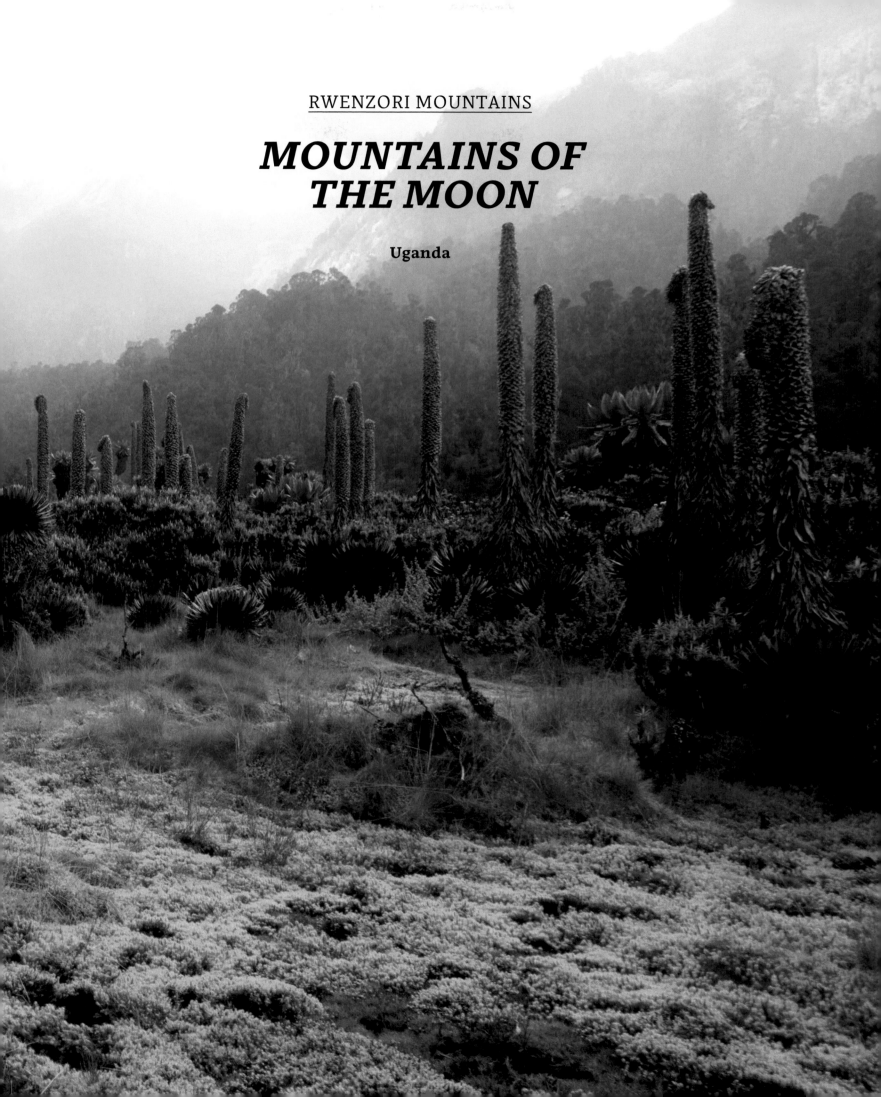

RWENZORI MOUNTAINS

MOUNTAINS OF THE MOON

Uganda

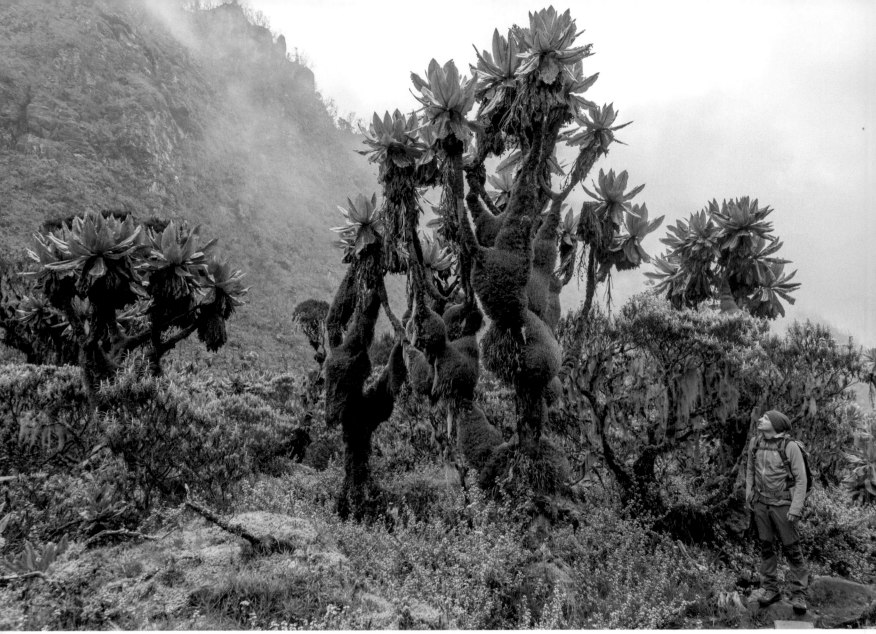

Gazing at giant groundsels.

R
emote and infrequently visited, the Rwenzori Mountains (also known as the "Mountains of the Moon") are Africa's best-kept hiking secret. Situated on the border of Uganda and the Democratic Republic of the Congo, this 120 km (75 mi) long range features the third highest peak on the continent (Mount Stanley) and constitutes a natural barrier between the savanna grasslands of Eastern Africa and the Congolese rainforests to the west. Since ancient times, the Rwenzori have been shrouded in lore and mystery, and for those wishing to experience these storied mountains firsthand, there is no better way to do so than by hiking the Central Circuit (also known as the Bujuku-Mubuku Circuit).

The legends of the Mountains of the Moon can likely be traced to the tales of Arab traders in the region. However, it was the Greco-Roman geographer Ptolemy who forever cemented the

A local guide and his vintage glacier glasses.

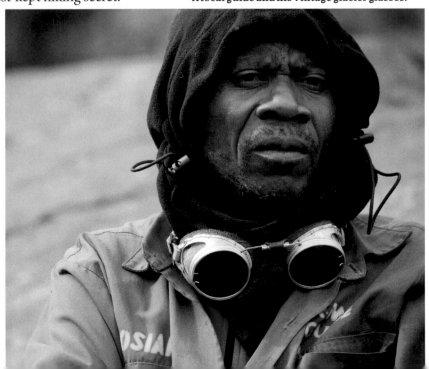

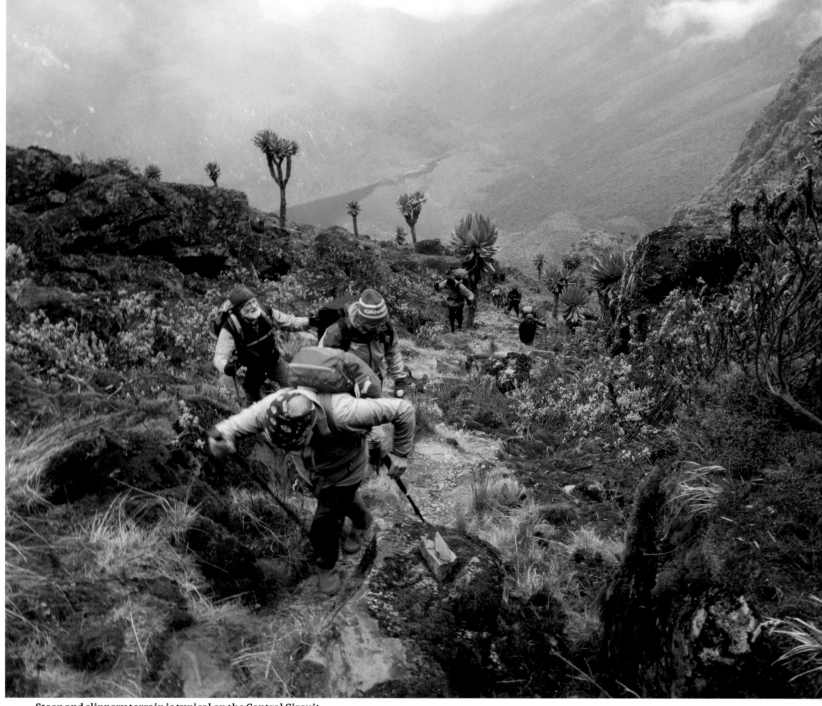
Steep and slippery terrain is typical on the Central Circuit.

range's place in history with his seminal work *Geographia* (ca. 150 AD), in which he identified the "Lunae Montes" as the source of the Nile River. After centuries of conjecture and debate, it wasn't until the 1858 expedition of John Speke and Richard Burton that Lake Victoria, which lies to the east of the Rwenzori, was finally confirmed as the true source of the Nile. This finding was later verified in the 1870s by Henry Morton Stanley, who, during the same journey, gave the range its name, taking "Ruwenzori"—the original spelling—from a local word meaning "rainmaker."

Situated entirely within the UNESCO World Heritage-listed Rwenzori Mountains National Park, the Central Circuit is a 62 km (38.5 mi) loop hike that passes through multiple ecosystems and has an altitudinal range of 2,936 m (9,633 ft). The circuit can only be done as part of a guided group excursion and takes between seven and nine days to complete. The steep and challenging trail is often slippery, overgrown, and muddy—no surprise considering that the Rwenzori Mountains are one of the wettest places in Africa. Even when it isn't raining, the ground is soaked and the air seems to be perpetually misty. Thankfully, a moisture-free sanctuary awaits at the end of each hiking day in the form of the cozy mountain huts located at regular intervals along the route.

The Central Circuit starts (and finishes) at the park headquarters in the small village of Nyakalengija. ►

The trail ascends through five overlapping vegetation zones, the first of which is evergreen montane forest (up to 3,000 m [9,843 ft]). Following the course of the Mubuku River, it passes through dense thickets that hide blue monkeys, hyrax, chameleons, and, if you are very lucky—or perhaps unlucky, depending on the proximity—maybe even elephants and leopards. Next is the bamboo zone (2,500 to 3,500 m [8,202 to 11,483 ft]), followed by the heather and Rapanea zone (3,000 to 4,000 m [9,843 to 13,123 ft]), which is characterized by gnarled, lichen-cloaked trees and stands of the decidedly phallic giant lobelia plant (*Lobelia bequaertii*). The penultimate vegetation zone is alpine moorland (4,000 to 4,500 m [13,123 to 14,764 ft]), though by this point the degree of vegetation, along with the amount of oxygen available to weary trekkers, has decreased considerably. This lofty, tussock-laden area marks the departure point for what is the most popular side trip of the circuit, ▶

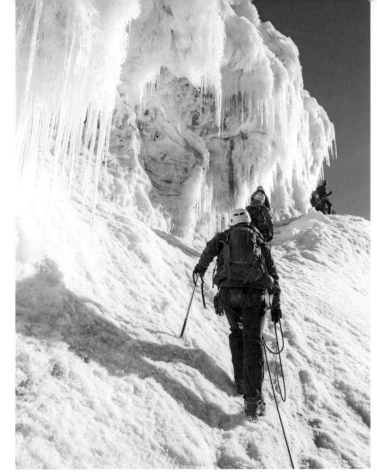

Right: The Rwenzori Mountains are one of Africa's wettest places, where every moment of blue skies should be cherished. Above: Final ascent to the summit of Margherita Peak.

The Nival zone, between 4,400 and 5,000 m (14,435 and 16,404 ft), is the highest of five overlapping vegetation zones in the range.

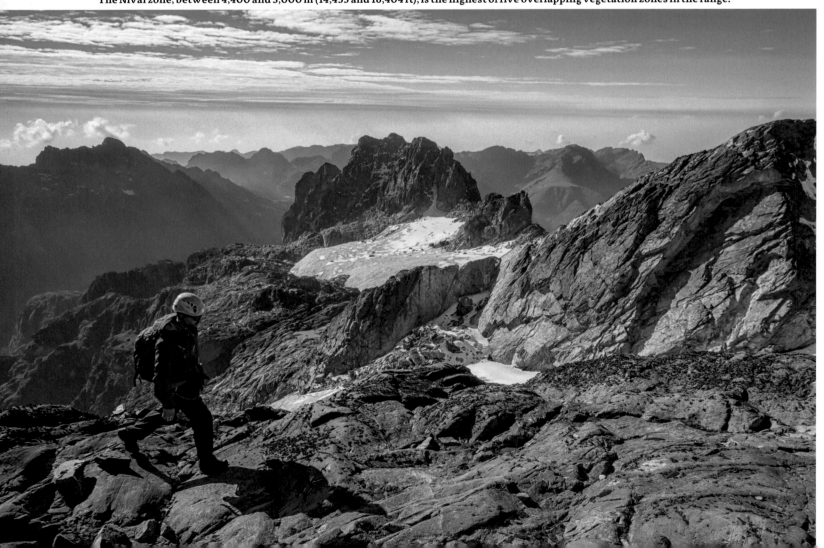

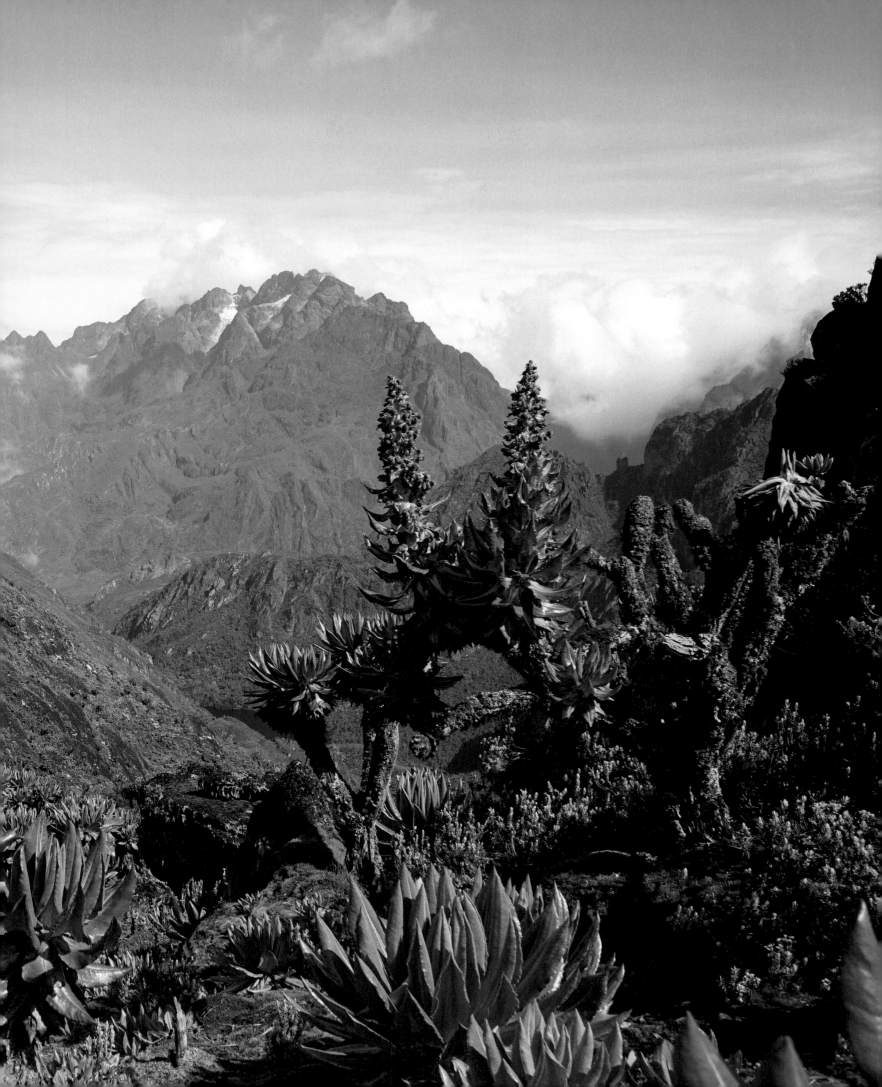

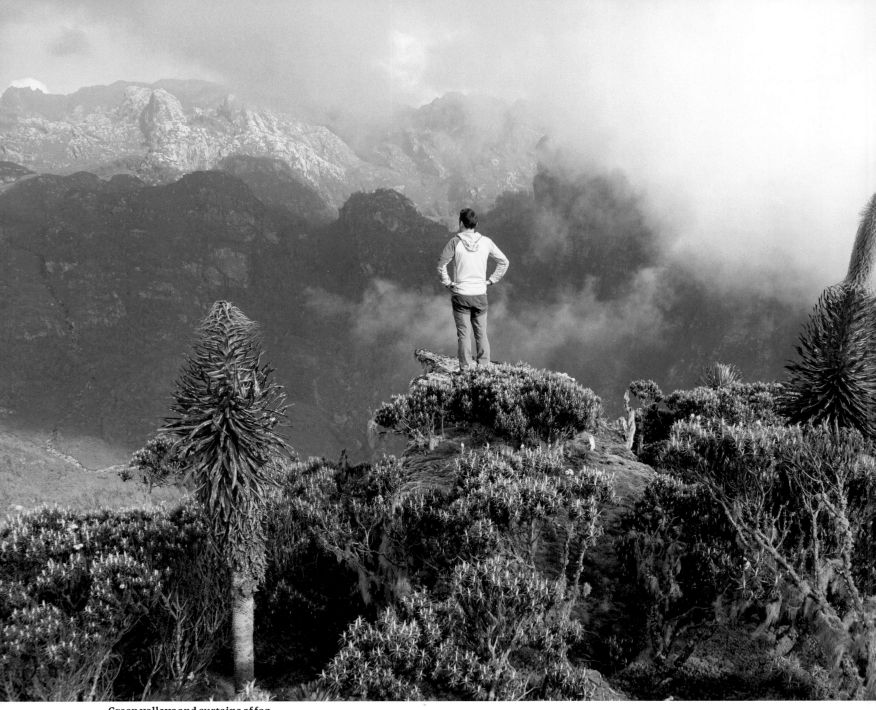

Green valleys and curtains of fog.

a climb of Margherita Peak (5,109 m [16,762 ft]), the highest peak of Mount Stanley.

The summit ascent is generally undertaken after spending the night at Elena Hut (4,551 m [14,931 ft]). Although not technically difficult, crampons, rope, and ice axes are required to negotiate the Margherita Glacier and Stanley Plateau (Africa's largest ice field). Upon reaching the top, the views are incredible: a 360-degree visual feast of snow-capped rocky peaks juxtaposed with the dense Congolese rainforest stretching out to the west. In the words of the famed Himalayan mountaineer Eric Shipton, who climbed to the top of Mount Stanley in 1932, "it felt as though we had emerged from a world of fantasy, where nothing was real but only a wild and lovely flight of imagination. I think perhaps the range is unique. It is well named 'Mountains of the Moon.'"

From jungle to glaciers and back again, perhaps the only constant when hiking in the Rwenzori Mountains is that of change. But for those who can accept and embrace the extremes of Africa's highest mountain chain, the rewards are waiting—unique flora and fauna, enchanting landscapes, breathtaking views, and the satisfaction of completing a challenging trek in a little-visited part of the world. With the future of its dramatically receding glaciers in doubt (see info box), the time to hike among the fabled Mountains of the Moon is undoubtedly now. ◆

GOOD TO KNOW

About the Trail
/ <u>DISTANCE</u> 62 km (38.5 mi)
/ <u>DURATION</u> 7 to 9 days
/ <u>LEVEL</u> Challenging

Start / Finish
⚑ Round trip starting and finishing at the village of Nyakalengija.

Highest Point
Elena Hut (4,551 m [14,931 ft])

Lowest Point
Nyakalengija (1,615 m [5,299 ft])

Season and Conditions
Theoretically speaking, the "dry" seasons are best for trekking in the Rwenzori. These run from the end of May to early October, and from late November to early March. However, the Rwenzori are famously wet throughout the entire year: irrespective of when you hit the trail, come prepared for variable conditions.

Accommodation
A combination of huts and camping.

Permits
Hikers on the Central Circuit must be accompanied by a local guide. This can be arranged online, or once you arrive in Uganda. The tour company you trek with will organize all necessary transport and permits.

BACKGROUND

Vanishing Glaciers The glaciated peaks for which the Rwenzori Mountains have long been famous may soon be a part of history. Over the last century, they have been melting at an unprecedented rate, with their total area decreasing from 7.5 sq km (2.9 sq mi) in 1906 to only 1.04 sq km (0.4 sq mi) in 2014. According to Richard Taylor, professor of hydrogeology at University College London, the glaciers' dramatic retreat is due to rising temperatures rather than a lack of precipitation, and "by 2030, there won't be any ice left on the mountain."

FLORA & FAUNA

Rwenzori vs. Mount Kilimanjaro Perhaps the most common question about hiking in the Rwenzori Mountains concerns how the experience compares to hiking Africa's highest and most famous peak, Mount Kilimanjaro (5,895 m [19,341 ft]). In regard to commonalities, both treks move between multiple ecosystems, boast a wide variety of flora and fauna, and can only be done as part of a guided group. As for differences, the Rwenzori receive considerably more rainfall and a fraction of the foot traffic, cost considerably less, and, unlike the geographically isolated Kilimanjaro that is volcanic in origin, the Rwenzori are a true range of mountains comprising numerous high-altitude peaks and measuring 120 km (75 mi) long and 50 km (31 mi) wide.

Giant Lobelia Plant These magnificent plants are a common sight in the Heather and Rapanea vegetation zone of the Rwenzori mountains, and grow up to a height of 3 m (10 ft).

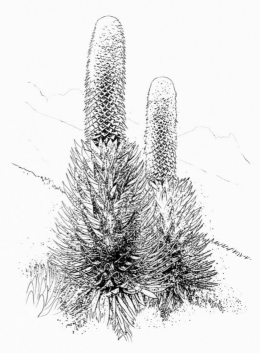

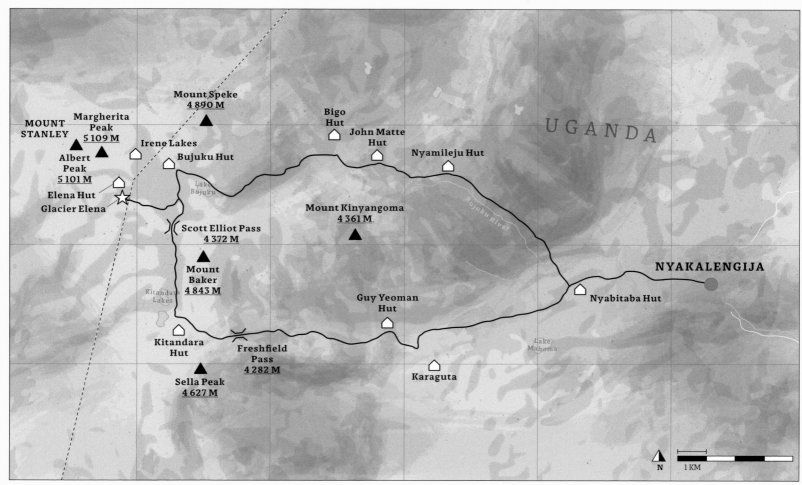

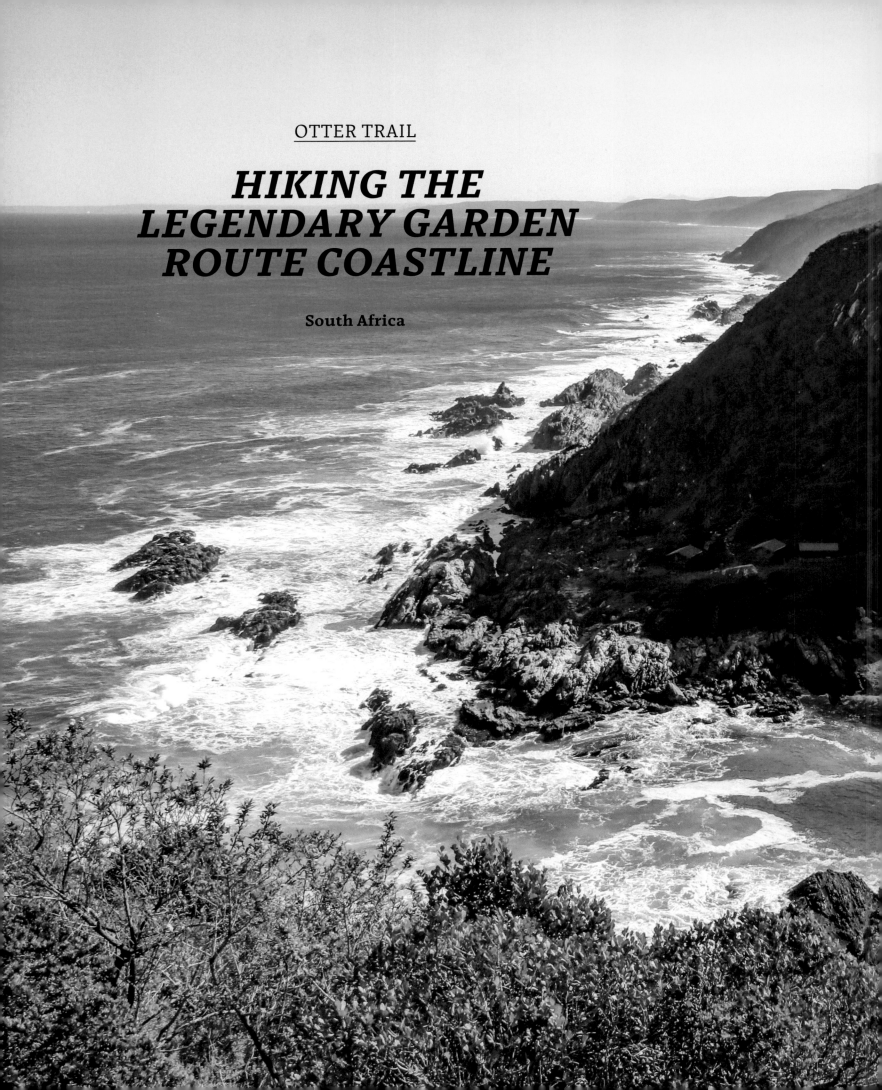

OTTER TRAIL

HIKING THE LEGENDARY GARDEN ROUTE COASTLINE

South Africa

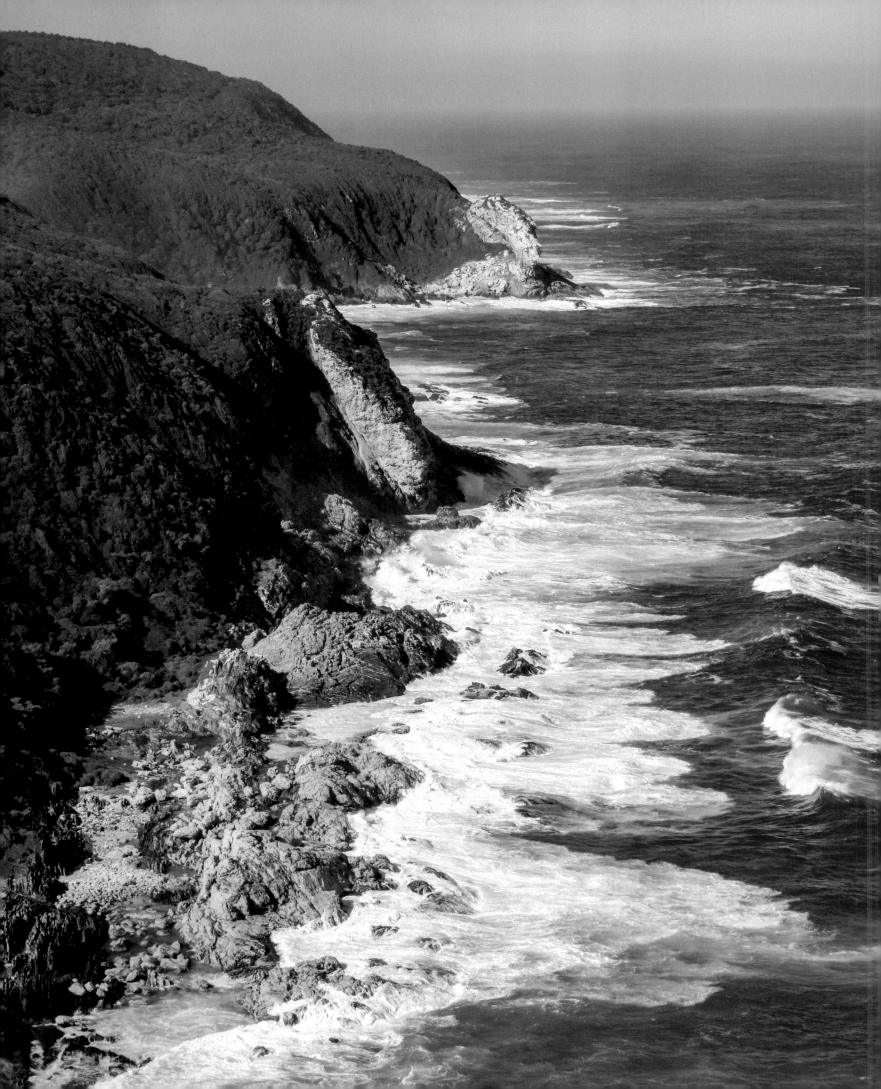

The Otter Trail is the hiking equivalent of an inspiring short story. Though brief in duration, the experience will resonate in the hearts and minds of all those who walk it for a long time to come. In the space of a mere 43 km (26.7 mi), it packs in an unsurpassed combination of breathtaking coastal scenery, virgin evergreen forests, lonely beaches, and cascading waterfalls.

Located entirely within Tsitsikamma National Park in South Africa's Garden Route region, the Otter Trail was inaugurated in 1968 and has since earned a reputation as being one of the world's finest coastal hikes. But despite its ever-increasing popularity, it is by no means a crowded pathway. Thanks to the quota system put in place by South African National Parks, only 12 hikers are permitted to start the Otter Trail per day. This equates to an enhanced wilderness experience, in which it is never overly ▶

Above: The trail is well marked throughout its course.
Left: The stretches of trail that hug the cliffs offer gorgeous ocean views.

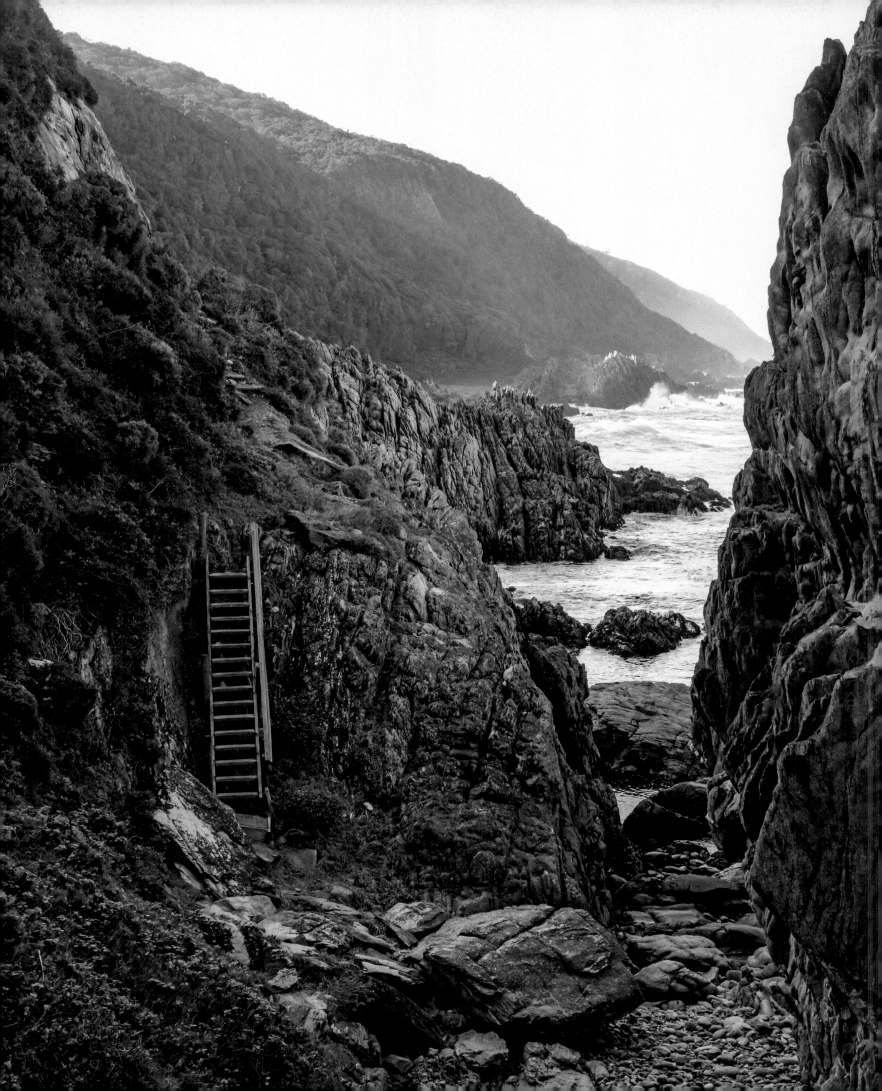

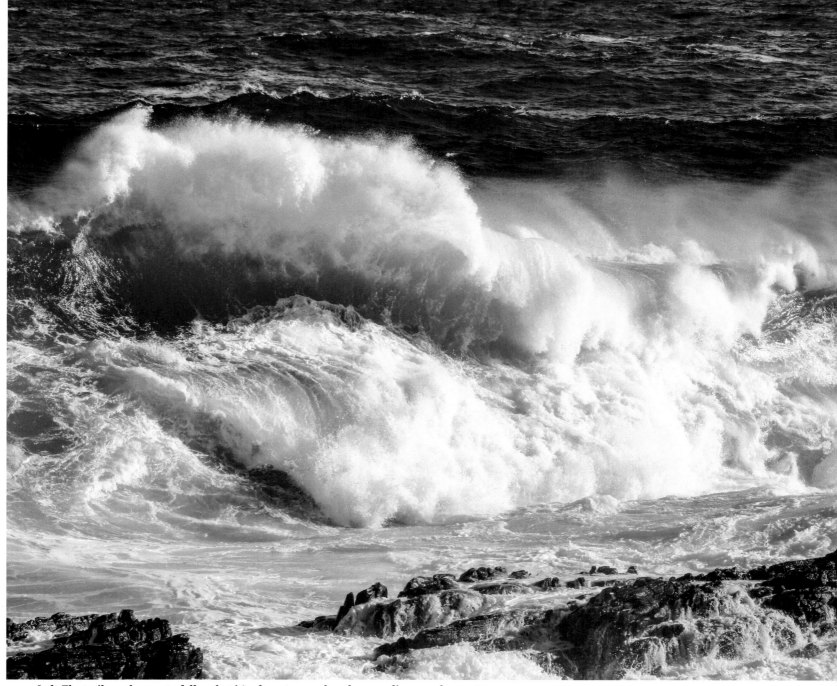

Left: The trail may be easy to follow, but it's often steep and can be very slippery when wet.
Above: Ocean views and crashing waves abound.

Given the abundance of marine life, lightweight binoculars and/or a zoom lens are a good idea for the Otter Trail.

The Otter Trail was inaugurated in 1968 and has earned a reputation as being one of the world's finest coastal hikes.

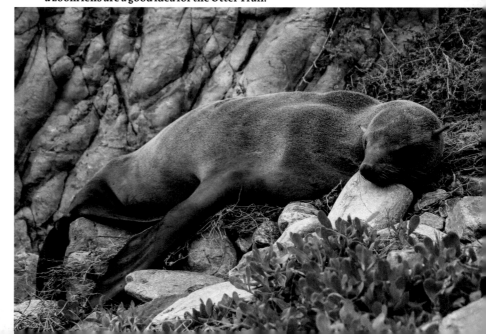

Some of the best views can be enjoyed from the comfort of your very own throne (see info box).

difficult to find solitude in the form of a cliff-top lookout, a hidden cove, or a secluded forest pool.

The trail begins at Storms River Mouth village in the east and finishes at Nature's Valley in the west. It takes five days to complete, with hikers overnighting in designated huts along the way. Perhaps more than any other multiday trek in this book, the Otter Trail is an ideal option for backpacking novices. The stages are short, the trail is clear and well maintained, the accommodations are comfortable, and though there are some steep ascents and descents, there is nothing unmanageable for a person in reasonable shape.

The most hazardous challenge potentially facing you on the Otter Trail are the river fords, the most notable of which is the Bloukrans River on the fourth day. It is highly recommended to make this crossing at low tide, when the water is usually knee deep or lower (check your tide timetable in advance). If you ford at or close to high tide, the water will be between

Only 12 hikers are permitted to start the Otter Trail per day, which means it is never overly difficult to find solitude in the form of a cliff-top lookout, a hidden cove, or a secluded forest pool.

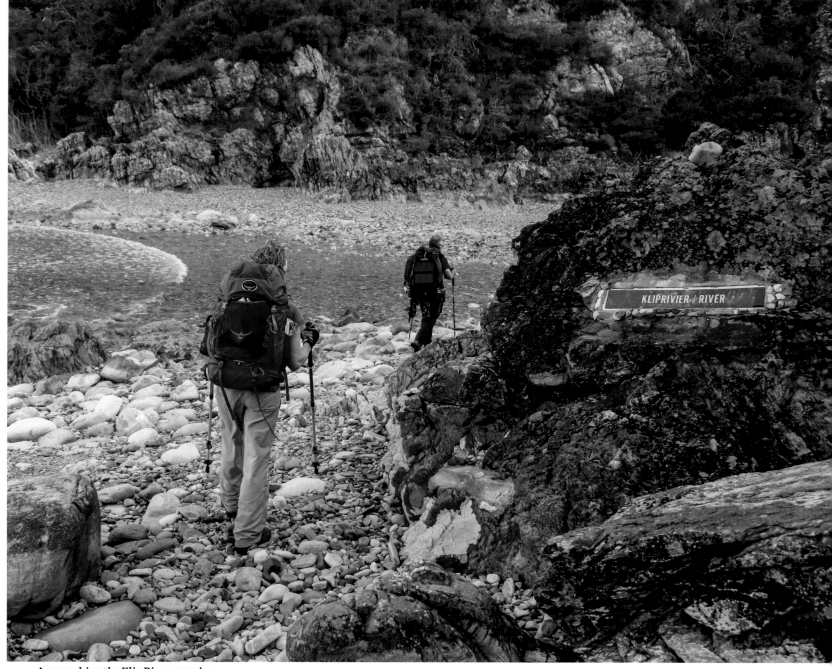

Approaching the Klip River crossing.

waist and shoulder height and potentially dangerous. Whatever the level, note that during the final meters of the crossing, there are often strong undercurrents; particular care needs to be taken, as hikers have been dragged out to sea in the past. (Tip: Before making the crossing, place all electronics and valuables inside sealable waterproof sacks or dry bags. Also ensure that the trash bag you are using as a pack liner is tied off at the top, which will make your pack buoyant if a worse-case scenario occurs.)

Speaking of getting wet, thanks to the relative brevity of each of the Otter Trail's five stages (between 4.8 km [3 mi] and 13.8 km [8.5 mi]), there are ample opportunities to stop and enjoy a refreshing swim at the many wondrous pools and watercourses along the route. Among the standout places to take a dip are the Waterfall Trail on day one, ▶

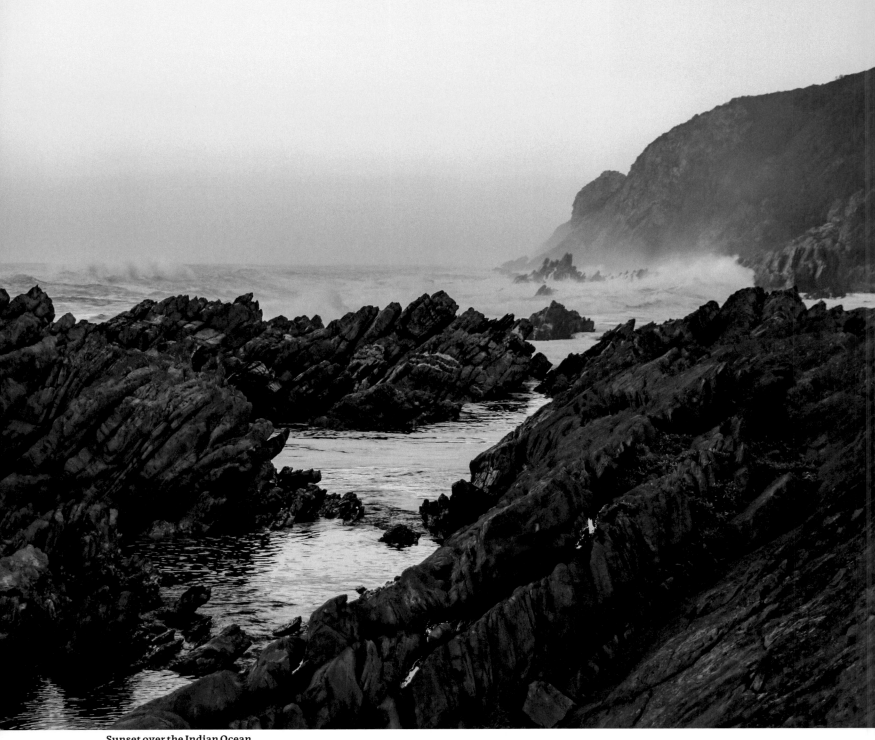

Sunset over the Indian Ocean.

the tidal rock pools of Blue Bay on day two (via a steep up-and-down 6 km [3.7 mi] side trail), the Lottering River on day three, and, for a celebratory swim in the ocean on the final day, Nature's Valley beach. While embracing the watery character of the Otter Trail, don't forget to keep an eye out for the Cape clawless otter, the pathway's elusive namesake that inhabits the streams and estuaries along the route.

From start to finish, there are no ho-hum sections on the Otter Trail. Ancient temperate forests are dissected by vertiginous ravines and winding rivers. Solitary beaches dotted with crystal-clear tidal pools are nestled beneath towering fynbos-covered cliffs.

It is a track that is brimming over with natural wonders. But of all that the Otter Trail has to offer, perhaps time is its most important gift. There is never a need to rush along this hike. Each stage only takes between 1.5 and 5 hours to complete, leaving the rest of each day to explore, read, swim, observe, or take in the sunset over the Indian Ocean—you choose. ◆

GOOD TO KNOW

About the Trail
/ <u>DISTANCE</u> 43 km (26.7 mi)
/ <u>DURATION</u> 5 days
/ <u>LEVEL</u> Easy to moderate

Start / Finish
⚲ Storms River Mouth
⚲ Nature's Valley

Season
The Otter Trail can be done all year round, and conditions are fairly mild no matter when you decide to hike. Average temperatures range between 16 °C and 25 °C (60.8 °F and 77 °F) in the summer, and 8 °C and 19 °C (46.4 °F and 66.2 °F) in the winter.

Permits
Only 12 hikers are allowed to begin the Otter Trail every day, and all bookings are made through the South African National Parks website. If you are looking at a specific date and/or you are part of a large group, it is recommended that you book well in advance.

Accommodation
There are two six-person huts at each of the four overnight stops along the trail. No camping is allowed.

Age Restrictions
Due to the physical demands of the trail, South African National Parks have put in place certain age restrictions. Children below 12 years old and adults above 65 years old are not permitted on the Otter Trail.

HELPFUL HINTS

Tide Times Before beginning the trail, be sure to pick up a copy of the tide timetables at the information center at Storms River.

Equipment Trail-running shoes (rather than heavy boots), sleeping bag, hat, sunscreen, swimming trunks, lightweight towel, rain jacket, sunglasses, headlamp, small dry bags or sealable plastic bags for your valuables, and a trash compactor bag to line (waterproof) your backpack. Though by no means necessary, you may want to consider carrying a small pair of binoculars for spotting whales, dolphins, and other marine life.

FLORA & FAUNA

Wildlife Viewing in Style At each of the four campsites is a flush toilet with a spectacular view over the Indian Ocean. From the comfort of your very own throne, you can gaze out through a big one-way glass window and potentially spot whales, dolphins, or even the elusive Cape clawless otter playing in the shallow surf below.

BACKGROUND

Five Facts about the Otter Trail

1. Inaugurated in 1968, the Otter Trail is the oldest official hiking trail in South Africa.

2. Whale-watching season is between June and October (peaking in September).

3. Each year there is a race on the route called the Otter African Trail Run. As of 2018, the record time is an astonishing 3 hrs and 54 min.

4. Leopards have been spotted on the Otter Trail.

5. The unofficial end of the Otter Trail—it's an extra 2.3 km (1.4 mi)—is the Valley Inn at Nature's Valley, where a well-earned post-hike celebratory beer and big meal await.

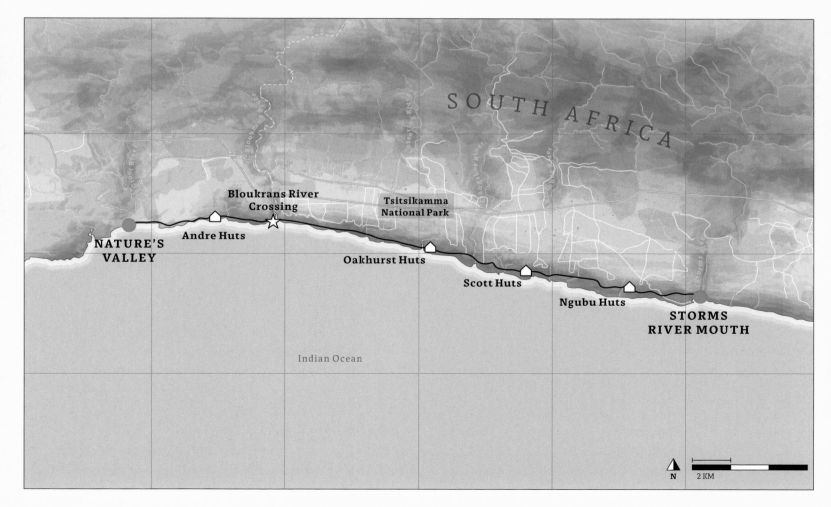

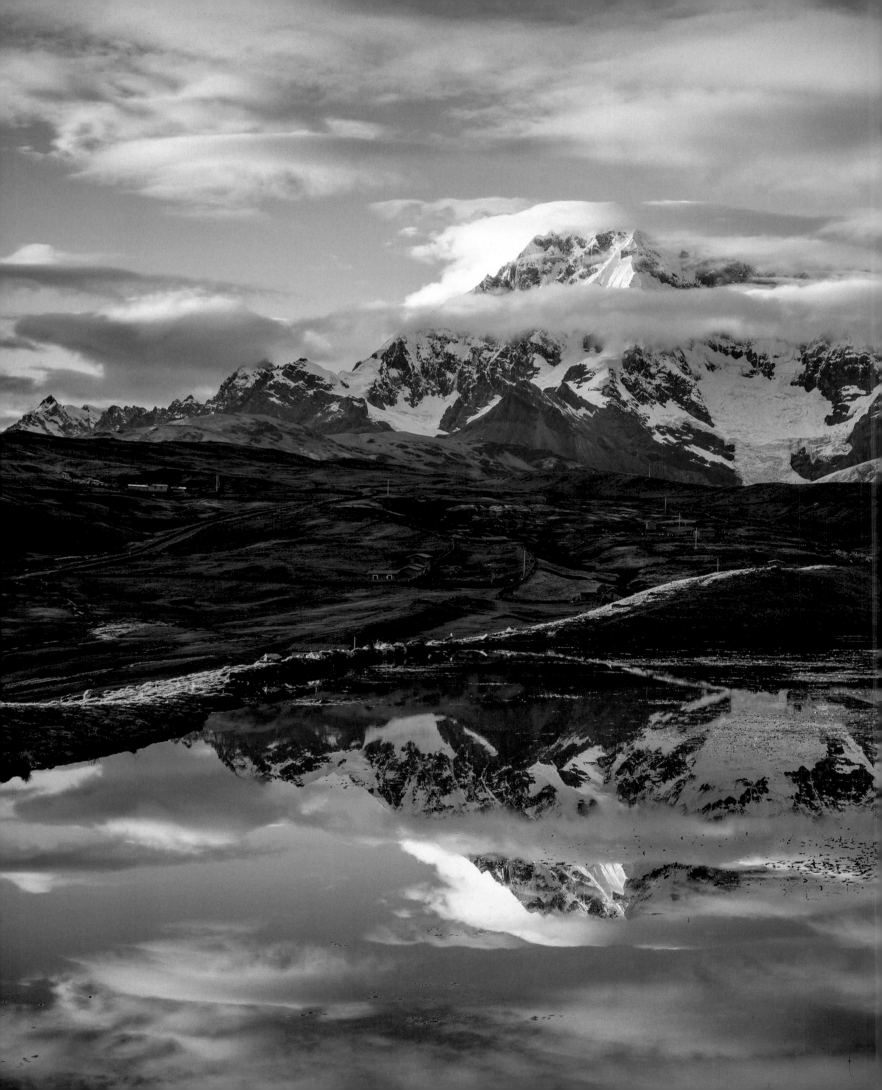

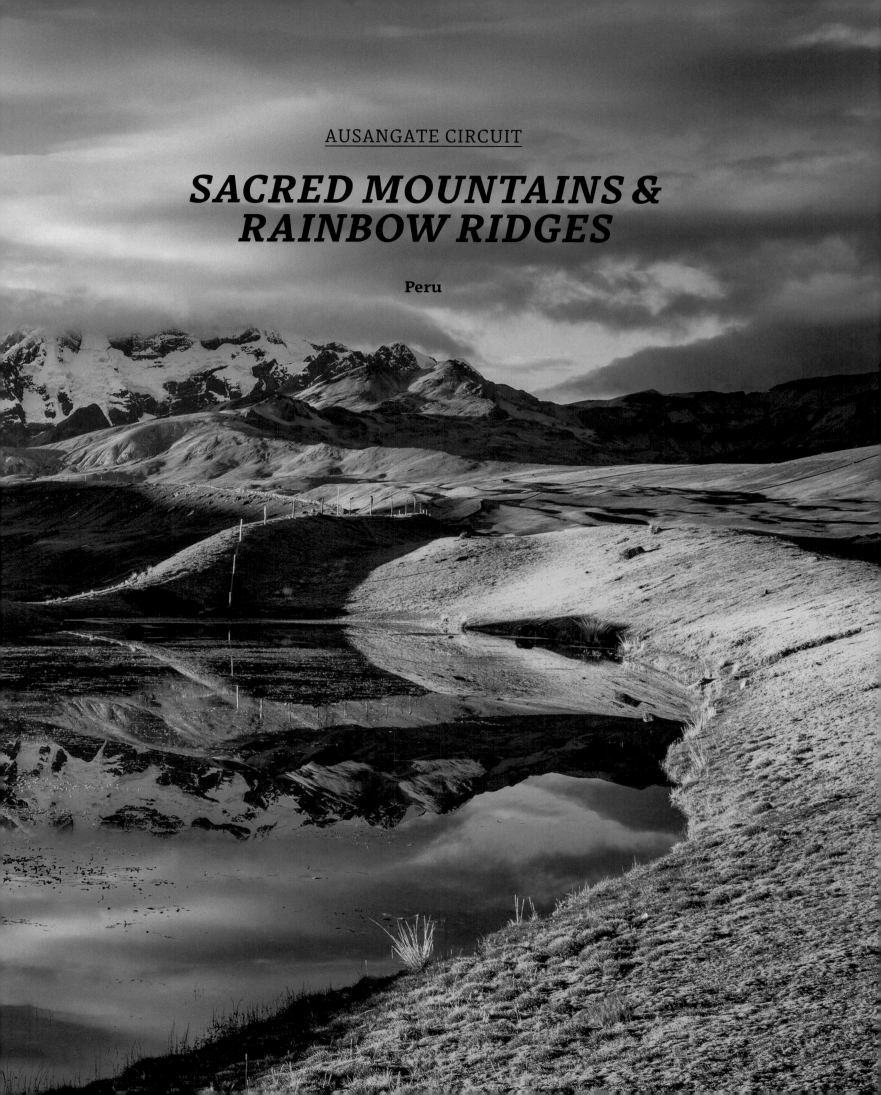

SACRED MOUNTAINS & RAINBOW RIDGES

Peru

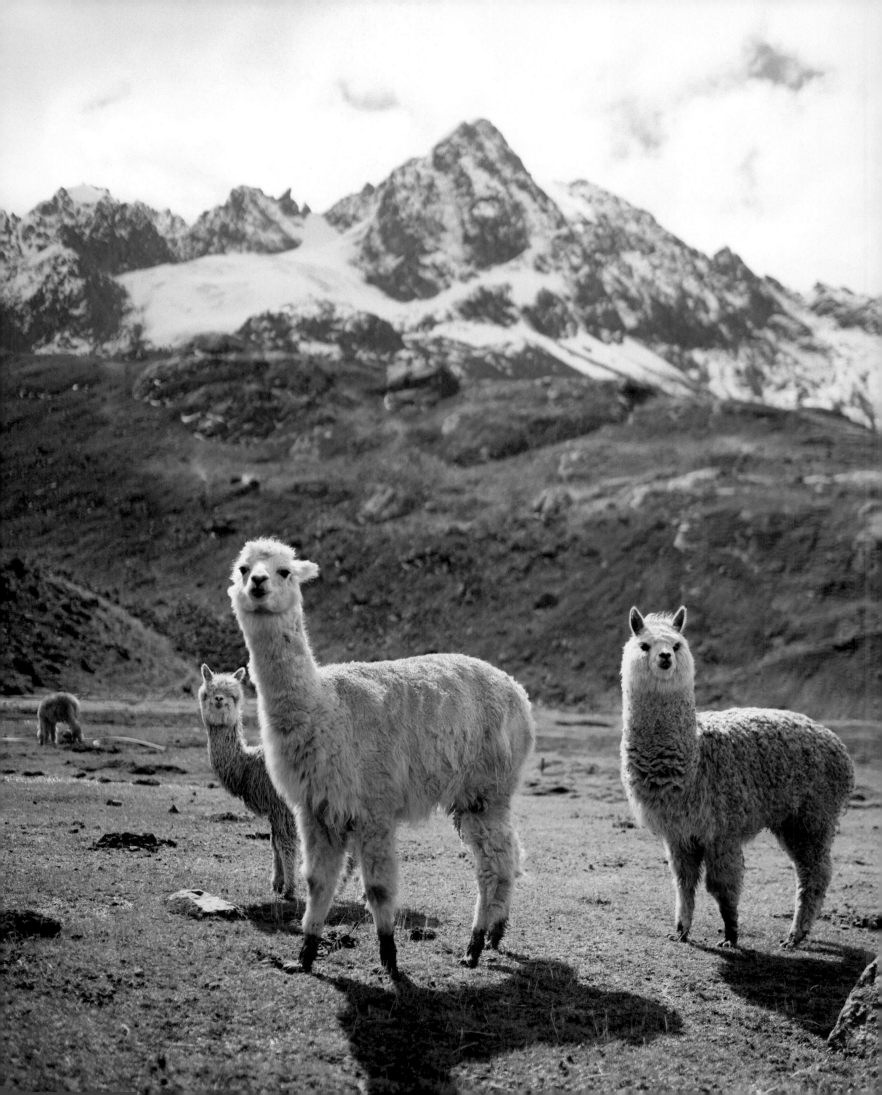

The Ausangate Circuit is a classic Andean trek around one of South America's most sacred peaks. Located southeast of Cusco, Peru, it features glaciers, hot springs, and incredible mountain scenery, yet receives only a fraction of the foot traffic experienced on the region's most famous walks, the Inca Trail and the Salkantay Trek. This 70 km (43.5 mi) circumnavigation of Nevado Ausangate (6,384 m [20,945 ft]) arguably surpasses both in terms of alpine beauty. Plus, hikers can take a side trip to one of the continent's most celebrated natural wonders, Rainbow Mountain (Vinicunca).

Beginning and ending in the dusty town of Tinqui, the Ausangate Circuit is a topographical roller coaster that traverses four high-altitude passes—all of which are over 4,757 m (15,607 ft)—and meanders through marshy valleys and the starkly beautiful, dry Puna (a high, treeless plateau). During its course, hikers will encounter multiple herder camps where the locals speak Quechua ▶

Quechua people are believed to be direct descendants of the Incas.

Left: According to local legend, the Ausangate area is where llamas and alpacas originally come from.
Below: Crossing the Puna (high, treeless plateau) in the shadow of the Ausangate massif.

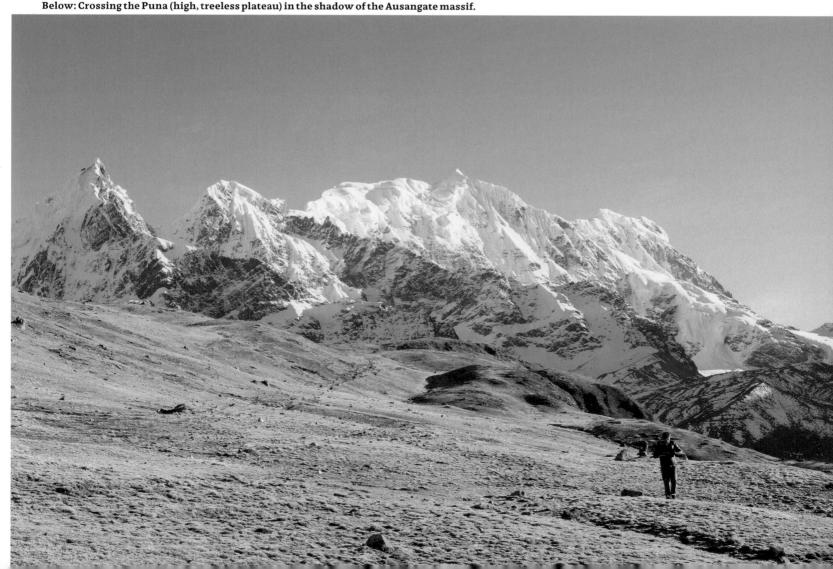

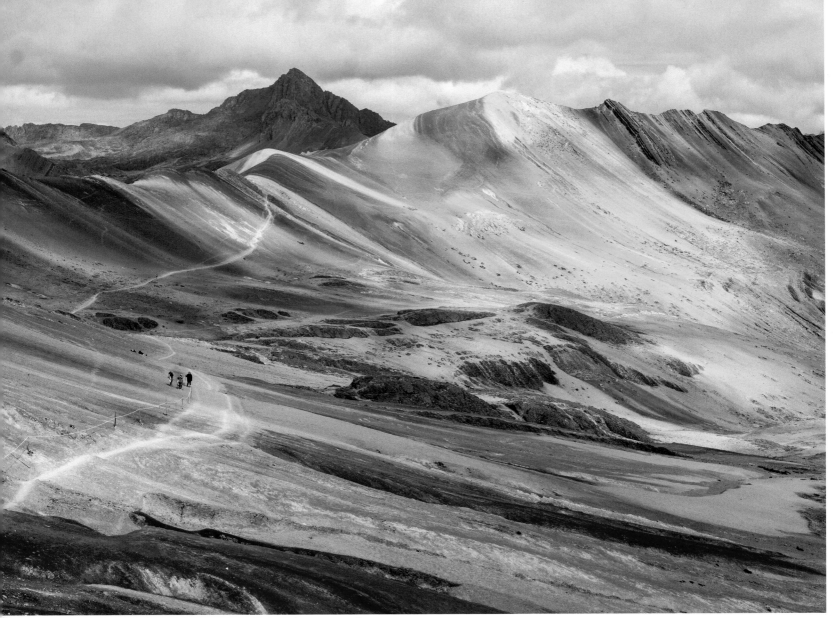

Side trip to Vinicunca, the famed Rainbow Mountain.

(the principal native tongue of the Andes) and pay homage to the *apus,* sacred deities in the form of mountains that are possessed of *kamaq* (vital force). The most important *apu* is Ausangate, the region's highest mountain as well as the *pakarina* (place of origin) of alpacas and llamas, according to legend.

Every year, the indigenous peoples of the Ausangate area convene between late May and early June to celebrate the Quyllurit'i (Star of the Snow) festival. Taking place at the foot of Ausangate, at an altitude of 4,750 m (15,584 ft, perhaps the world's highest party?), this four-day, non-alcoholic gathering is held to mark the winter solstice and appease the mountain deity Apu Ausangate. But there is also an important Christian element to the fiestas, as it is said that in the year 1783, ▶

Right: Ausangate's awe-inspiring glaciers.
Below: Hiring a guide and horses is an option for those who want a bit of assistance on their trek.

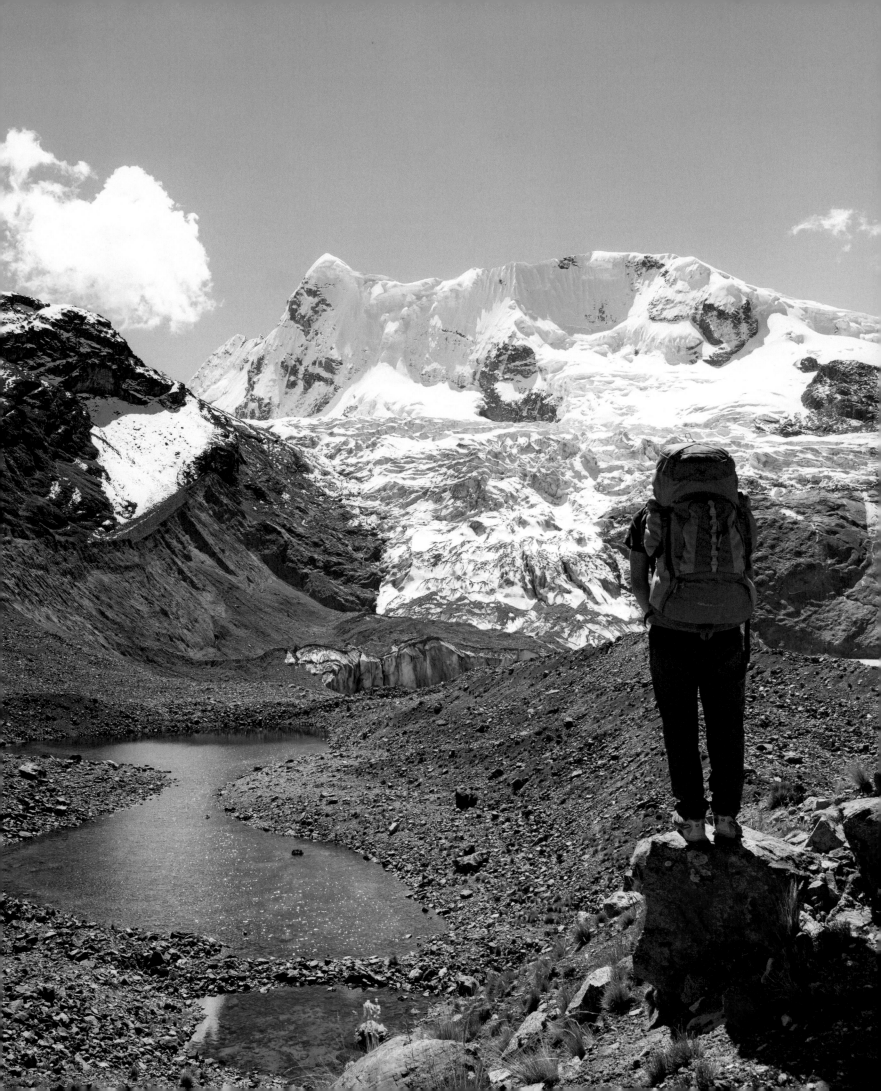

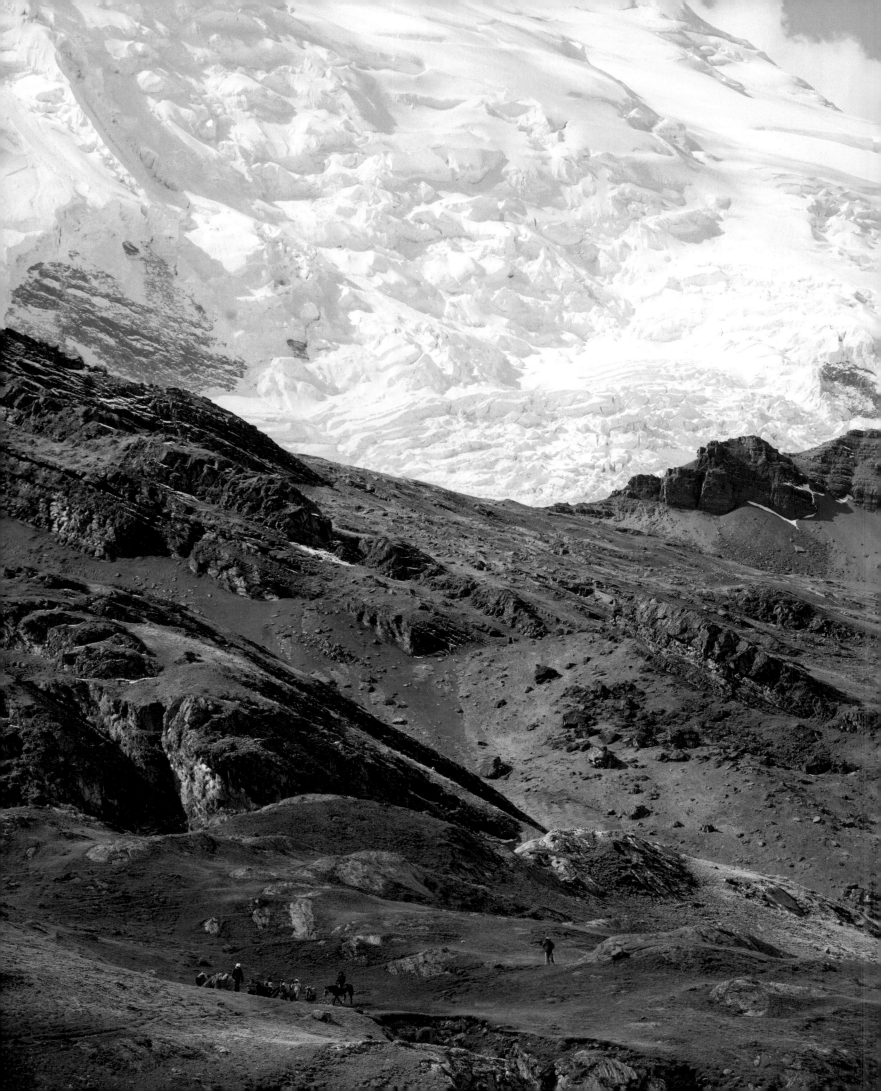

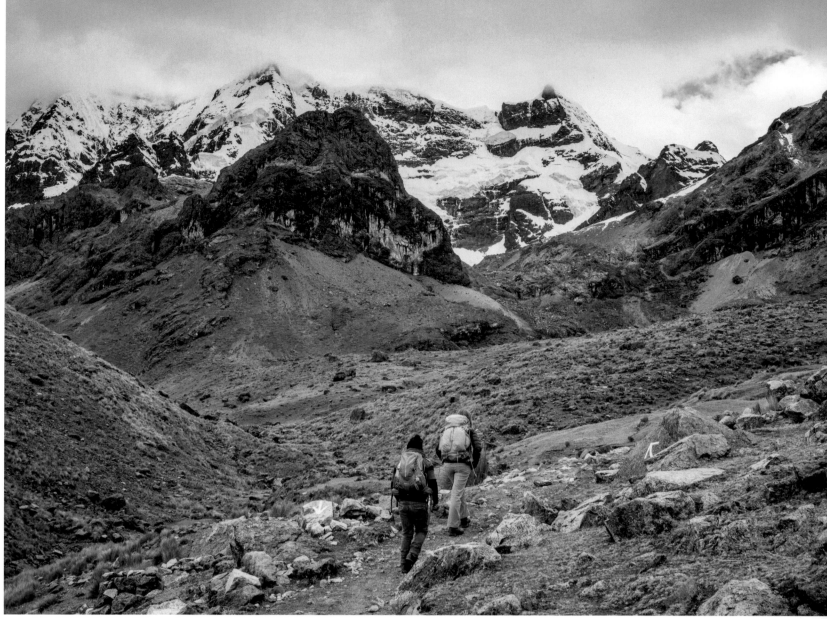

Hiking towards Arapa Pass (4,757 m [15,607 ft]).

an image of Christ appeared in the Sinakara Valley at this very site. In 2011, the cultural importance of Quyllurit'i was recognized by its inclusion in the UNESCO Intangible Cultural Heritage Lists, and each year the celebration is attended by thousands of pilgrims from all over Peru.

Besides the massif itself, the place that most foreigners want to see is Rainbow Mountain. Situated south-southwest of the circuit, this multihued mountain, formed out of sedimentary layers created from mineral deposits over millions of years, has become a very popular day trip for tourists from Cusco, receiving hundreds of visitors per day during the high season. Visiting Rainbow Mountain from the circuit adds on an extra one to two days of hiking, and to access it you must depart from the trail near Laguna Jatan Pucococha. ▶

A starry night in the Andes.

The way is not marked, and a trekking guide is recommended, or at least GPS waypoints and good route-finding skills. If you want to avoid the crowds, aim at camping close t o Rainbow Mountain the night before and reaching it first thing the following day—normally the tour vehicles from Cusco don't arrive until mid-morning.

Back to the trail. The biggest challenge reported by the majority of Ausangate hikers is dealing with the effects of high altitude. On the first night of the circuit, you will probably be camping at about 4,500 m (14,764 ft), subsequently remaining above this elevation for all but the final kilometers on the return to Tinqui. The cause of hikers' altitude issues is almost always a lack of pre-hike acclimatization, and to avoid developing acute mountain sickness (AMS) the following course of action is strongly recommended: First, upon arrival in the high Andes, spend at least a couple of days walking around the regional hub

of Cusco (3,400 m [11,155 ft]). Second, before tackling the Ausangate, do at least one of the area's slightly lower altitude treks, such as the Inca Trail, Salkantay Trek, or Lares Trek. These measures, along with proper hydration and not pushing yourself too hard on the first couple of days, will exponentially improve your chances of finishing the Ausangate Circuit and help to ensure you remain healthy for the duration.

The Ausangate Circuit encapsulates much of what hikers look for in an Andean trek: towering snow-capped peaks, gorgeous sapphire lakes, sky-high mountain passes, and leg-soothing hot springs. Throw in some photogenic quadrupeds and the opportunity to observe the traditional shepherding culture up close and personal, and it is no surprise that when veteran hikers talk about their favorite trek in Peru, the Ausangate Circuit is usually one of the first names mentioned. ◆

Drinking in the views from Palomani Pass (5,165 m [16,945]), the highest point on the Ausangate Circuit.

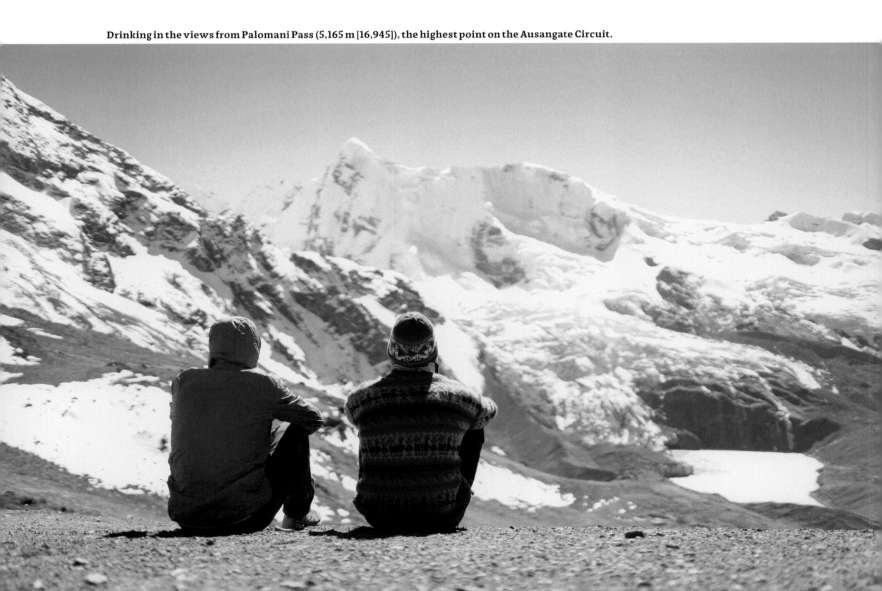

GOOD TO KNOW

About the Trail
/ DISTANCE 70 km (43.5 mi), not including the side trip to Rainbow Mountain
/ DURATION 4 to 5 days
/ LEVEL Challenging

Start / Finish
⚲ Tinqui

Highest Point
Palomani Pass (5,165 m [16,946 ft])

Lowest Point
Tinqui (3,800 m [12,467 ft])

Season
May to September. During this period, nights can be very cold (-10 °C [14 °F] is common), but days are generally clear.

Supplies
There are a couple of basic stores in Tinqui, but you are better off bringing all supplies from Cusco, the region's hub. Once you leave Tinqui, there is nowhere to purchase supplies along the route.

Water
There is plenty of water available throughout the circuit. However, due to the prevalence of grazing animals it is recommended that hikers treat all H$_2$O taken from wild sources before drinking.

FLORA & FAUNA

Cheeky Chinchillas According to legend, Ausangate is the *pakarina* (place of origin) of alpacas and llamas. As such, it is no surprise that these photogenic quadrupeds are seen in abundance throughout the Ausangate Circuit. Other wild animals you might spot during the trek include vicuñas, black-winged Andean geese, and, if you're lucky, the incredible Andean condor. Of all the creatures—both domesticated and wild—encountered on the Ausangate, the only ones to beware of are the cutest and smallest. Over the years, the circuit's opportunistic *viscachas* (chinchillas) have developed a reputation as snack thieves. They lie in wait for unsuspecting trekkers on the rocky slopes of the high mountain passes, so be sure to mind your food if you've stopped for a breather.

HELPFUL HINTS

Going Solo More than 95 percent of hikers who tackle the Ausangate Circuit do so as part of a guided group. But if you have the necessary warm-weather gear, a good amount of backpacking experience, and are well acclimatized, there are no issues with doing the hike independently.

Hot Springs There are two hot springs along the trail. Going in a counterclockwise direction, the first is located 20 minutes past the tiny village of Upis. The second can be found at the village of Pacchanta. From there it is an easy three-hour descent back to Tinqui.

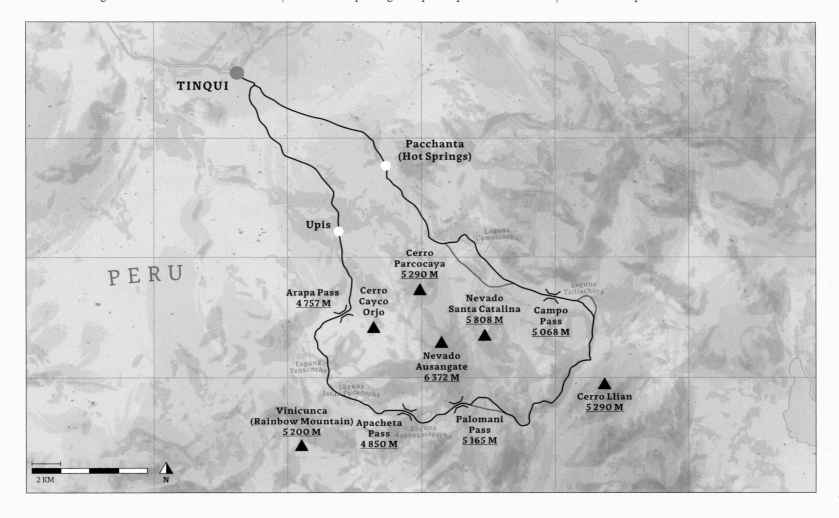

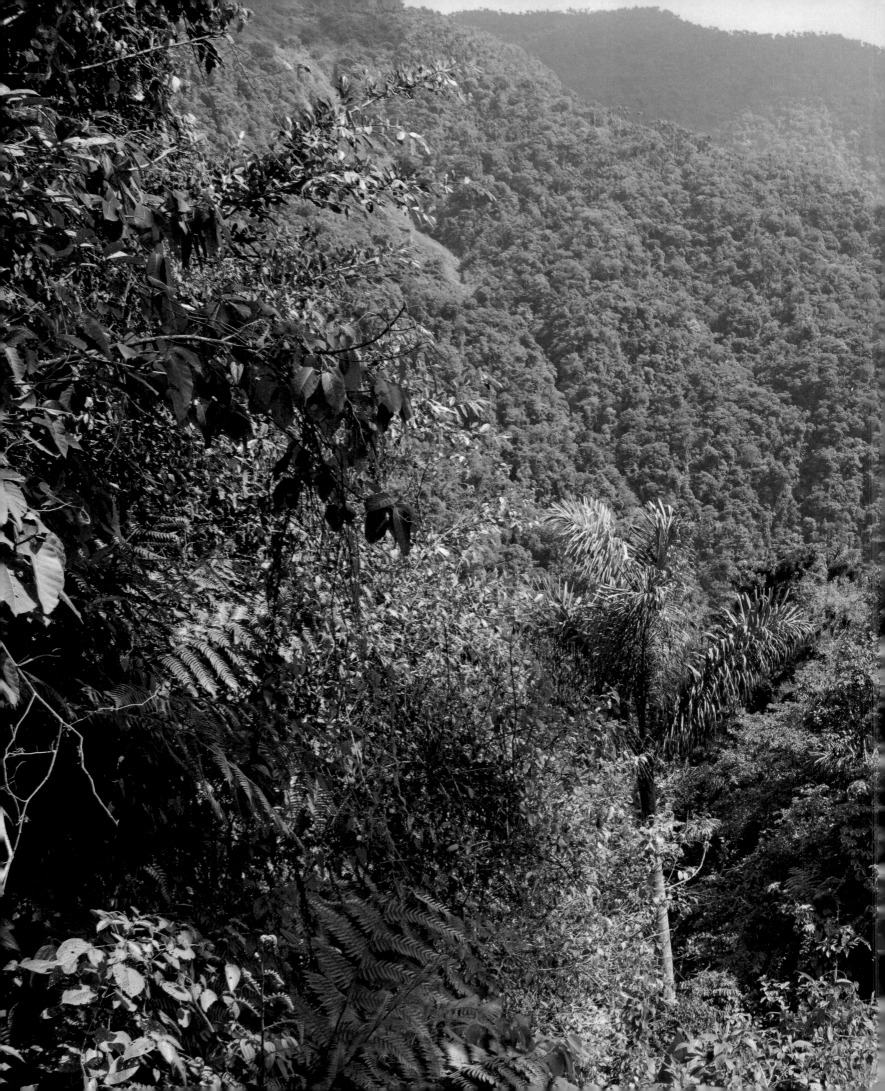

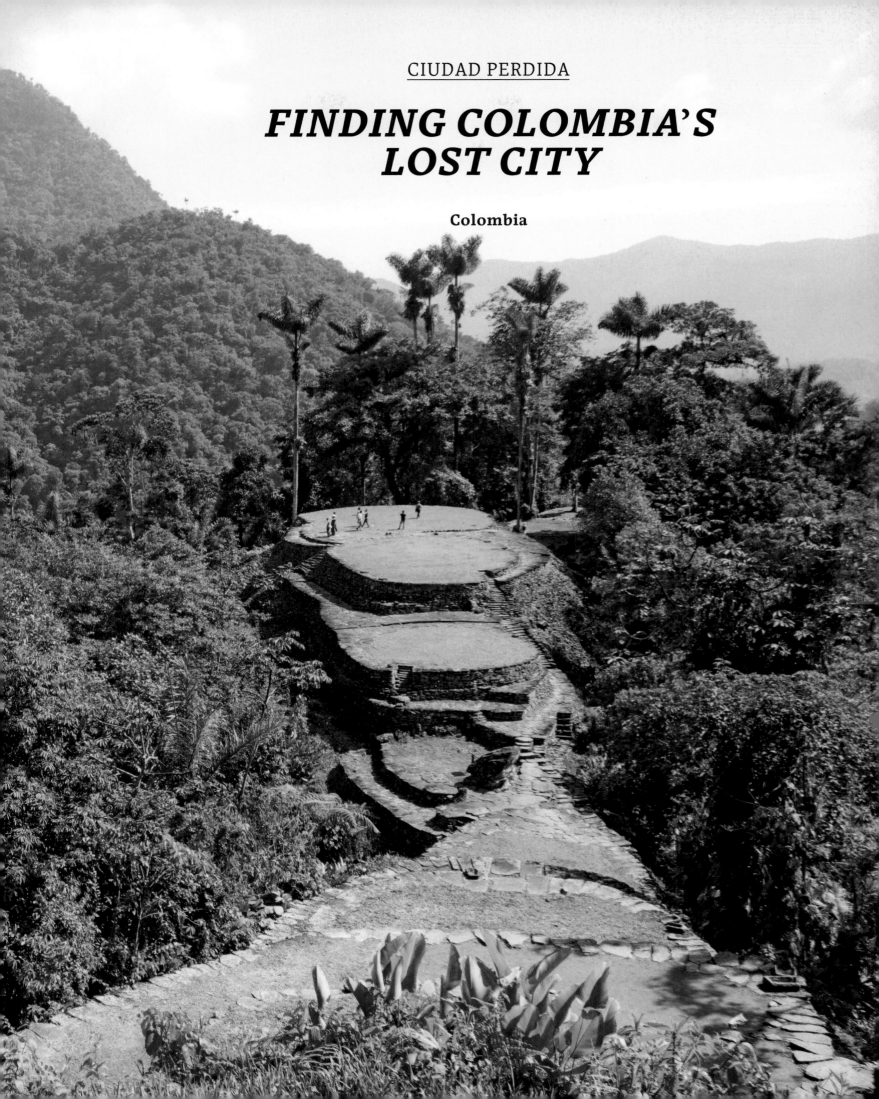

CIUDAD PERDIDA

FINDING COLOMBIA'S LOST CITY

Colombia

Located deep in the jungle of Colombia's Sierra Nevada, the Ciudad Perdida (Lost City) is a less touristy and more isolated version of Machu Picchu. However, unlike the famed Inca citadel in Peru, which can be accessed by train or bus, the lost city of the Tairona people can only be reached on foot, via a 44 km (27 mi) out-and-back trail from the village of El Mamey. While it is by no means a walk in the park, the trek is within the capabilities of most people, and offers a singular combination of historical, cultural, and environmental elements.

The lost city—known as "Teyuna" by locals—was established in approximately 800 AD, some 650 years before Machu Picchu. At its zenith, it was home to more than 2,000 inhabitants, and is said to have been the political and manufacturing center of the region. According to popular narrative, it was subsequently abandoned at the time of the Spanish conquest in the 1500s, and then lay hidden for the next four centuries. However, the indigenous peoples of the region—the Arhuaco, Kogi, and Wiwa— claim that the city was never actually lost. These descendants of the Tairona maintain that locals knew about its existence throughout this period but chose to keep it a secret from the rest of the world, fearing the site would be overrun by looters. Their concerns turned out to be justified, as when treasure hunters finally found the site in 1972, they immediately set about stripping it of most of its riches.

Following its rediscovery, the remote jungle citadel's ensuing decades were far from smooth sailing. Not long after archaeologists began excavating the site in 1976, the area was deemed off-limits due to extensive guerrilla and paramilitary activity. It wasn't until 2005 that things settled down enough for the region to be considered safe for tourists. Since then, the Colombian military has patrolled the area and no further security issues have been reported.

The trail itself is rated moderately difficult. There are some steep climbs, river crossings, and, as with any jungle trip, muddy and slippery conditions are common. Though the terrain can be challenging at times, dealing with the heat and humidity is arguably the biggest hurdle when considering this hike—the Lost City trek may well be South America's sweatiest hike. In addition to hydrating at regular intervals, you can combat the sweltering conditions by going for as many swims as possible in the rivers and waterholes situated along the trail. These places are a godsend, and kicking back in the cool waters while taking in the awesome jungle surroundings invariably rates as one of the highlights of the journey.

During its course, the trail passes through several small indigenous villages consisting of thatch-roofed huts, their residents attired in traditional white clothing. Accompanied

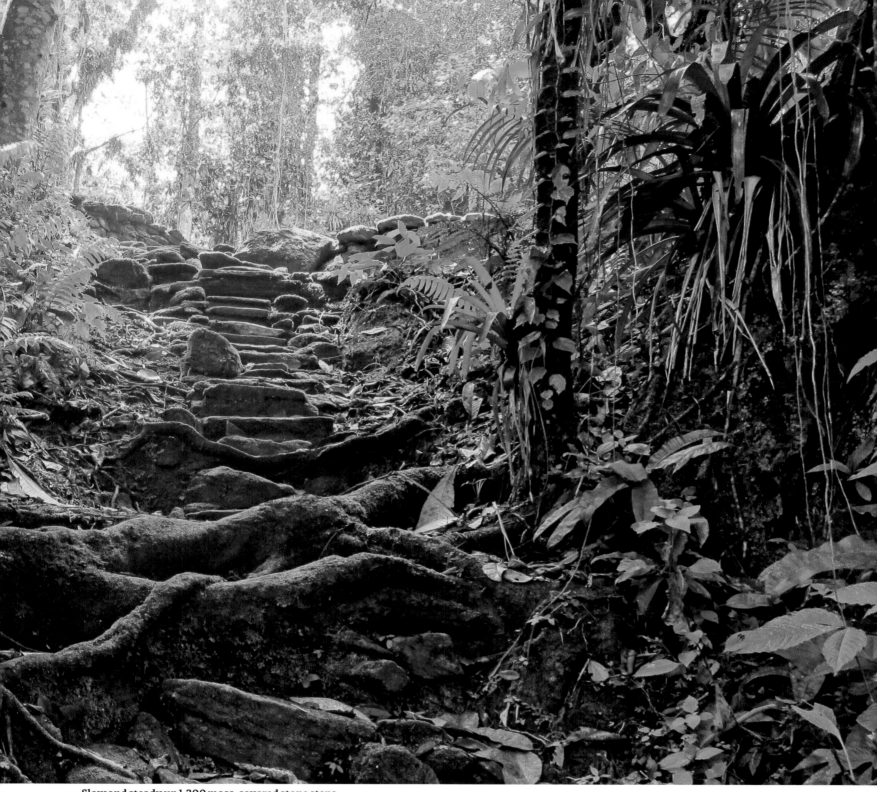

Slow and steady up 1,200 moss-covered stone steps.

by knowledgeable local guides, you will gain insights into regional customs, such as weaving techniques and the ritual use of *popuro,* a hollowed-out gourd that contains lime powder consumed in conjunction with coca leaves.

After two days and 22 km (14 mi) of walking, the trail arrives at the Lost City. The final approach is made via a flight of 1,200 excavated stone steps that climb through the jungle and eventually emerge among the ruins. The breathtaking site consists of more than 160 terraces and multiple circular plazas, all linked together by a system of interconnected stone pathways. Gazing out at the surrounding jungle in all directions, one cannot help but marvel at the work that must have gone into the construction of such a remote and largely inaccessible city. Even more incredible is the fact that archaeologists estimate that only 10 percent of the original city has been excavated thus far; the remainder lies mysteriously hidden underneath a cloak of thick jungle foliage. ▶

**Located deep
in the jungle
of Colombia's Sierra
Nevada, the
Ciudad Perdida
(Lost City)
is a less touristy
and more isolated
version of
Machu Picchu.**

Passing by a small Kogi village.

After the rains, as the clouds rise through the hills.

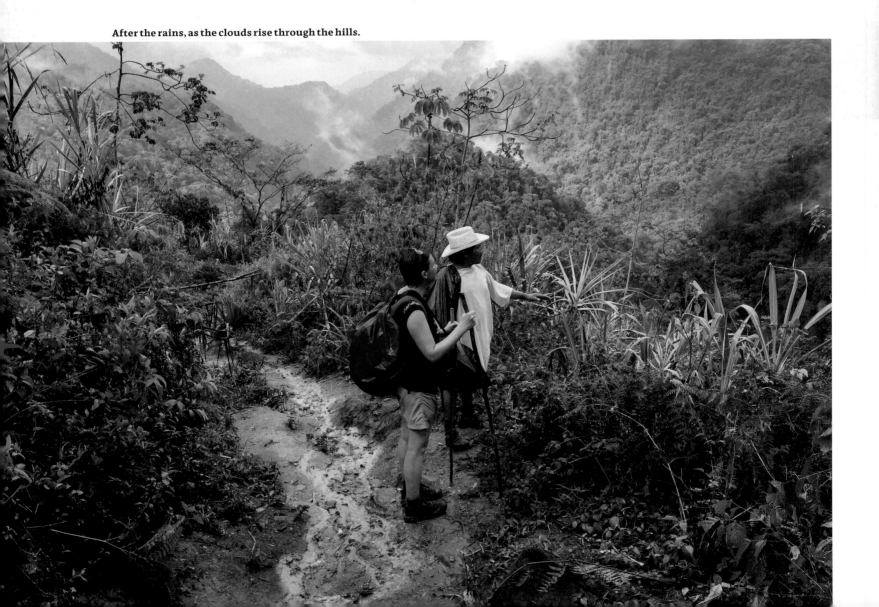

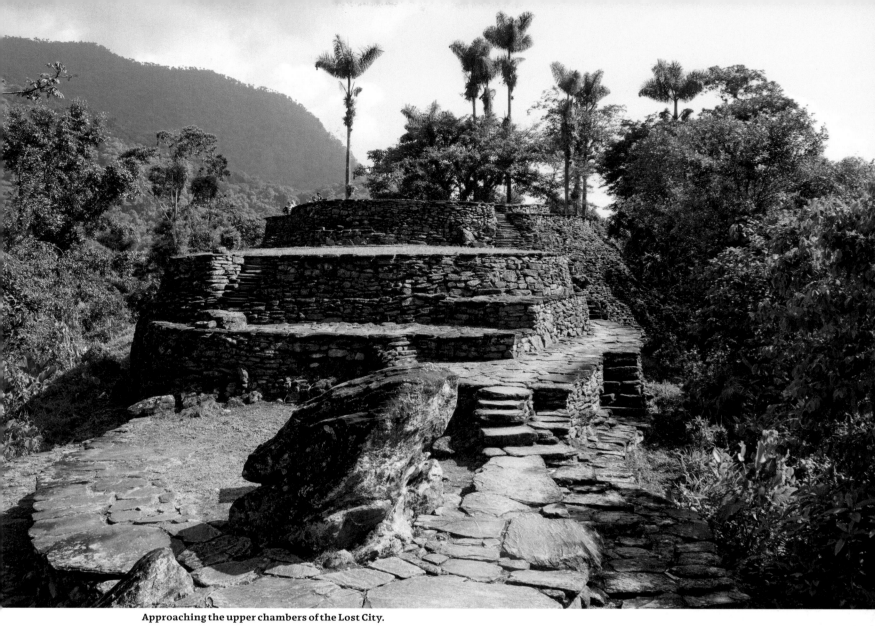

Approaching the upper chambers of the Lost City.

The trail crosses Rio Buritaca several times during the journey.

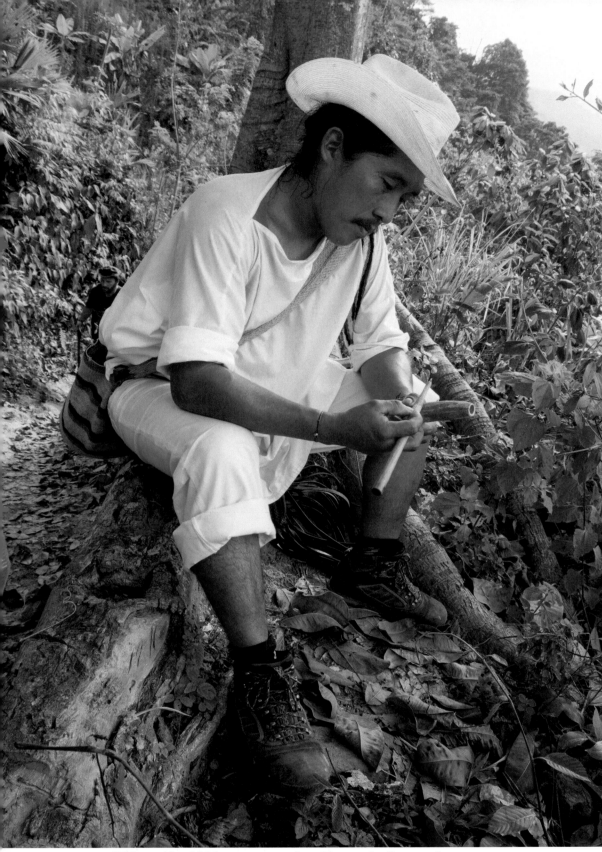

A Wiwa guide with his *poporo*, a gourd used for carrying lime powder.

Archaeologists estimate that only 10 percent of the original city has been excavated thus far; the remainder lies mysteriously hidden underneath a cloak of thick jungle foliage.

It may sound clichéd, but the Ciudad Perdida trek is more about the journey than the destination. While the archaeological site itself is undeniably impressive, it is what hikers experience before and after the turnaround point that seems to resonate the longest. It's about meeting and overcoming the challenges inherent to any jungle trek.

It's about learning firsthand how indigenous people have lived and thrived for centuries in such an unforgiving environment. It's about listening to Mother Nature's wondrous soundtrack as you drift off to sleep at night, pondering how a million distinct sounds can blend together in such perfect harmony. ◆

GOOD TO KNOW

About the Trail
/ DISTANCE 44 km (27 mi)
/ DURATION 4 or 5 days
/ LEVEL Moderate

Start / Finish
⚑ El Mamey village (out and back)

Season
It's possible to hike the trail year round, though the "dry" season between December and March is ideal.

Conditions
The Ciudad Perdida trek is in the tropics, so hot, humid, and wet conditions should be expected at any time of year.

Clothing
Bring two sets of clothes: one set for hiking (which will usually be wet from either rain, sweat, or both) and one set for camp (which will hopefully stay dry).

Altitude
2,700 m (8,858 ft) of elevation gain and loss. The highest point on the trail is the Lost City itself, situated 1,150 m (3,772 ft) above sea level.

Accommodation
During the journey, hikers stay at established campsites, where food, filtered drinking water, and bedding are provided.

Note
The Ciudad Perdida Trek cannot be done independently. Trekking agencies can be booked online or upon arrival in Colombia.

FLORA & FAUNA

Coca Plant The notorious plant is ubiquitous along the trail and is used by the native people as a stimulant, instead of coffee. The content of the psychoactive alkaloid cocaine, is relatively low in fresh coca leaves.

HELPFUL HINTS

Jungle Hiking Tips Perhaps the two biggest challenges facing hikers on the Ciudad Perdida trek are heat and bugs.

In order to combat the former, you should plan on hitting the trail just after sunrise, hydrating at regular intervals, and going for as many swims as possible in the rivers and waterholes along the trail. As for the bugs, the best defenses are good insect repellent, a head net, and light-colored, breathable long-sleeved shirts nd pants. With regard to the latter two items, models that have been factory treated with permethrin (a proven and safe insecticide that remains effective for up to 70 launderings) will provide the best long-term protection.

BACKGROUND

Security Issues Although the trek to Colombia's Lost City has been safe for tourists for more than a decade, this wasn't always the case. In 2003, eight hikers were kidnapped by the Ejercito de Liberación Nacional (ELN), a Marxist guerrilla group that had been at war with the Colombian government for more than four decades. The tourists were subsequently held captive for 101 days before finally being released in exchange for an international investigation into the human rights violations that the ELN claimed had been committed against the region's indigenous people by government-backed paramilitary groups.

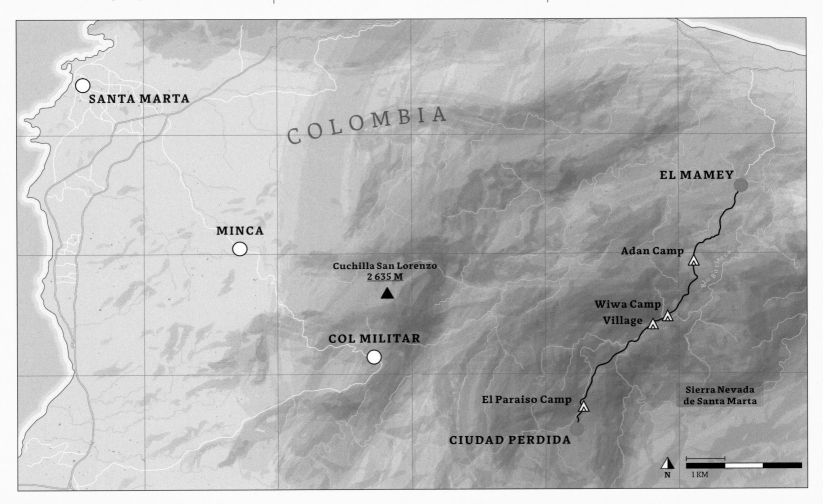

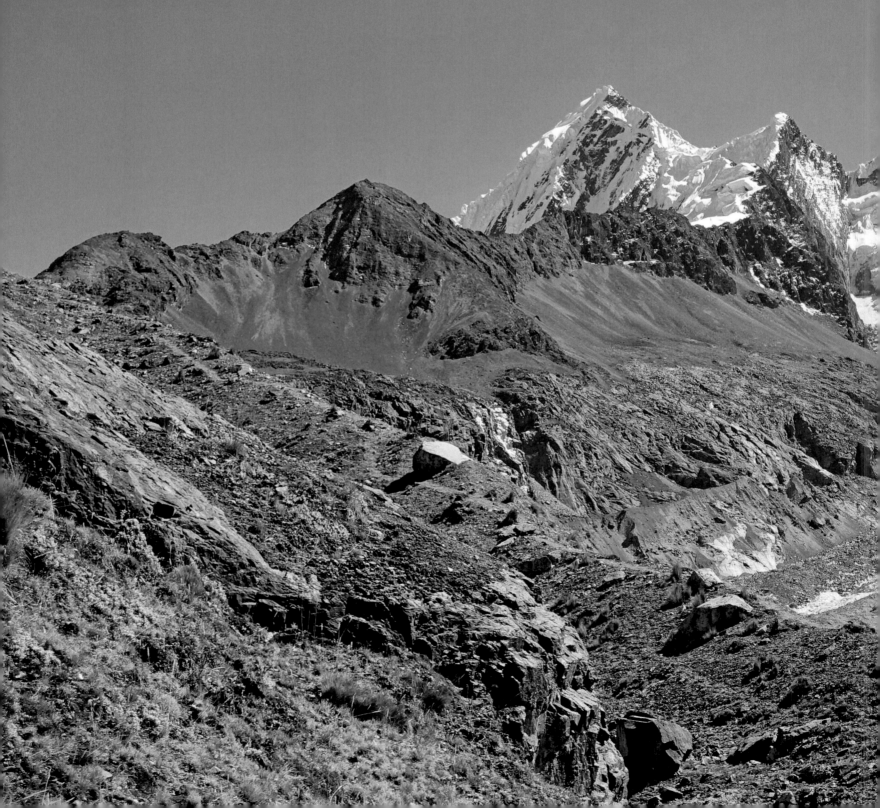

CORDILLERA HUAYHUASH CIRCUIT

VALLEY HOPPING IN PERU'S ALPINE WONDERLAND

Peru

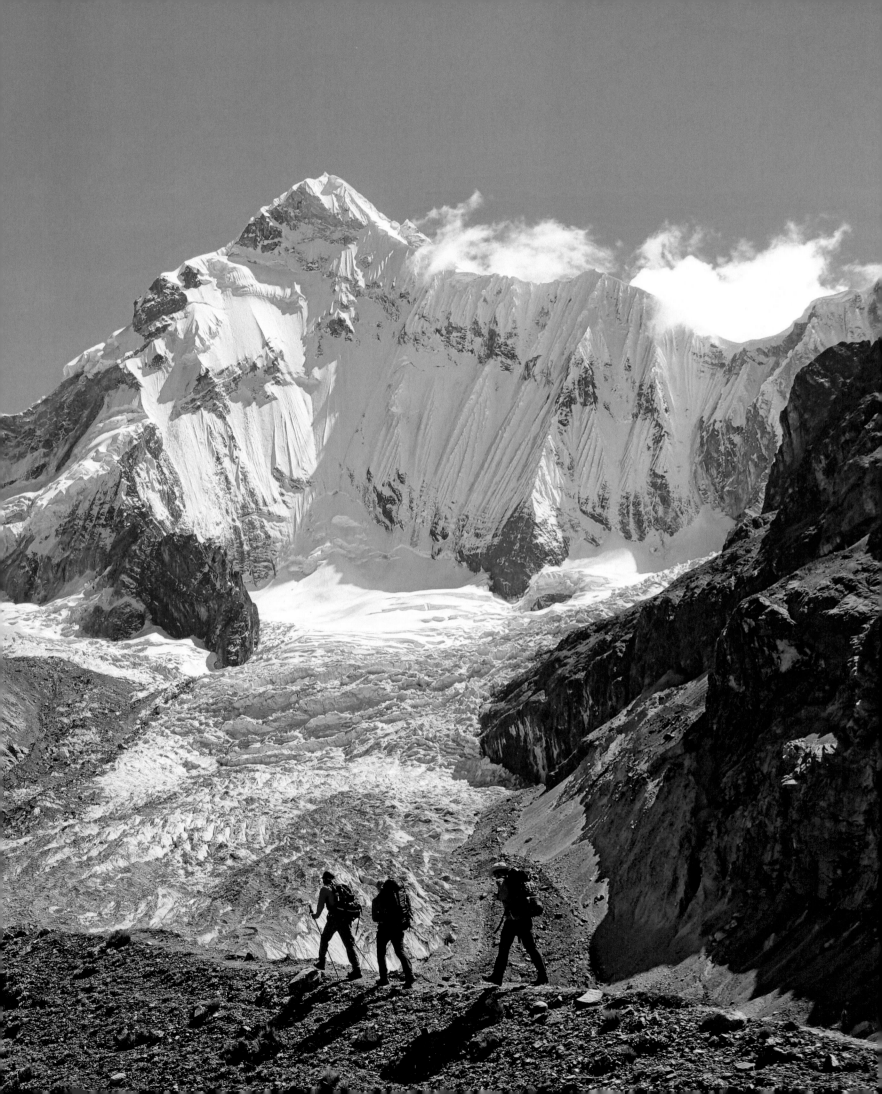

The trek around the Cordillera Huayhuash's circumference measures only 30 km (18.6 mi) as the crow flies from north to south and offers hikers majestic 6,000 m (20,000 ft) peaks, sweeping glacier-carved valleys, and sparkling azure lakes. Throw in some limb-soothing hot springs and the chance to observe the mighty Andean condor up close and personal, and it is no surprise that the Cordillera Huayhuash Circuit is widely recognized as one of the world's finest long-distance hikes.

Despite its renowned natural beauty, the Huayhuash was infrequently visited by hikers for many years due to security issues. For much of the 1980s and 1990s, the area was employed as a remote base by a Peruvian militant group known as Sendero Luminoso (Shining Path). Safety continued to be of concern until 2004, when local communities banded together and began charging visitors

Three Lakes viewpoint on the way to Siula pass.

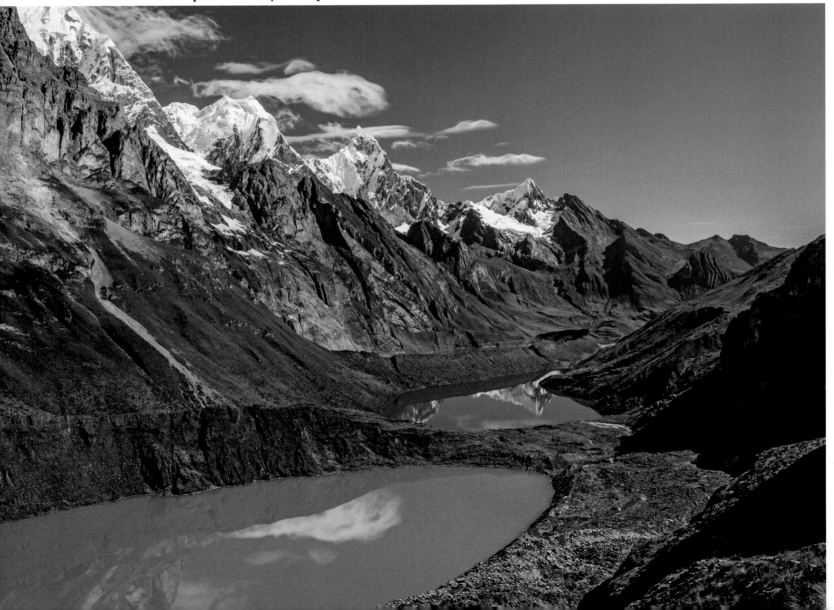

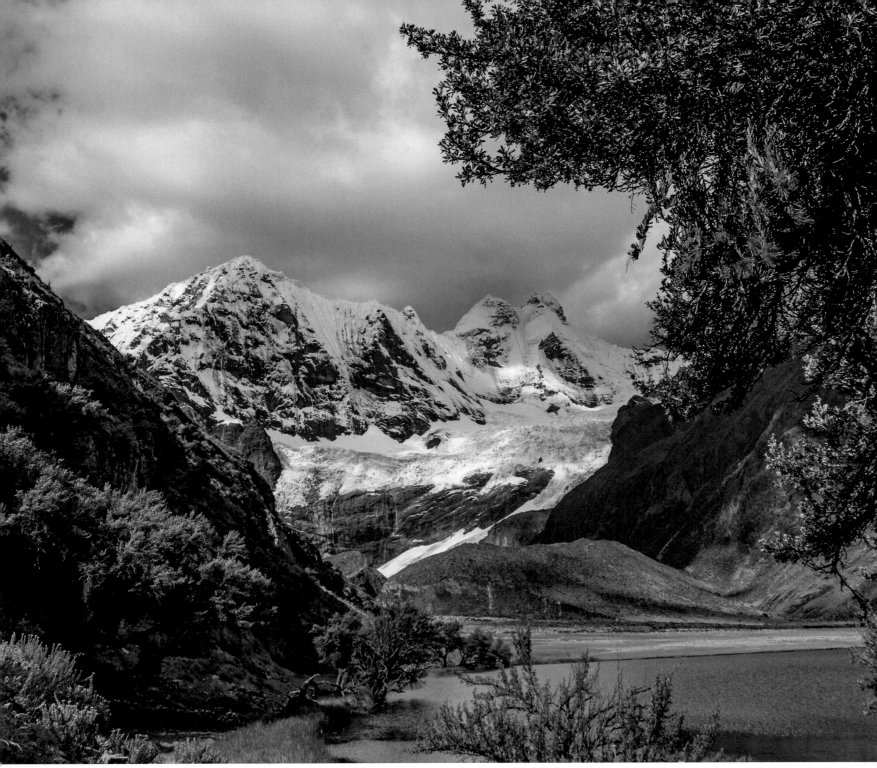

Snow-capped peaks overlooking Jahuacocha lake.

a protection fee to hike in the region. The security situation has improved dramatically since that time, and the Cordillera Huayhuash is now considered a safe destination for trekking parties.

As for the trail itself, the Huayhuash Circuit traverses a dozen high-altitude passes (all higher than 4,300 m [14,000 ft]) during its course, and takes place entirely above tree line. Geographically speaking, it is a roller coaster of a hike, with flat, easy stretches few and far between. Whether you are considering doing the hike independently or with a trekking group, it is of paramount importance to be well prepared in terms of equipment, fitness, and altitude. As to the latter point, one of the keys to successfully completing the circuit is pre-hike acclimatization. Before beginning your trek, plan to spend at least a few days in the Huaraz (the regional capital) area going for day hikes, drinking lots of water, and getting as much rest as possible. This is critical, as the Cordillera Huayhuash Circuit reaches an elevation of 4,300 m (14,000 ft) within a few hours of leaving its starting point in Llamac. ►

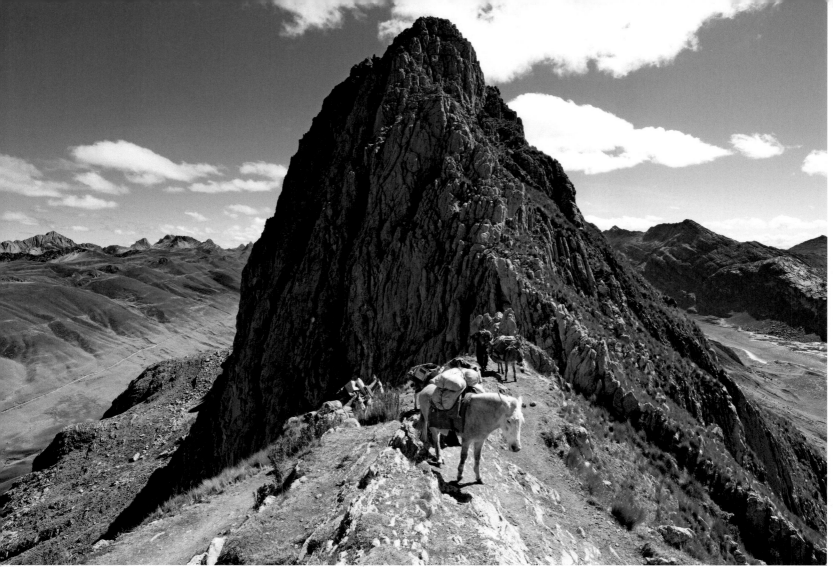

Most Huayhuash hikers opt to go with trekking agencies that provide guides and pack animals. Following double page: Traversing the eastern side of the Huayhuash massif.

It's difficult to pinpoint the standout features of this trek, simply because the scenery is uniformly impressive from start to finish. However, when it comes to stunning vistas, the Siula and San Antonio passes are two particularly notable sections.

The former is perhaps the most photographed section of the entire trail, offering jaw-dropping views of the eastern side of the Huayhuash massif, as well as of the cerulean lakes of Qanrajancacocha, Siulacocha, and Quesillococha. San Antonio is a much more trying proposition. The alternate route up and over the pass is uncommonly steep and often loose underfoot. But with calculated risk comes reward: a breathtaking diorama of the Jurao, Yerupajá, and Siula Grande peaks. The latter summit is famed as the backdrop of Joe Simpson's mountaineering memoir, *Touching the Void.*

A less scenic but equally inviting part of the trek comes in the form of the Rio Pumarinri hot springs. The soothing waters can be found just a couple of kilometers from Laguna Viconga; organizing your itinerary so that you can camp nearby is highly recommended. The temperature of the pools is ►

Right: Sunset over Lake Carhuacocha. Below: Purple lupins cover the Huayhuash slopes in the spring.

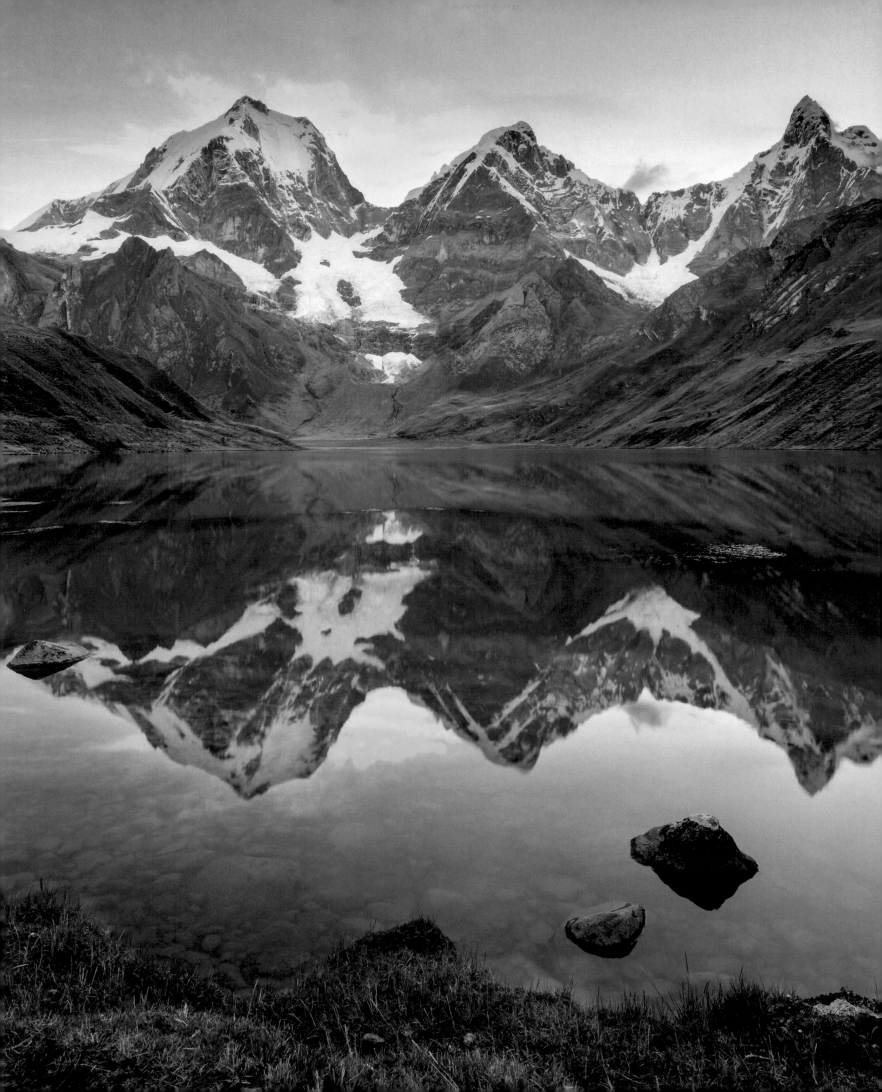

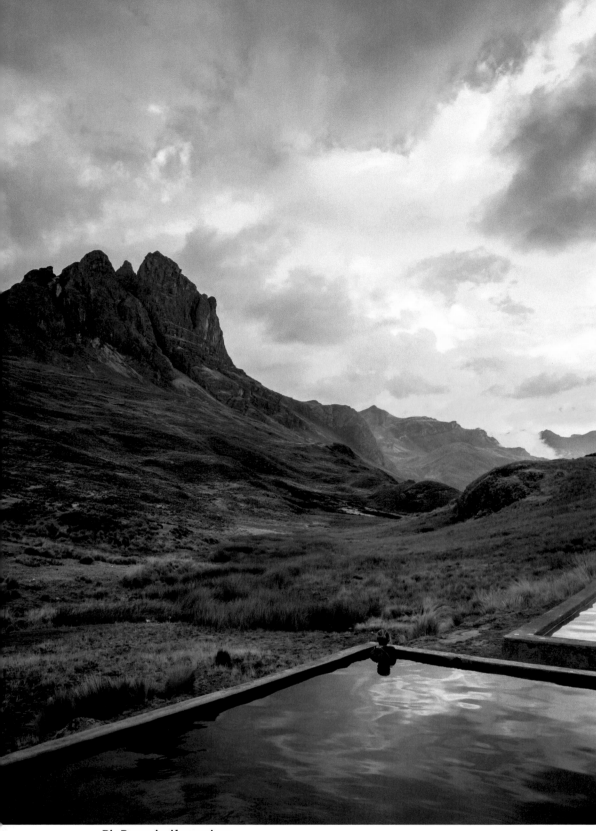
Rio Pumarinri hot springs.

Whether you are considering doing the hike independently or with a trekking group, it is of paramount importance to be well prepared in terms of equipment, fitness, and acclimatization.

perfect, neither too hot nor too cold, and their location— roughly halfway along the circuit—makes them an ideal place for rest and rejuvenation before tackling the final part of the journey.

When you hear veteran hikers talk about the Cordillera Huayhuash, the emphasis is invariably focused on the spectacular scenery; by any criteria, it is a stunning trek.

Yet, for all the superlatives, arguably the most important reward that hikers derive from finishing the circuit is one that you can't actually see. It is the satisfaction that comes from a challenge well met. A reward that results from preparing thoroughly, leaving your comfort zone to travel halfway around the world, and successfully completing one of the toughest hikes in the Peruvian Andes. ◆

GOOD TO KNOW

About the Trail
/ <u>DISTANCE</u> 130 km (81 mi)
/ <u>DURATION</u> 8 to 11 days
/ <u>LEVEL</u> Challenging

Start / Finish
⚲ Llamac (loop hike)

Season
The dry season between May and September is ideal for trekking. Nights can be cold (-10 °C [14 °F]) and days are generally clear.

Acute Mountain Sickness (AMS)
In order to avoid issues with AMS while hiking the Huayhuash, pre-hike acclimatization is vital. In addition to spending a day or two walking around the regional capital of Huaraz, going on a couple of day hikes in the area is highly recommended. The stunningly situated Laguna Churup (4,450 m [14,600 ft]) and Laguna 69 (4,604 m [15,104 ft]) are both excellent options.

Alpamayo Circuit
For those looking for something extra, a great companion hike to the Huayhuash can be found in the form of the Alpamayo Circuit (140 km [87 mi]). Situated in the neighboring Cordillera Blanca range, the Alpamayo Circuit takes hikers on an amazing journey around the region's most famous peak, the pyramid-shaped Nevado Alpamayo.

BACKGROUND

Touching the Void In recent decades, the Cordillera Huayhuash became known as the site of Joe Simpson and partner Simon Yates's harrowing mountaineering survival tale, documented in *Touching the Void* (1988). It details their successful first ascent of Siula Grande, and what happened as they subsequently

began the descent. Most notably, Simpson fell off an ice ledge, breaking his leg, and in the hours that followed, Yates attempted to lower his partner to safety. Yates was eventually faced with an impossible decision: either cut the rope and thereby seal Simpson's fate, or keep holding on, and, in so doing, doom both of them to die. The story of what happened after this momentous decision has become the stuff of climbing legend.

HELPFUL HINTS

Guided vs. Independent For those who aspire to trek the Cordillera Huayhuash Circuit, one of the biggest decisions to be made is whether or not to walk independently. Traditionally, approximately 90 percent of people opt to hike the Huayhuash as part of an organized group. Trekking agencies provide transport, guides, cooks, and pack animals. If you are short on time and fitness, and looking to experience beautiful mountain scenery with like-minded people, a guided trip may well be for you. On the other hand, if you are well acclimatized, a proficient navigator, and used to carrying six to eight days worth of food, then there are no significant issues with hiking independently. Principal among the benefits of going *sans agencies* is freedom—the freedom to choose where you camp, what you eat, whom you hike with (if anyone), when you take a break, and how you pace yourself.

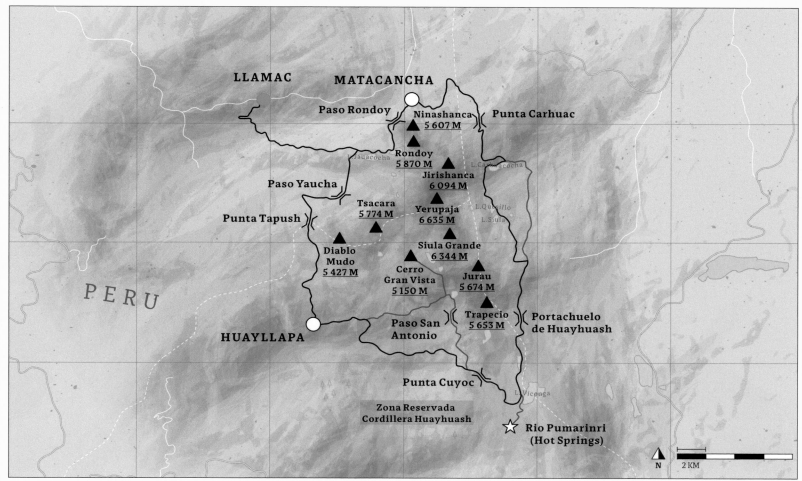

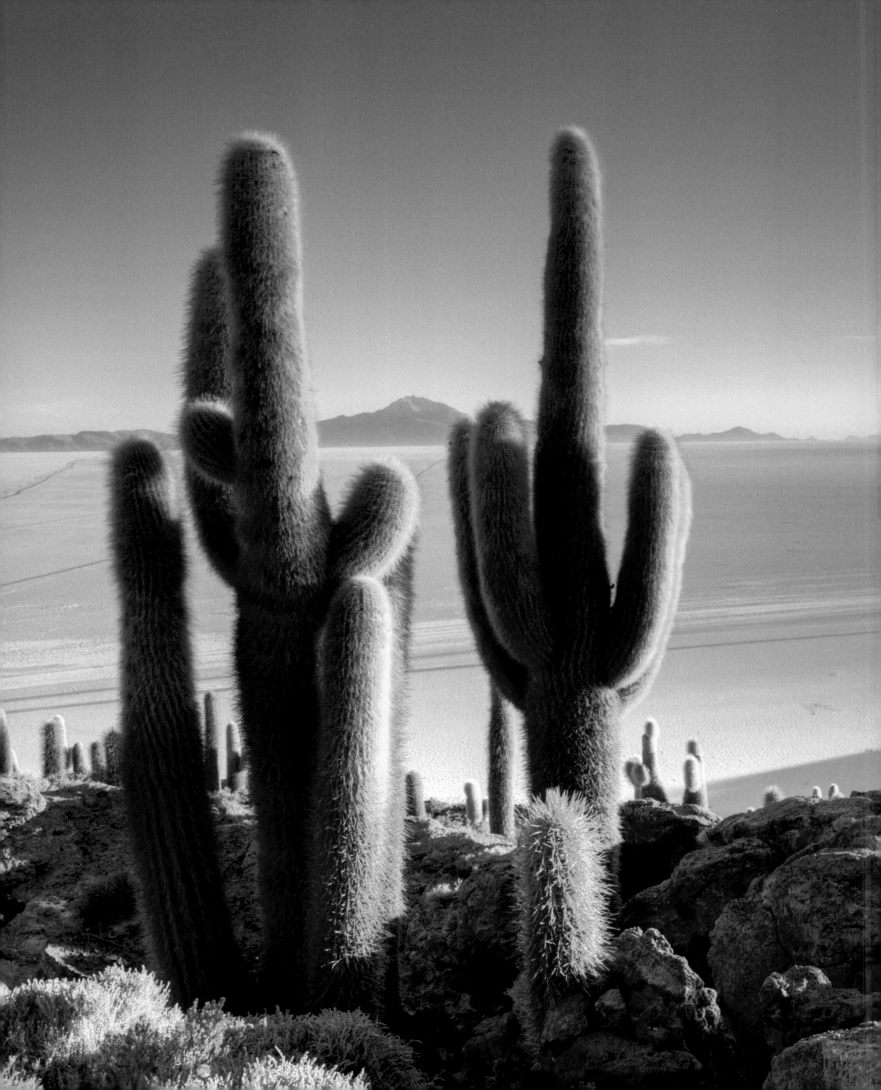

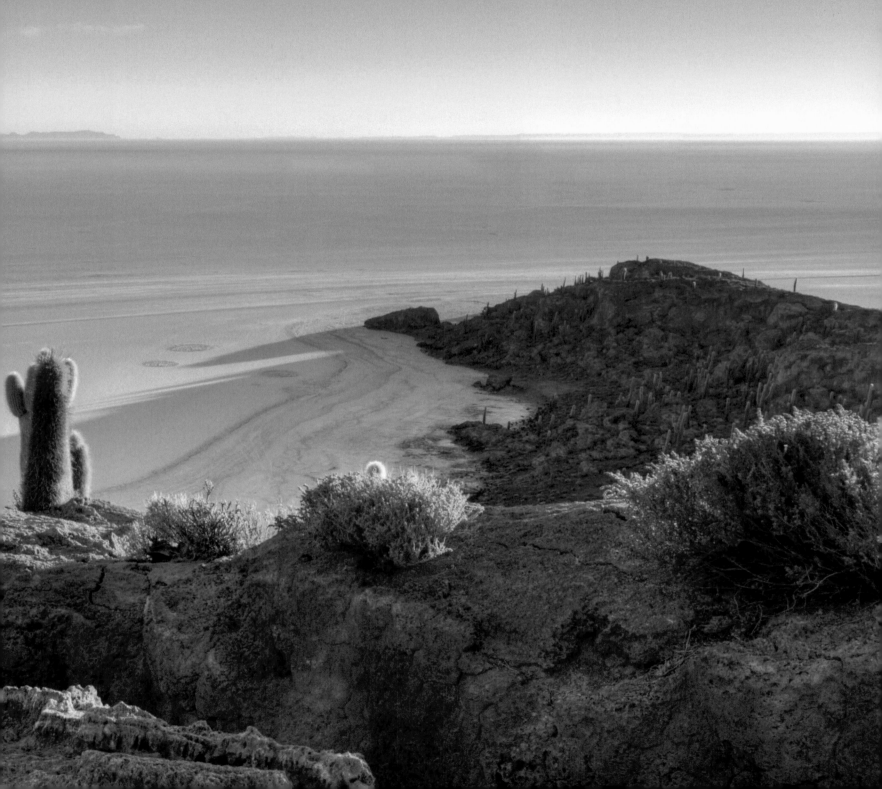

SALAR DE UYUNI

CROSSING THE WORLD'S LARGEST SALT FLAT

Bolivia

**The salt crystals
are hard underfoot and
the terrain pancake flat;
with an altitudinal
variation of less
than one meter,
the Salar de Uyuni rates
as the flattest region
on the planet.**

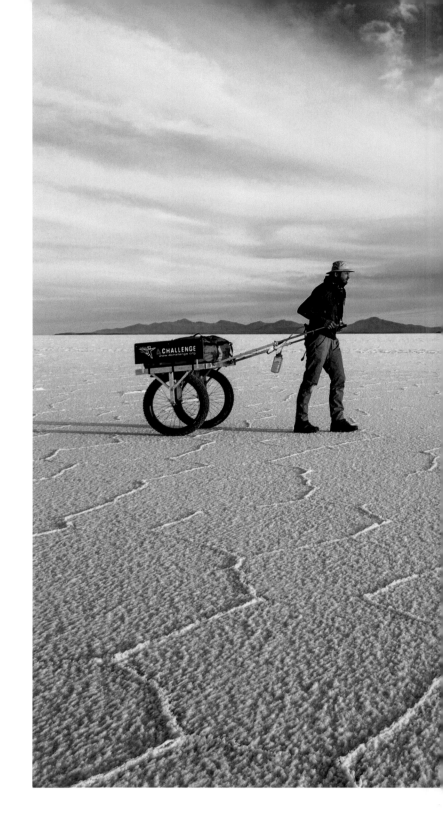

The Salar de Uyuni is the Earth's largest salt flat. Situated in the southwest corner of Bolivia's Altiplano, it measures a staggering 12,106 sq km (4,674 sq mi), more than 20 times bigger than America's largest salt flat, the infamous Death Valley. It is an otherworldly sight to behold, a glistening ocean of white stretching as far as the eye can see to the bluest of blue horizons. For strong and well-prepared hikers who have prior experience backpacking in arid environments, it is possible to walk north to south across this unforgiving expanse on what is undoubtedly one of the world's most unique hiking journeys.

In its current manifestation, the Salar de Uyuni was formed approximately 12,000 years ago as a result of the sequential transformation of two prehistoric lakes, namely Minchin and Tauca. When the waters of the latter evaporated, the salt deposits that leached from the surrounding mountains took shape in the form of two vast salt deserts—the Salar de Uyuni and its smaller cousin to the north, the Salar de Coipasa (still, it's the fifth largest on Earth). Before it dried up, Lake Tauca was said to have a depth of approximately 100 m (328 ft). Nowadays, during the annual rainy season between December and March, its direct descendant—the Salar de Uyuni—fills with 15

to 50 cm (6 to 20 in) of H_2O. At this time of year, the area transforms into the world's largest natural mirror; a surreal sight in which the Earth and sky merge to form a singular, dream-like landscape.

From a hiking perspective, the Salar's wet season is best avoided. The thin film of water covering its surface makes progress significantly slower, afternoon electrical storms are common, and stopping for a break becomes a difficult proposition—unless you feel like sitting in

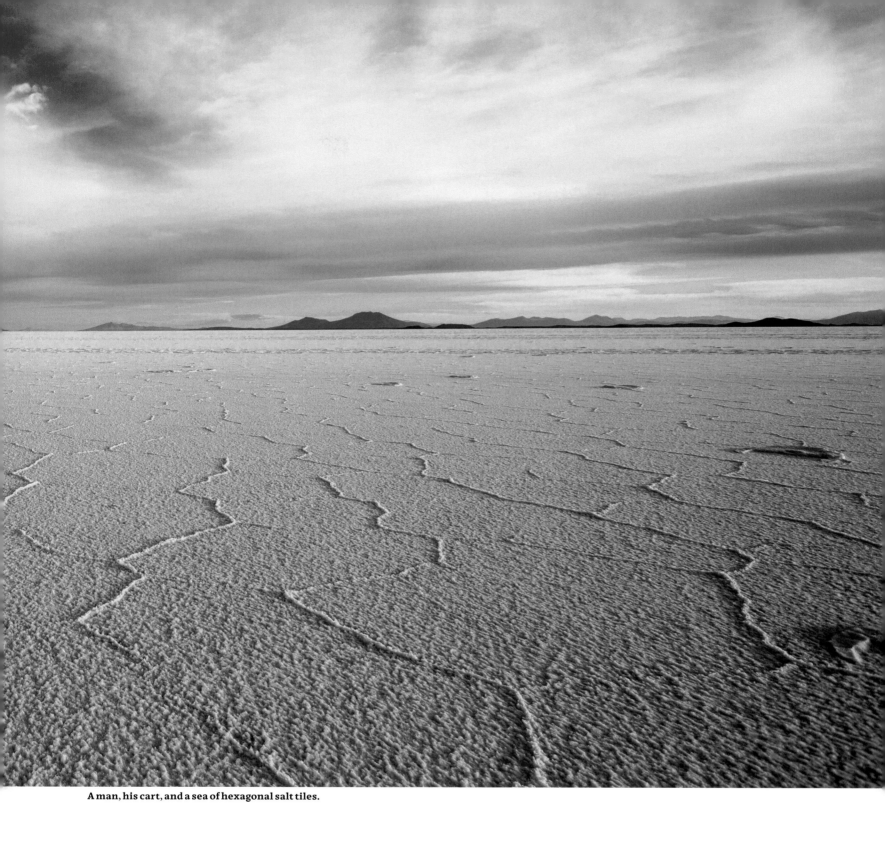

A man, his cart, and a sea of hexagonal salt tiles.

salt water while you eat your breakfast or lunch. For those attempting to cross the salt flat on foot, the best time is between June and September, after the water has dried up and before the October rains arrive. (Note: this is also winter, when temperatures regularly drop down to -20 °C[-4 °F].)

Going from north to south, the trek begins at the village of Tahua. It is approximately 82 km (51 mi) in length, takes two days to complete, and consists of two stages that are roughly equal in distance. The salt crystals are hard underfoot and the terrain pancake flat; with an altitudinal variation of less than one meter, the Salar de Uyuni rates as the flattest region on the planet. Hikers should always carry GPS and/or a map and compass, as it is easy to become disoriented in the middle of so much nothingness. Each segment will take between seven and eleven hours, and carrying at least four to six liters of water per stage is recommended. ▶

Logistically speaking, the traverse could not be simpler. Along the route, there is only one place to sleep and obtain food and water: the island of Incahuasi. Measuring a total of 0.25 sq km (0.1 sq mi), this hilly, rocky islet is situated in the heart of the salt flat. Surrounded on all sides by a vast sea of hexagonal salt tiles and laden with giant cacti (*Trichocereus pasacana*), it was a quiet, unfrequented place once upon a time. However, in recent years, Incahuasi has become one of the main attractions on four-wheel-drive tours of Bolivia's Altiplano. When you arrive at the island, expect to be accompanied by scores of tourists who have come to watch the sunset. It makes for a stark contrast to the solitude of the day's hike. But after the sun goes down, the tourists depart, and with the exception of the island's caretakers, you will likely have the place to yourself. After you've had some dinner and settled in, consider taking a nighttime stroll on one of the island's well-maintained pathways. ▶

Covering up against the Salar de Uyuni's often brutal winds.

Consider at least one night in a salt hotel, simple guesthouses where the walls, floor, and furniture are all made of salt.

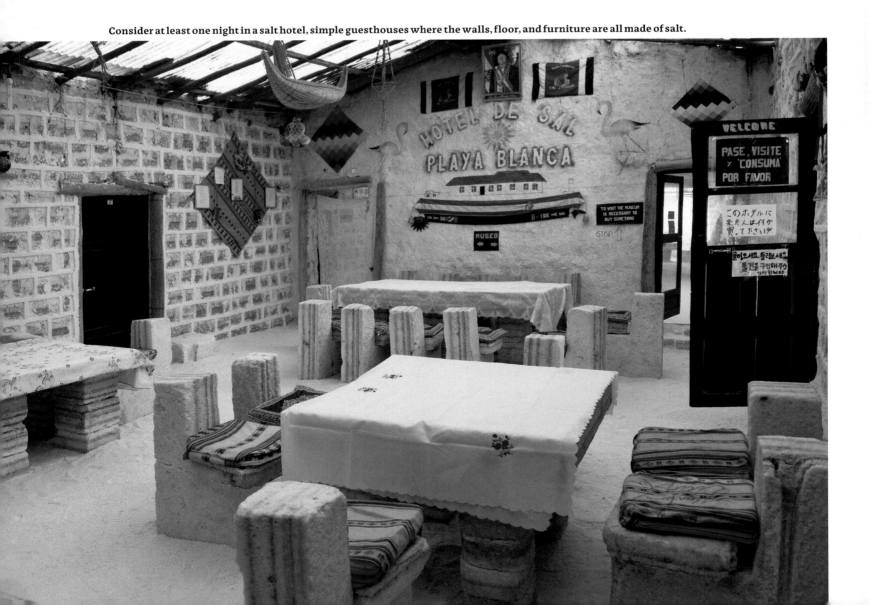

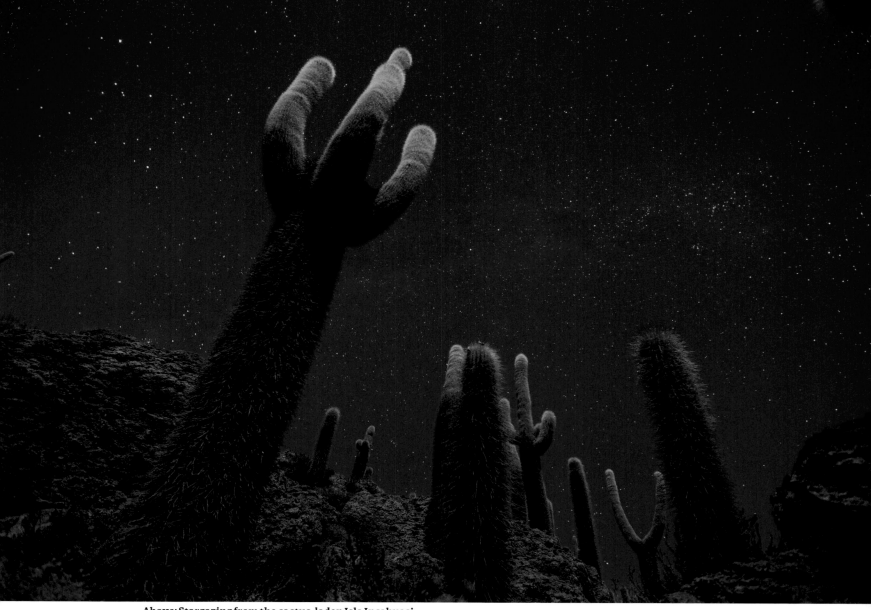

Above: Stargazing from the cactus-laden Isla Incahuasi.
Below: Crossing the Earth's largest salt flat, an endless white expanse that also happens to be the flattest area on the planet, with an altitudinal variation of less than one meter.
Following page: Post-hike trip to the Termas de Polques, a soothing 29.4 °C (85 °F) hot springs on the shores of Laguna Chalviri.

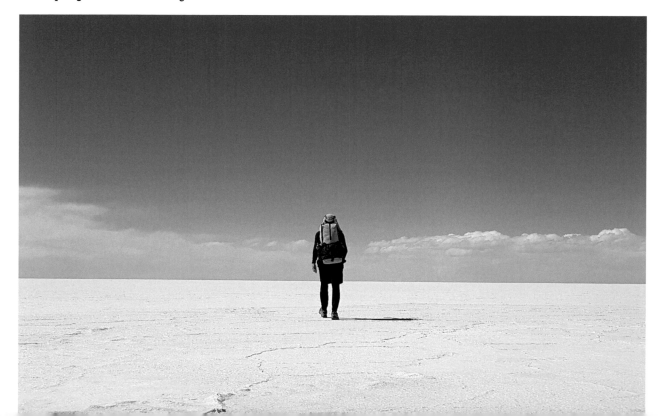

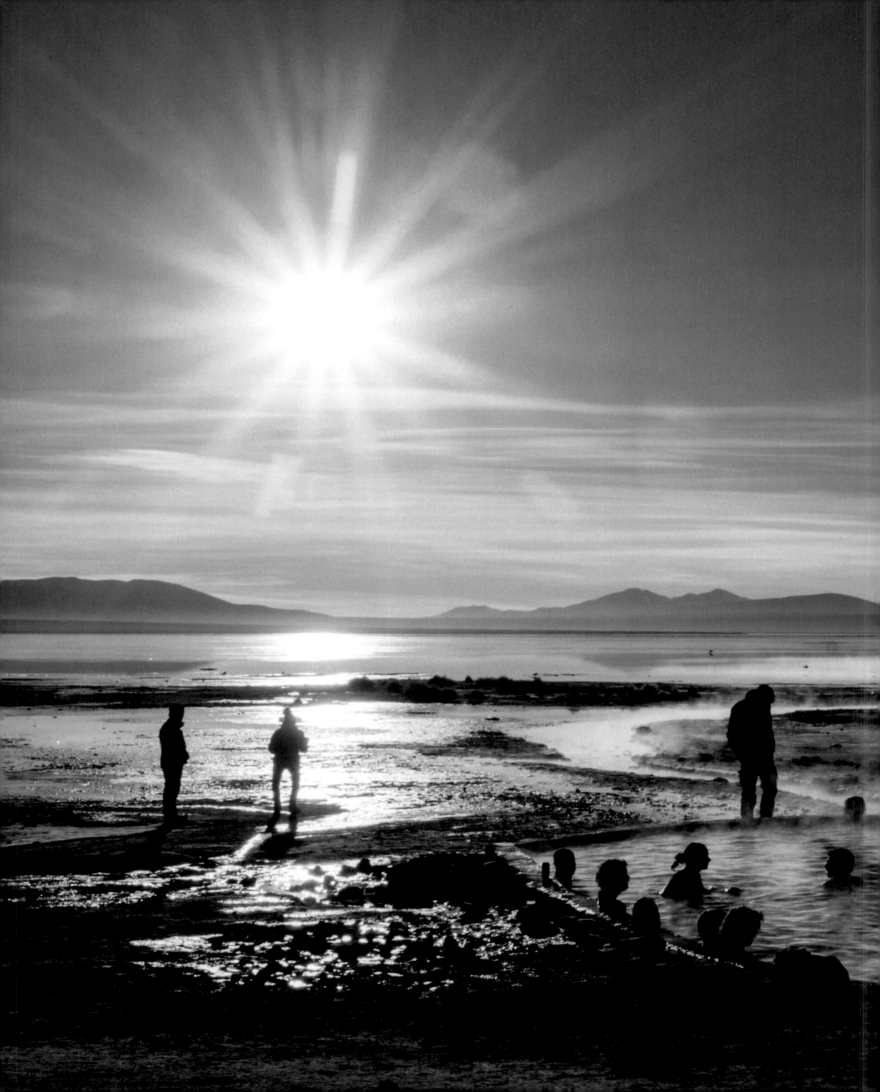

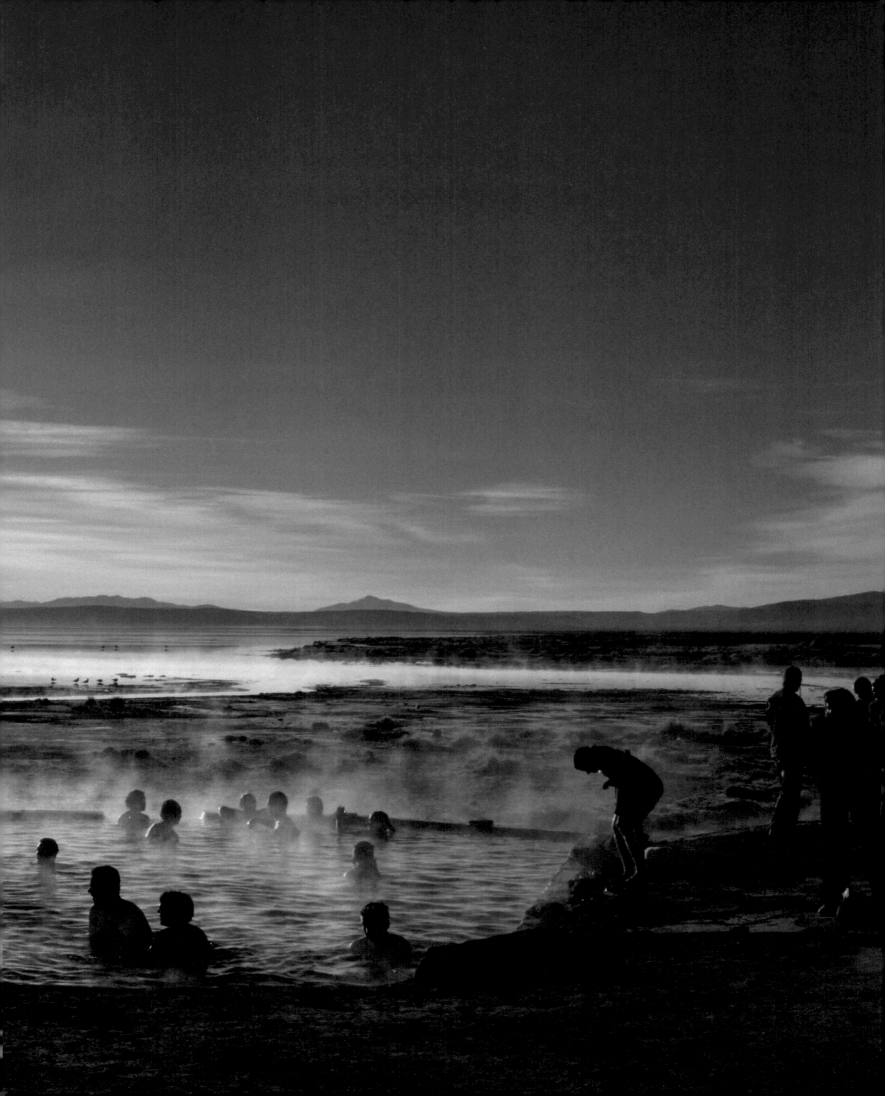

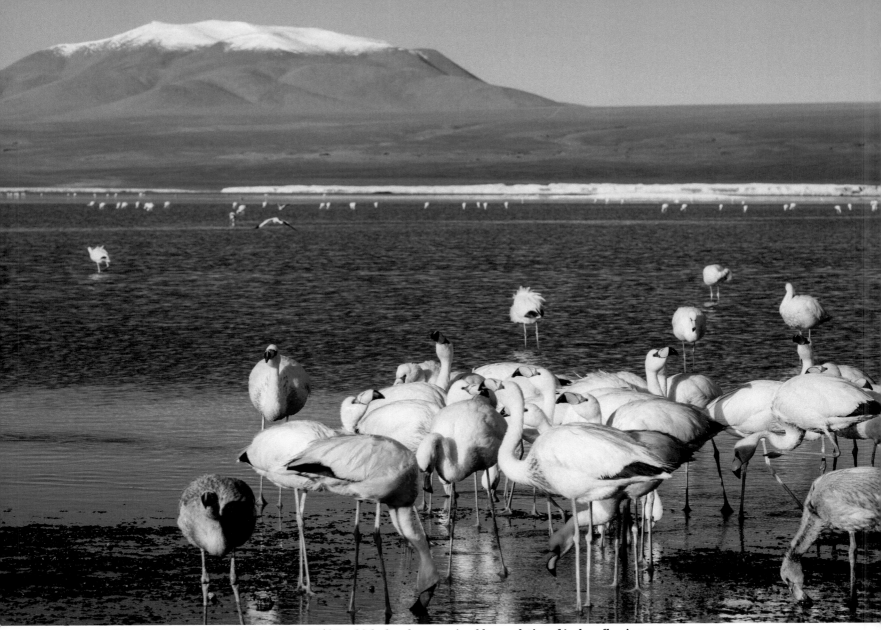

Side trip to Laguna Colorada (4,278 m [14,035 ft]), which plays host to a sizeable population of Andean flamingos.

Gazing out from your hilltop perch, the cacti stand silhouetted against the moon, and the gentle light softly illuminates the ethereal white sea surrounding you. As far as once-in-a-lifetime experiences go, they don't come much more enchanting.

Leaving Incahuasi the following morning after sunrise, the second stage of the hike is a carbon copy of the first: completely exposed, bone-chillingly cold, and jaw-droppingly beautiful. After another long day, you will eventually arrive at Chuvica on the southwestern edge of the salt flat. The village is notable for two things: its spectacular location and its multiple salt hotels—simple guesthouses that have salt walls, floors, and furniture. Be sure to overnight in one of these unique establishments. It's hard to imagine a more appropriate way to conclude the Salar de Uyuni traverse than by kicking back with a hot cup of coca-leaf tea while relaxing in a hotel made of the same stuff you've just spent two days walking across. ◆

The Salar de Uyuni is an otherworldly sight to behold, a glistening ocean of white stretching as far as the eye can see to the bluest of blue horizons.

GOOD TO KNOW

About the Trail
/ <u>DISTANCE</u> 82 km (51 mi)
/ <u>DURATION</u> 2 days
/ <u>LEVEL</u> Challenging

Start / Finish
⚲ Tahua
⚲ Chuvica

Season
June to September. Avoid the rainy season between December and March: during this period, the salt flat transforms into the world's biggest infinity pool; wonderful for reflection shots, not so good for hiking.

Conditions
During June to September, also the driest time of the year, temperatures of -20 °C (-4 °F) are not uncommon.

Accommodation
As of 2018, no camping is permitted on Isla Incahuasi. However, hikers and cyclists are allowed to stay in the hostel, which is actually more like a hall with some chairs and tables. No bedding is available, so you will need to bring your own sleeping bag and pad.

Resupply
Isla Incahuasi has a restaurant and also a small store, where it is possible to purchase snacks, basic meals, and water.

Solitude
On the Salar de Uyuni, nearly all tourist vehicles use the same four-wheel-drive roads. In order to avoid the traffic, at the beginning of both stages head in a southwest direction for approximately 300 m (984 ft). By that point, any vehicles in your vicinity will be specs in the distance. Once you are far enough away from the road, take a bearing and head toward your chosen destination.

HELPFUL HINTS

Tunupa Volcan Looming over the village of Tahua—the starting point of the Salar de Uyuni traverse—stands a 5,321 m (17,457 ft) dormant volcano called Tanupa. Named after the Andean god of lightning, its massif flanks, if scaled, afford hikers incredible aerial views over the salt flat below. During the ascent, it is possible to visit a cave that contains various mummies, which, according to local legend, were entombed thousands of years ago when the volcano last erupted.

BACKGROUND

Lithium Lithium is the world's lightest metal, and is used to power our smartphones, laptops, and other digital devices. According to estimates, the Salar de Uyuni holds between 50 and 70 percent of the world's supply beneath its glistening white surface.

FLORA & FAUNA

Giant Cacti There isn't much in the way of flora on the Salar de Uyuni, but one notable exception are the giant cacti (*Trichocereus pasacana*) of the Isla Incahuasi. These plants can be found at altitudes between 2,000 m (6,562 ft) and 4,000 m (13,123 ft). They grow up to 10 m (33 ft) in height, and are endemic to the Andean regions of Bolivia, Argentina, and Chile.

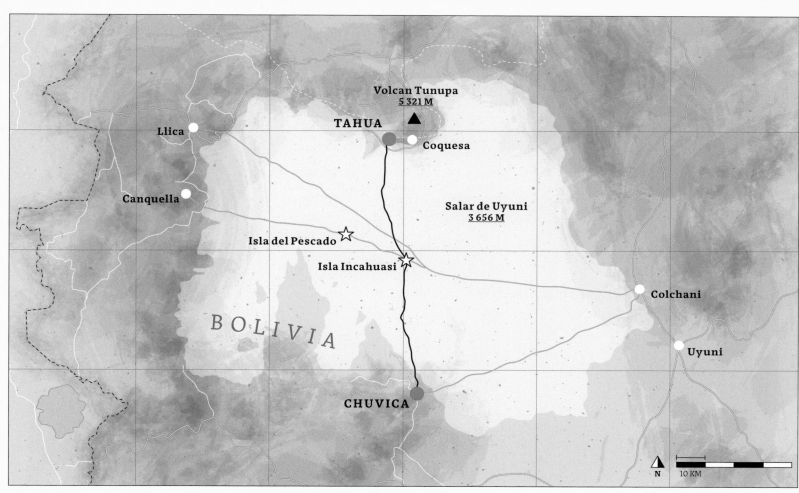

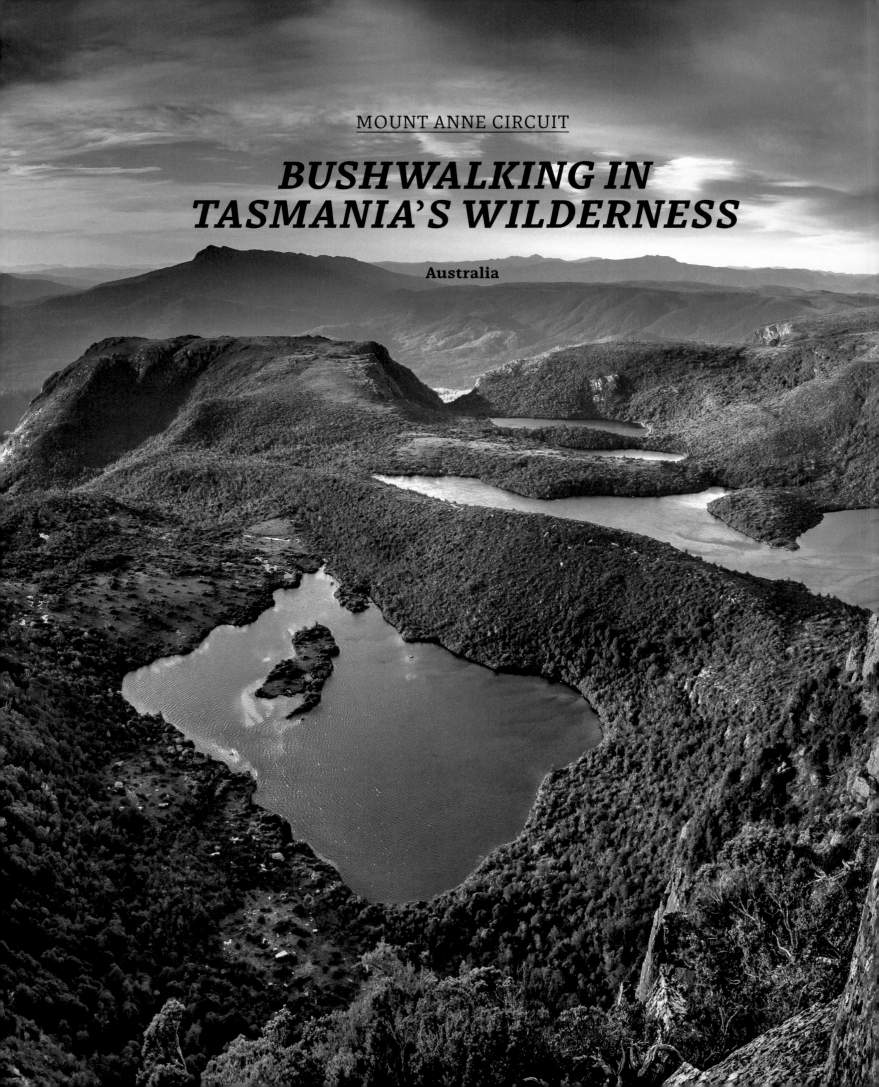

BUSHWALKING IN TASMANIA'S WILDERNESS

Australia

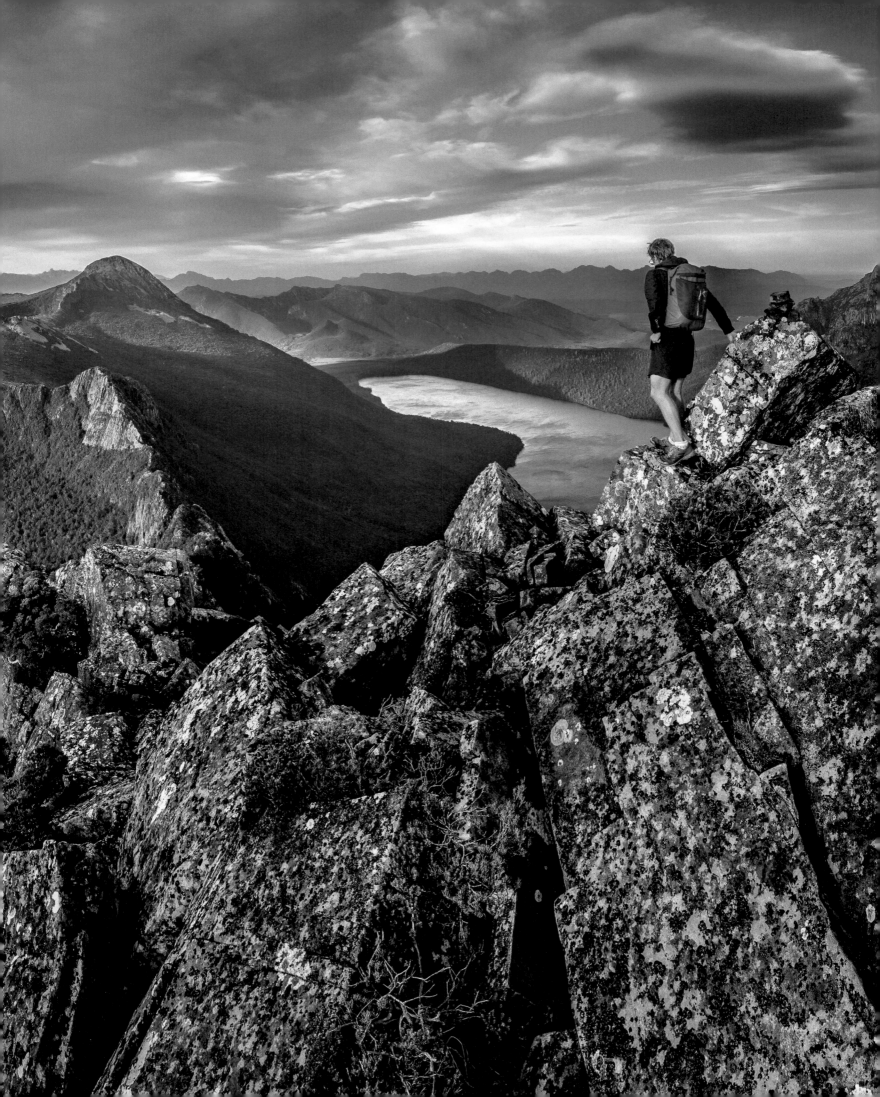

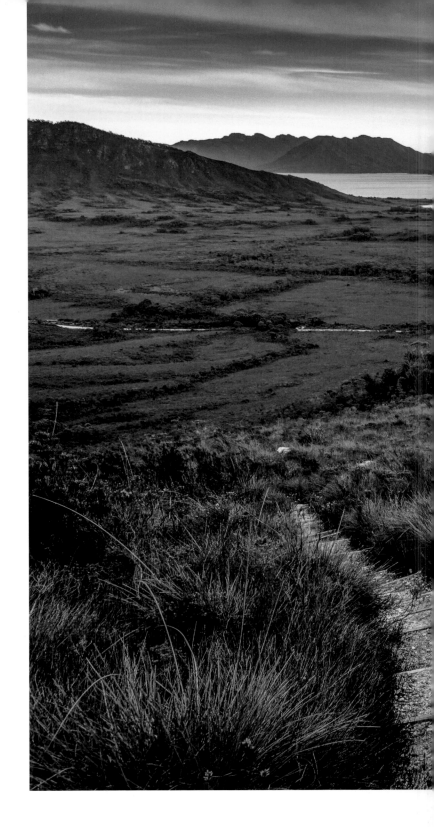

Tasmania's primeval wilderness is home to a unique array of flora and fauna, along with some of Australia's largest limestone cave systems, where remains of Aboriginal habitation dating back more than 20,000 years have been discovered.

T he Tasmanian wilderness is Australia's bushwalking mecca, a glacier-carved landscape of jagged quartzite peaks, expansive moraines, and secluded hanging valleys. Throughout the island state, there are myriad hiking options, ranging from family-friendly day walks to some of the toughest multiday treks on the planet. Located in the upper-middle part of this broad spectrum is the Mount Anne Circuit, one of the most iconic treks in Tasmania (or "Tassie," as everyone calls it).

Described by UNESCO as "one of the last expanses of temperate rainforests in the world," the Tasmanian Wilderness is a World Heritage-listed area that covers 15,842 sq km (6,116 sq mi) and constitutes roughly 20 percent of the entire island. Its primeval landscape contains unique plants and wildlife, and some of Australia's largest limestone cave systems, where remains of Aboriginal habitation dating back more than 20,000 years have been discovered. Along with Mount Tai in China, the Tasmanian Wilderness is one of only two World Heritage sites on Earth

that fulfill seven of the ten UNESCO designation criteria, including geology, flora and fauna, extraordinary natural phenomena, and singular human culture and history.

The Mount Anne Circuit is a 22.5 km (14 mi) track located in Southwest National Park, the wildest and most pristine part of Tasmania's expansive wilderness. Although the distance is short, most parties take three to four days to complete the hike due to the exacting nature of the terrain, and because there are multiple not-to-be-missed side trips

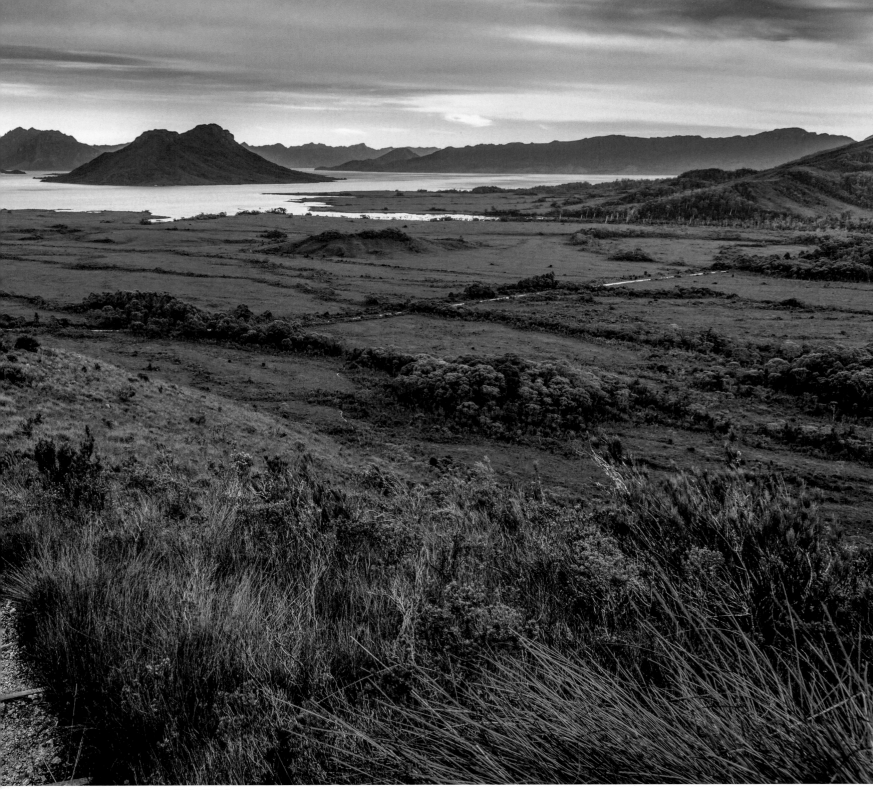

Looking out toward Lake Pedder.

(they add on an extra 8 to 9 km [5 to 5.6 mi]). The dramatic scenery includes cirques, knife-edge ridges, enchanting lakes, and ancient pandani groves—a singular fusion of geological and biological elements.

Among the highlights of the route are the recommended side trips to Lake Judd, Lots Wife (a distinctive rocky crag situated two kilometers from the trail), and Mount Anne, the peak for which the circuit is named. Measuring 1,423 m (4,669 ft) Mount Anne is the highest mountain in Tasmania's

southwest. The climb to its summit involves a steep scramble over exposed rocky terrain. Although not technically difficult, extreme care should be taken, particularly if it's wet or snowy. On a clear day, a magnificent 360-degree panorama will be there to greet you at the top.

Apart from the challenges of the topography, hiking in southwest Tasmania cannot be mentioned without talking about the weather. On average, it rains 250 days per year on this part of the island, and much of the precipitation ▶

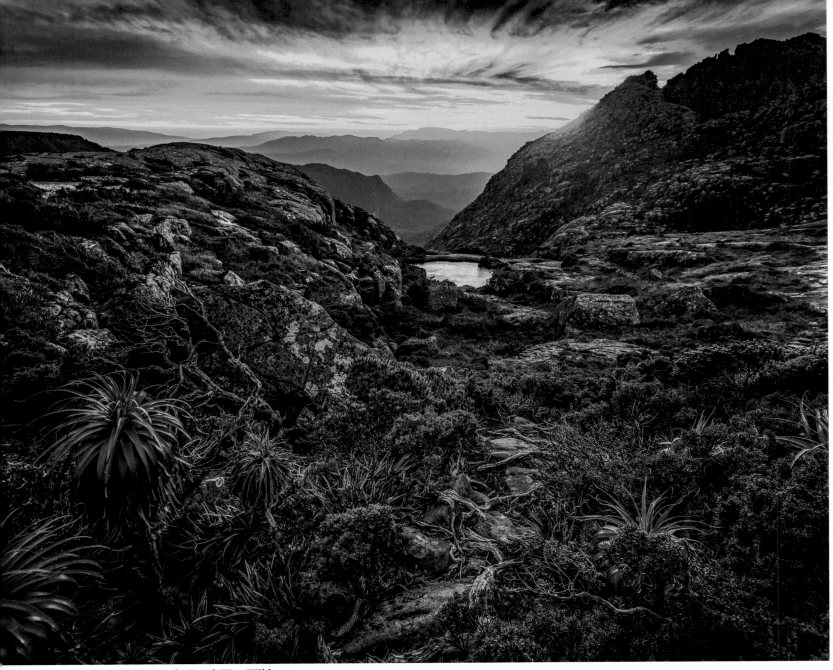

Sunset over the South West Wilderness.

Right: Overlooking Lake Judd.
Below: Tasmanian devil.

arrives in the form of wild storms rumbling in from the nearby Indian Ocean. In addition to a sturdy shelter and good rain gear, a stoic attitude toward incessant wet weather is highly recommended for anyone thinking about hiking in Tassie's southwest.

Due to these variable conditions, it also behooves hikers to keep their pack weights as light as possible on the Mount Anne Circuit. This can make a big difference in regard to comfort, enjoyment, and safety. For example, when you are scrambling up and down slippery rocks and cliffs, a lighter pack will not only enhance your agility, but also free your mind from the burden of a heavy load, so you can focus solely on the job at hand.

Upon completing the Mount Anne Circuit, most hikers head straight back to the Tasmanian capital of ▶

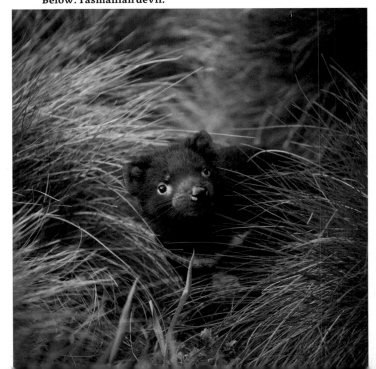

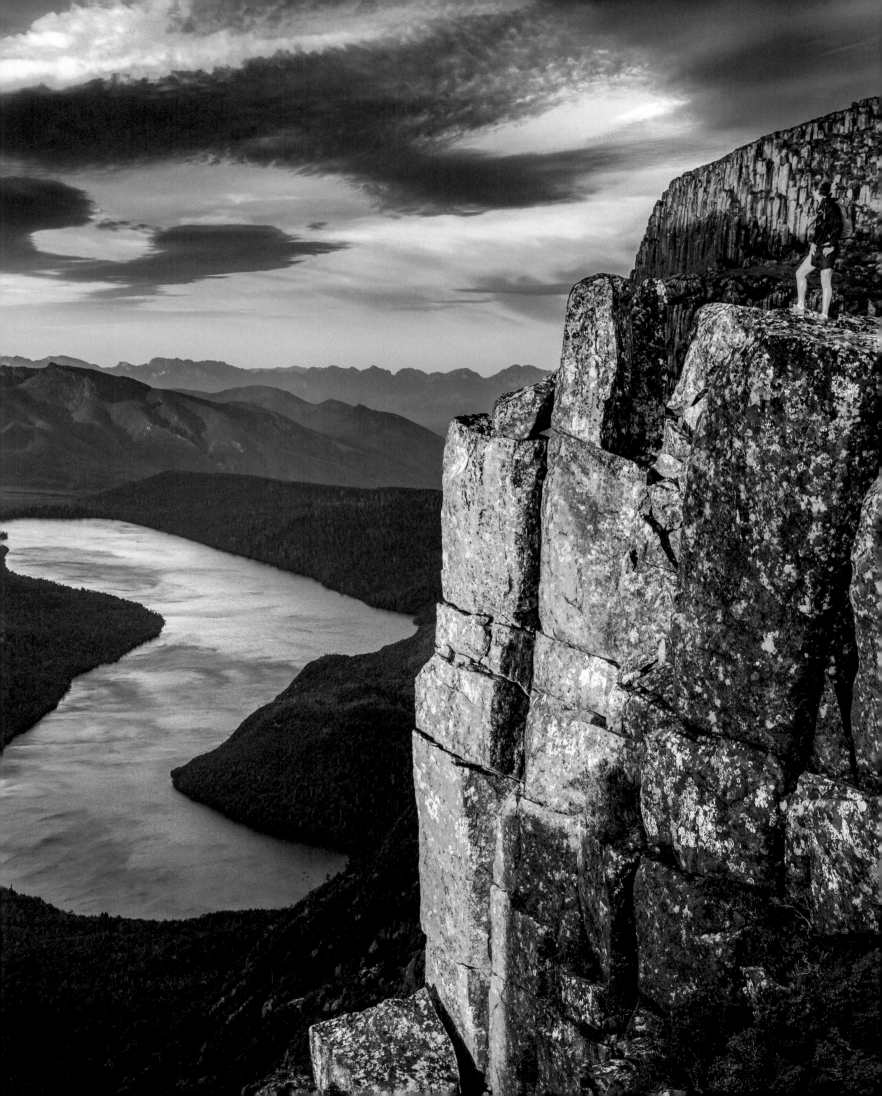

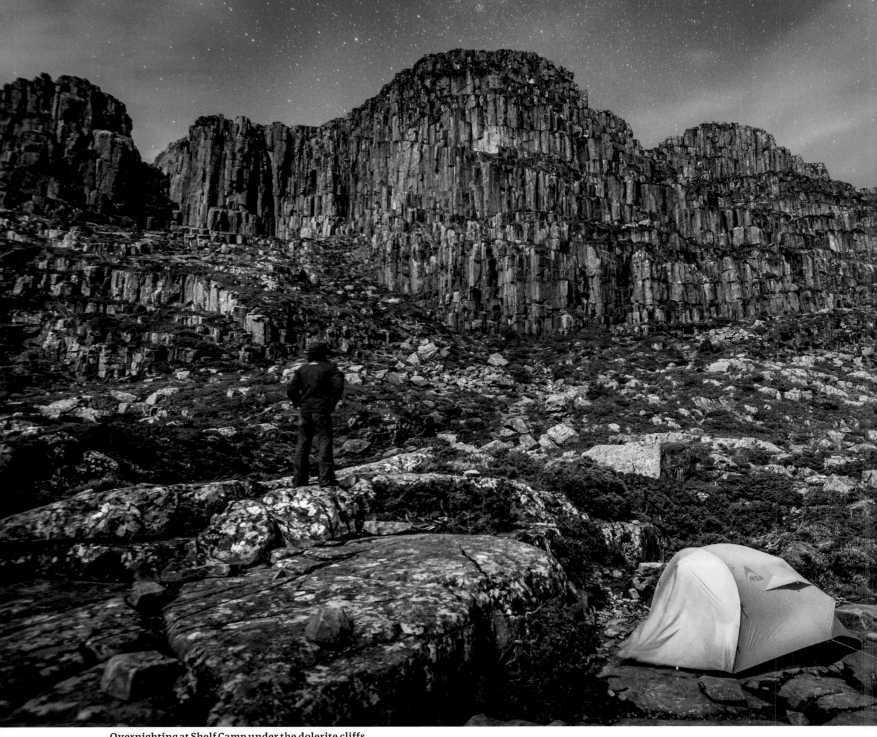

Overnighting at Shelf Camp under the dolerite cliffs.

Hobart, a three-hour drive to the east. For those with the time and inclination, approximately halfway along the route is a very accessible side trip to the state's first national park, Mount Field. An ideal option for those who wish to experience the southwest wilderness without actually camping overnight, Mount Field has long been one of Tassie's most beloved national parks. Established in 1916, among the park's hightlights are the three-tiered Russell Falls, forests of towering tree ferns, stark alpine moorlands, and the idyllic Lake Dobson. The lake is accessed via a 17 km (10.6 mi) gravel road, and the short and mellow 30-minute hike around its circumference (be on the lookout for platypus!) is the ideal warm-down stroll after backpacking the Mount Anne Circuit. ◆

The Tasmanian wilderness is Australia's bushwalking mecca, a glacier-carved landscape of jagged quartzite peaks, expansive moraines, and secluded hanging valleys.

GOOD TO KNOW

About the Trail
/ <u>DISTANCE</u> 22.5 km (14 mi),
not including side trips
/ <u>DURATION</u> 3 days (4 days with side trips)
/ <u>LEVEL</u> Moderate to challenging

Start / Finish
⚑ Condominium Creek
⚑ Red Tape Creek

Season
December to March. Snow, high winds, and heavy rain are possible at any time of year.

Permits
A permit is required for entry into all of Tasmania's national parks. These can be organized online or purchased at national park visitor centers and various other outlets throughout the state.

Accommodation
Due to a high probability of inclement conditions, hikers should bring a storm-worthy tent. There is a tiny two-story stone hut that sleeps six people at High Camp, 3.6 km (2.2 mi) from the starting point at Condominium Creek. This shelter is often used by those who are attempting out-and-back excursions to the summit of Mount Anne.

HELPFUL HINTS

Pack Hauling It is commonly recommended to bring 20 m (66 ft) of rope for pack hauling on the final climb to the summit of Mount Anne, as well as for another rocky section of the circuit known as the Notch. If you are relatively inexperienced and tend to have a problem with heights, this is advice to heed. However, if your scrambling skills are solid and your pack isn't excessively large—which lessens the difficulty of negotiating these technical sections—rope will not be necessary.

BACKGROUND

Mount Anne's Underbelly One of Australia's deepest limestone caves (373 m [1,224 ft]), Anne-a-Kananda is located on the northeastern ridge of Mount Anne. Over the years, several cavers have died attempting to explore its treacherous depths, and it is said to have the fourth biggest cave pitch (abseil) in the country—the 118 m (387 ft) Heartbeat pitch.

FLORA & FAUNA

Ancient Flora Endemic to the central and southwestern parts of Tasmania, the pandani is the world's tallest heath plant. Among the oldest surviving plant species on the planet, these shaggy-headed relics from the Gondwana period—the southern supercontinent that broke up approximately 180 million years ago—grow two to three meters in height. The tallest ones have been known to reach over 10 meters.

Tasmanian Devils under Threat
The animal that almost every visitor to the Apple Isle wants to see is the Tasmanian devil. However, this iconic creature is under threat of extinction due to the emergence of devil facial tumor disease (DFTD), an aggressive type of contagious cancer that was first noticed in the mid-1990s. In the decades since the disease's emergence, the Tasmanian devil population has decreased by about 80 percent. As of 2018, there is still no known cure or vaccine.

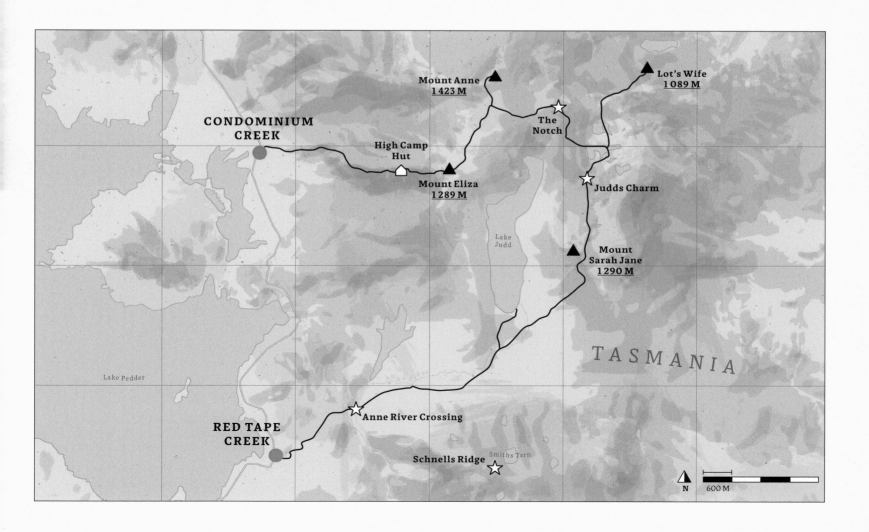

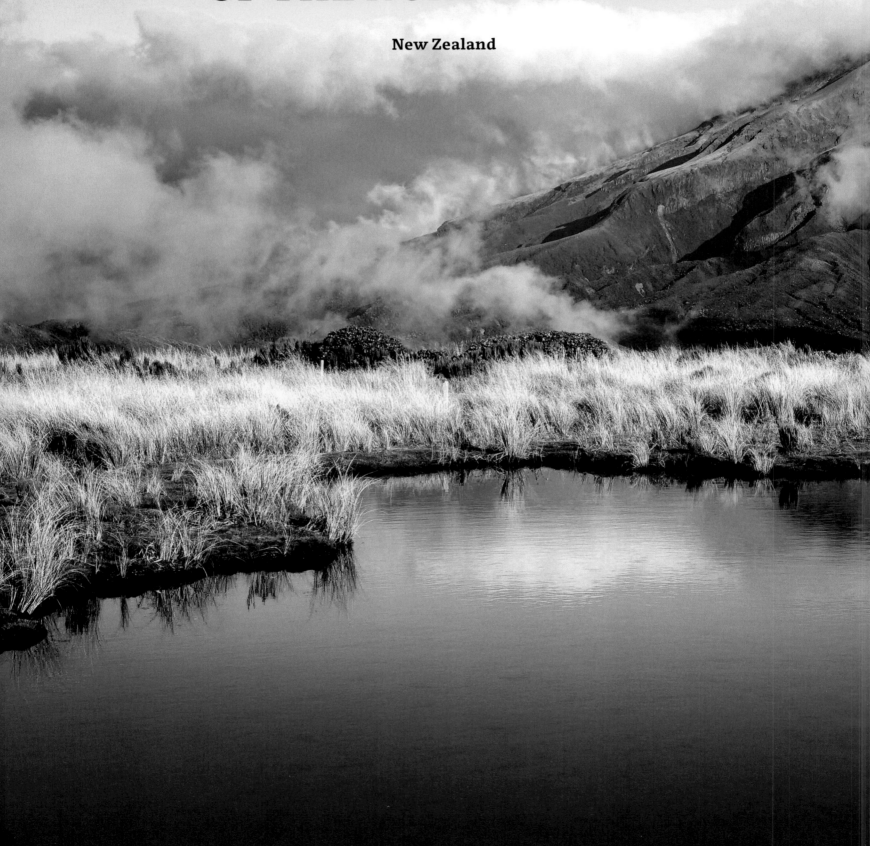

THE LONELY MOUNTAIN OF THE NORTH ISLAND

New Zealand

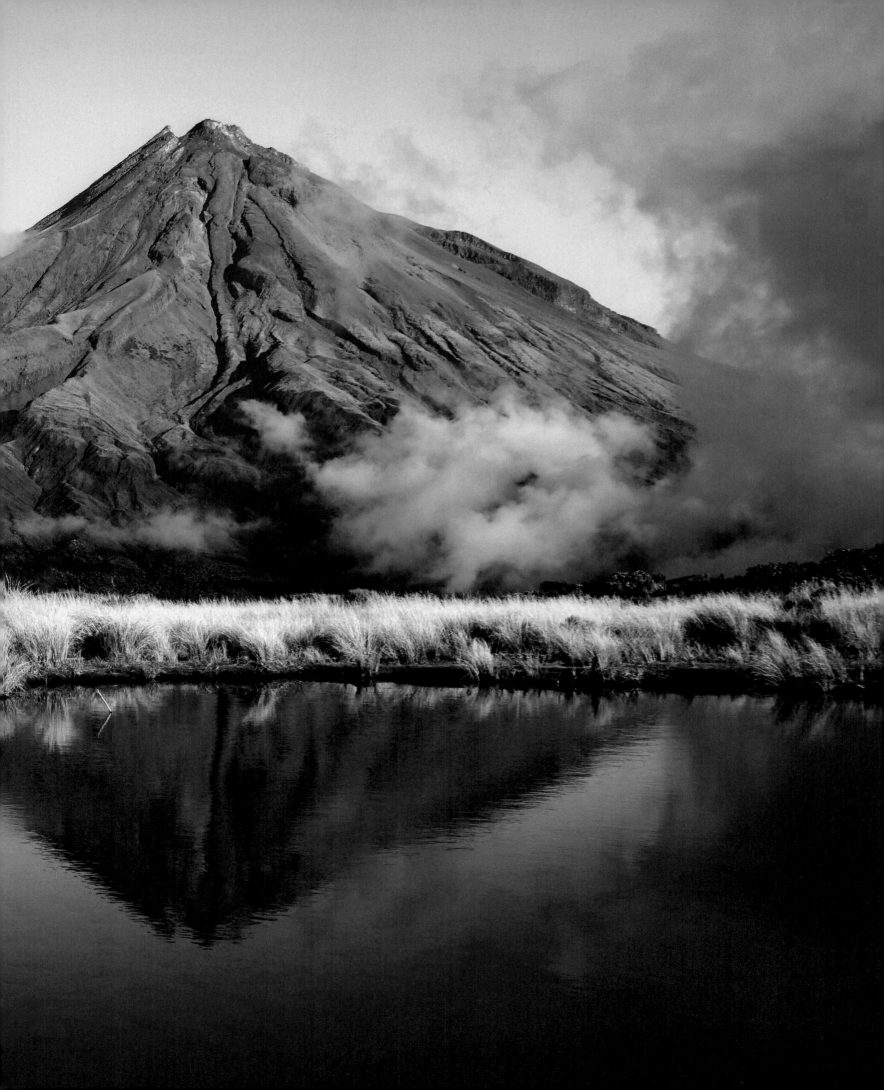

**Long before
the dormant
Taranaki—its last
major eruption was
in 1854—became
a renowned hiking
destination,
the mountain held
a special place
in the hearts of
New Zealand's
original inhabitants,
the Māori.**

In the southwestern corner of New Zealand's North Island lies a lonely mountain by the name of Taranaki (or Egmont). Rising some 2,518 m (8,261 ft) above sea level, it is recognized as one of the world's most symmetrical volcano cones, and its Mount Fuji-esque profile exercises a magnet-like pull over those fortunate enough to behold it. For wayfaring types who are interested in experiencing the mountain's wonders on foot, the area boasts more than 300 km (186 mi) of maintained pathways, the longest and most challenging of which is the Around the Mountain Circuit (AMC).

As the name suggests, the AMC is a complete loop of the Taranaki volcano. Located in Egmont National Park (New Zealand's second oldest), it is a challenging track best suited to fit, experienced backpackers. Undulating from start to finish, the trail passes through a combination of lush forests and spectacular alpine landscapes as it traverses the flanks of the North Island's second highest peak. During its course, hikers are presented with multiple high- and low- level route options; the former being more scenic and difficult, and the latter representing a safer option in foul weather.

Long before the dormant Taranaki—its last major eruption was in 1854—became a renowned hiking destination, the mountain held a special place in the hearts of New Zealand's original inhabitants, the Māori. According to legend, Taranaki once resided in the central part of the North Island along with fellow volcanoes Tongariro, Ngauruhoe, and Ruapehu. Being hot-tempered and more

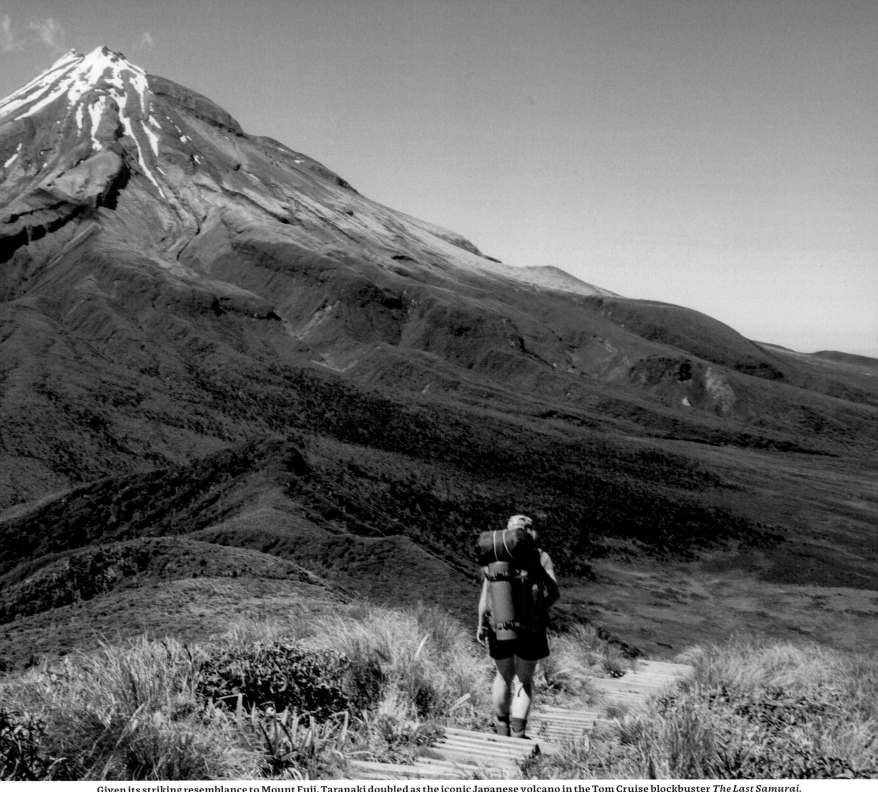

Given its striking resemblance to Mount Fuji, Taranaki doubled as the iconic Japanese volcano in the Tom Cruise blockbuster *The Last Samurai*.

than a little explosive by nature, Taranaki had a falling-out with Tongariro over a woman, the lovely forest-clad Pihanga. A fierce battle ensued, which was eventually won by Tongariro. As a consequence, Taranaki fled west toward the setting sun, leaving a trail of tears in his wake that formed the Whanganui River. To this day, he remains in splendid isolation, forever brooding over his lost love. It is said that when the mountain is shrouded in cloud, the nebulous veil is hiding Taranaki's tears.

Speaking of melancholy, over the years, many AMC hikers have been driven to despair not because of lost love, but instead owing to the mountain's notoriously changeable weather. In addition to dominating the region's skyline, Taranaki's impressive bulk also plays a significant role in the area's meteorological patterns. In short, it is one of the wettest places in the country, with the summit receiving an average of 8,000 mm (315 in) of rain per year. It's worth noting that the higher you go up the mountain, the more likely you are ►

Through the Goblin Forest.

A mossy forest floor.

to encounter significant precipitation and strong winds; all hikers should keep this in mind when deciding on whether to take the high- or low-level alternatives along the route.

As with many of New Zealand's classic trails, accommodation on the AMC can be found in the form of mountain refuges. Well-traveled hikers will attest that the Kiwis' backcountry hut system is second to none, and there is nothing better at a day's end than reaching one of these cozy, dry sanctuaries, removing your wet clothes, and enjoying a nice cup of piping-hot tea. Weather permitting, you may even get to enjoy your beverage while watching the sun set over the mountain. ▶

Rising some 2,518 m (8,261 ft) above sea level, Taranaki is recognized as one of the world's most symmetrical volcano cones, and its Mount Fuji-esque profile exercises a magnet-like pull over those fortunate enough to behold it.

Wildflowers and lonely mountains.

Surveying the slopes of Taranaki.

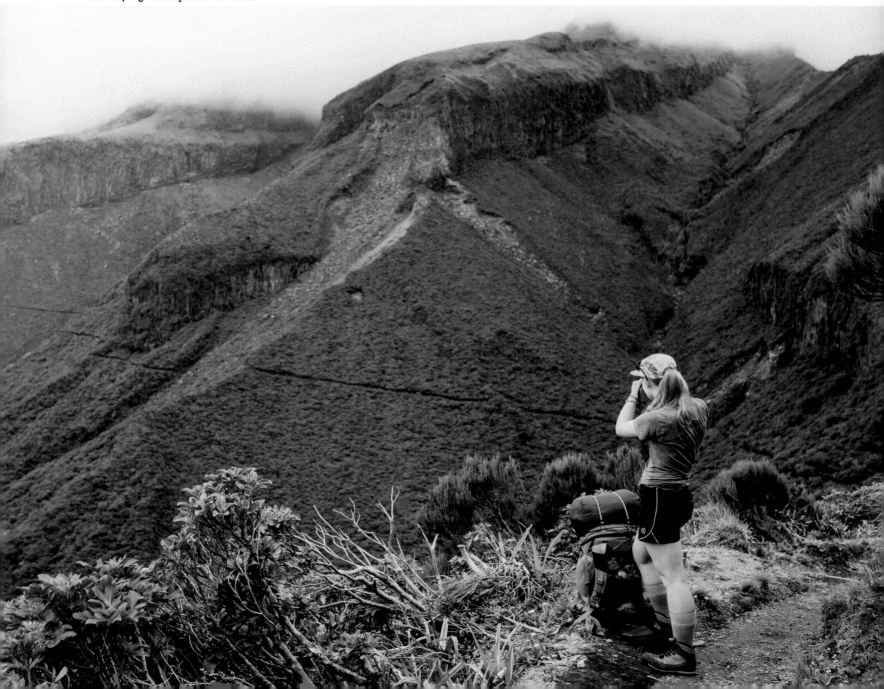

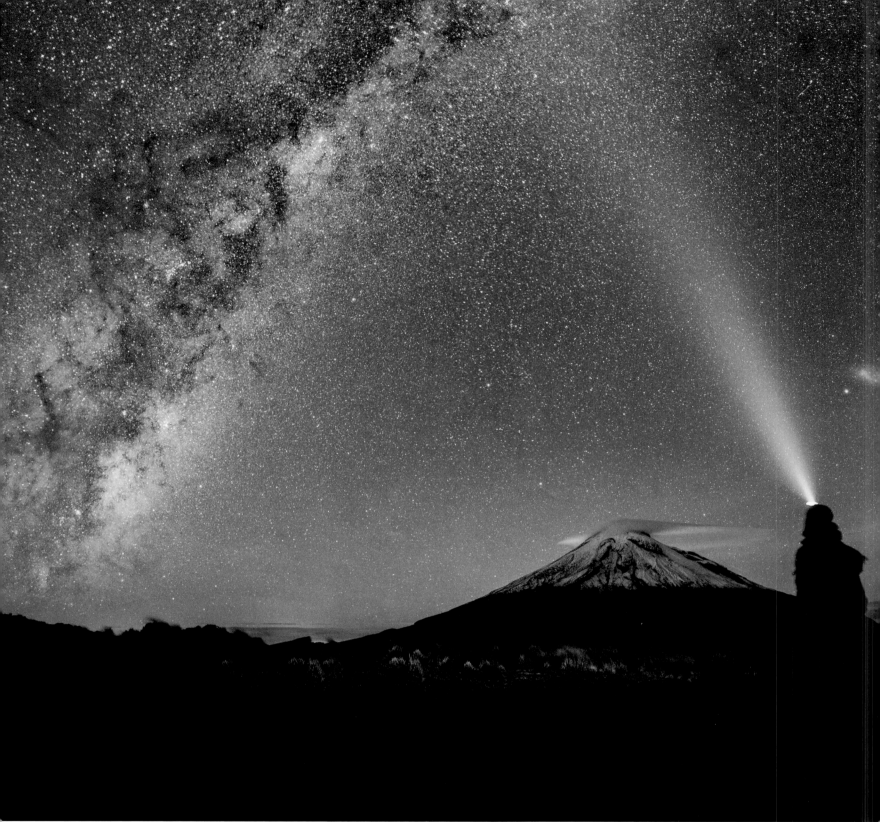

The Milky Way over Mount Taranaki.

Nothing beats finishing the AMC by trekking to the top of the volcano itself. As the journey nears its conclusion, keep a watchful eye on the weather forecast, because this seven- to ten-hour side trip should be attempted only in fine conditions—outside of the main hiking season, alpine equipment (ice axe and crampons) will likely be required. Though steep and challenging, the trail is very well marked, and upon reaching the summit, hikers will be rewarded with incredible 360-degree panoramic views. Should you have the good fortune of arriving there on a day that the skies are blue and the air is clear, take a moment to gaze eastward toward the mighty volcanoes of Tongariro National Park, and remember that—at least according to Māori mythology—true love really can move mountains. ◆

GOOD TO KNOW

About the Trail
/ <u>DISTANCE</u> 52 km (32 mi)
/ <u>DURATION</u> 4 or 5 days
/ <u>LEVEL</u> Moderate to challenging

Start / Finish
🔑 North Egmont

Season
October to May. January to April is the best time to climb to the summit.

Conditions
Mount Taranaki is known for its changeable weather. High winds and heavy rain can occur at any time of year, and hikers should always be equipped with warm clothing and good wet-weather gear.

Accommodation
Mountain huts. No bookings required; first come, first served.

The Last Samurai
Due to its uncanny resemblance to Mount Fuji, Taranaki doubled as Japan's most iconic peak in the 2003 Tom Cruise blockbuster *The Last Samurai*. In addition to their similarly shaped symmetrical cones, it was thought that the farmland and forests that surround Taranaki resembled the Japanese landscape around Fuji in 1877 (i.e. when the movie was set).

HELPFUL HINTS

Pouakai Crossing The 17 km (10.6 mi) Pouakai Crossing is a shorter and easier but equally scenic alternative to the Around the Mountain Circuit. Also beginning at North Egmont, this popular day walk traverses swamps, rainforests, and a tarn-laden plateau, while affording spectacular views of Mount Taranaki.

BACKGROUND

Two Names, One Mountain Taranaki is the Māori name for the mountain; Egmont is the name that Captain James Cook bestowed upon it in 1770. After many years of debate and controversy, in 1986 the New Zealand Geographic Board decided to officially recognize both monikers under its policy of allowing alternative names for national landmarks.

FLORA & FAUNA

Goblin Forest Due to a combination of its volcanic activity, high altitude, and maritime climate, Mount Taranaki possesses a unique vegetation pattern. One of its most notable features are the *Kamahi* which can be found at an altitude of approximately 900 m (2,953 ft). These gnarled, twisted, and highly resilient trees— collectively known as goblin forests—grow around the trunks of other trees that have died in past volcanic eruptions. They are often covered in thick green hanging moss, ferns, and lichen, and resemble something out of J. R. R. Tolkien's Fangorn Forest from *The Lord of the Rings*.

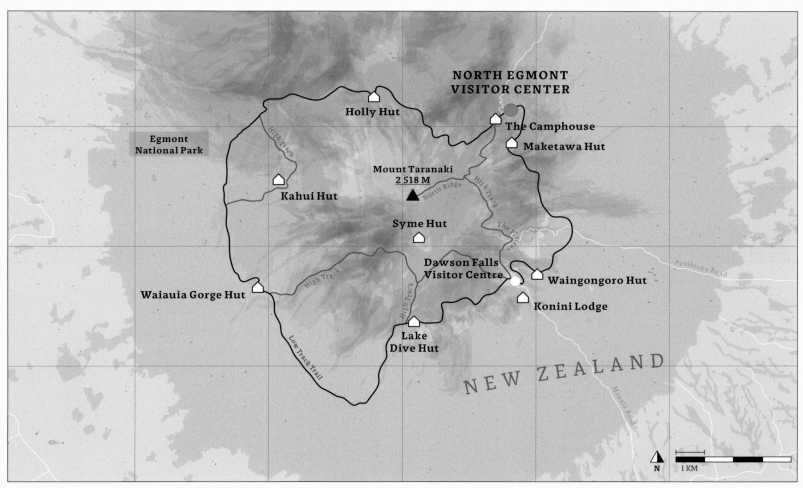

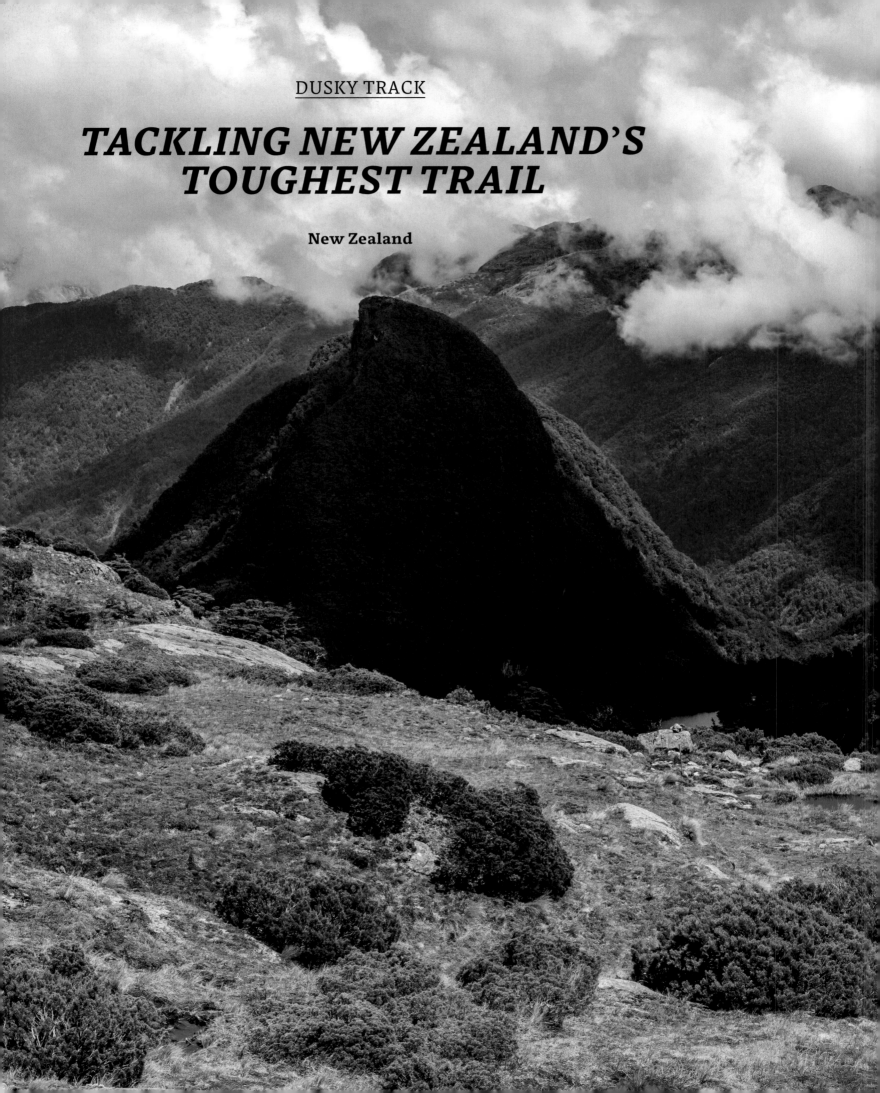

TACKLING NEW ZEALAND'S TOUGHEST TRAIL

New Zealand

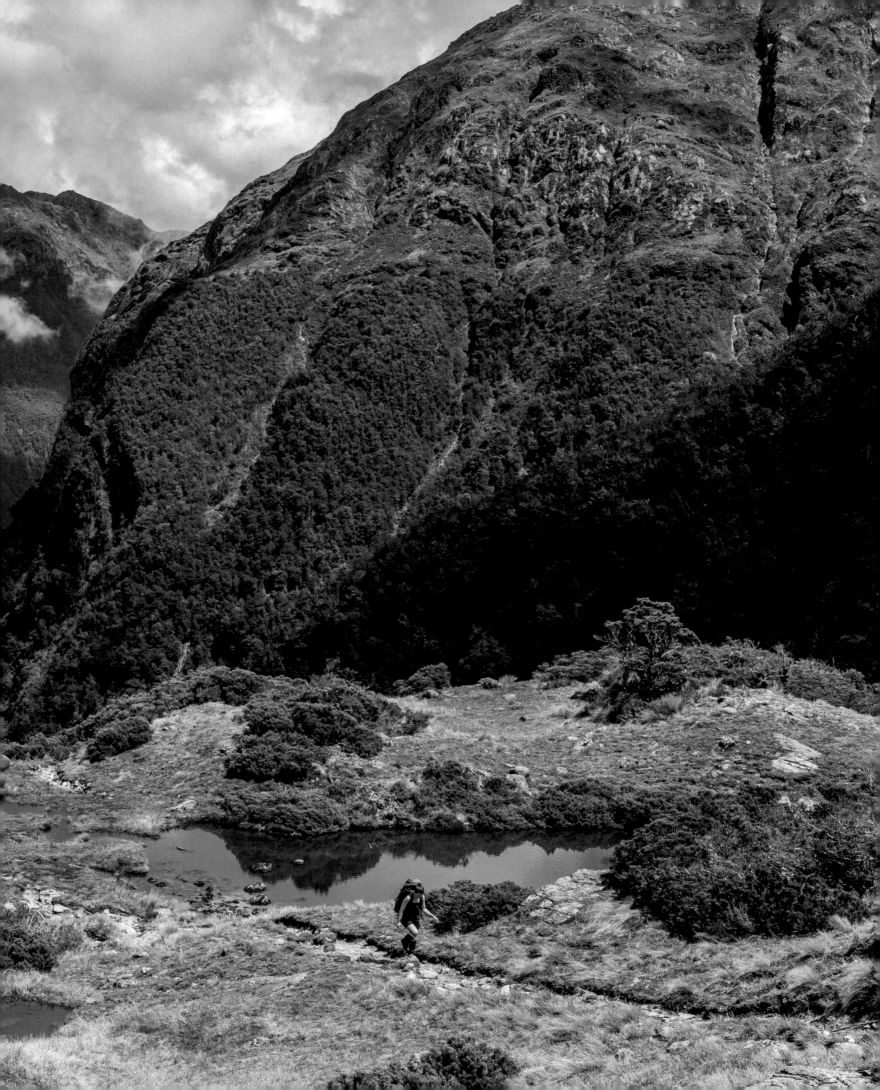

**While the
Dusky Track may
be best known
for its demanding
character,
it also boasts some
of the finest
wilderness scenery
in New Zealand.**

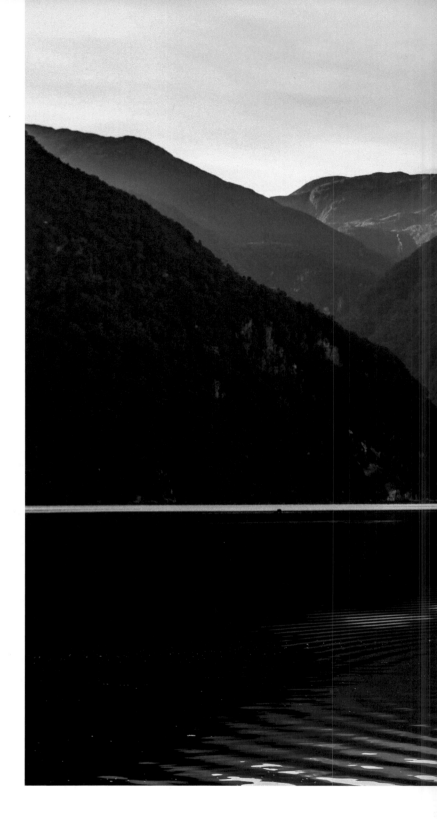

The Dusky Track is one of New Zealand's toughest hikes. It includes some of the wettest, muddiest, and buggiest conditions on the planet. However, it is largely thanks to these less-than-enticing qualities that it has long flown under the world's backpacking radar. For the handful of hardy souls that decide to accept the challenge, the Dusky provides ample compensation in the form of dramatic scenery, lots of solitude, and the satisfaction of knowing you have completed one of New Zealand's most exacting wilderness tramps (local speak for "hike").

Situated in Fiordland National Park on the South Island, the 84 km (52.2 mi) Dusky Track spans two mountain ranges, three valley systems, and hundreds of years of fascinating history. Its Māori name is Tamatea, in honor of the legendary explorer who paddled the full length of New Zealand in his *waka* (canoe). From a non-indigenous perspective, the first visitor to the region was Captain James Cook, who gave the area its English name, Dusky Bay, during his first visit in 1770.

The Dusky Track is bookended by New Zealand's two deepest lakes, Manapouri in the north and Hauroko in the south. Seven to nine days is the average time needed to hike between these bodies of water, though this estimate can vary considerably depending on the conditions, and on the fitness and experience of the hiker. During the route, aspirants will negotiate 21 three-wire bridges, numerous river and creek crossings, and a constant array of slippery, moss-covered roots and rocks. Suffice

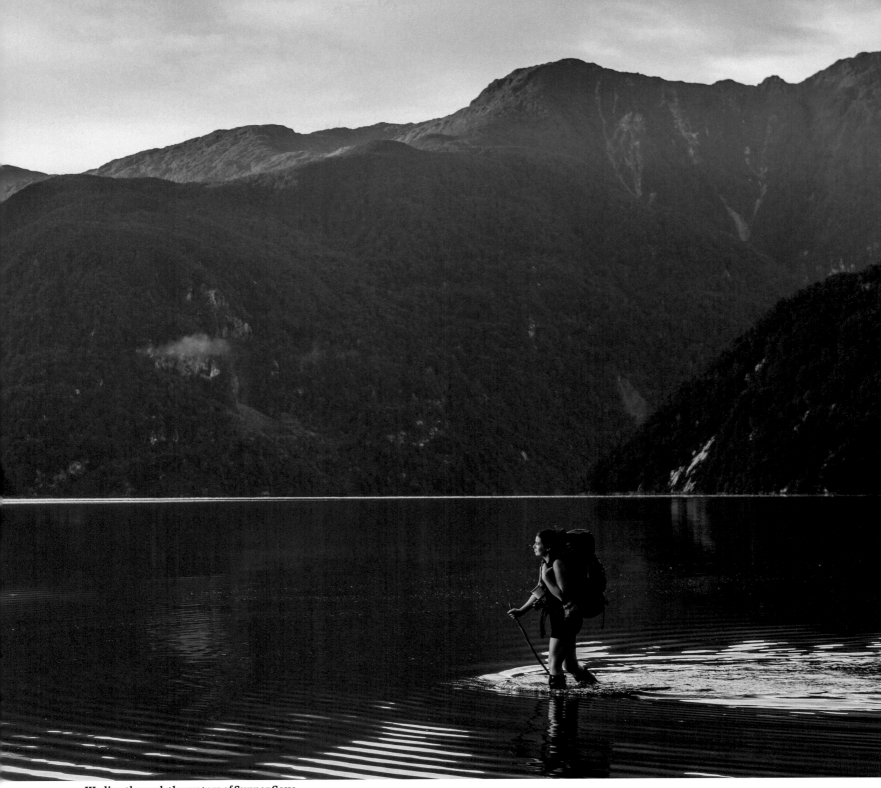

Wading through the waters of Supper Cove.

to say, if you are looking to cruise through mellow terrain at 5 km/h (3.1 mph), this is not the trail for you.

While the Dusky Track may be best known for its demanding character, it also boasts some of the finest wilderness scenery in New Zealand (otherwise only masochists would do it). Highlights of the trail include the Lake Roe and Lake Horizon areas, the views toward Dusky Sound from the Pleasant Range, and a higly recommended side trip to Supper Cove. In regard to the latter, this short and relatively easy detour not only offers hikers the chance to visit the beautiful cove itself, but also provides an opportunity to take a well-earned dip in an idyllic swimming hole just 30 minutes from the turnaround point. This inviting rocky pool, complete with a tumbling waterfall as a backdrop, is like something out of a Tahitian postcard—not to be missed if you are fortunate enough to visit on a warm, sunny day.

One of the most memorable aspects of the Dusky Track is bantering with fellow hikers in the mountain huts. ▶

The beautifully situated Supper Cove Hut.

Right: Gazing out from the Pleasant Range.
Below: A Venus fly trap in action.

The rarely crowded mountain huts are like beacons of dryness and warmth for the cold, drenched, and weary of foot.

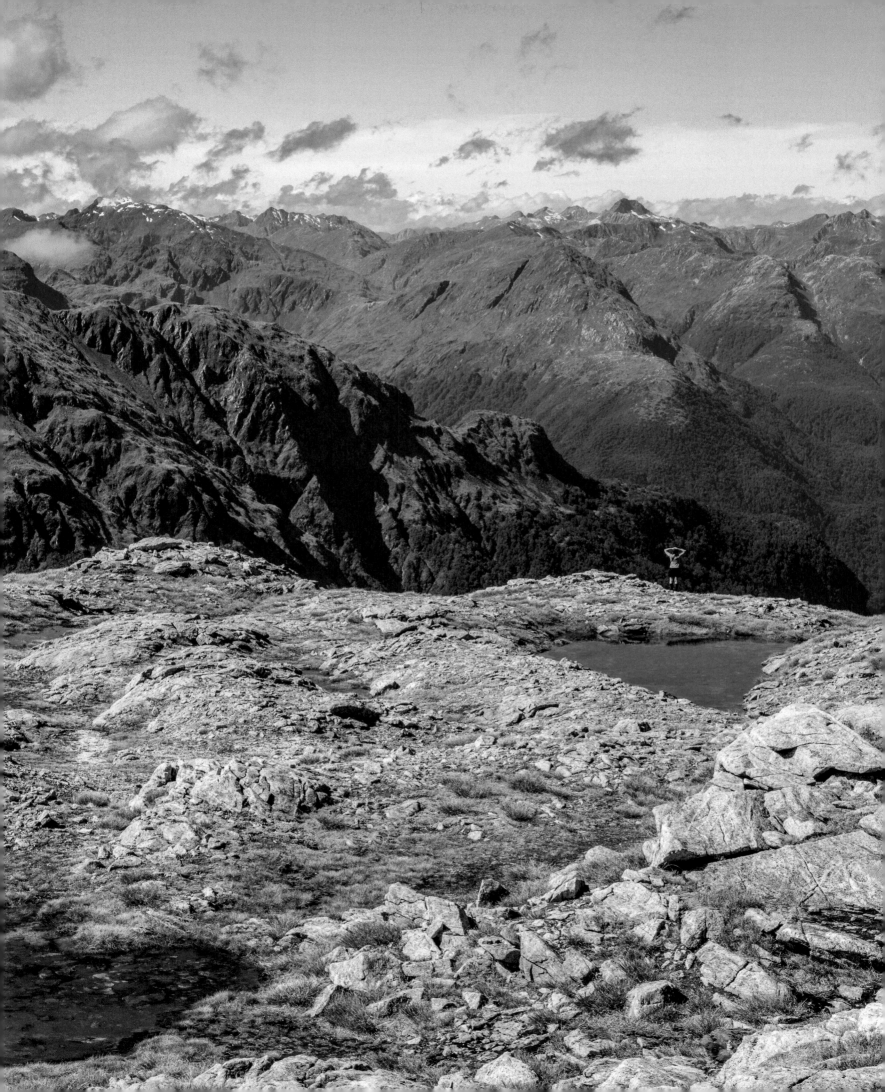

These rarely crowded refuges are like beacons of dryness and warmth for the cold, drenched, and weary of foot. Jokes about the waist-high mud, flooded watercourses, and maddening sandflies invariably fly thick and fast as hikers huddle together around the communal dining tables to enjoy a well-earned evening meal.

The Dusky Track is suitable for experienced hikers armed with good wet-weather gear and a Monty Python-esque "always look on the bright side of life" mentality. Indeed, when viewed through the prism of positivity, it makes for a wonderful litmus test. For those who can embrace and accept the hardships, and come out the other side eager for more, chances are they will become all-weather hikers for the rest of their lives. On the other hand, those that derive nothing but misery and suffering from their Dusky Track experience may well find their future hiking excursions trending toward drier, warmer, and sunnier locales. ◆

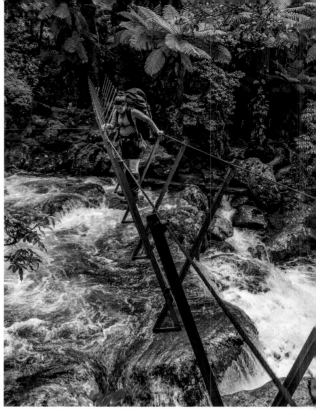

River crossing via a three-wire bridge.

Reflections in Fiordland.

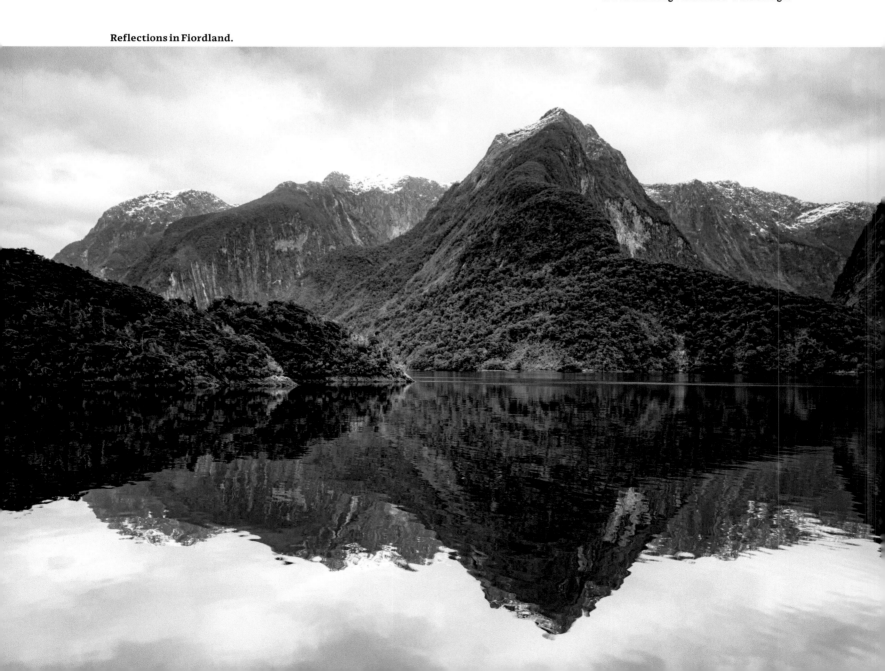

GOOD TO KNOW

About the Trail
/ <u>DISTANCE</u> 84 km (52.2 mi)
/ <u>DURATION</u> 7 to 9 days
/ <u>LEVEL</u> Challenging

Start / Finish
⚑ Lake Manapouri
⚑ Lake Hauroko

Season
Beginning of November to the end of April

Gear
Essential items for a hike of the Dusky Track include a head net, rain jacket, trail-running shoes, gaiters, and an ironic sense of humor—it is difficult to overstate just how muddy and wet this place really is.

Conditions
The Dusky Track is situated in the Fiordland region of New Zealand's South Island. Freezing temperatures, heavy rain, high winds, and snow can occur at any time of year (sometimes all on the same day). According to the New Zealand Department of Conservation (DOC), Fiordland receives "an average of about seven metres of rainfall per year, over an average of about 200 rain-days per year." It is worth noting that after periods of especially heavy precipitation, certain sections of the trail may become impassable due to flooding.

BACKGROUND

Beer and Astronomy On his first trip to New Zealand in 1770, famed English explorer Captain Cook named the area Dusky Bay. On a subsequent journey some three years later, he and his crew spent two months exploring the region, during which time they established an astronomical observatory and are said to have produced New Zealand's first-ever beer. In consequence, Dusky Sound has held a special place in the hearts of brew-loving Kiwis ever since.

HELPFUL HINTS

Accommodation Fiordland is one of the wettest and most sandfly-infested areas you are ever likely to encounter. Therefore, it is strongly recommended that hikers leave their tents at home and make use of the trail's excellent mountain hut system. Huts on the Dusky Track are cheap, rarely crowded, and provide welcome respite from the harsh conditions.

Tip If you're a light sleeper, be sure to bring ear plugs in case you are sharing the huts with heavy snorers.

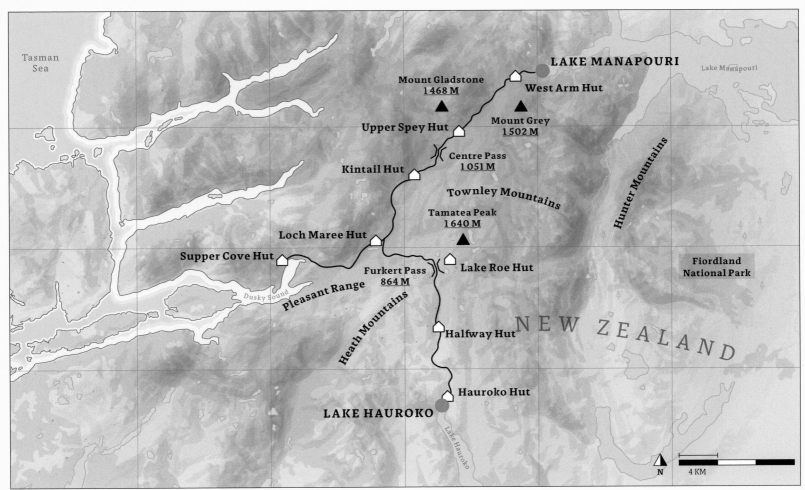

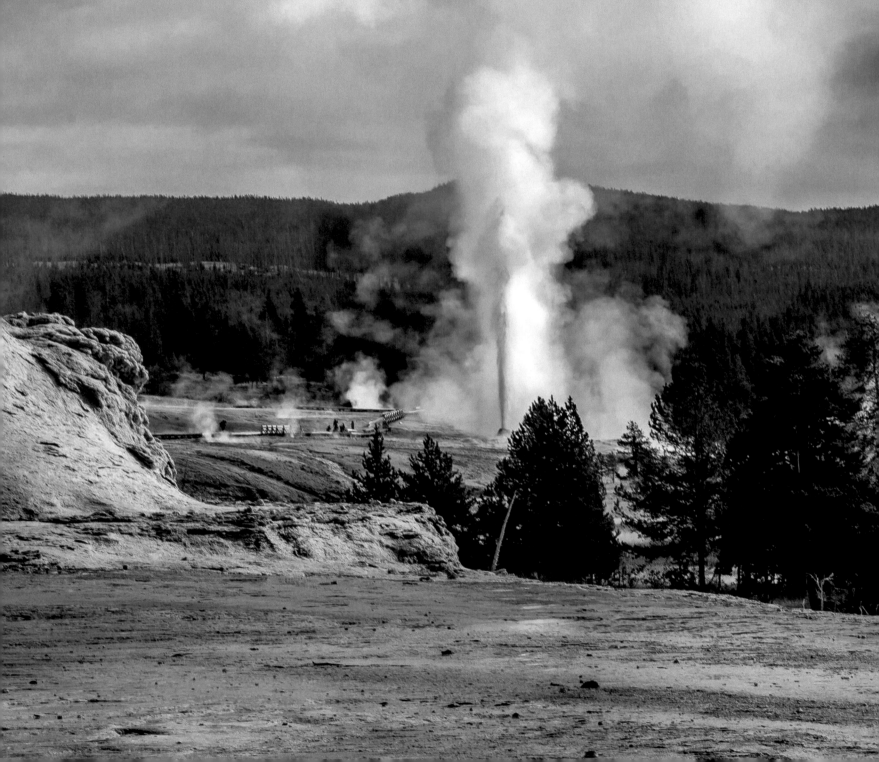

TRACING THE BACKBONE OF AMERICA

U.S.A.

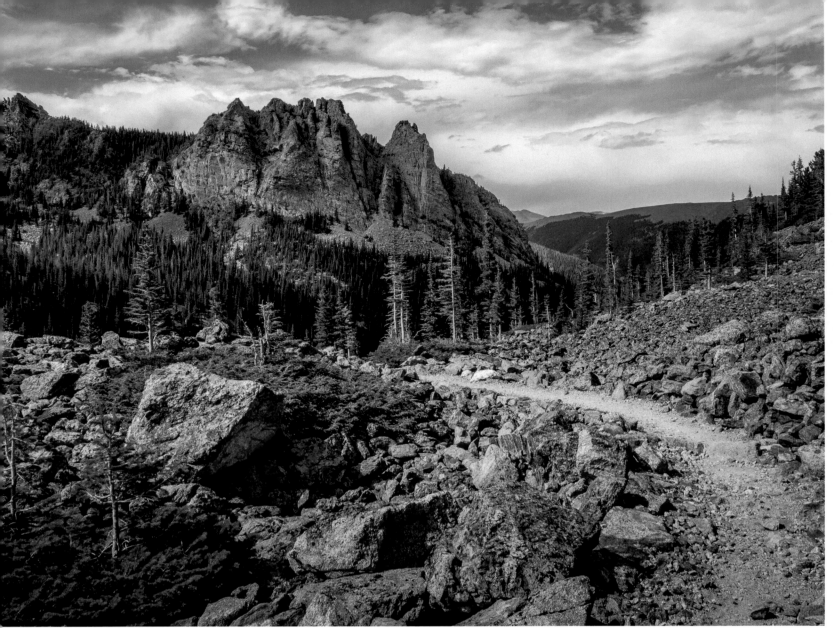

Little Matterhorn.

The Continental Divide Trail (CDT) extends approximately 5,000 km (3,100 mi) north to South, and passes through five states: Montana, Idaho, Wyoming, Colorado, and New Mexico. It traverses a variety of ecosystems that range from high desert to alpine tundra. The most rugged and challenging of America's National Scenic Trails, it arguably includes more wide open spaces than any other long-distance trek in the world. Yet ultimately, the CDT is a hike like any other: it must be tackled one step at a time. On this particular trail, though, you will need to take between six and seven million steps to get from one end to the other.

Along with the Appalachian and Pacific Crest Trails, the CDT forms what is known as the "Triple Crown" of American long-distance hiking. Together, these three mega treks cover approximately

Twin Lakes General Store, a small resupply point on the Colorado section of the trail

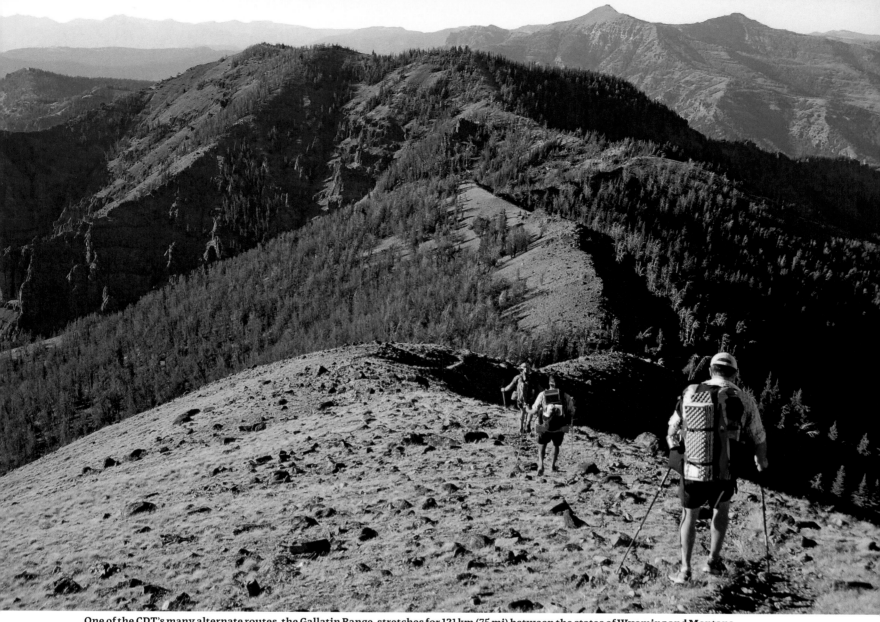

One of the CDT's many alternate routes, the Gallatin Range, stretches for 121 km (75 mi) between the states of Wyoming and Montana.

A sure-footed mountain goat.

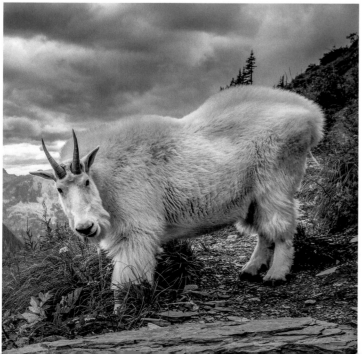

12,714 km (7,900 mi) across 22 states, and total more than 304,800 m (1,000,000 ft) of elevation gain. However, unlike its older and more famous cousins, the CDT is only 85 percent complete as of 2018, isn't well marked in many places, and counts its thru-hiking numbers in the low hundreds rather than the thousands (thru-hikers: people who attempt to complete the entire trail in a single season). This obscurity is due, in no small part, to the remoteness of many of its sections, which are often routed a long way from population centers. During these isolated stretches, it is not uncommon for thru-hikers to go for days without seeing a single soul. Some will find that the solitude presents as big a challenge as the often testing terrain and conditions. On the CDT, it is often just you, the wide open landscape, and a seemingly endless sky.

Going from south to north, most CDT hikers begin their journey at an isolated monument in New Mexico on the U.S.-Mexico border called Crazy Cook. There isn't much ▶

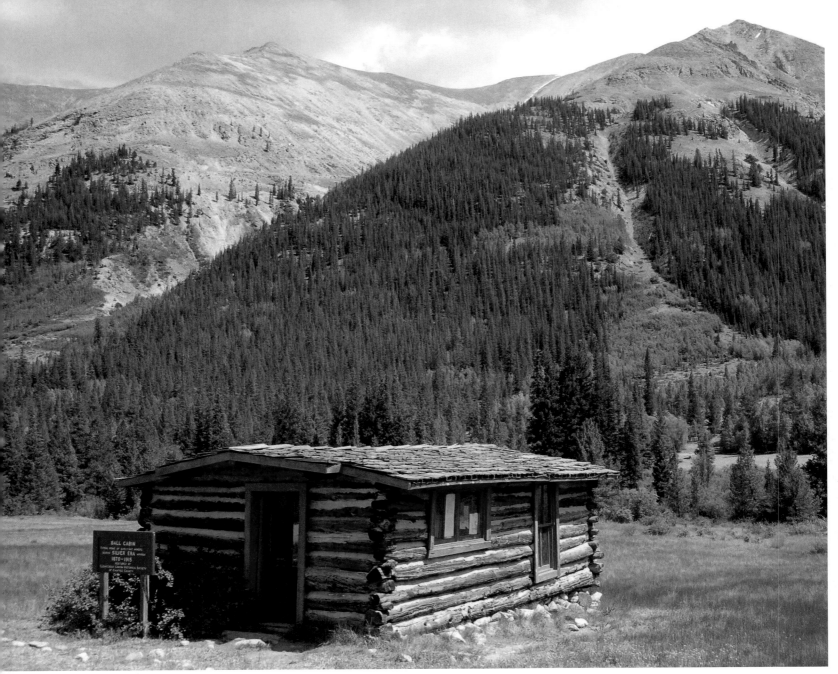

Ball Cabin at the ghost town of Winfield, Colorado.

The Parting of the Waters at Two Ocean Pass (see info box).

On the CDT,
it is often just
you, the
wide open
landscape, and
a seemingly
endless sky.

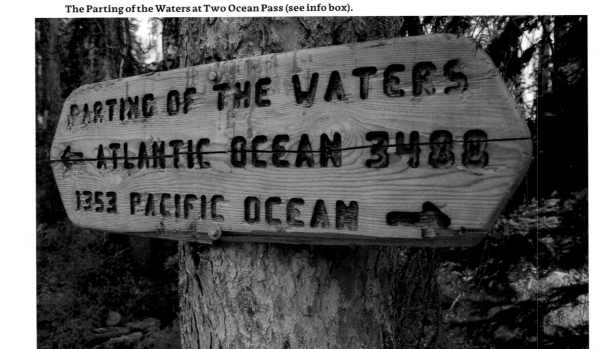

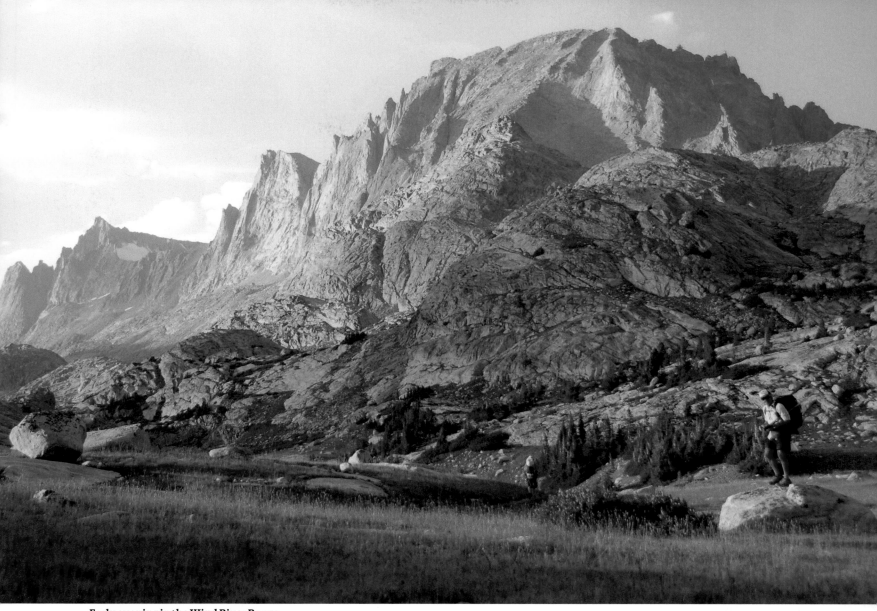

Early evening in the Wind River Range.

Deer skulls and sage brush.

there except a stone obelisk and a small barbed wire fence that marks the frontier. This lonely outpost is a harbinger for what's to come, and represents one of three possible southern termini; the other two, Columbus and Antelope Wells, are also situated in New Mexico. Throughout the course of the CDT, hikers are presented with a multitude of such alternate route options, which means that although the official trail distance from Mexico to Canada is 5,000 km (3,100 mi), in reality most people end up hiking somewhere between 4,185 and 4,500 km (2,600 and 2,800 mi). To a large extent, the CDT is a hike in which you can design your own wilderness experience. Some of the most highly recommended alternates along the route are the Gila River with its hot springs and cliff dwellings, the El Malpais lava field, the Argentine Spine, and the jaw-droppingly beautiful Cirque of the Towers and Knapsack Col in the Wind River Range.

As stunning as some of these surrogate trails may be, the official path is no slouch either when it comes to both natural and man-made wonders. Regarding the former, you have Colorado's majestic San Juan Mountains, Montana's ice age-sculpted Glacier National Park, ▶

171

and the one and only Yellowstone National Park in Wyoming—a geothermal wonderland of geysers, hot springs, steam vents, and multicolored bubbling mud pots. As for man-made marvels, one spot that holds a special place in the hearts (and stomachs) of every hiker passing through is Pie Town, New Mexico. With a population of 123, this dusty, windswept, tastily named hamlet has become a culinary mecca for not only hungry trekkers, but also passing cyclists, horsemen, and motorists. It is one of those places where people lose track of time and stay longer than they anticipated. In the words of Stanley King, co-owner of the legendary Pie-O-Neer pie shop: "We're not in a hurry. We're in Pie Town, and the clock stops in Pie Town."

On a journey as long as the CDT, you will have no choice but to adapt to Mother Nature's clock (just like Pie Town's, only slightly faster). For multiple months, be prepared to experience life at 4 to 5 km/h (2.5 to 3.1 mph), carrying only what you need on your back. It is a simple existence in which the focus is on necessities, rather than superfluous luxuries. Food in your belly, clothes on your back, shelter over your head. In a nutshell, this is one of the biggest gifts that can be derived from completing a thru-hike, because the realizations that come with it are universally applicable. Whether you are on- or off-trail, a diligent commitment to simplicity is one of the surest ways to a happy and healthy life. ◆

Previous double page: Grand Prismatic Spring, only a short side trip for CDT hikers while passing through Yellowstone National Park.
Below: Taking the plunge in the scenic Titcomb Lake.

GOOD TO KNOW

About the Trail
/ <u>DISTANCE</u> 5,000 km (3,100 mi) approx.
/ <u>DURATION</u> 4 to 6 months
/ <u>LEVEL</u> Challenging

Start / Finish
📍 North: Waterton Lake, Glacier National Park, Montana
📍 South: Crazy Cook Monument, Columbus, or Antelope Wells

Season
Northbound: Mid-April to September
Southbound: Late June to October

Highest Point
Grays Peak, Colorado (4,352 m [14,278 ft])

Lowest Point
Waterton Lake, Montana (1,280 m [4,200 ft])

Conditions
As you might expect for a multi-month hike that spans high mountain ranges and deserts, there is a lot of variation. You will need to prepare for conditions ranging from below freezing to scorching hot and everything in between.

Permits
CDT hikers must obtain permits for Yellowstone National Park, Glacier National Park, Rocky Mountain National Park, and the Indian Peaks Wilderness.

FLORA & FAUNA

Pronghorn Antelope The pronghorn antelope (*Antilocapra americana*) is the second fastest land animal in the world after the cheetah. On the CDT, you have the opportunity to observe these swift and graceful creatures while crossing the sagebrush-covered Great Divide Basin of Wyoming.

HELPFUL HINTS

Travel Lightly While there is no universal blueprint as to what you should carry on a long-distance hike, one thing that everyone can agree on is that walking is substantially easier and more enjoyable if your pack doesn't weigh a proverbial ton. When organizing your backpacking kit for the CDT, aim at carrying a base weight of no more than 7 kg (15.4 lb). That is the weight of all your gear except for perishables (i.e. food, water, fuel) and the items you are wearing.

BACKGROUND

The Parting of the Waters The Continental Divide of the Americas is the primary hydrological divide of North and South America. It extends from the top of Alaska to the tip of Tierra del Fuego, and separates the drainage systems that run into the Pacific Ocean to the west and the Atlantic Ocean to the east. At Two Ocean Pass in the state of Wyoming, CDT hikers can experience the only creek in the United States that flows into both oceans at a place called "Parting of the Waters." This little-visited hydrologic site was officially designated a National Natural Landmark in 1965.

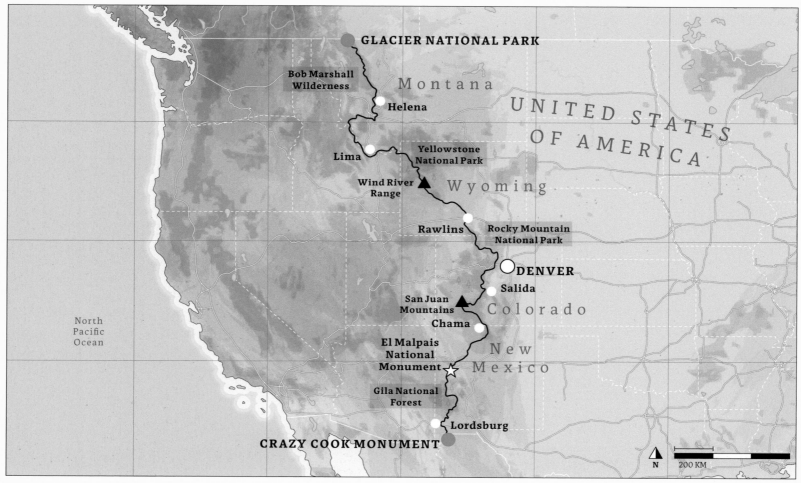

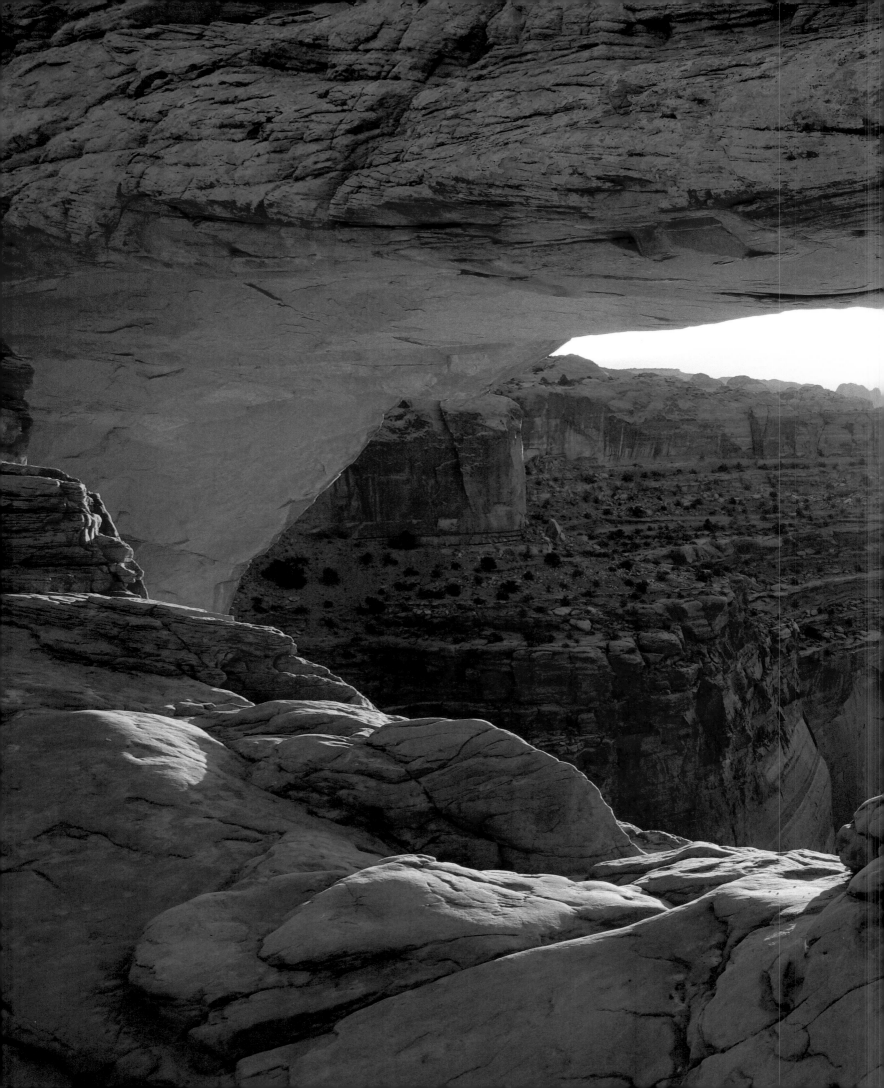

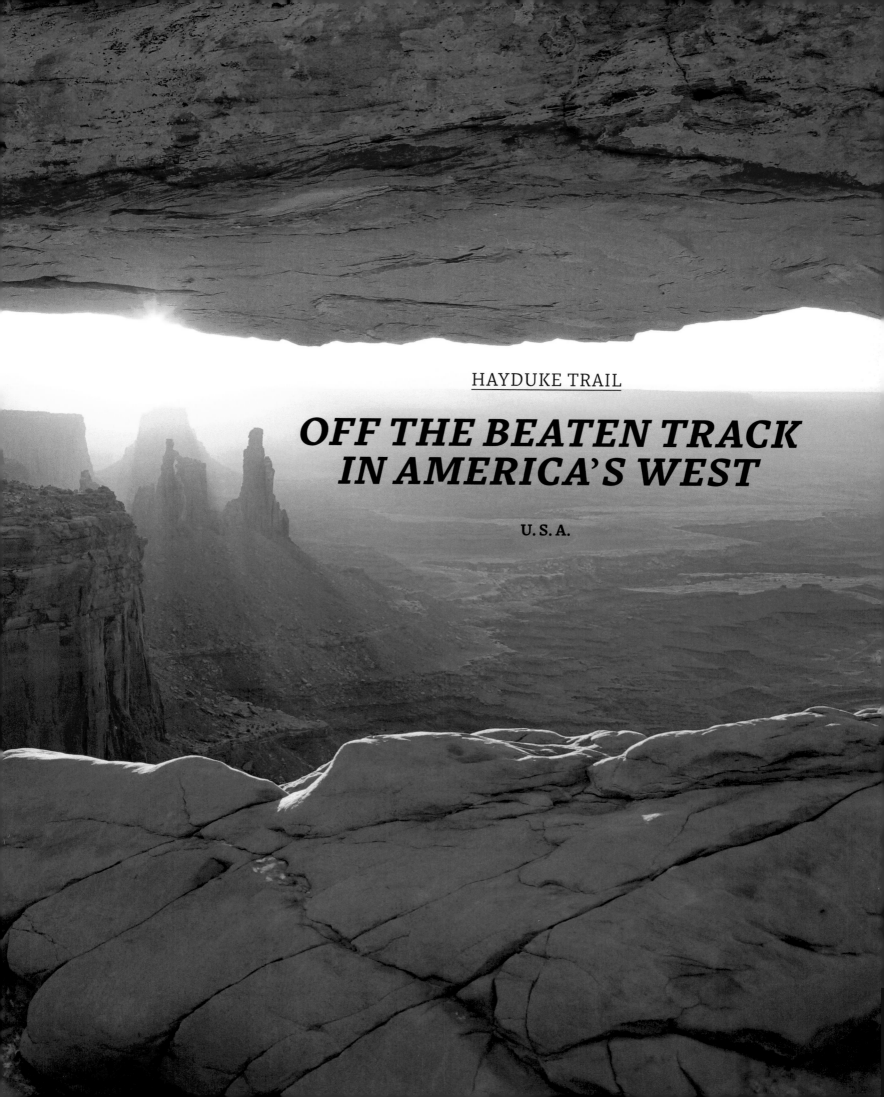

HAYDUKE TRAIL

OFF THE BEATEN TRACK IN AMERICA'S WEST

U.S.A.

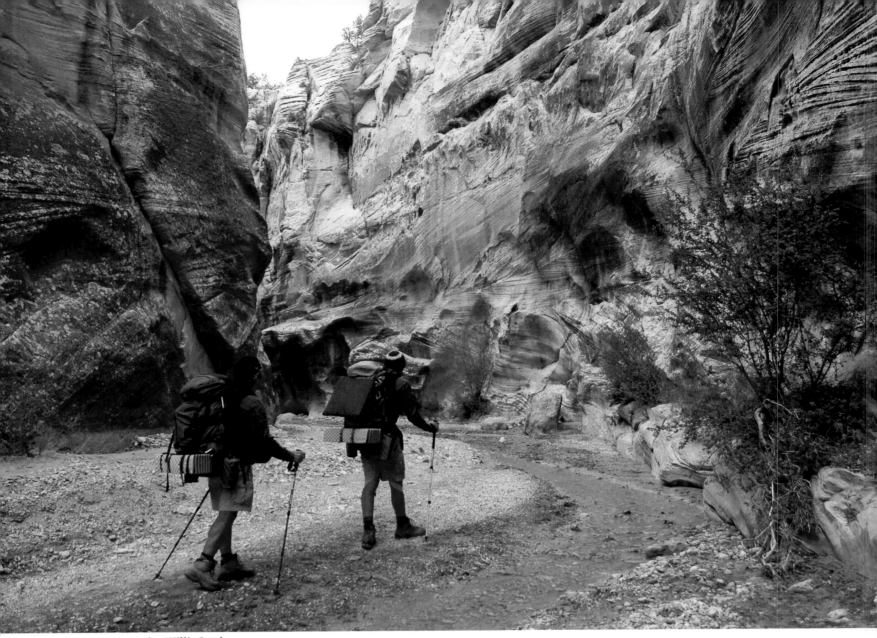

Traversing Willis Creek.

By any criteria, the Hayduke Trail is one of America's toughest long-distance hikes. Winding its snake-like way 1,307 km (812 mi) across the Colorado Plateau, it takes place in a one-of-a-kind environment that includes more amazing geological features than any other trail in the world. There are canyons, domes, caverns, hoodoos, rock monoliths, mesas, river narrows, plateaus, caves, natural bridges, slot canyons, and barren badlands. Whew. If you are an experienced backpacker with a love of rocks and wide open spaces, look no further—this is the hike for you.

The Hayduke Trail is named after George Washington Hayduke III, a fictitious character from Edward Abbey's eco-anarchist classic *The Monkey Wrench Gang.* Abbey's book narrates the efforts and fortunes of a small group of environmental radicals, whose goal is to protect America's Southwest region

The hottest temperature ever recorded in the Grand Canyon was 48 °C (120 °F).

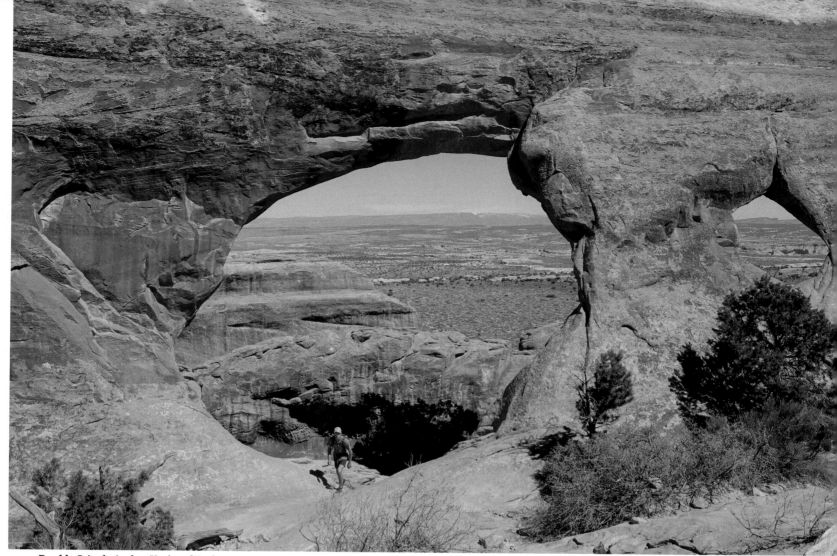

Double O Arch, Arches National Park.

> ## "Warning! Because of the extremely challenging and dangerous nature of this route, you must be a very experienced desert backpacker in peak physical condition before attempting any section of the Hayduke Trail! Thru-hikers beware!"

—JOE MITCHELL & MIKE CORONELLA, FOUNDERS OF THE HAYDUKE TRAIL

by any and all means necessary. The most extreme member of this wild bunch is Hayduke, and the trail's founders, Mike Coronella and Joe Mitchell, felt that the name encapsulated not only the hike's rogue-like character, but also Abbey's insatiable passion and drive to preserve the Colorado Plateau wilderness.

During its exacting course, the Hayduke passes through six national parks (Arches, Canyonlands, Capitol Reef, Bryce Canyon, Grand Canyon, and Zion) and an assortment of other designated wilderness areas. It also takes place entirely on public land. However, the Hayduke is not a "trail" in the traditional sense, but instead an unmarked route that combines cross-country travel, remote four-wheel-drive roads, animal paths, and man-made tracks. Its difficulty lies mainly in the off-trail sections, which include challenging scrambles, boulder fields, pour-offs, lengthy wades through freezing water, and even pockets of quicksand.

Although the terrain is testing, for many hikers, the biggest challenge of the Hayduke exists in the sparsity of food and water sources. In regard to the former, there are multiple stretches where you will need to carry more than a week's worth of provisions between resupply points. As to the latter, water sources are both scarce in quantity ▶

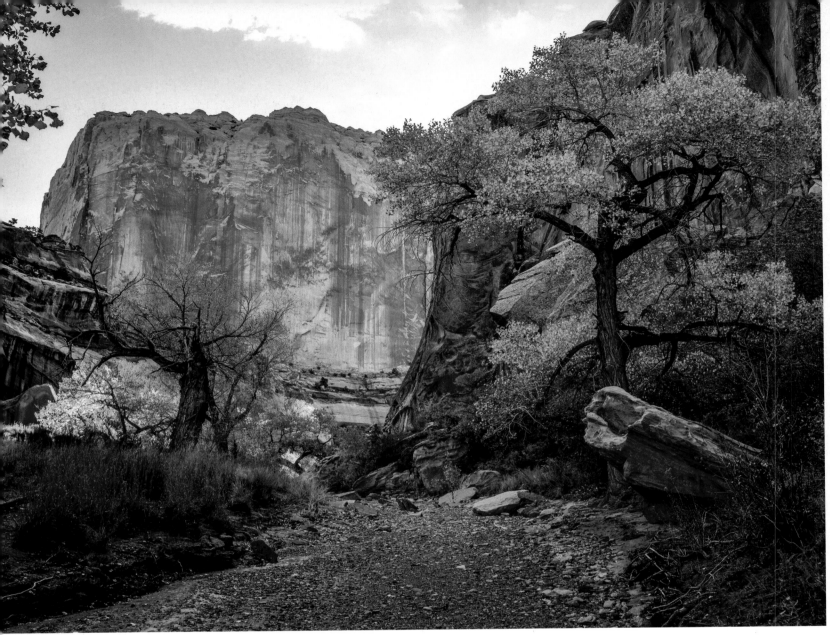
Cottonwood trees and giant rock walls.

and lacking in quality. Depending on the season, it will often be necessary to haul four to eight liters of water between fill-up points. Upon arriving at a source, it is not uncommon to find it alkaline or infested by cow patties. Indeed, many a Hayduke hiker has been known to grumble that Utah must be a topflight contender for the title of "cow poo" capital of the U. S. Better start looking over your shoulder, Texas.

One of the most common questions asked about any trail is, "What are the highlights?" Trying to select just one or two standout features on the Hayduke Trail is the hiking equivalent of attempting to pick the best Beatles song or Shakespeare's greatest play—borderline impossible. Places such as Arches, Zion, and Bryce Canyon National Parks are world famous for a reason, namely their veritable treasure trove of diverse natural wonders. ▶

Right: A moment of illumination at Buckskin Gulch. Below: Desert spiny lizard.

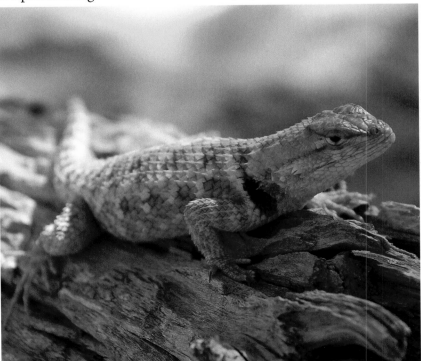

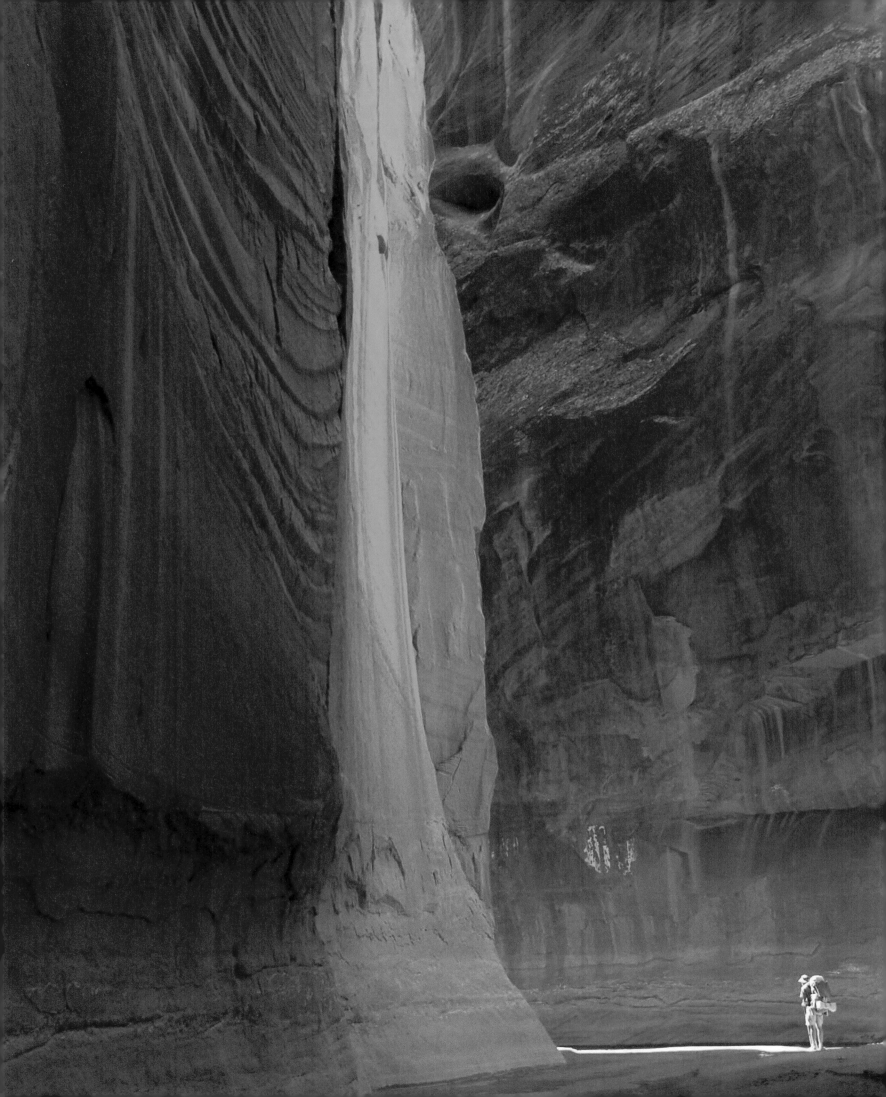

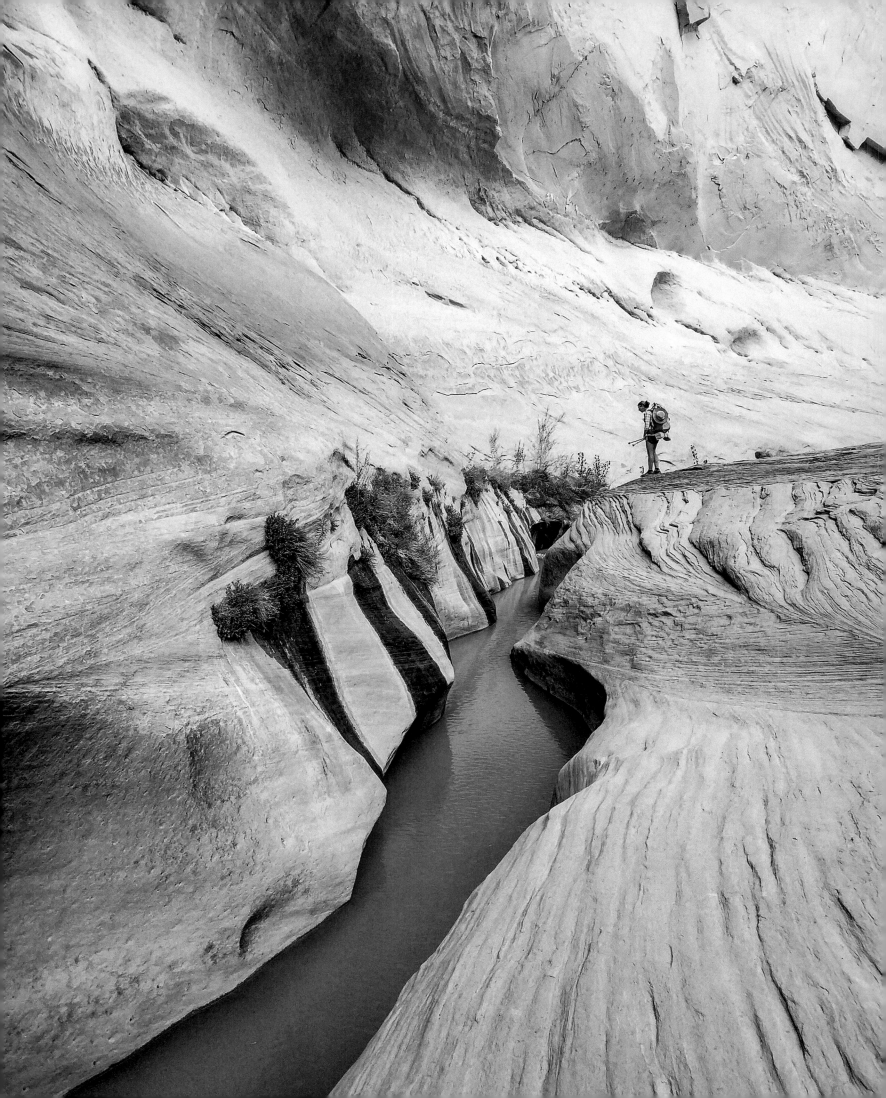

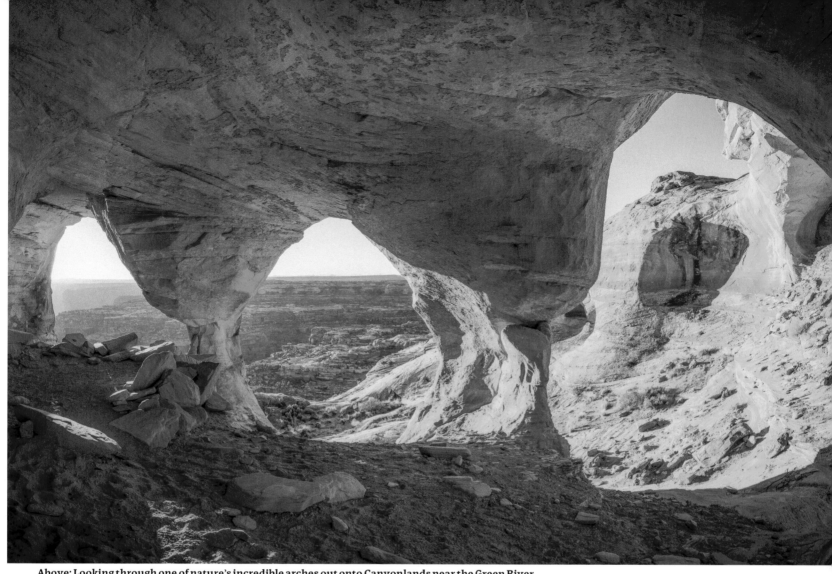

Above: Looking through one of nature's incredible arches out onto Canyonlands near the Green River.
Left: Narrow cut in the Halls Creek Narrows, Capitol Reef National Park.

A curious Harris's antelope squirrel.

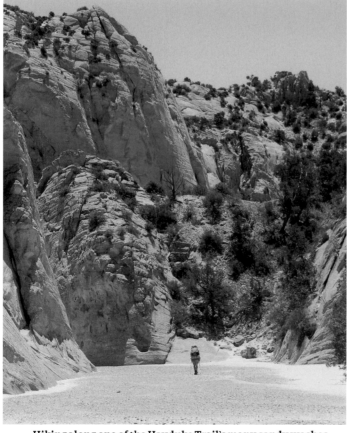

Hiking along one of the Hayduke Trail's many sandy washes.

Nevertheless, among the myriad red-rock delights encountered on the Hayduke Trail, two places that invariably take every hiker's breath away are Arizona's Grand Canyon and the Wave. The Grand Canyon is renowned as one of the Seven Natural Wonders of the world, and Haydukers are gifted the opportunity to experience it in a way in which very few people ever do. Approaching from the North Rim, hikers will enter the canyon via the Nankoweap Trail, a steep, challenging, and little-used path often referred to as "the most difficult trail in the Grand Canyon." The views are awe-inspiring and, unlike the more popular sections of the national park, chances are you will have them all to yourself. On a historical note, long before hikers first trod the Nankoweap (which was built in 1882), the trail was used by horse thieves to drive their four-legged plunder out of the canyon and onto the North Rim. ▶

Claret cup cactus.

Right: The Wave, Arizona's legendary sandstone formation.
Below: Abandoned cabin among red rock hills.

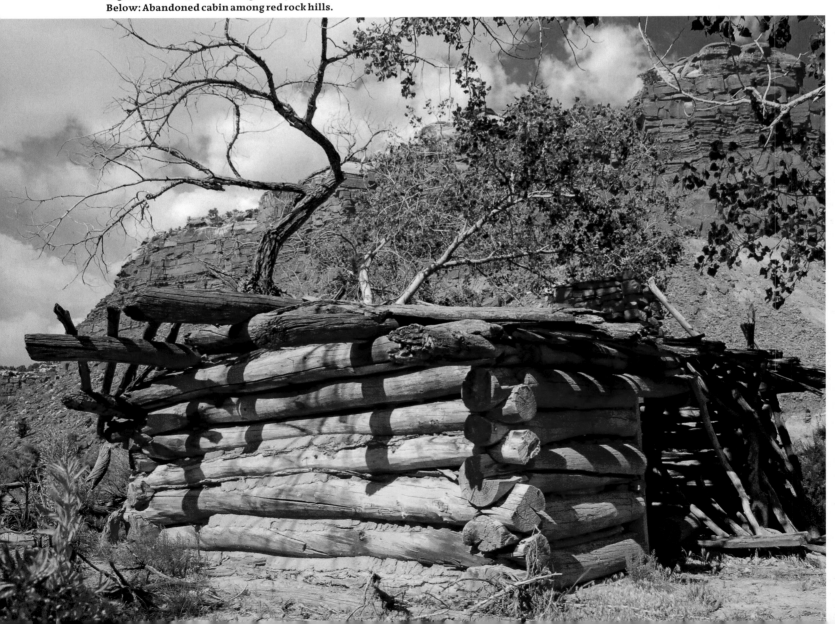

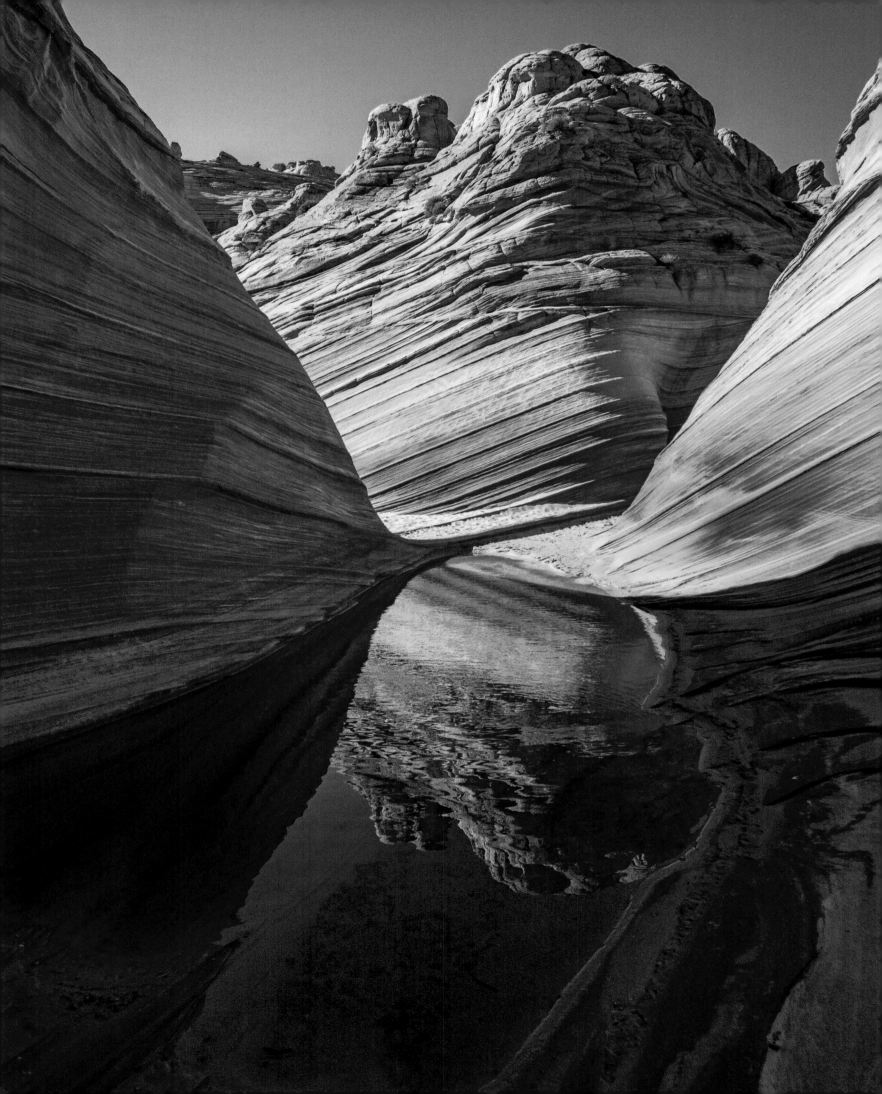

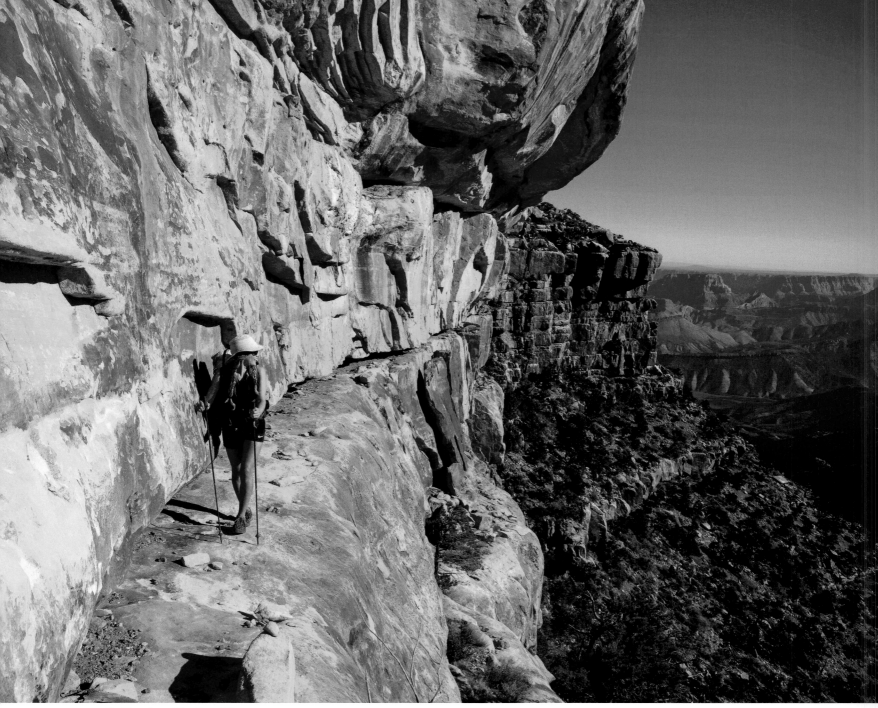

On the edge of the Grand Canyon.

The Wave is one of the most visually stunning features of America's Southwest. Located at Coyote Buttes near the Arizona-Utah border, it lies around 5 km (3 mi) off the standard Hayduke Trail; but for those fortunate enough to obtain an advance permit, this standout highlight is a very worthy diversion. Nestled among sentinel-like conical domes, the Wave is a multicolored rock formation comprised of interconnected sandstone gullies. Its swirling strata and sweeping, eroded forms give the area a completely surrealistic feel—a bit like being transported by Mother Nature into a Salvador Dalí painting.

In the space of a little over 1,287 km (800 mi), the Hayduke Trail conjoins the wonders of the Colorado Plateau in a way that no other experience can possibly equal—be it on trail, road, or river. It has long been one of the backpacking world's best-kept secrets, and due to its extreme nature, it is unlikely to ever receive the quantity of foot traffic seen on the country's more well-known long-distance hikes. And that untamed character seems in perfect alignment with the spirit of the man who inspired its creation, Edward Abbey: "In the first place you can't see anything from a car; you've got to get out of the goddamned contraption and walk, better yet crawl, on hands and knees, over the sandstone and through the thornbush and cactus. When traces of blood begin to mark your trail you'll see something, maybe" (Edward Abbey, *Desert Solitaire*). ◆

GOOD TO KNOW

About the Trail
/ <u>DISTANCE</u> 1,307 km (812 mi)
/ <u>DURATION</u> 60 days approx.
/ <u>LEVEL</u> Very challenging

Start / Finish
⚑ Arches National Park
⚑ Zion National Park

Highest Point
Mount Ellen (3,512 m [11,522 ft])

Lowest Point
Grand Canyon (610 m [2,000 ft])

Season
March to May (spring) and September
to November (autumn)

Conditions
During spring, snow will usually be
encountered at high altitudes, and marginal
water sources (e.g. seasonal streams) are
more likely to have water. In autumn, there is
little to no snow at altitude and intermittent
water sources are less likely to be viable.

Permits
Hikers will need to obtain permits for all six
national parks on the route. Owing to high
demand, those interested in visiting the Wave
at Coyote Buttes will likely need to organize
a permit well in advance.

FLORA & FAUNA

The Return of the California Condor
The majestic California condor is North
America's largest bird. Due to a combination
of habitat destruction, lead poisoning,
and hunting, by 1982 there were only
22 of them left in the wild. However, thanks
to the efforts of the California Condor
Restoration Project (part of the Peregrine
Fund) based in Northern Arizona, the
species has made an incredible comeback,
and as of 2018, their population is over 500.
Hayduke Trail hikers should keep an
eye out for the condor around Vermillion
Cliffs and the South Rim of the Grand Canyon.

HELPFUL HINTS

Hydration Preparation
One of
the primary challenges of hiking the
Hayduke Trail is staying properly
hydrated. This is where previous
experience hiking in arid, off-trail terrain
will prove invaluable. According to
veteran Hayduke hiker Brian Tanzman:
"There are many times when sources
are so far apart that if you were counting
on a source and it was dry you could
be in a world of trouble. The experience
factor comes into play by knowing
beforehand your personal H_2O needs,
the speed at which you hike, and most
importantly, how to process all the
up-to-date information you have about
a given source, in order to determine
whether or not water will actually be there."

BACKGROUND

Edward Abbey
The Hayduke Trail
is named after a character in Edward
Abbey's novel, *The Monkey Wrench
Gang*. Abbey (1927 – 1989) was an essayist and
novelist known for his passionate
and often controversial views on
environmental issues relating to America's
Southwest. Apart from *The Monkey
Wrench Gang*, his most notable work is
the autobiographical classic *Desert Solitaire:
A Season in the Wilderness*.

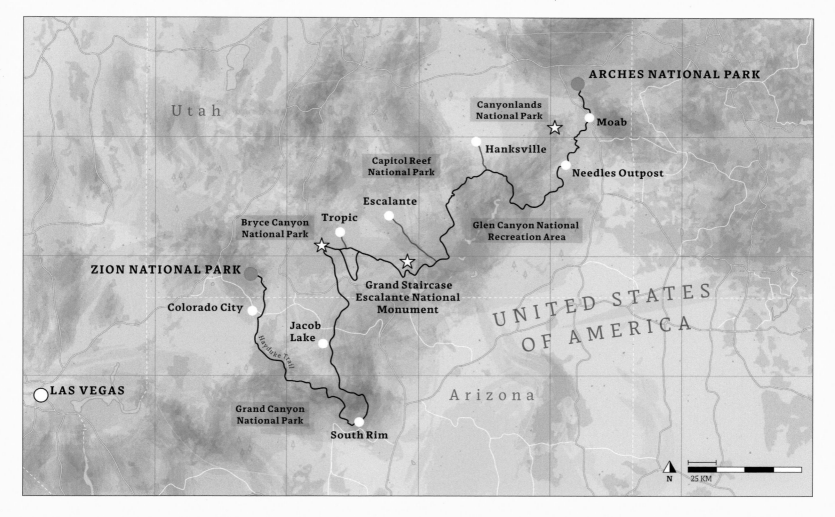

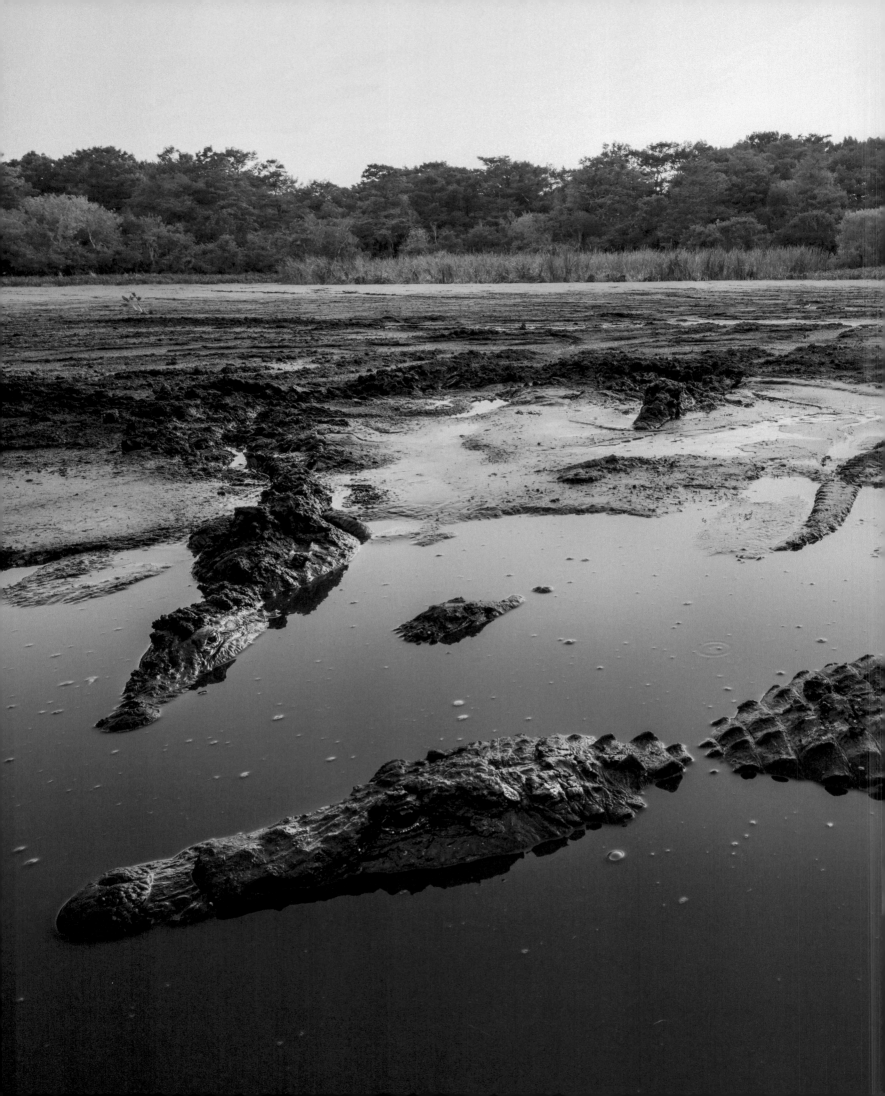

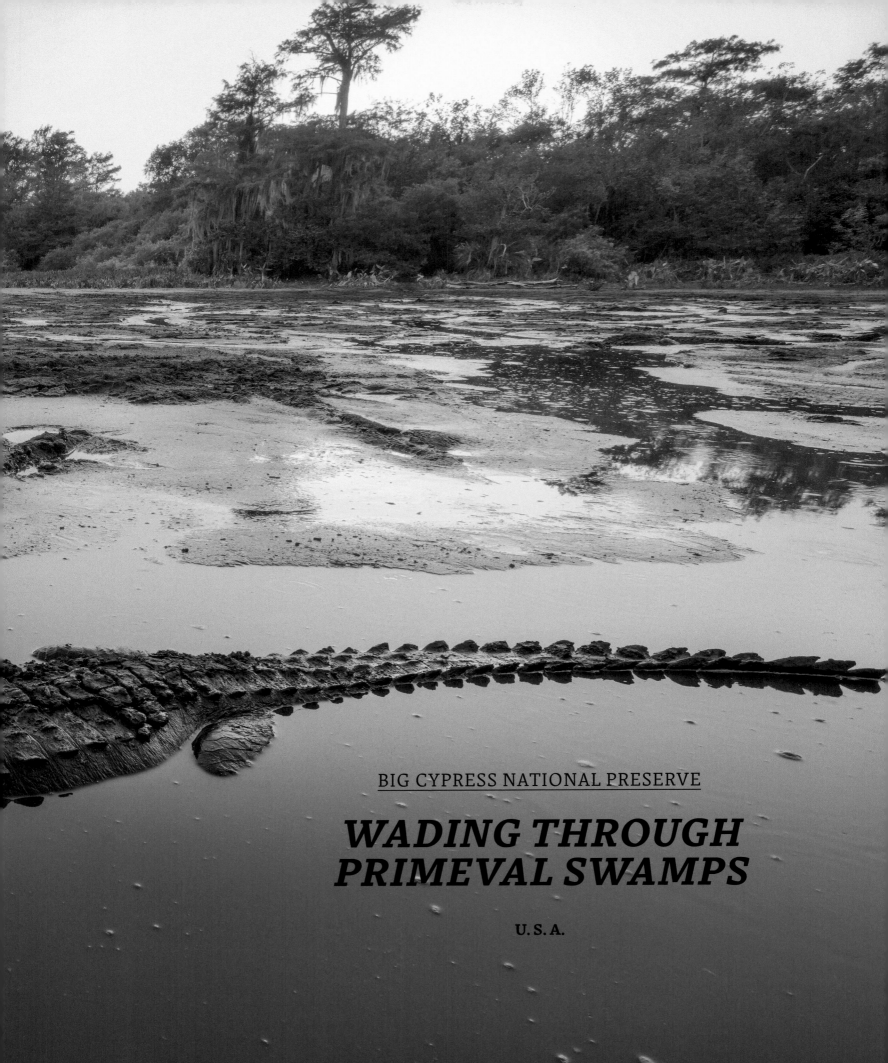

BIG CYPRESS NATIONAL PRESERVE

WADING THROUGH PRIMEVAL SWAMPS

U. S. A.

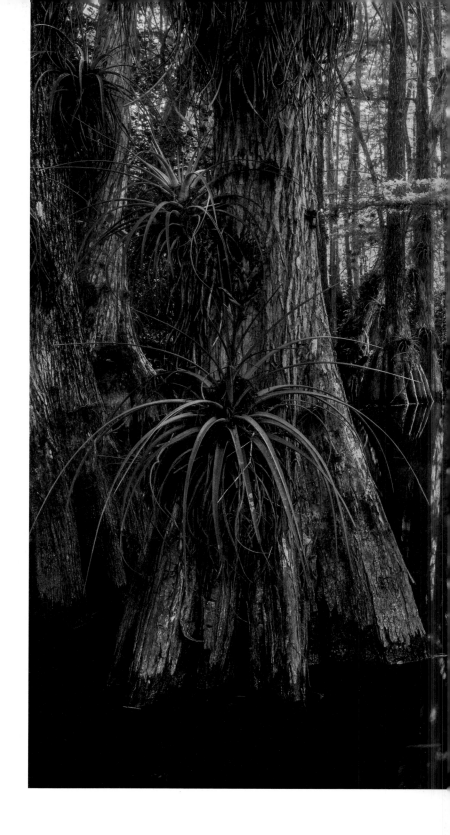

**Dry is a relative term
when it comes to
swampland, and chances
are you will be walking
through water, mud,
or muck for much of the
journey, regardless
of when you go.**

L ess than an hour's drive from the city of Miami,
Big Cypress National Preserve is one of the most
biologically diverse areas in North America.
While its larger and more famous neighbor Everglades
National Park grabs most of the headlines, the 2,914 sq km
(1,125 sq mi) Big Cypress is home to a vast array of flora
and fauna, including the highest concentration of fern
and orchid species in the U.S., as well as cottonmouth
snakes, alligators, black bears, and Florida panthers. It is
a watery wilderness par excellence, and there is no better
way to experience its wonders than by splashing through
the heart of it on foot.

The featured hike runs north to south for 50 km
(31 mi), between the I-75 trailhead and the Oasis Visitor
Center. It represents the southernmost section of the
2,092 km (1,300 mi) Florida National Scenic Trail, and is
best hiked during the "dry season" between November and
April. Dry is a relative term when it comes to swampland,
and chances are you will be walking through water, mud,
or muck for much of the journey, regardless of when you go.

With water levels typically ankle-high or above, the
"Big Cypress South" may well be the wettest multiday hike
in the United States.

Though the swampy character of the trail is
noteworthy, more than anything else, hiking in Big Cypress
is about experiencing the plant and animal life. During
its course, hikers will pass through a variety of distinct
ecosystems, including pinelands, sawgrass prairies, marsh,
hardwood hammock, and, of course, the cypress for

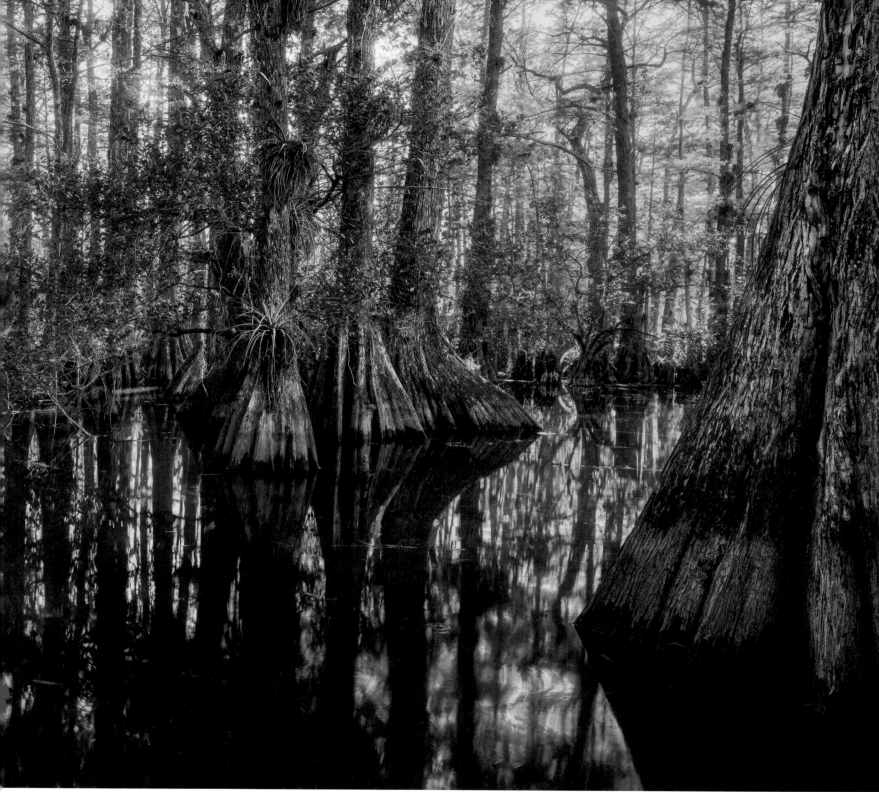

Epiphytes growing on bald cypress trees (*Taxodium distichum*).

which the preserve is named. Though there is an abundance of bird life—egrets, anhingas, and herons, to name just a few—the impressive lineup of potentially dangerous animals in Big Cypress is what grabs the attention of most people. "Wait," you might proclaim. "You expect me to go hiking for two days through snake- and alligator-infested water?!"

Thankfully, the reality isn't as bad as what many imagine. The rule of thumb: as long as you don't bother

them, they won't bother you. Here are three important tips to keep in mind when hiking through Big Cypress: First, never approach or feed animals, as it doesn't take long for them to become desensitized and/or make the association between humans and an easy meal. Second, use hiking poles or sturdy sticks. These not only help with balance, but will also give any toothy reptiles underneath the surface an additional heads up as to your presence. Third, try to avoid filling up your water bottles at either dawn or dusk, which is when gators are ►

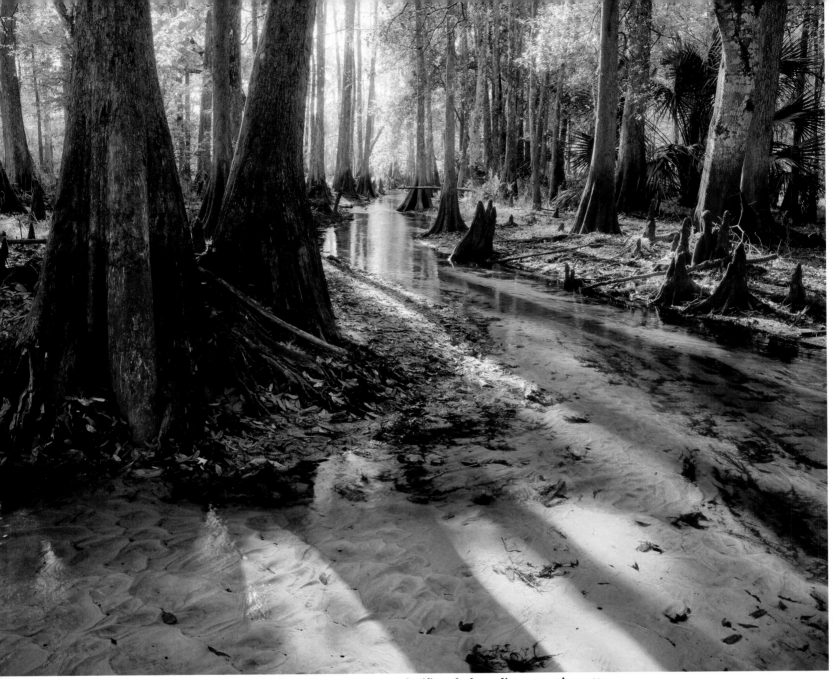

The water levels in Big Cypress National Preserve can vary significantly depending on weather patterns.

Hikers conversing in the swamp, wet feet guaranteed.

During the course of the trail, hikers will pass through a variety of distinct ecosystems, including pinelands, sawgrass prairies, marsh, hardwood hammock, and, of course, the cypress for which the preserve is named.

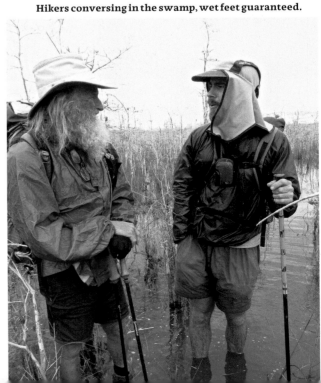

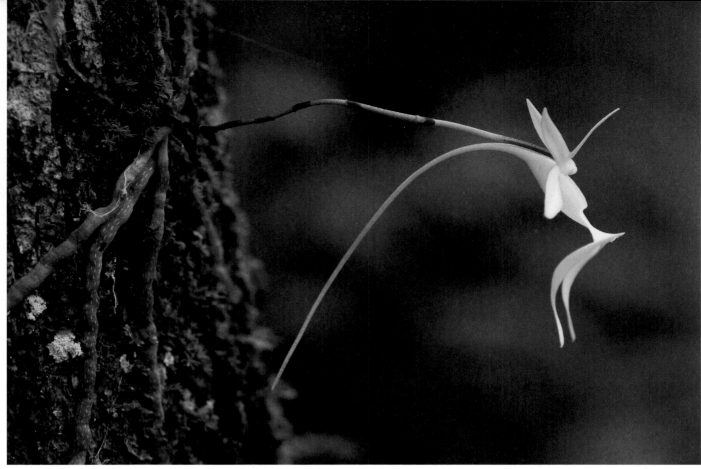

The fragile beauty of an endangered species, the ghost orchid.

Big Cypress also has some dry trails for those that don't like getting their feet wet.

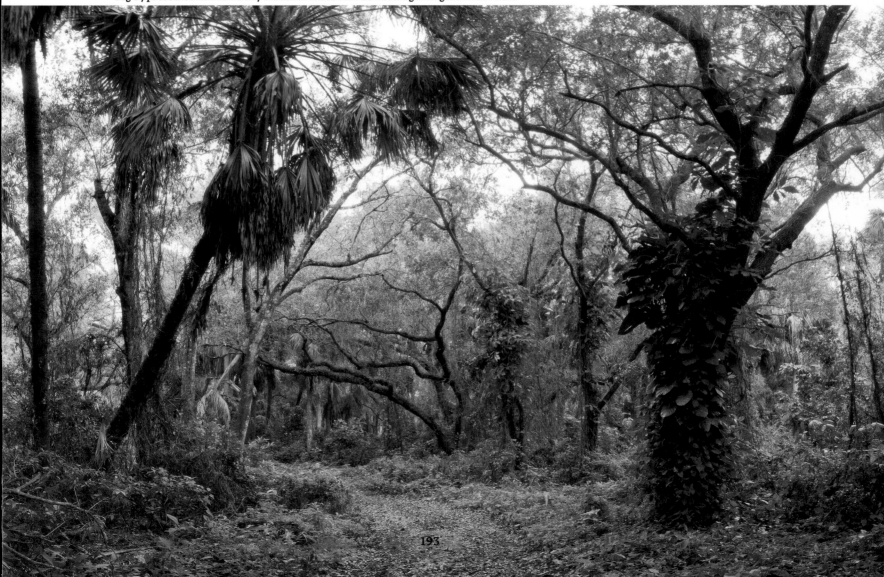

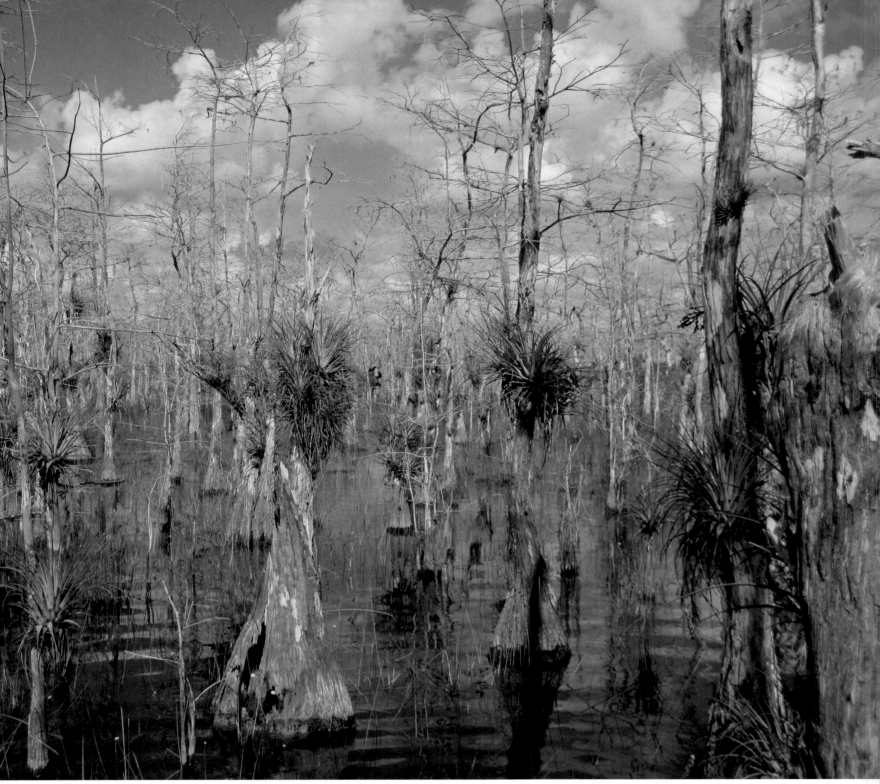

Following the Florida "Trail." Can you spot the reflection of the orange marker?

most active. According to the Florida Trail Association, "the profile of a hiker bent over a canal or stream looks a lot like a deer from an alligator's perspective."

A trek through the Big Cypress swamplands represents one of the most unique hiking experiences in North America. And one of the highlights of any backpacking journey in the Preserve is reaching dry land at day's end; the feeling of taking off your wet shoes after hours of walking through water and mud is simply glorious. A sensation that is soon surpassed in the form of fading sunbeams gently filtering through the forest canopy, illuminating the slow moving waters all around. And as day fades into night, the sounds of the swampland transform from a steady hum into an increasingly loud, but still harmonious chorus of whistles, chirps, ribbits, rustlings, and squawks. And ultimately, it is with thoughts of wonder and appreciation for the extraordinary environment which is Big Cypress, that you eventually drift off to the Land of Nod. ◆

GOOD TO KNOW

About the Trail
/ <u>DISTANCE</u> 50 km (31 mi)
/ <u>DURATION</u> 2 to 3 days
/ <u>LEVEL</u> Moderate

Start / Finish
⚑ Oasis Visitor Center, U.S. Hwy 41
⚑ I-75 rest area/Florida Trail trailhead

Season
November to April. January and February are best.

Signage
Marked with the orange blazes of the Florida Trail

Accommodation
There are five campsites situated along the trail.

History
The swampland of Big Cypress was originally slated to be part of the Everglades National Park. In 1947, however, it was omitted due to private land issues. It wasn't until 27 years later, in 1974, that the area was designated by the U.S. Congress as a national preserve.

FLORA & FAUNA

Florida Panther This subspecies of cougar is one of the most endangered and reclusive large mammals in the U.S. These iconic creatures live in the swamps and forests of southwestern Florida and can weigh up to 73 kg (160 lbs). During the 1970s, it was estimated that only 20 remained in the wild; however, in recent decades, they have made a comeback, and as of 2017, there are an estimated 230.

BACKGROUND

Indigenous People of Big Cypress Evidence of humans living in Big Cypress dates back almost 3,000 years. The diverse swampland ecosystem provided a rich hunting and foraging ground for the Calusa and Tequesta peoples. However, due to high levels of precipitation and seasonal flooding, settlement in the region was almost exclusively transitory, rather than permanent. The aboriginal culture of Southwest Florida changed irrevocably with the arrival of the Spanish in the early 1500s, and by the end of the 1700s, after years of war, slavery, and disease, their traditional way of life had all but disappeared.

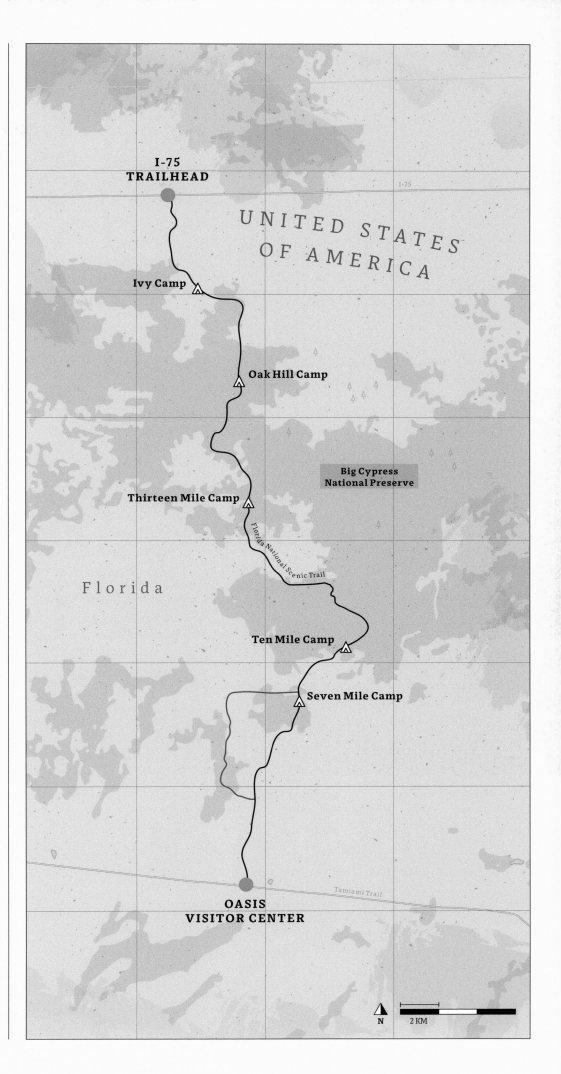

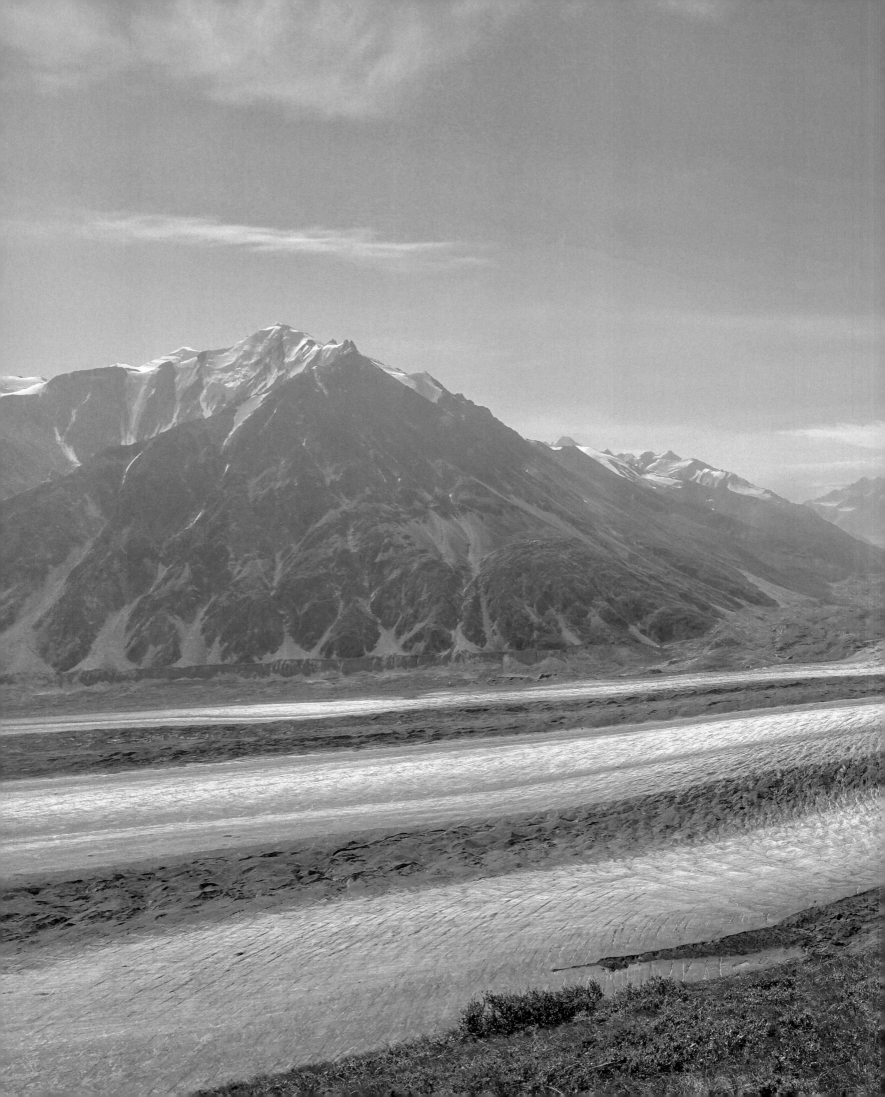

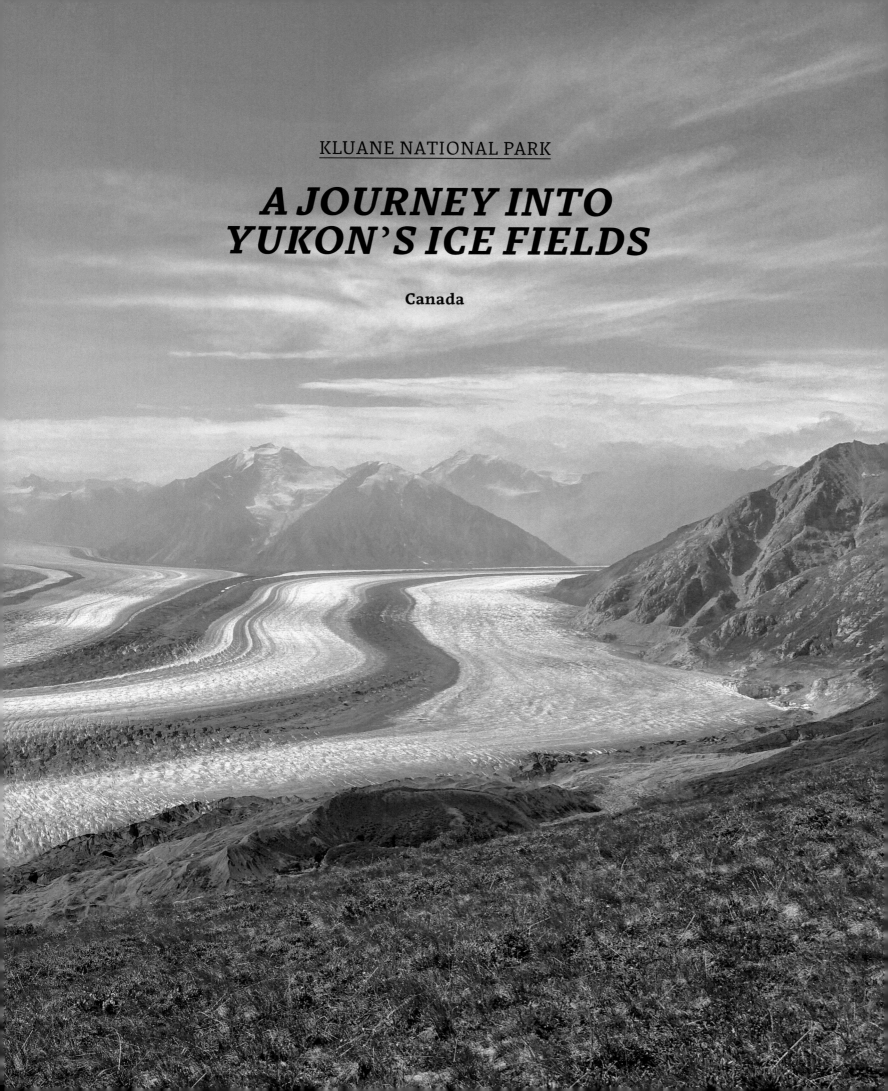

KLUANE NATIONAL PARK

A JOURNEY INTO YUKON'S ICE FIELDS

Canada

**In Kluane,
the sweeping landscape
isn't the only part
of the environment that
has the potential
to make us feel small
(in the best of ways).
There are also
the grizzly bears.**

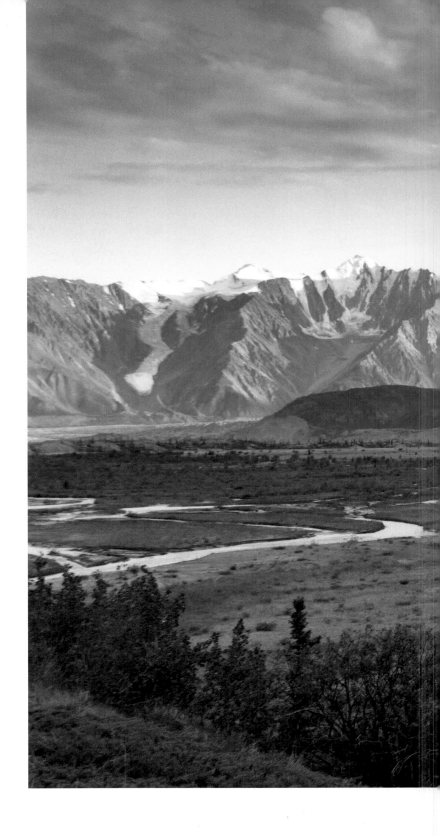

Kluane National Park boasts one of the most extraordinary environments on the planet. Located in the remote Yukon Territory, it is home to Canada's highest mountain (Mount Logan: 5,959 m [19,545 ft]), one of North America's densest concentrations of grizzly bears, and the largest non-polar ice field in the world. Among its mind-boggling collection of more than 2,000 glaciers, arguably the most striking of all is Kaskawulsh: a black-and-white frozen river that can be accessed on foot via the Slim's River West trail.

A short drive from the Thachäl Dhäl (Sheep Mountain) Visitor Center, the Slim's River West trail is a 64 km (40 mi) out-and-back hike to the top of Observation Mountain. It normally takes three days to complete and, as the name suggests, it stays on the true west side of Slim's River for the duration. The route is fairly straightforward to follow, although hikers should be aware that after periods of heavy rainfall, certain areas on the river flats can become exceedingly muddy, necessitating a move to higher and drier ground along the valley's edge. The landscape is uniformly raw, vast, and untamed, with the immense "U"-shaped glacial valley acting as a tangible reminder of our miniscule size in relation to the natural world all around.

In Kluane, the sweeping landscape isn't the only part of the environment that has the potential to make us feel small (in the best of ways). There are also the grizzly bears. Among Kluane's diverse range of fauna—including wolverine, moose, wolves, Canadian lynx, and up to 120 bird species—these giant creatures are the ones that provoke the widest range of emotions among hikers.

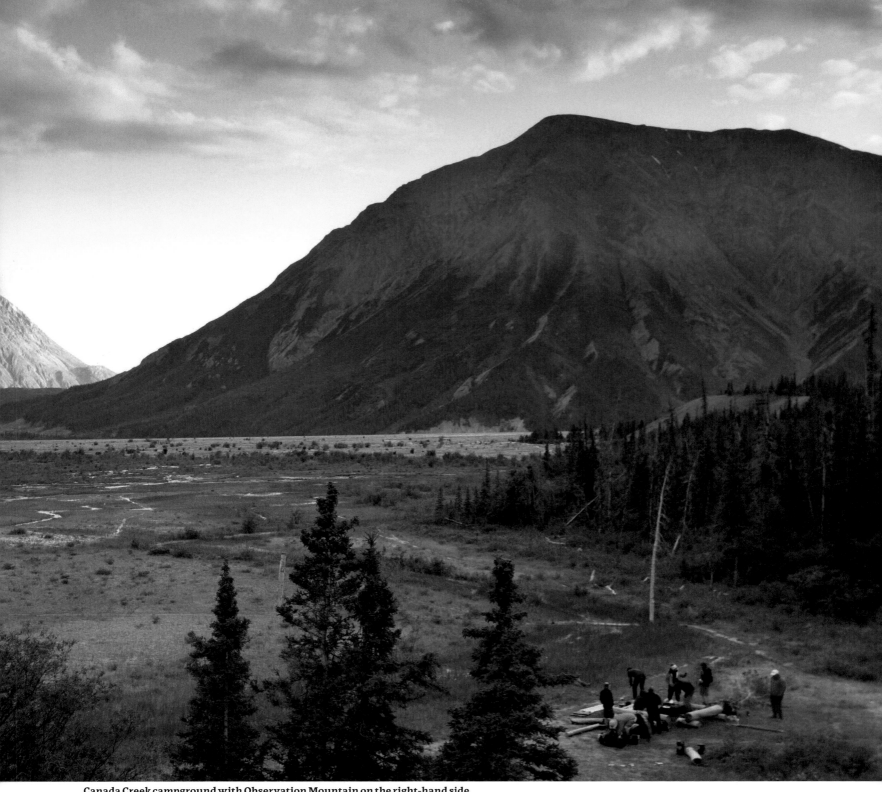

Canada Creek campground with Observation Mountain on the right-hand side.

From anticipation to jaw-dropping wonder to butt-clenching and palm-sweating nervousness, bears are the animals that no one wants to encounter but everyone hopes to see—from a safe and secure distance.

Grizzlies may stir the emotions, but as long as you take the necessary precautions, such as using a canister for your odorous items and making noise in heavily vegetated areas, you have a significantly greater chance of being hit by lightning than attacked by a bear. From a safety perspective, the most dangerous aspect of the Slim's River West trail is not any creature, but instead the river crossings. This holds true for two fords in particular: Bullion Creek (located at the 6 km [3.7 mi] mark) and Canada Creek (near the campground at the end of day one). Both of these watercourses can be swift, deep, and icy cold. Extreme care should be taken.

Some tips for fording these challenging creeks: First, timing. It is easier to ford glacial-fed rivers early ▶

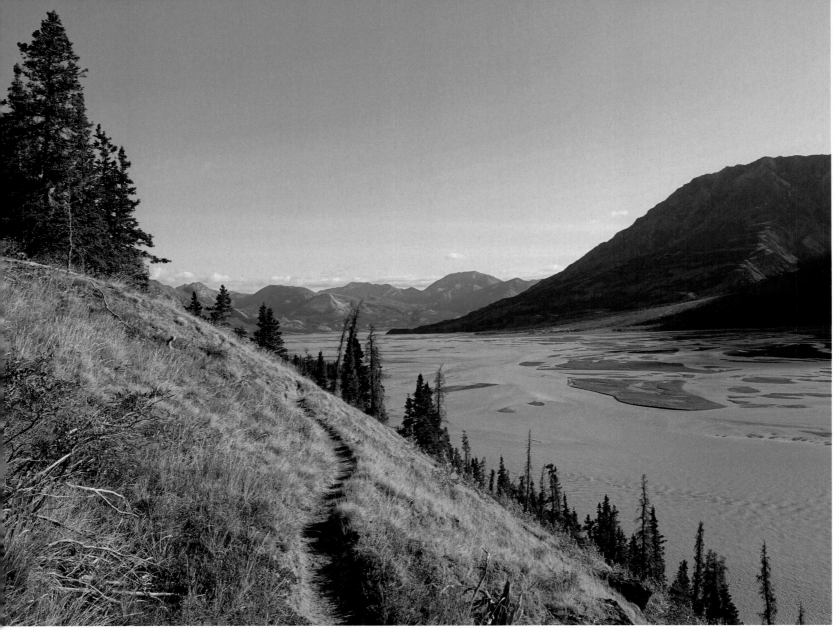

Right: Fresh grizzly bear footprints along the banks of Slim's River.
Above: Hiking above Slim's River.

in the morning, as progressively warmer temperatures mean that water levels will rise throughout the day. Second, width. Generally speaking, look for a spot that is wide and shallow, or braided. Avoid crossing at narrow ("choke") points where the current will be strongest. Third, protection. In case you take a tumble, it is important to line your pack with a large plastic trash bag, and to have all of your electronics and other valuables stored safely inside smaller waterproof bags. Fourth, keep your shoes on. If the crossing is a difficult one, keep them on. Wet feet are a small price to pay for the added protection, traction, and stability that shoes/boots offer. Fifth, technique. Enter the water facing upstream, and, using a trekking pole or sturdy stick for stability, bend at the knees and lean slightly forward into the oncoming water. In your low-profile tripod stance, proceed to slowly shuffle across the river, making things easier by angling slightly downstream (while still facing upstream) rather than straight across; this will mean you are moving with the current, rather than fighting against it. ▶

"Hmm, I'm sure I smelled food around here somewhere."

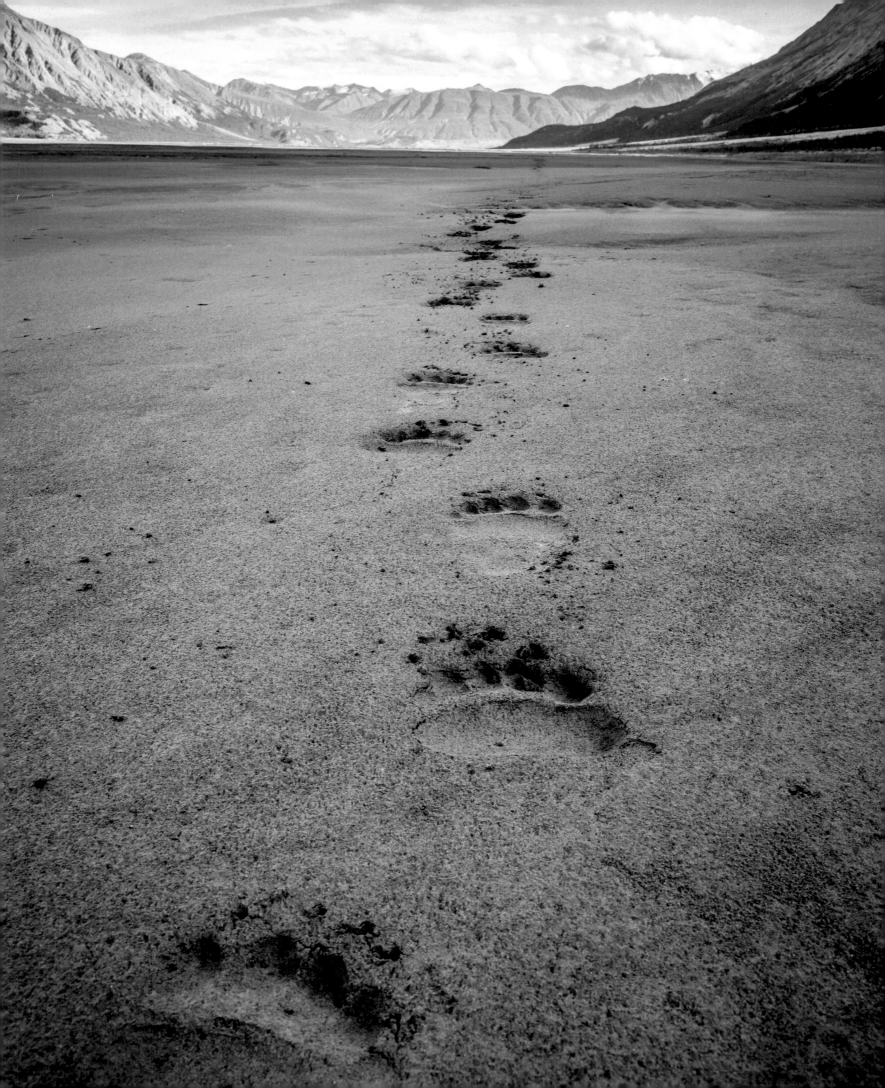

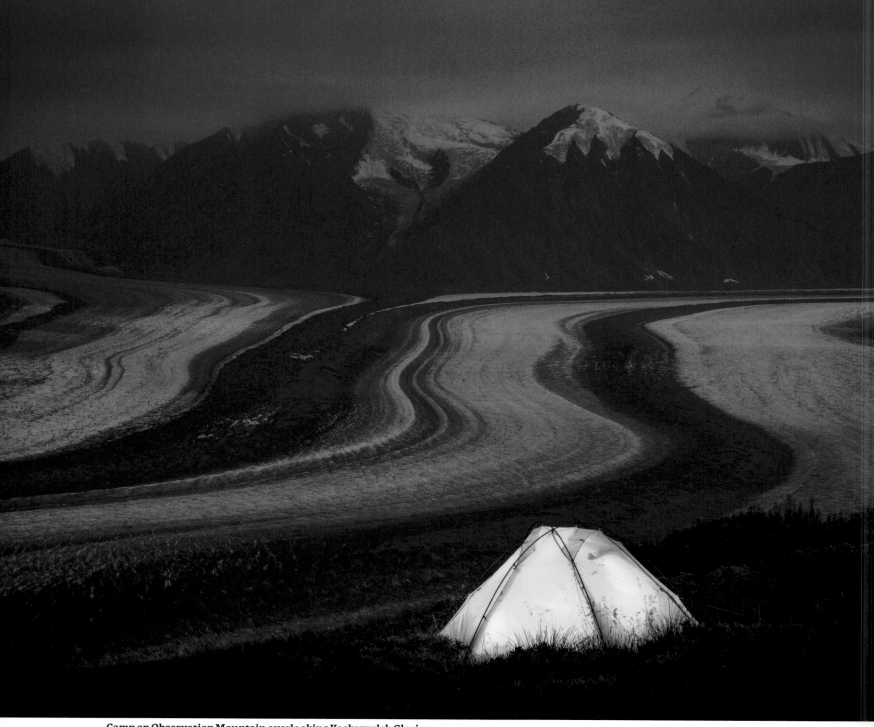

Camp on Observation Mountain overlooking Kaskawulsh Glacier.

Test each foothold as you go, as foot entrapment is one of the principal reasons people fall during crossings.

The second of the fords, the multi-channeled Canada Creek, should be tackled early morning on day two. Once across, follow the watercourse west toward its confluence with Columbia Creek, and then follow the latter until you reach the steep and rocky path that leads to Observation Mountain. Upon reaching the plateau below the summit, the views of Kaskawulsh Glacier are breathtaking. The serpentine highway of multihued ice creeping its frozen way among snow-capped peaks is undoubtedly one of the finest vistas in North America—take your time here before beginning the journey home.

Kluane is one of those places in which everything seems big. Together with Wrangell St. Elias, Glacier Bay, and Tatshenshini-Alsek parks, it forms the largest protected area in the world at 97,958 sq km (37,822 sq mi). That's an expanse bigger than the state of Maine and more than twice the size of Switzerland. In all its vastness, it is the compilation of little moments that resonate most profoundly during a visit to Kluane. A crimson sunset over Kaskawulsh Glacier, the distant howls of gray wolves at night, your first grizzly bear sighting, and the feeling of tension while fording a deep and rapid river, followed by the elation experienced upon safely reaching the other side. ◆

GOOD TO KNOW

About the Trail
/ <u>DISTANCE</u> 64 km (40 mi)
/ <u>DURATION</u> 3 days
/ <u>LEVEL</u> Moderate

Start / Finish
⚑ Thachäl Dhäl (Sheep Mountain) Visitor Center, Kluane National Park

Season
July to early September

Resupply
Bring all supplies from Haines Junction, Haines, or Whitehorse.

Permit & Bear Canisters
A permit and bear canisters are required for all overnight trips into Kluane National Park. These can be organized at the visitor center. Park authorities also recommend that you bring a can of bear spray, which should be purchased before arrival at Kluane.

HELPFUL HINTS

Bear Encounters Generally speaking, bears want to avoid a close encounter as much as you do. However, in the unlikely scenario that one does occur, here are some tips to follow:

1. If you see a bear from a relatively close distance and it doesn't run off the moment it spots you, stay calm and speak to the bear in a strong and even tone. Raise your arms to make yourself look bigger and, in theory, more intimidating.

2. If the bear stands its ground but otherwise seems disinterested, move away slowly and sideways, without losing sight of the bear.

3. In the event that all else fails and you find yourself being charged by a bear, whatever you do, don't run. That can cause the bear to think of you as prey, and subsequently trigger an instinctive reaction to chase.

4. Most bear charges are bluffs (a bear will run toward you and at the last moment veer off). However, if it becomes apparent that the charge is not a bluff, use bear spray as a last resort. Wait until the bear is within 10 to 15 m (32 to 49 ft). Make sure you are not aiming the spray into the wind.

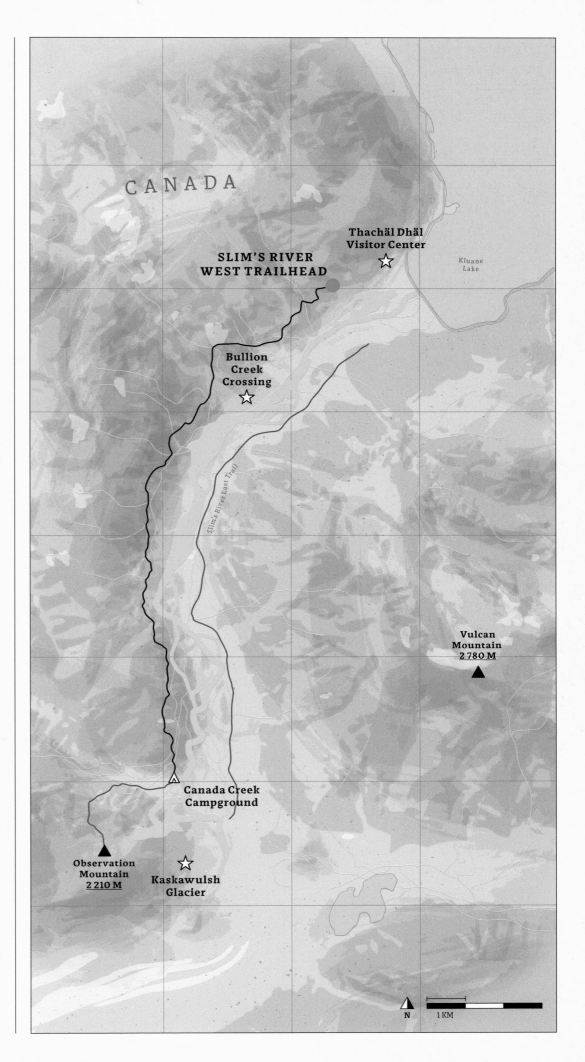

CANADA

Thachäl Dhäl Visitor Center ☆

SLIM'S RIVER WEST TRAILHEAD

Kluane Lake

Bullion Creek Crossing ☆

Slim's River East Trail

Vulcan Mountain 2 780 M ▲

Canada Creek Campground

Observation Mountain 2 210 M ▲

Kaskawulsh Glacier ☆

N 1 KM

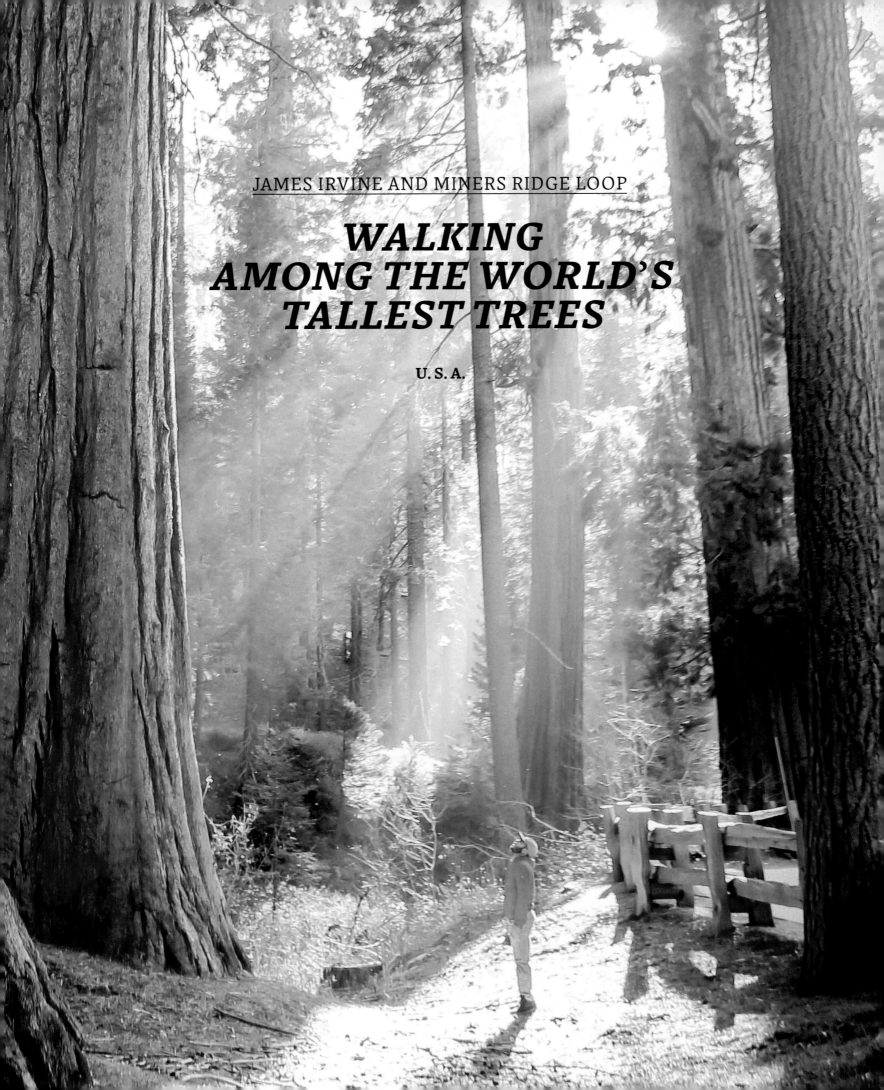

JAMES IRVINE AND MINERS RIDGE LOOP

WALKING AMONG THE WORLD'S TALLEST TREES

U. S. A.

Walking among California's redwoods can be hazardous to your health. Perhaps in no other part of North America do hikers find themselves stubbing their toes and straining their necks as much as they do in these ancient coastal forests. The reason, of course, is the trees themselves. Measuring over 100 m (328 ft) in height, redwoods are not only the world's tallest trees, but also the biggest living things on the planet. Visitors will inevitably spend as much time gazing up in awe as they will looking at the trail in front of them.

The James Irvine and Miners Ridge Loop (18.7 km [11.6 mi]) is a combination of two separate trails that has long been recognized as one of the best redwood hikes in California. However, its status is not solely based on the kilometers of old-growth forest one will encounter along its sinuous path. What sets this particular trail apart is that it combines the famed trees with an isolated stretch of coastline and a primeval fern-lined canyon. Each natural feature is extraordinary in its own right, but altogether they embody an ecologically diverse hiking experience that can be enjoyed all year round by people of all ages and fitness levels.

Redwoods are not only the world's tallest trees, but also the biggest living things on the planet.

The magical Fern Canyon.

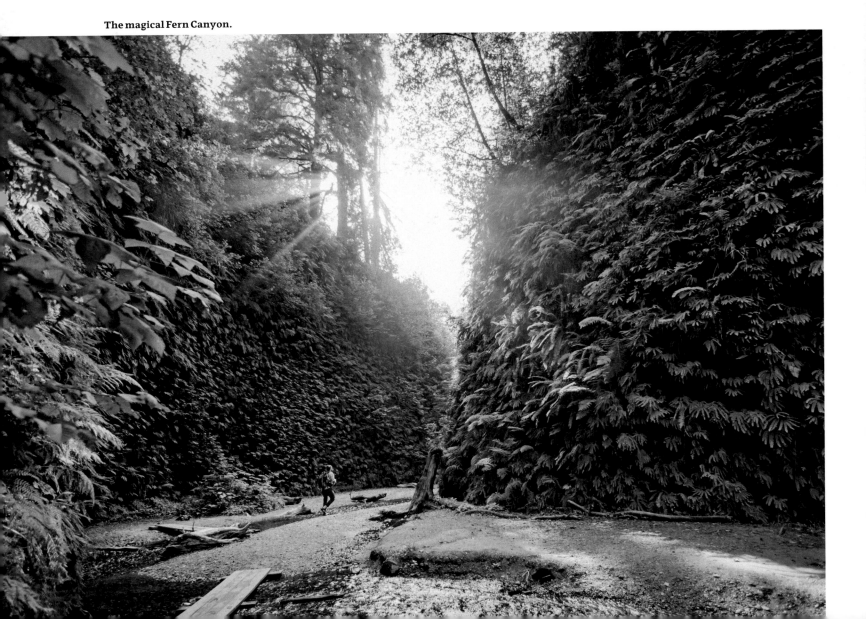

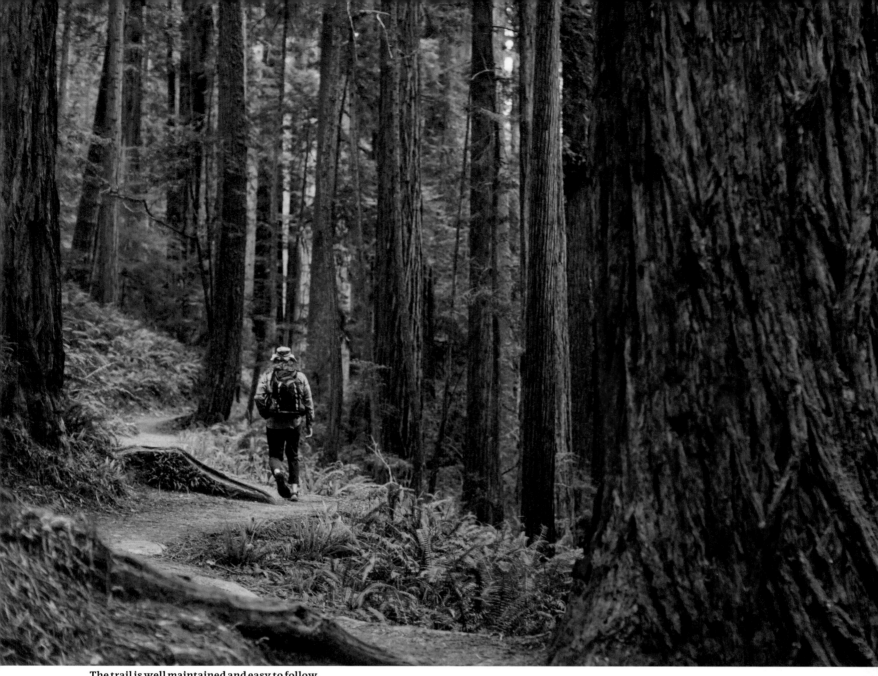

The trail is well maintained and easy to follow.

The cool and soft feeling of putting your hand in moss.

The trail begins and ends at the Prairie Creek Visitor Center. Heading in a clockwise direction, it takes about a kilometer to reach the giant redwoods for which the region is best known. At this point, you may feel as if you have entered an arboreal time warp; the sunlight has decreased, the foliage has grown denser, and the ancient sentinels of the forest are quietly standing guard all around, just as they have done for the past 20 million years.

Continuing westward on the Miners Ridge Loop section, the redwoods eventually give way to coastal pines and the sound of crashing waves. Before reaching the coast, hikers will have a choice: either stay inland and follow a lightly used dirt road for 1.5 km (0.9 mi), or head a little farther west and walk along the shore. Unless you are in a rush to finish, go with the latter option. Once you reach Gold Bluffs Beach, take your shoes off, feel the sand between your toes, and follow the Pacific coastline north. You have momentarily swapped hiking companions: the world's tallest trees for the world's biggest ocean. ▶

207

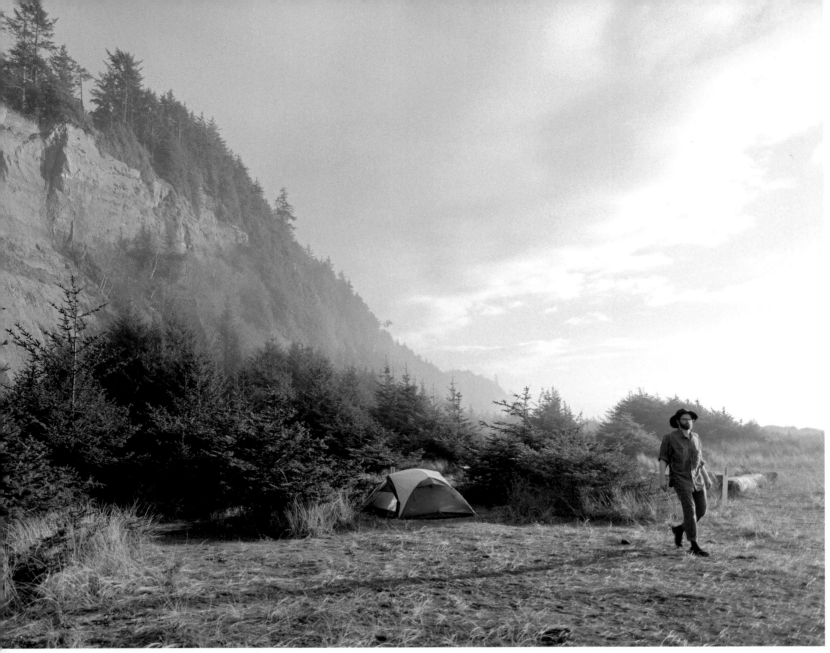

Gold Bluffs Beach Campground.

Right: Bridge over fern-laden waters.
Below: Planning the route ahead.

It is on this open stretch of shoreline that you have the opportunity to observe Roosevelt elk. Watching these massive quadrupeds graze among the dunes, wetlands, and bluffs makes for a memorable scene, one which seems eons removed from the Tolkien-esque forest of a couple hours prior.

Soon the coast is left behind, the trail once again heading inland to reach the famed Fern Canyon. This fern-lined gorge has a magical quality that has long made it a drawcard for not only tourists and hikers, but also filmmakers. It was here, among the narrow green walls and hanging gardens, that Steven Spielberg filmed a scene for *The Lost World: Jurassic Park* in the late 1990s.

Upon leaving Fern Canyon, take the James Irvine Trail all the way back to the visitor center. In the ▶

final stretch, you will be gifted one more opportunity to walk among the redwoods. Soak up every second of your time in the presence of these enchanting natural wonders because there is nothing quite like them anywhere else in the world. In the words of acclaimed author John Steinbeck, from his classic memoir *Travels with Charley: In Search of America:* "The redwoods, once seen, leave a mark or create a vision that stays with you always. No one has ever successfully painted or photographed a redwood tree. The feeling they produce is not transferable. From them comes silence and awe. It's not only their unbelievable stature, nor the color which seems to shift and vary under your eyes, no, they are not like any trees we know, they are ambassadors from another time." ◆

Mushrooms can be found in abundance throughout the lush redwood forests.

Preparing breakfast on a chilly morning.

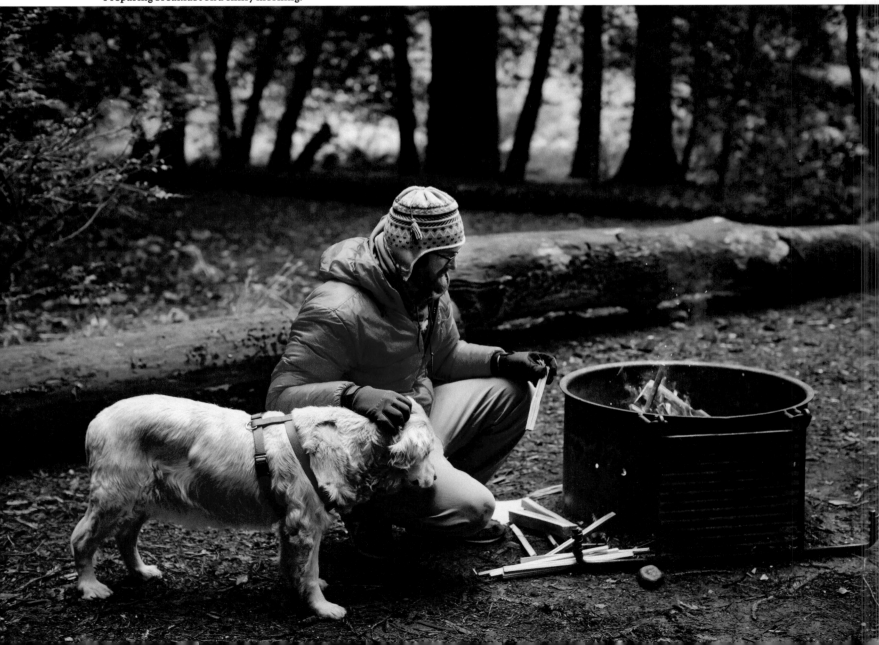

GOOD TO KNOW

About the Trail
/ DISTANCE 18.7 km (11.6 mi)
/ ELEVATION GAIN 410 m (1,345 ft)
/ DURATION 4 to 7 hours
/ LEVEL Easy to moderate

Start / Finish
⚲ Loop hike from the
Prairie Creek Visitor Center

Season
Year round

FLORA & FAUNA

Roosevelt Elk The largest of six sub-
species of elk in North America, they can
regularly be spotted on the James Irvine
and Miners Ridge Loop around the Gold Bluffs
Beach area. Roosevelt elk are wild animals,
so keep your distance at all times. This
especially holds true during calving season
(late spring) and the autumn rut, which takes
place between the end of August and October.

REDWOOD TRIVIA

Scientific Name
Sequoia sempervirens

Height
The California redwoods are the world's
tallest trees. They can grow to heights
of over 110 m (360 ft), with diameters of
up to 7 m (23 ft).

Age
Redwoods have been known to live for more
than 2,000 years, with an average age of 500
to 700 years old.

Old-growth Forest
Fossil records of species related to coast
redwoods date back 160 million years,
to the Jurassic period. In their current form,
they have existed for at least 20 million years.
As of today, only 4 percent of the original
redwood old-growth forest remains.

Protection
The Redwood National and State Parks were
recognized by UNESCO as a World Heritage
Site in 1980.

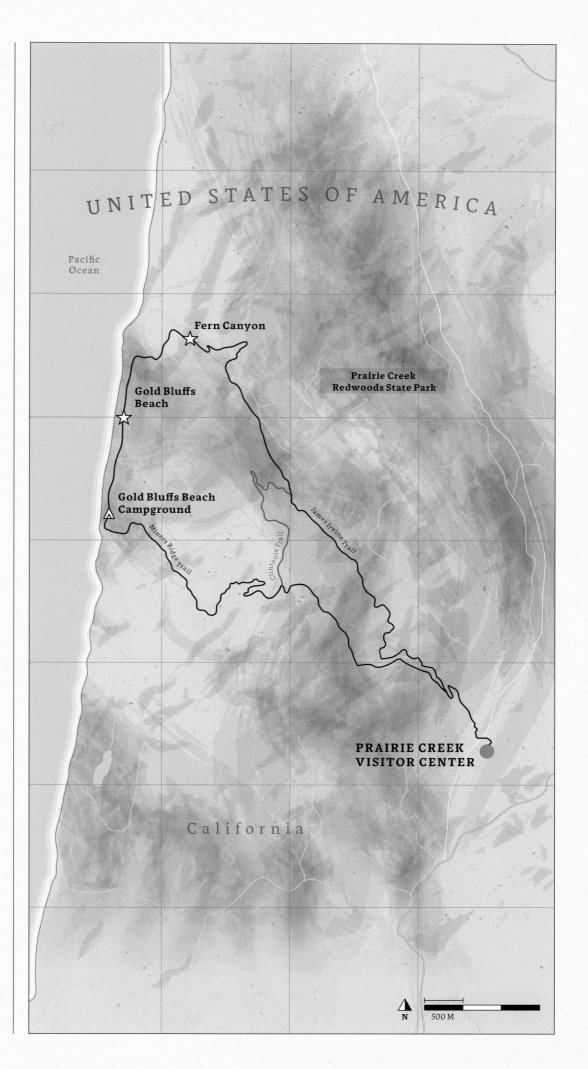

UNITED STATES OF AMERICA

Pacific
Ocean

Fern Canyon

Gold Bluffs
Beach

Prairie Creek
Redwoods State Park

Gold Bluffs Beach
Campground

Miners Ridge Trail

Clintonia Trail

James Irvine Trail

PRAIRIE CREEK
VISITOR CENTER

California

N 500 M

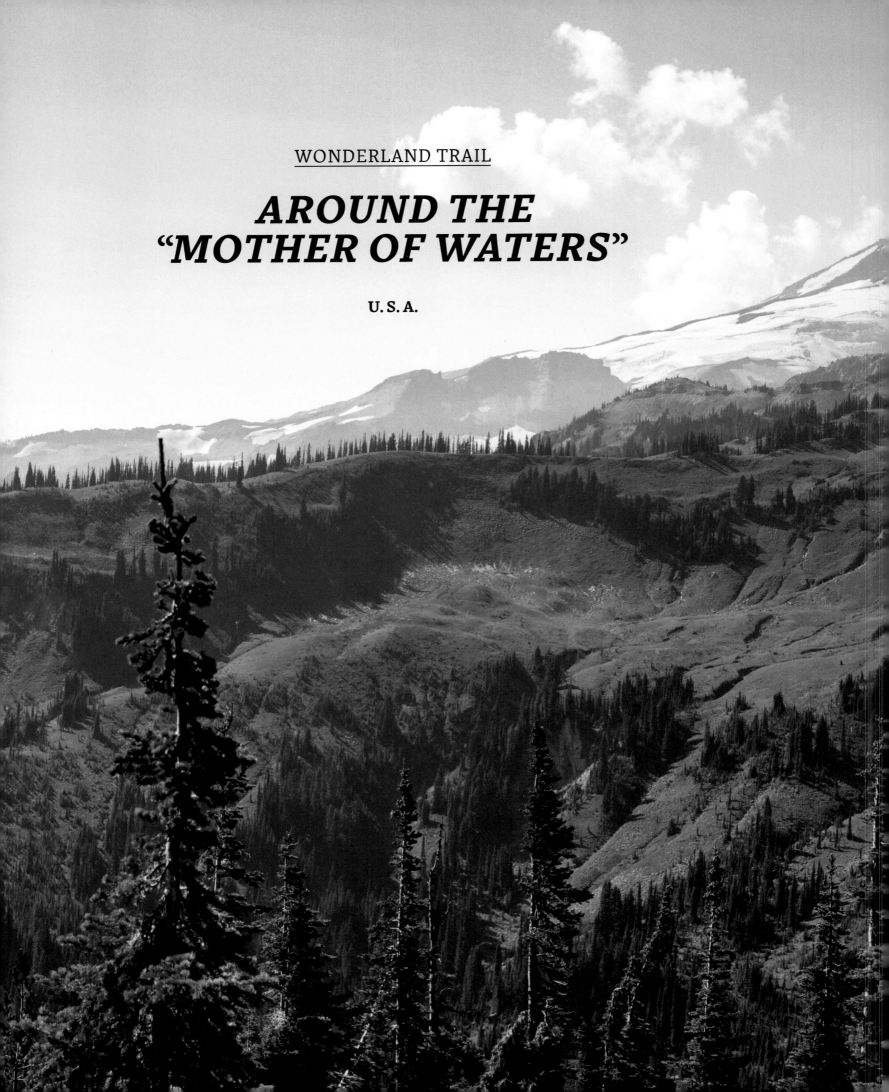

AROUND THE "MOTHER OF WATERS"

U.S.A.

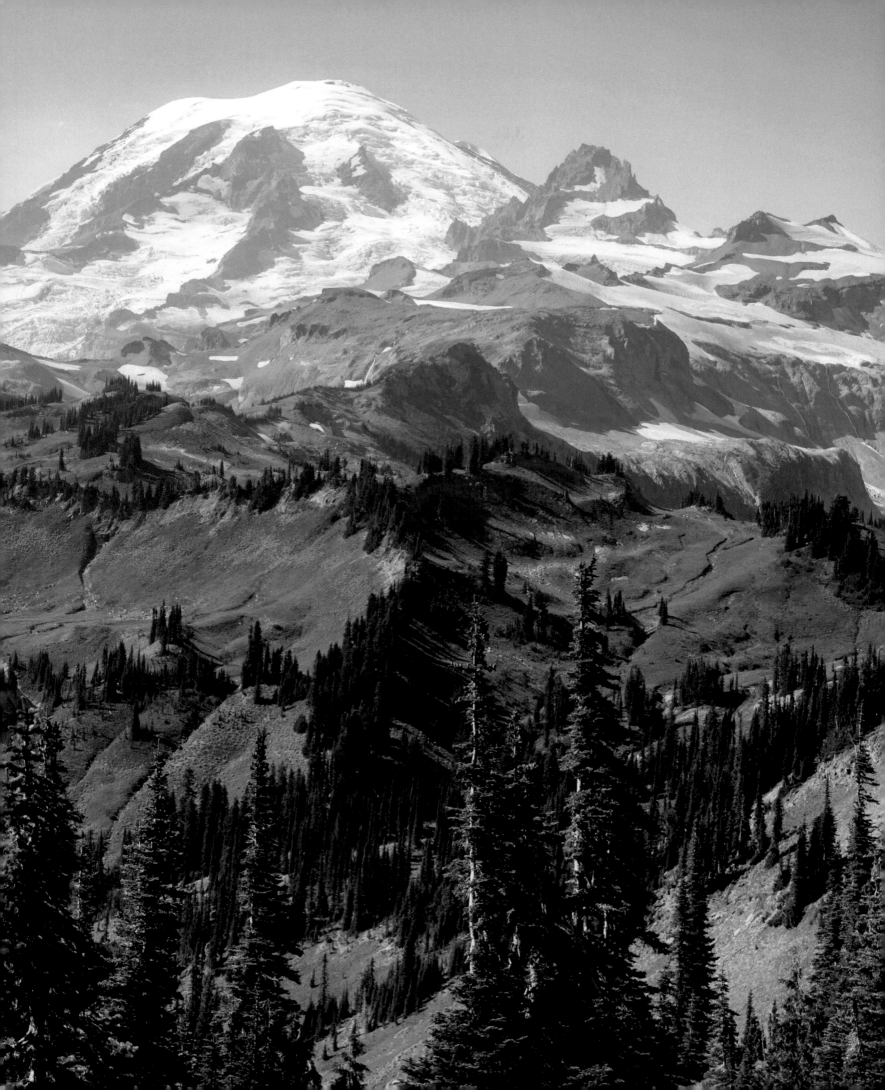

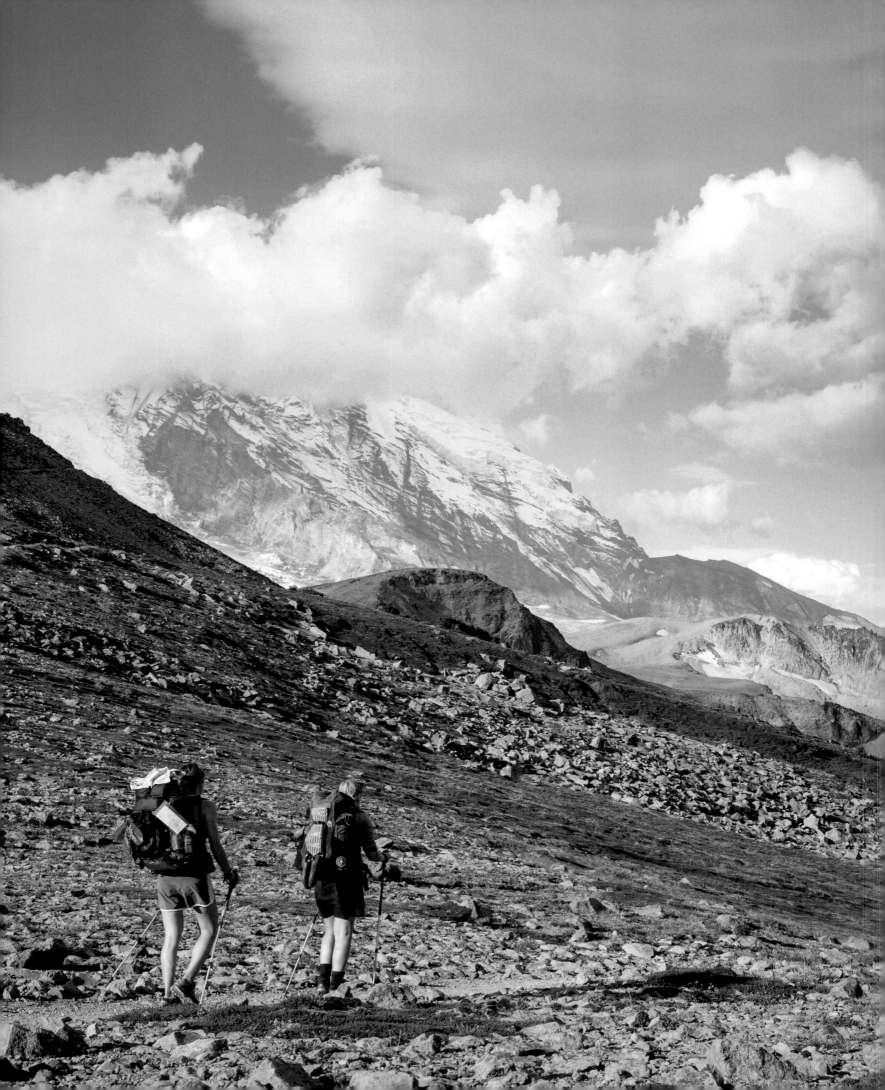

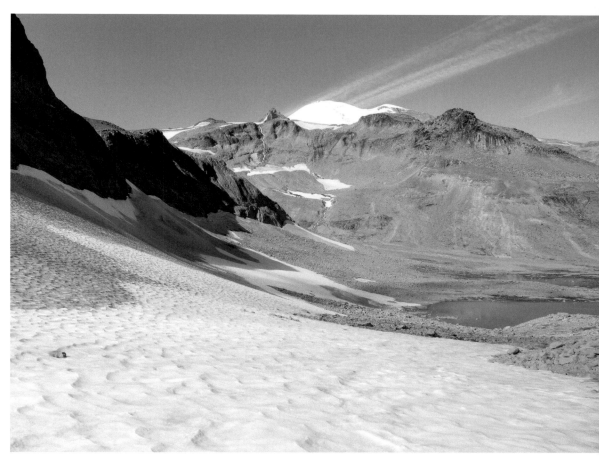

Above: The view from Panhandle Gap (2,060 m [6,760 ft]), the highest point on the Wonderland Trail.
Left: The Wonderland Trail is well marked and maintained throughout its undulating course.

"There is a trail that encircles the mountain.
It is a trail that leads through primeval forests,
close to the mighty glaciers, past waterfalls
and dashing torrents, up over ridges, and down
into canyons; it leads through a veritable
wonderland of beauty and grandeur."

—ROGER TOLL, MOUNT RAINIER NATIONAL PARK SUPERINTENDENT, 1920

Despite the fact that it is shrouded in cloud for much of the year, Mount Rainier is nearly impossible to miss when visiting Washington state. The image of the iconic volcano appears on billboards, postcards, beer cans, and license plates. Its massif bulk dominates the state's western skyline, and its majestic profile has long evoked superlatives from all who are fortunate enough to behold it in fine weather. For those that are interested in experiencing the mountain's diverse range of marvels from a more intimate perspective, there is no better way to do so than by circumnavigate the peak by way of the aptly named Wonderland Trail.

Measuring 150 km (93 mi) and consisting of a knee-wobbling, breathtaking 7,010 m (23,000 ft) of total elevation gain and loss, the Wonderland Trail is a ▶

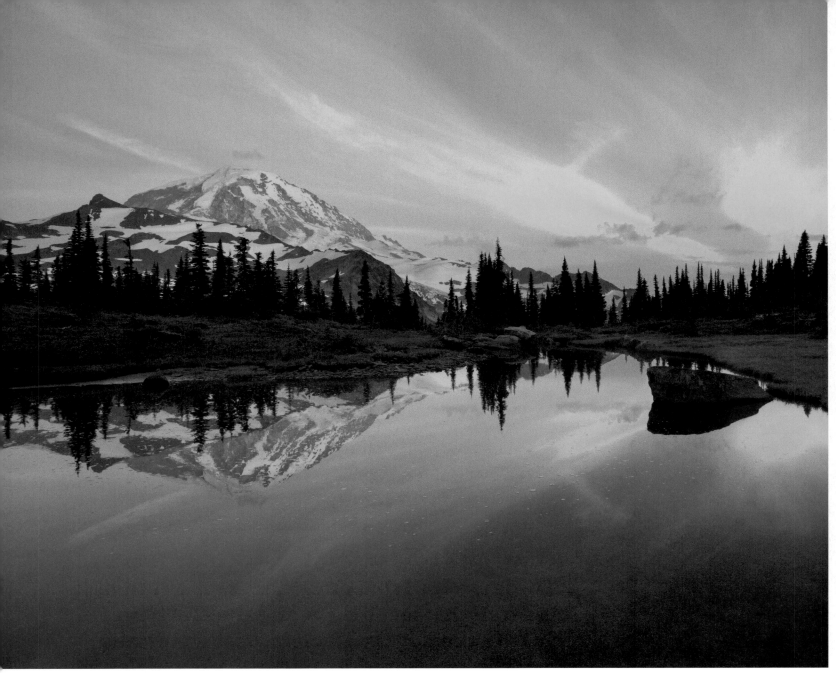

Alpenglow and a reflective Mount Rainier at Spray Park.

tour de force of nature from beginning to end. It passes through a diverse collection of ecosystems, ranging from temperate rainforest to subalpine meadow to alpine tundra. Among its many striking features are its glaciers. With 25 of them, Mount Rainier has more than any other peak in the contiguous United States. These incredible icy masses gave birth to nine major rivers and their tributaries. It is therefore no surprise that many native Americans refer to the mountain as Talol, or Tahoma, which translates to "mother of waters."

The trail itself is a challenging undertaking that includes numerous long climbs and descents. As with any multiday wilderness excursion, preparedness is key to a successful and enjoyable journey. Before beginning the trek, it is important to make a realistic assessment

There are 18 designated campsites along the 150 km (93.2 mi) trail.

of skill, strength, and fitness level. Due to the tempestuous conditions experienced at Rainier (it's so large it creates its own weather), it is also of paramount importance to pack environment-appropriate clothing and equipment. The Wonderland Trail is not a hike to be underestimated, a fact that many underprepared backpackers have discovered, much to their chagrin.

In addition to fellow ambulators, hikers will share the Wonderland experience with the national park's abundant array of wildlife. There are 126 species of birds and 54 species of mammals within Mount Rainier's boundaries. It is possible to spot elk, mountain goats, deer, mountain lions, and black bears. Due to the constant variations in altitude, the trail continuously passes between ecosystems. With each ascent and descent, expect new wonders to reveal themselves,

not least of which is the mountain itself, whose profile constantly changes when negotiating the high ridges and glacier-carved valleys around its circumference. For almost all of its course, the Wonderland Trail is the hiking equivalent of a masterpiece painting; it's hard to imagine it being much better than it already is.

There is one notable route variation that is widely recognized as being superior to the standard trail: the Spray Park alternate between Carbon River and Mowich Lake. It is longer, higher, and tougher than the official trail, but also unforgettable. In midsummer, Spray Park comes alive with an explosion of wildflowers, and the close-up, expansive views of Rainier are arguably the best of the entire trek. Additionally, it affords the opportunity to visit the spectacular 107 m (350 ft) high Spray Falls, accessed via a short, signposted side trail. ▶

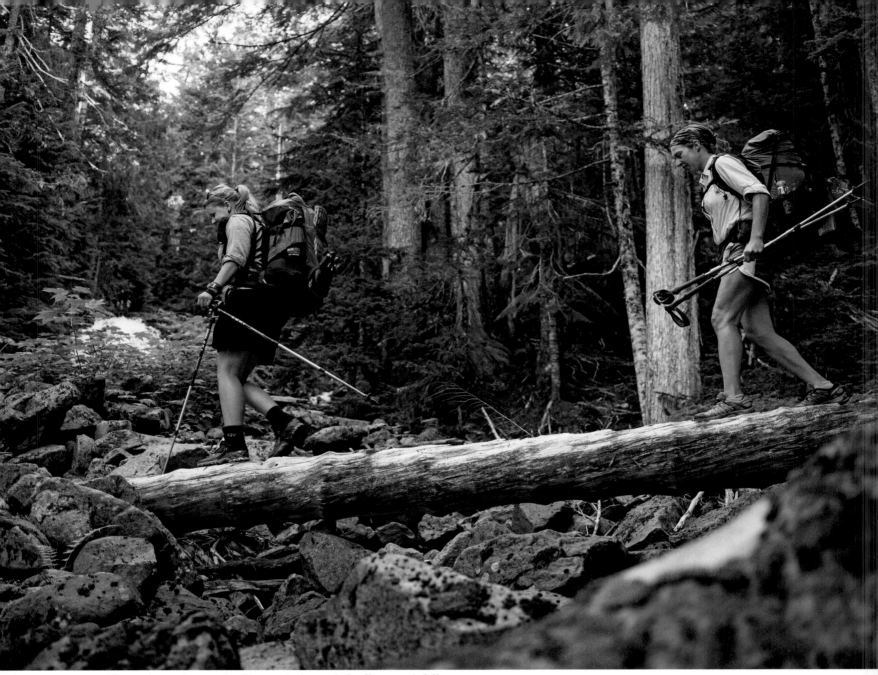

The creek crossings can be slippery during periods of heavy rainfall.

Tip: Once you reach Spray Creek, you will see the falls up to your left. Although the view at the end of the pathway is good, it is highly recommended to scramble up the true right side of the watercourse to the base of the falls themselves.

The Wonderland Trail has been challenging and inspiring wayfarers since it was founded in 1915. Traversing its high passes and rugged volcanic ridges, gazing in awe at its mirror-like lakes and tumbling cascades, hikers often find themselves both wearied and energized at the same time. No matter how many treks you have done or places you have been, the Wonderland Trail and Mount Rainier combine to make an indelible impression that few hiking experiences can equal. ◆

After the rain, mushrooms sprout along shadowy stretches of the trail.

GOOD TO KNOW

About the Trail
/ <u>DISTANCE</u> 150 km (93 mi)
/ <u>DURATION</u> 9 to 11 days
/ <u>LEVEL</u> Moderate to challenging

Start / Finish
📍 Longmire Wilderness Information Center or Sunrise Visitor Center (loop hike)

Highest Point
Panhandle Gap (2,060 m [6,760 ft])

Lowest Point
Ipsut Creek Campground (720 m [2,320 ft])

Season
July to early October. Mid to late September is ideal if you want to avoid both crowds and bugs.

Conditions
Rain, snow, and heavy storms can occur at any time of year. Regardless of when you hit the trail, come prepared for changeable conditions. Be sure to check the short- and long-range weather forecast before departure.

Permits
A wilderness permit is required for all overnight camping on the Wonderland Trail. There are 18 designated campsites along the trail. As of 2018, 70 percent of these permits can be booked in advance, with the remainder distributed on a first come, first served basis at the National Park Service's various ranger stations.

FLORA & FAUNA

Black Bears Despite the fact that there have been no recorded attacks in Mount Rainier National Park's history, one of the biggest concerns for many Wonderland Trail hikers are black bears. To help keep this statistic at zero, hikers should note the following points: First, never approach or feed a bear (no matter how cute or cuddly a cub may appear). Second, each campsite is equipped with "bear poles," from which hikers can hang their food in stuff sacks at night (along with any other items that have a scent). Third, if you encounter a bear on the trail, do not run. Instead, back away slowly and speak in a loud, forceful voice. Keep the bear in view at all times.

HELPFUL HINTS

Resupply Most people that hike the Wonderland Trail take eight days or more to complete it. That's a lot of food to carry, especially considering that for most of the hike, you will either be ascending or descending. For those interested in lightening their pack loads, it is possible to cache food along the way at various points, including the White River Campground, Sunrise Visitor Center, and Mowich Lake Patrol Cabin.

BACKGROUND

Four Facts about Mount Rainier:

1. Measuring 4,392 m (14,410 ft), Mount Rainier is the highest mountain in both the Cascade Range as well as the state of Washington.

2. Rainier is located 95 km (59 mi) southeast of Seattle, and on a clear day can be seen from most of the city.

3. The mountain was named in 1792 by explorer George Vancouver, in honor of Rear Admiral Peter Rainier.

4. More than 10,000 people attempt to climb Mount Rainier every year, with approximately half making it to the summit.

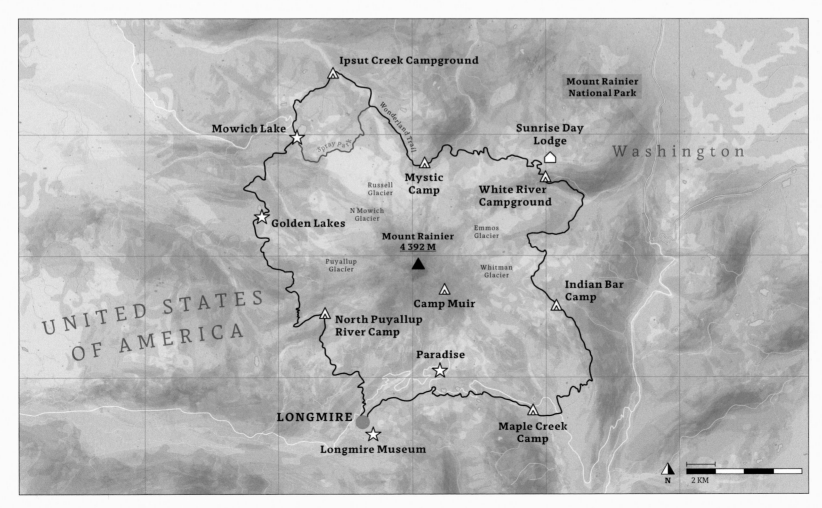

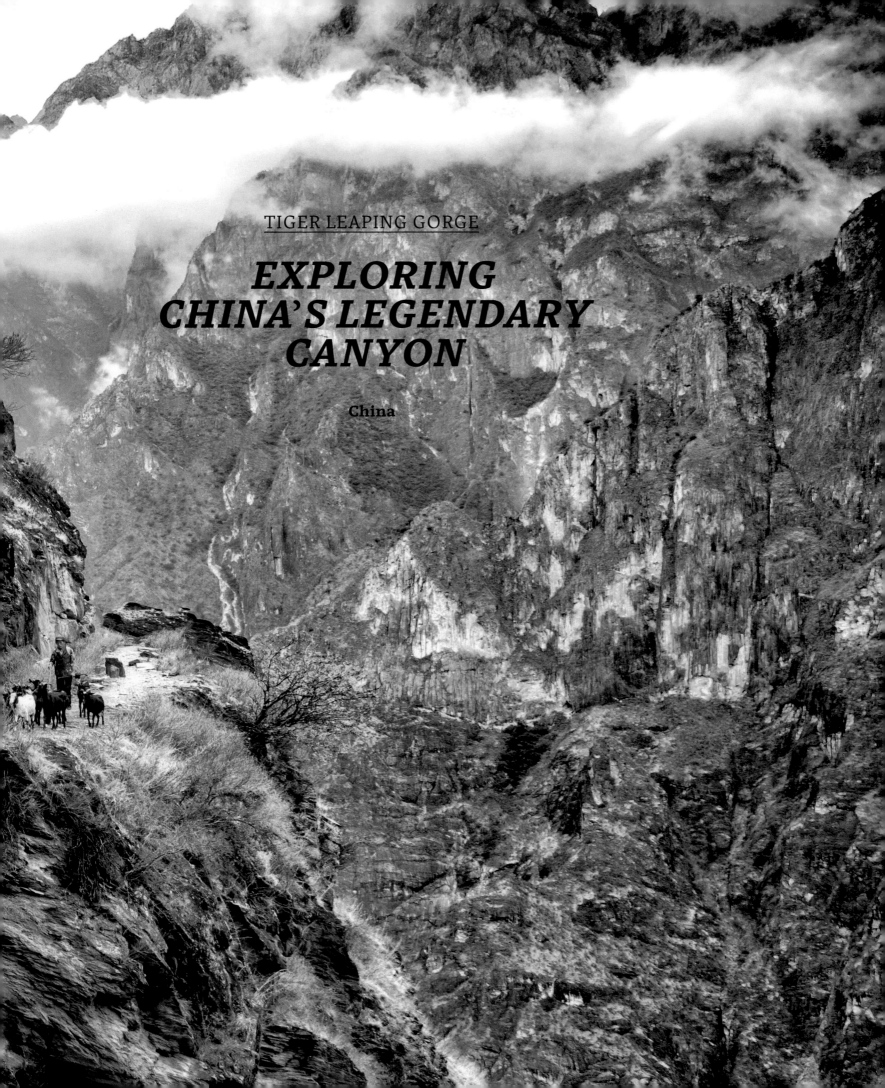

TIGER LEAPING GORGE

EXPLORING CHINA'S LEGENDARY CANYON

China

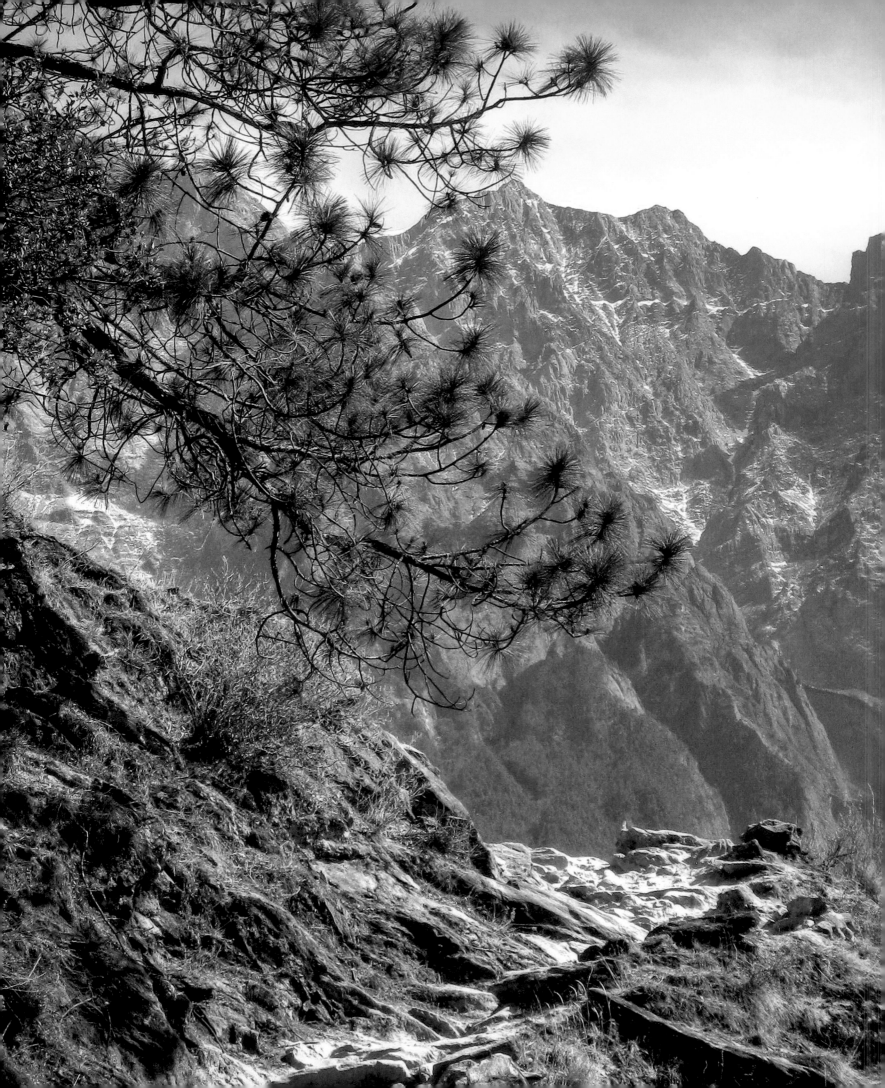

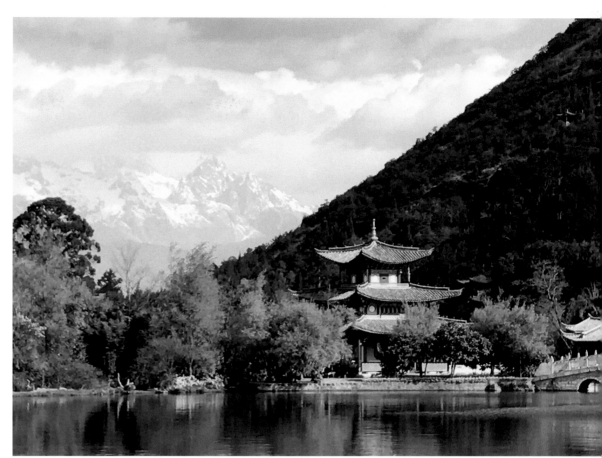

Above: Black Dragon Pool in scenic Jade Spring Park, a short walk north of the Old Town of Lijiang; Jade Dragon Snow Mountain in the background.
Left: Mountain vistas along the trail.

The name Tiger Leaping Gorge sounds like it was lifted straight out of a Chinese fantasy film. Upon viewing this UNESCO World Heritage site for the first time, many visitors indeed find this extraordinary place a fairytale come true. But this dramatic gorge, with its sheer cliffs, raging rapids, and mighty snow-capped peaks on either side, is very much of this world. And hiking through it on the Tiger Leaping Gorge high trail is the most authentic way to experience this fantastical place.

Located in the Yunnan Province of southwestern China, Tiger Leaping Gorge is one of the deepest canyons in the world. Spanning 15 km (9.3 mi) from one end to the other, it has a maximum depth of 3,790 m (12,434 ft), from the waters of the Jinsha River (a tributary of the Yangtze) to the peak of Jade Dragon Snow Mountain (5,596 m [18,360 ft]). The trail that traverses its steep slopes was officially opened to foreigners in 1993 and, with its jaw-dropping vistas and welcoming Himalayan-style guesthouses, quickly established itself as one of China's premier trekking adventures.

The hike is generally done in a easterly direction, beginning in the town of Qiaotou and finishing approximately 30 km (18.6 mi) later in the town of Daju. In days past, there used to be two options for hiking the gorge: the high trail and the low trail. The latter now exists in name only, having been converted into a road that runs close to the floor of the gorge. Unless you feel like sharing your walking space with scores of tourist buses and other vehicles, the high trail is the way to go. ▶

The trail that traverses steepling slopes was officially opened to foreigners in 1993 and, with its jaw-dropping vistas and welcoming Himalayan-style guesthouses, quickly established itself as one of China's premier trekking adventures.

A mule on the trek.

The Walnut Garden.

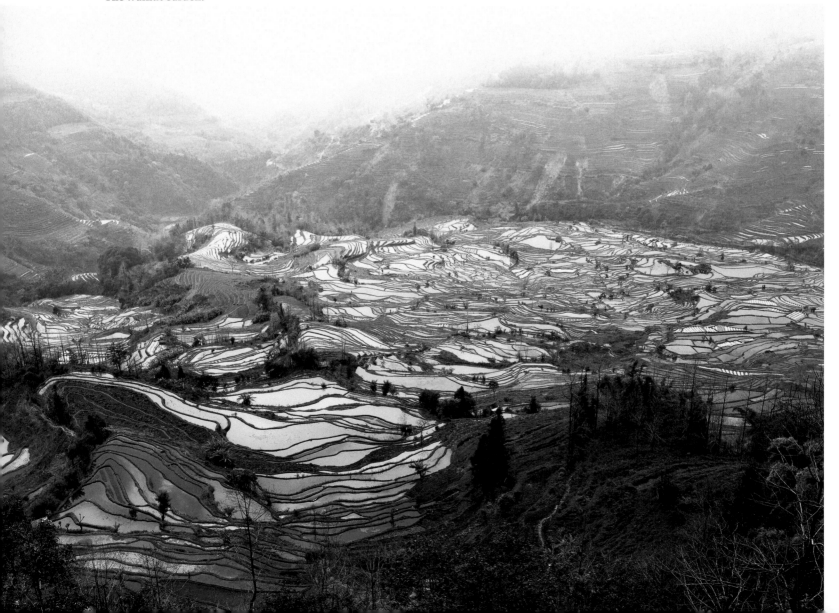

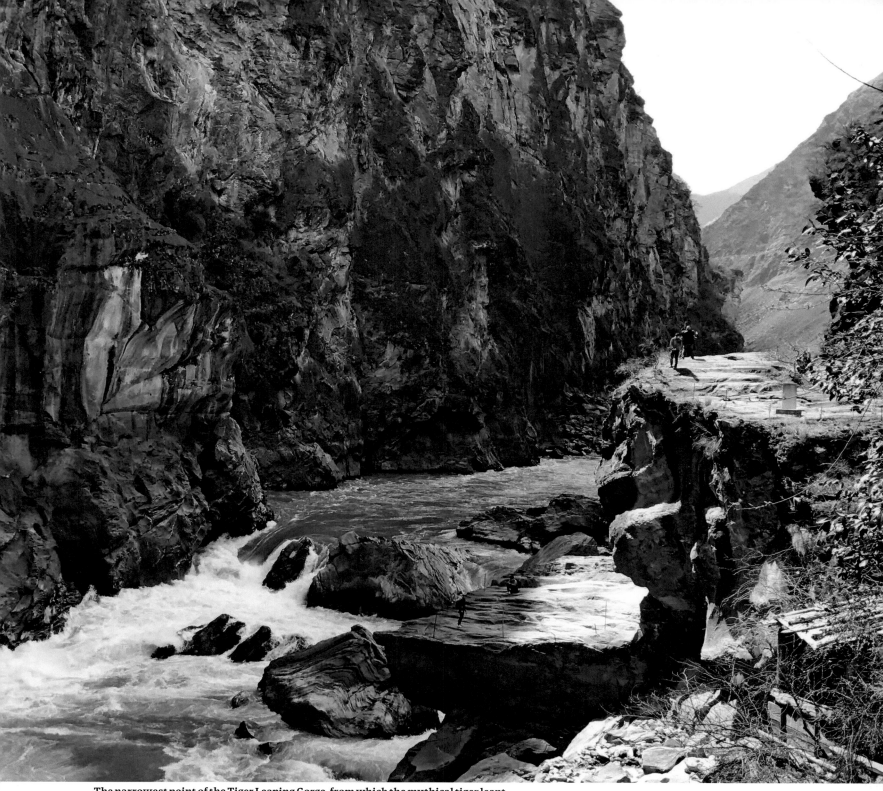

The narrowest point of the Tiger Leaping Gorge, from which the mythical tiger leapt.

Upon setting out from Qiaotou, the initial two hours of the hike are relatively easy, as the path winds its way through the terraced farmlands of the indigenous Naxi people, who are said to have migrated south from the Tibetan Plateau many centuries ago. After passing through the small village of Nuoyo, hikers begin the toughest part of the trek—the 28 bends. Most people take about an hour to negotiate this 2.5 km (1.5 mi) series of switchbacks. Upon completing the final turn and reaching the highest

point of the trail at 2,650 m (8,694 ft), you are rewarded with a stunning view of Jade Dragon Snow Mountain on the eastern side of the river valley.

After a short descent, the trail continues to contour along the western flanks of Habu mountain, eventually arriving at the accurately named Halfway House in the village of Bendiwan. This small hamlet makes for an ideal place to overnight. The views from the guesthouse deck are arguably the best of the entire trek. Be sure to wake ▶

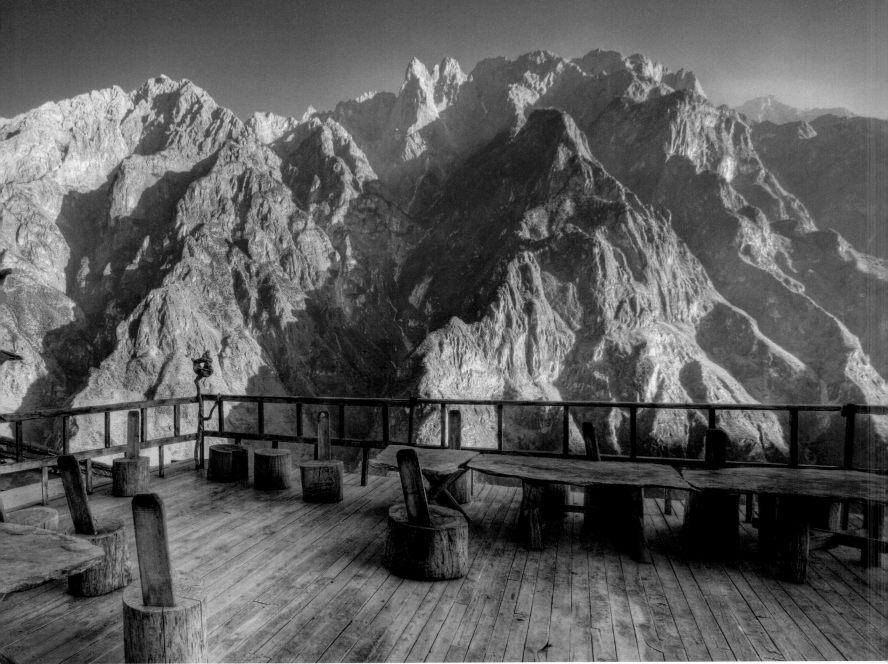

Scenic views from Halfway House.

up early the following morning, as watching the sunrise through the serrated 5,000 m (16,404 ft) peaks on the opposite side of the valley is a sublime experience.

During the second half of the trek, hikers will pass by the impressive Guanyin Waterfall and tip-toe across a spectacular cliff-hugging section of trail, before descending to Tina's Guesthouse. From here, it is a short return hike down to the middle rapids of the Jinsha River and the famous Tiger Leaping Stone (for which the gorge was named). According to legend, a tiger that was being pursued by hunters jumped across the river at the narrowest point, hopped on the huge boulder in the middle, and made his escape to the other side.

At this point, many hikers decide to finish their journey and head back along the gorge road to Qiaotou. For those who wish to continue, there is a picturesque stretch of trail through Walnut Garden before a final descent to the river in order to catch the ferry to the eastern side. From here, it is possible to either walk or arrange for transport to the finishing point at Daju.

Like other famous holes in the ground, such as America's Grand Canyon and Mexico's Copper Canyon, the majority of tourists visiting Tiger Leaping Gorge arrive by motorized transport, take some photos, buy a souvenir or two, and then head on their way. But to really experience the immensity of this place from the inside out rather than the outside in, you should strap on a pack and go hiking on the high trail. The views are amazing, the locals hospitable, and, as with any walk in nature, the physical, mental, and spiritual health benefits are immeasurable. ◆

GOOD TO KNOW

About the Trail
/ <u>DISTANCE</u> 30 km (18.6 mi)
/ <u>DURATION</u> 2 days
/ <u>LEVEL</u> Easy

Start / Finish
⚲ Qiaotou
⚲ Daju (or Tina's Guesthouse, a shorter alternative that comes in at 22 km [13.7 mi] total)

Highest Point
The lookout at the top of the 28 bends (2,650 m [8,694 ft])

Lowest Point
Qiaotou (1,900 m [6,234 ft])

Season
October to May. Avoid the June to September rainy season when landslides are not uncommon.

Permits
You pay an entrance fee to the gorge upon arrival at Qiaotou village.

FLORA & FAUNA

Saving the Tiger Leaping Gorge
In 2003, the Chinese government proposed building a hydroelectric dam across the Jinsha River, which would have resulted in the forced relocation of more than 100,000 Naxi residents, along with irreparable changes to the landscape of the Tiger Leaping Gorge. The plan evoked fierce public opposition, and thanks to the combined efforts of environmental activists, journalists, and local farmers, the project was eventually scrapped in 2007.

HELPFUL HINTS

The Old Town of Lijiang Situated approximately 100 km (62 mi) southeast of Tiger Leaping Gorge is Dayan, commonly known as the Old Town of Lijiang. A UNESCO World Heritage site, it represents the historic center of Lijiang city and dates back more than 800 years. Notable for its traditional architecture, cobblestone streets, waterways, and countless footbridges, it makes for a great place to base yourself while exploring the wonders of Yunnan Province.

BACKGROUND

Naxi People Tiger Leaping Gorge is primarily inhabited by the indigenous Naxi people, who live in small villages throughout the area. The Naxi are the descendants of Tibetan nomads who migrated south many centuries ago. A strong, independent people, they have traditionally made their living from agriculture, though in recent decades, tourism has become an increasingly important source of income. Most of them belong to the Dongba Jiao faith, which, according to social anthropologist Åshild Kolås, "is a primordial religion in which every rock, tree, spring, and every living being has a spirit."

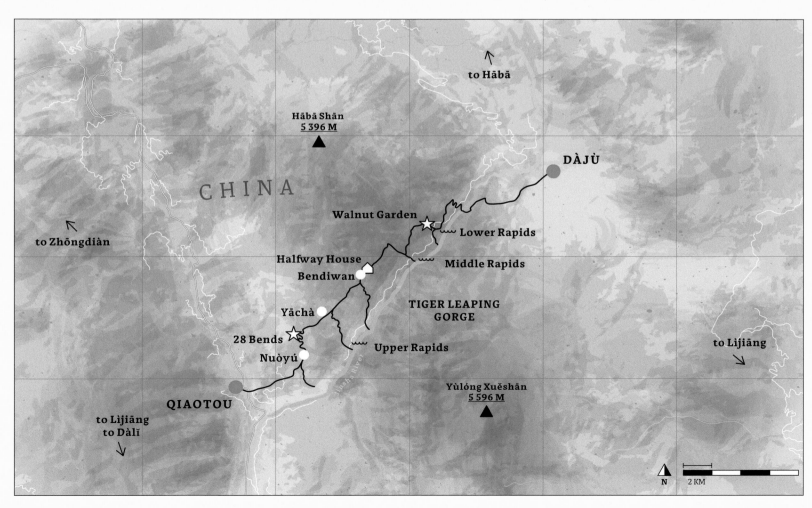

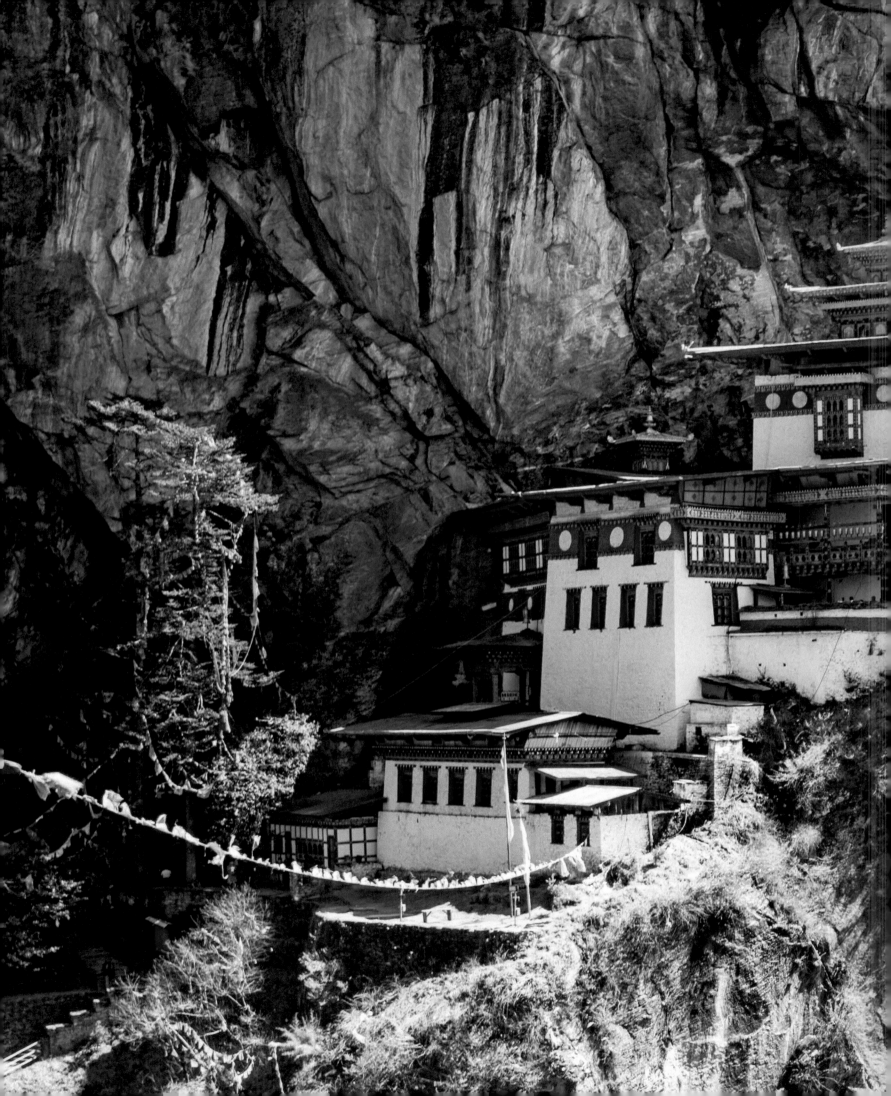

THROUGH THE LAND OF THE THUNDER DRAGON

Bhutan

Bhutan. The name conjures up images of towering snow-capped peaks, cliff-hanging monasteries, and a government policy of Gross National Happiness (GNH). The country is shrouded in an aura of mystery, in no small part due to the fact that it was largely closed off from the rest of the world until the 1970s—by choice. In more recent times, the "Land of the Thunder Dragon" has permitted a limited amount of tourists to enter. Many travel here for the hiking, with the legendary Snowman Trek representing the longest, highest, and most challenging trekking route in the country.

Taking around 25 days to complete and measuring approximately 322 km (200 mi) in length, the Snowman Trek is regularly described as "the world's toughest trek." Such descriptions should always be taken with a grain of salt, but there is no denying that this crescent-shaped trail in northern Bhutan is one of the most exacting ▶

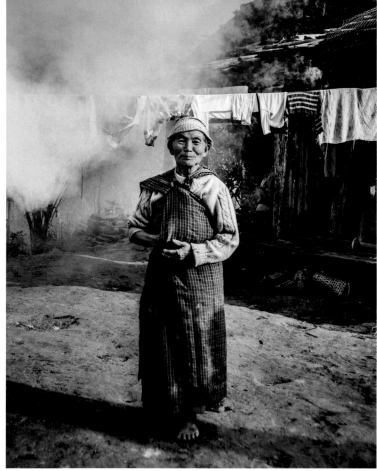

The Bhutanese value happiness over GNP.

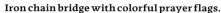

Iron chain bridge with colorful prayer flags.

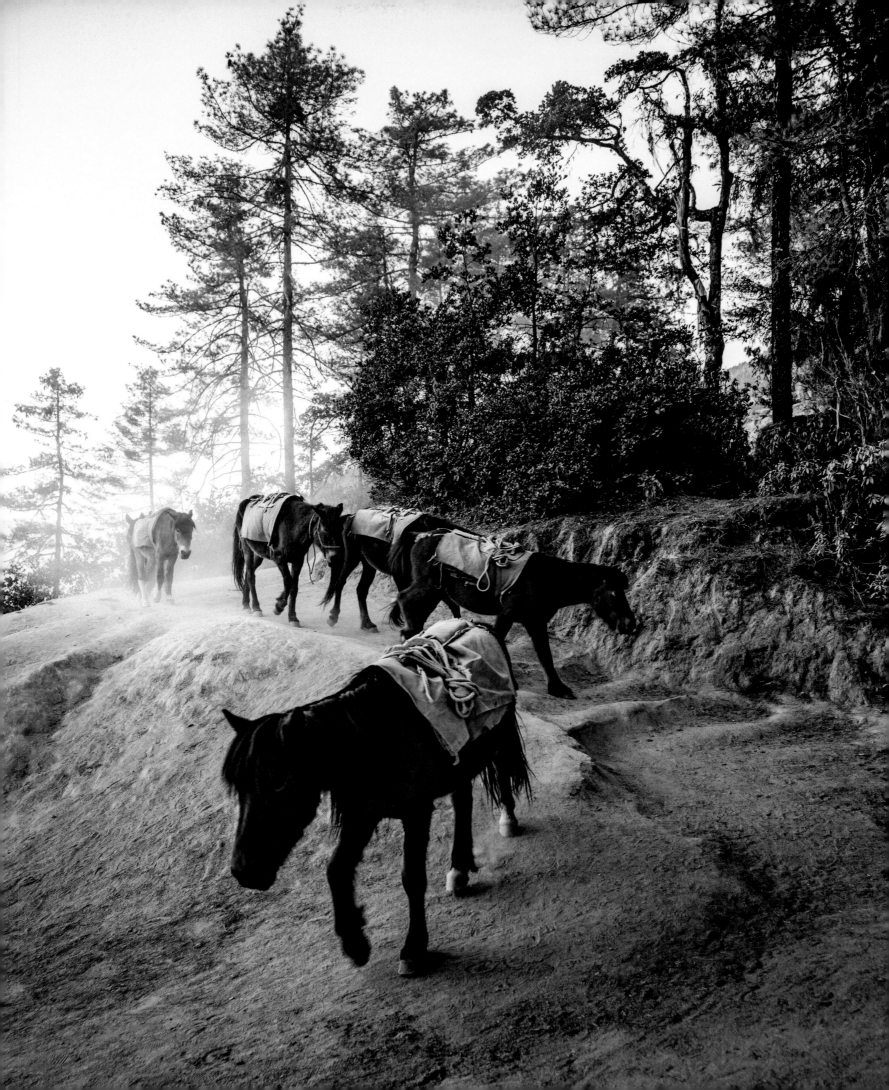

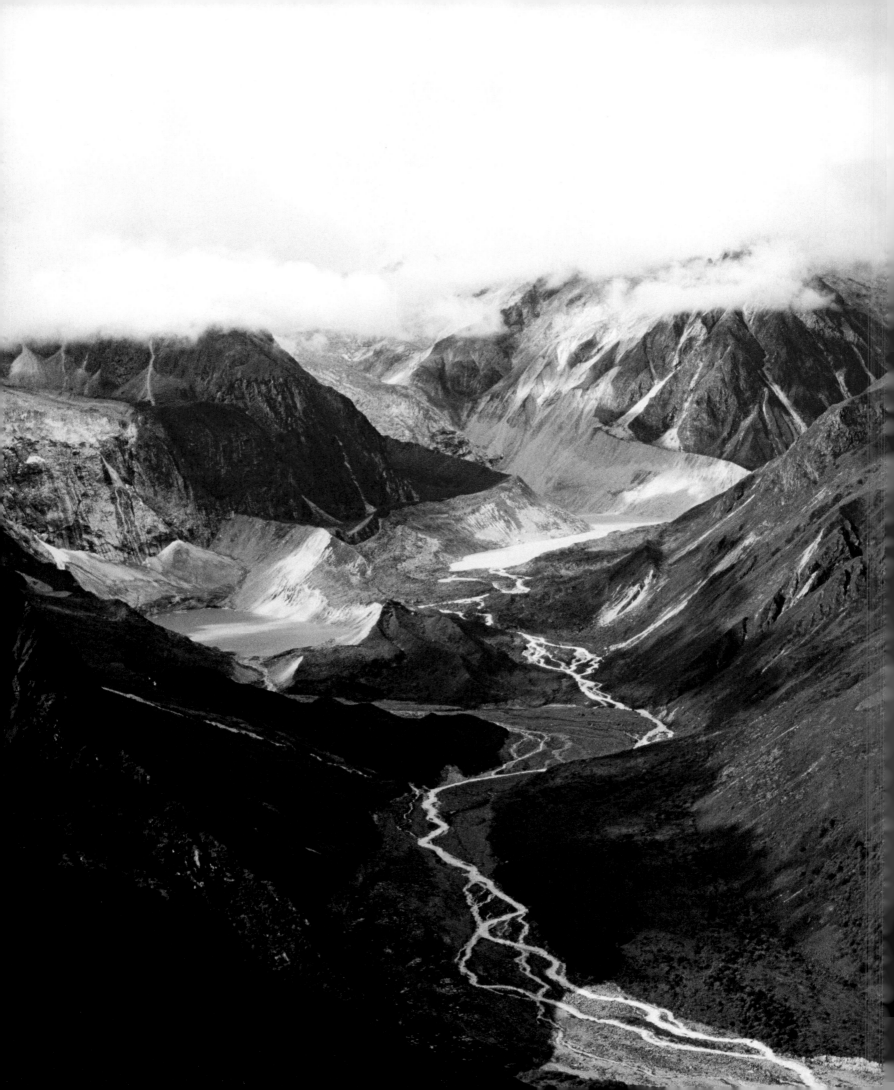

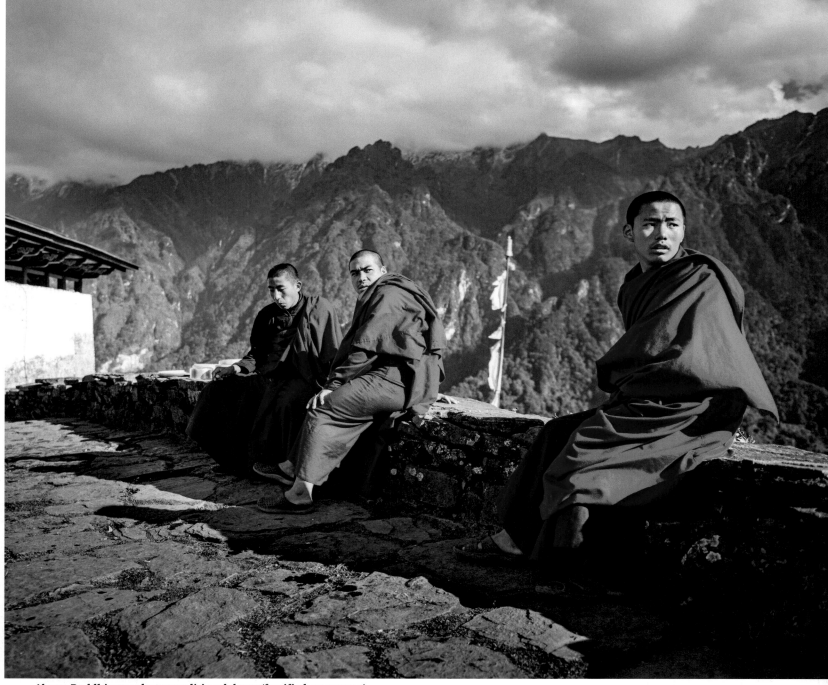

**Above: Buddhist monks at a traditional *dzong* (fortified monastery).
Left: Riverbed and moraine lakes in Lunana.**

hikes in the Himalayas due to a combination of altitude, length, and heavy snowfall. During its undulating course, it traverses 11 passes, most of which are over 4,877 m (16,000 ft), and has a lungbusting total elevation gain of 14,630 m (48,000 ft). Anyone setting out on the Snowman Trek should begin in very good physical shape, both to improve the chances of finishing and to ensure an experience that is as enjoyable as possible—less than half of those who embark on this trail end up making it to the end.

Due to the restricted level of tourism, short seasonal windows, and the generally high cost of travel, the amount of people trekking in Bhutan is but a fraction of that which is seen in Nepal, the long-time mecca of mountain-related activity in the Himalayas. Although both landlocked

nations boast spectacular alpine scenery and friendly hosts, the trekking experiences in Bhutan and Nepal are quite distinct. In Bhutan, you will not see the teahouses for which Nepal is famous, the daily altitude gain and loss is generally greater, horses rather than porters carry your gear, and there are far fewer villages and people along the routes.

There is much more of a "wilderness" feel to trekking in Bhutan. Approximately 72 percent of the entire country, which is roughly the size of Switzerland, is still forested; once you set out on a multi-week trek, the roads, towns, and other trekkers are often few and far between. This especially holds true for the Snowman Trek, which largely takes place in the Lunana district, the most remote and pristine region in the country. Situated in the far north ▶

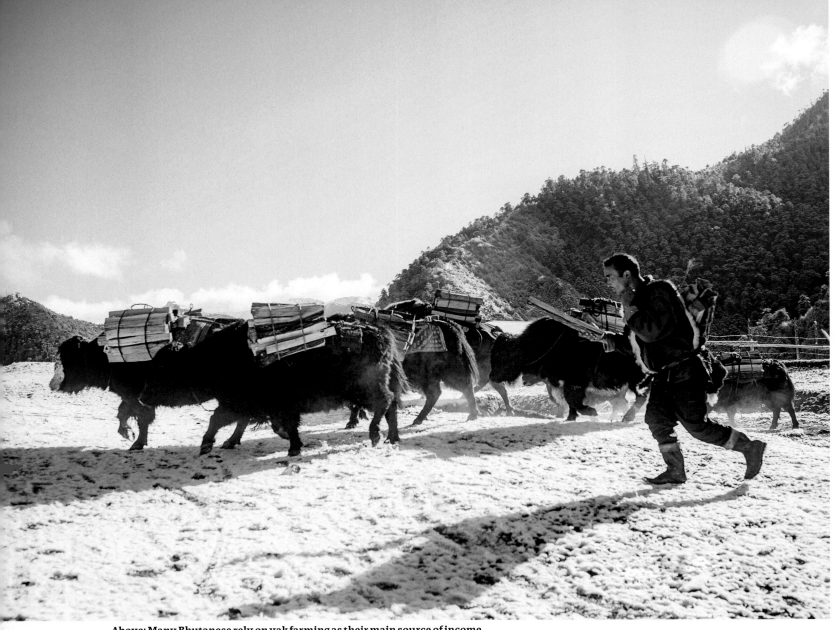

Above: Many Bhutanese rely on yak farming as their main source of income.
Right: Paro Valley.

of Bhutan, on the border with Tibet, Lunana is a magical area of high mountain passes, snow leopards, blue sheep, lonely monasteries, and secluded villages, many of which remain cut off from the rest of the country for much of the year. Hiking through these areas feels like being transported back to a simpler place and time, where the principal modes of transport are on two or four legs, and where strangers welcome you with a smile or an invitation to join them for tea or a meal.

On the Snowman Trek, as in all of Bhutan, the forces of culture, nature, and faith are constantly intertwined. There are more than 2,000 monasteries and temples across the country, and for the Bhutanese—approximately 75 percent Buddhist and 25 percent Hindu—deities and spirits exist not only in these sacred man-made places, but also in the rivers, lakes, caves, forests, rocks, and mountain peaks that dominate the landscape. A 1994 decree in ▶

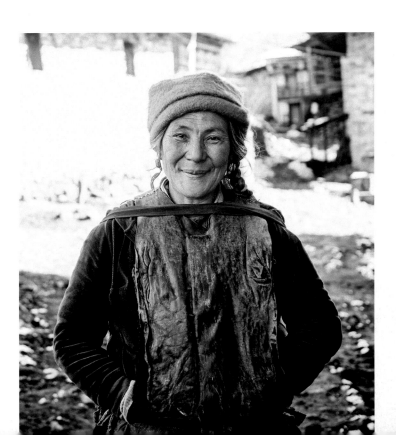

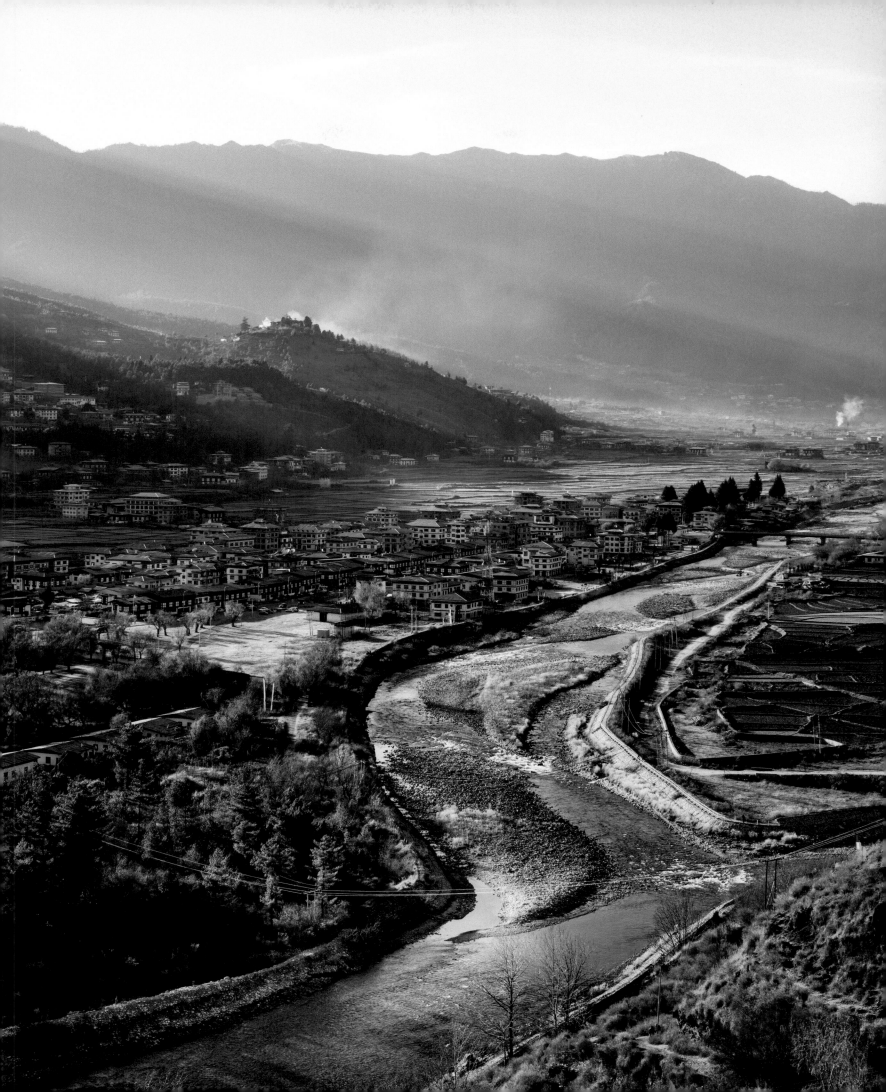

Bhutan banned climbing any mountain higher than 6,000 m (19,685 ft), and since 2003, a blanket ban on mountaineering has been enforced out of respect for local spiritual beliefs. To this day, the world's highest unclimbed mountain, Gangkar Puensum (7,570 m [24,836 ft]), lies within the borders of Bhutan. The Snowman Trek affords hikers a close-up view of not only this beautiful peak, but of countless other icy summits, including Jomolhari, Jichu Drake, and Gangchenta.

The Snowman Trek is a journey into the cultural heart of Bhutan as much as it is a testing high-altitude adventure across lofty mountain passes and vast glacier-carved valleys. The seamless quality of passing between natural wonders and the occasional pocket of human settlement is an enriching experience. In the words of Jamie Zeppa, author of *Beyond the Sky and the Earth: A Journey into Bhutan:* "You walk through a forest and come out in a village; and there's no difference, no division. You aren't in nature one minute and in civilization the next. The houses are made out of mud and stone and wood, drawn from the land around. Nothing stands out, nothing jars."

Each and every year, the Snowman Trek is undertaken by only a handful of hikers from around the world. A journey through the world's highest country—Bhutan has an average elevation of 3,280 m (10,760 ft)—provides a mountain-framed window into one of the world's most unique and welcoming cultures. A place that emphasizes happiness and conservation allows for a breath of fresh air away from the more materialistic, Western-centric experience. In Bhutan, the essence of Gross National Happiness is not found in any government policy, but in the simple way in which its people conduct their everyday lives. ◆

Gangla Karchung pass (5,100 m [16,732 ft]).

GOOD TO KNOW

About the Trail
/ <u>DISTANCE</u> 322 km (200 mi) approx.
/ <u>DURATION</u> 25 to 27 days
/ <u>LEVEL</u> Very challenging

Start / Finish
⚑ Drukgyel Dzong
⚑ Sephu

Season
Spring (March to April) and autumn (mid-September to end of October). During the winter, the passes are snowbound, and the summer months bring monsoonal rain.

Logistics
Independent trekking is not permitted in Bhutan. All trips are organized through trekking tour operators, who arrange visas, transport, food, and tent accommodation. Apart from shelters, it is recommended that hikers bring all of their own gear.

HELPFUL HINTS

The Tiger's Nest Taktsang Monastery, also known as the Tiger's Nest, is Bhutan's most iconic site and one of the world's most impressive buildings. Perched precariously on a cliff top overlooking the Paro Valley, this sacred Buddhist temple complex dates back to 1692, and rates as a "not-to-be-missed"

experience for any visitor to Bhutan. The round-trip hike to the monastery is approximately 7 km (4.3 mi) in length; with an elevation gain of 900 m (2,953 ft), it takes most people six hours to complete.

FLORA & FAUNA

The Ghost of the Mountains In 2016, Bhutan became the first country to conduct a full national census of the snow leopard, a large and reclusive cat found in the mountain ranges of Central Asia, usually at altitudes between 3,000 m (9,843 ft) and 5,400 m (17,717 ft). There were 96 discovered in total, many of which are active in the Jomolhari mountain region. The Snowman Trek passes through this beautiful high-altitude area during the first week, and though footprints of the snow leopard are regularly sighted, very few hikers are lucky enough to catch a glimpse of this majestic creature, known by locals as "the ghost of the mountains."

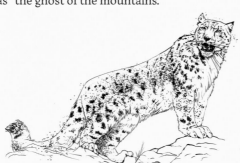

BACKGROUND

Gross National Happiness (GNH)
The guiding philosophy of the country's development process has been Gross National Happiness ever since former king Jigme Singye Wangchuck famously described it as "more important than gross national product" in 1972. Built on the principles of equitable and sustainable growth, cultural preservation, and environmental conservation, GNH was enshrined into the constitution of Bhutan on July 18, 2008.

Five Facts about Bhutan:

1. Along with Pyongyang in North Korea, Thimphu is the only capital city in Asia without any traffic lights.

2. Bhutan is the only country in the world in which tobacco is not sold.

3. It is written into the Bhutanese constitution that at least 60 percent of the country has to remain forested.

4. Bhutan's highest peak is Gangkhar Puensum, which at 7,570 m (24,836 ft) is the highest unclimbed mountain on Earth.

5. Bhutan is known as the land of the Thunder Dragon because of the huge storms that come rumbling through its valleys from the Himalayas.

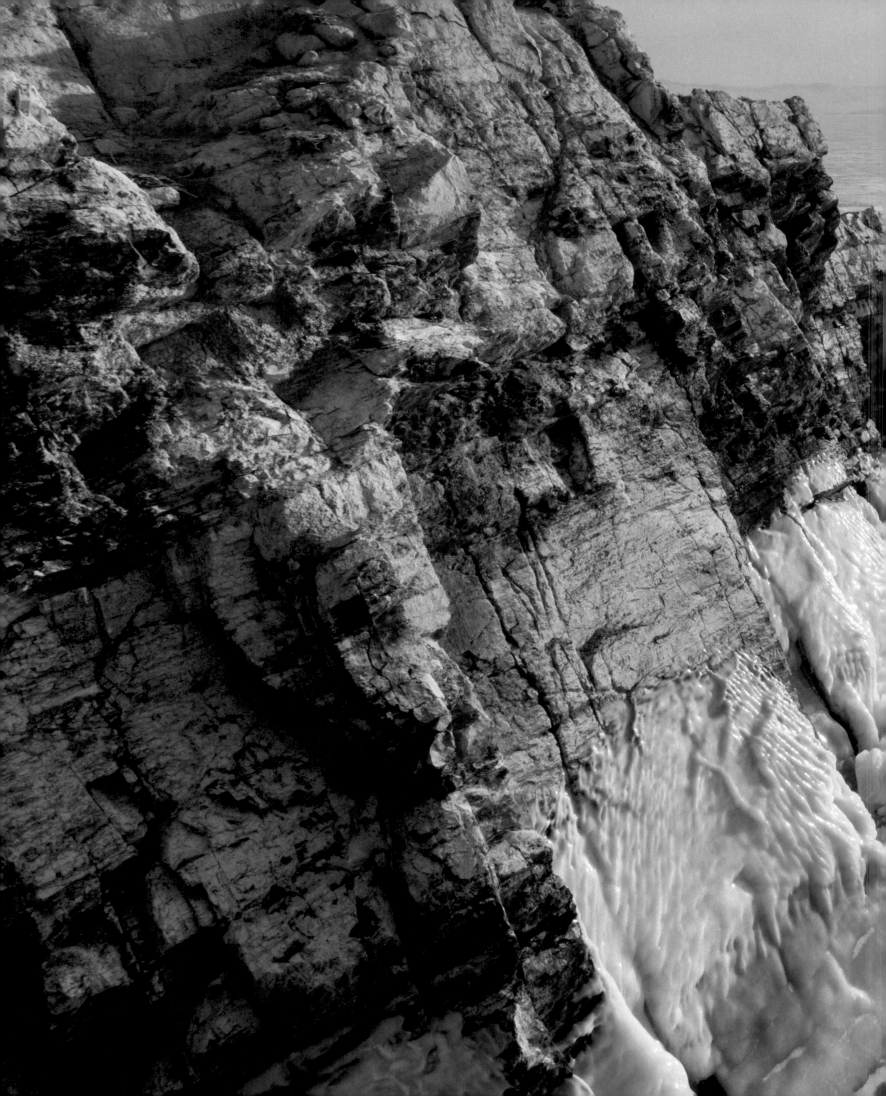

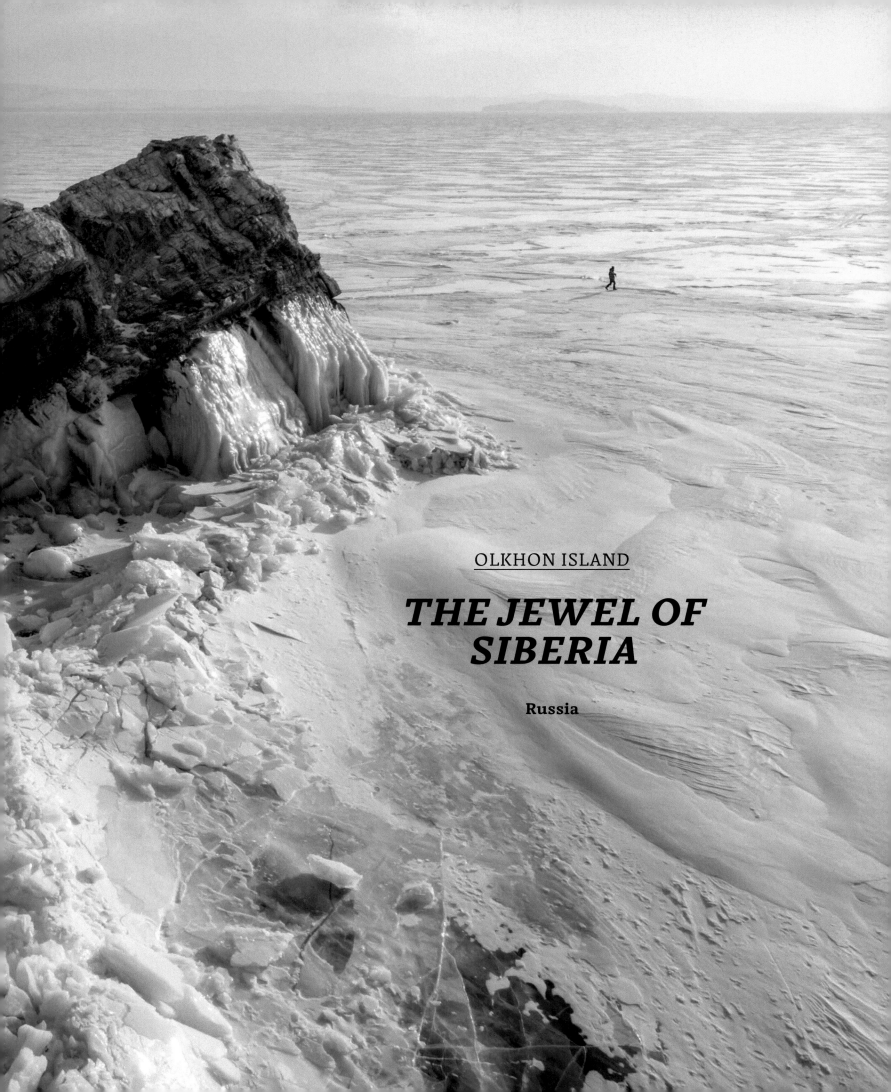

OLKHON ISLAND

THE JEWEL OF SIBERIA

Russia

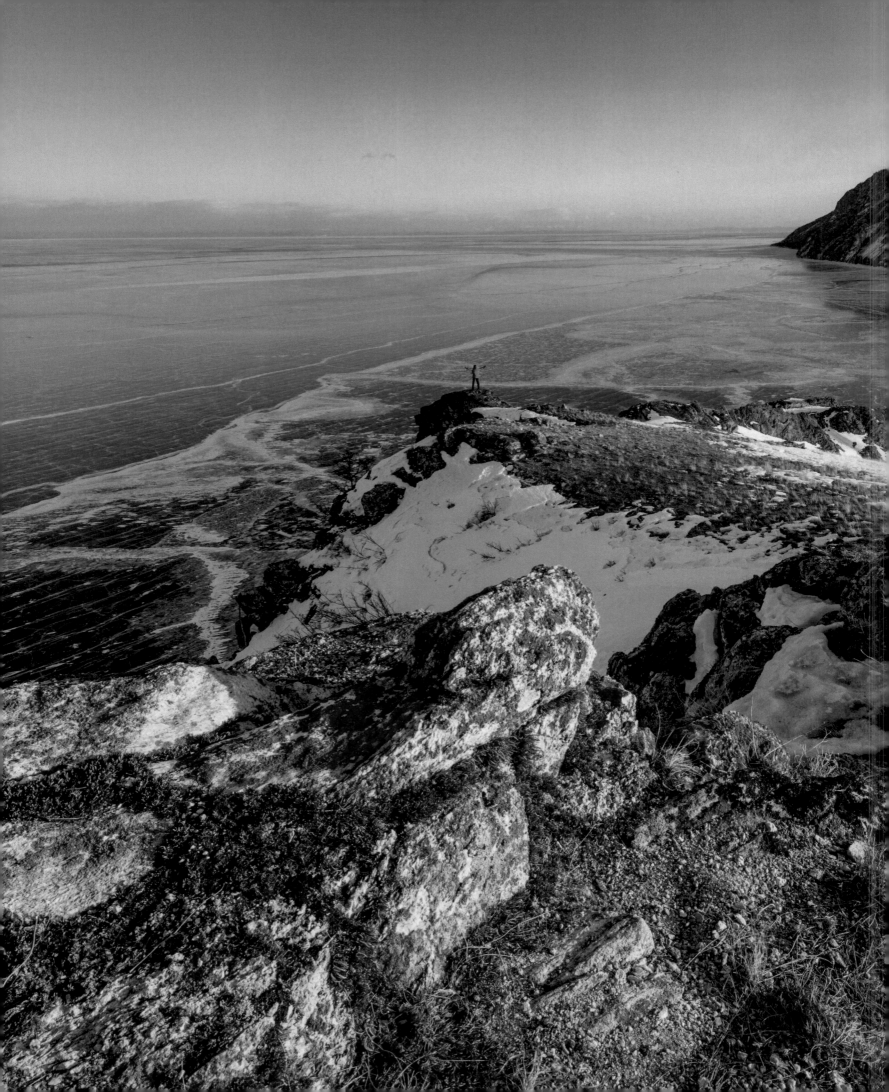

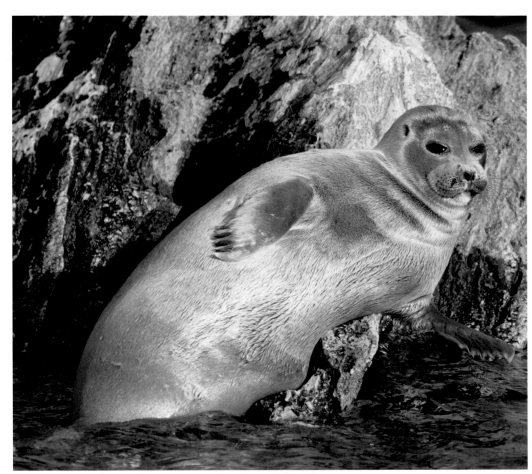

The nerpa, or Baikal seal, is the world's only species of freshwater seal.

Along the way, hikers are gifted a bird's-eye view of the color metamorphoses for which Lake Baikal is renowned. Clouds drift, winds rise, the angle of the sun changes ever so subtly, and each meteorological variance is mirrored by a corresponding alteration in the water below.

Lake Baikal is the oldest, deepest, and most voluminous lake in the world. Situated in the heart of Siberia, it contains a mind-boggling 22 % – 23 % of the planet's fresh water—more than all five of North America's Great Lakes combined. It is said that it would take all the water currently flowing in all the rivers on Earth one full year to fill it. By any criteria, it is one of the world's most incredible natural wonders, and the largest and most populous island that lies within its boundaries is named Olkhon.

Geographically speaking, Olkhon Island is a combination of coniferous forest (taiga), grassland (steppe), and even a small desert. Measuring some 72 km (45 mi) long and 15 km (9 mi) wide, it has been home to the Buryat people for ▶

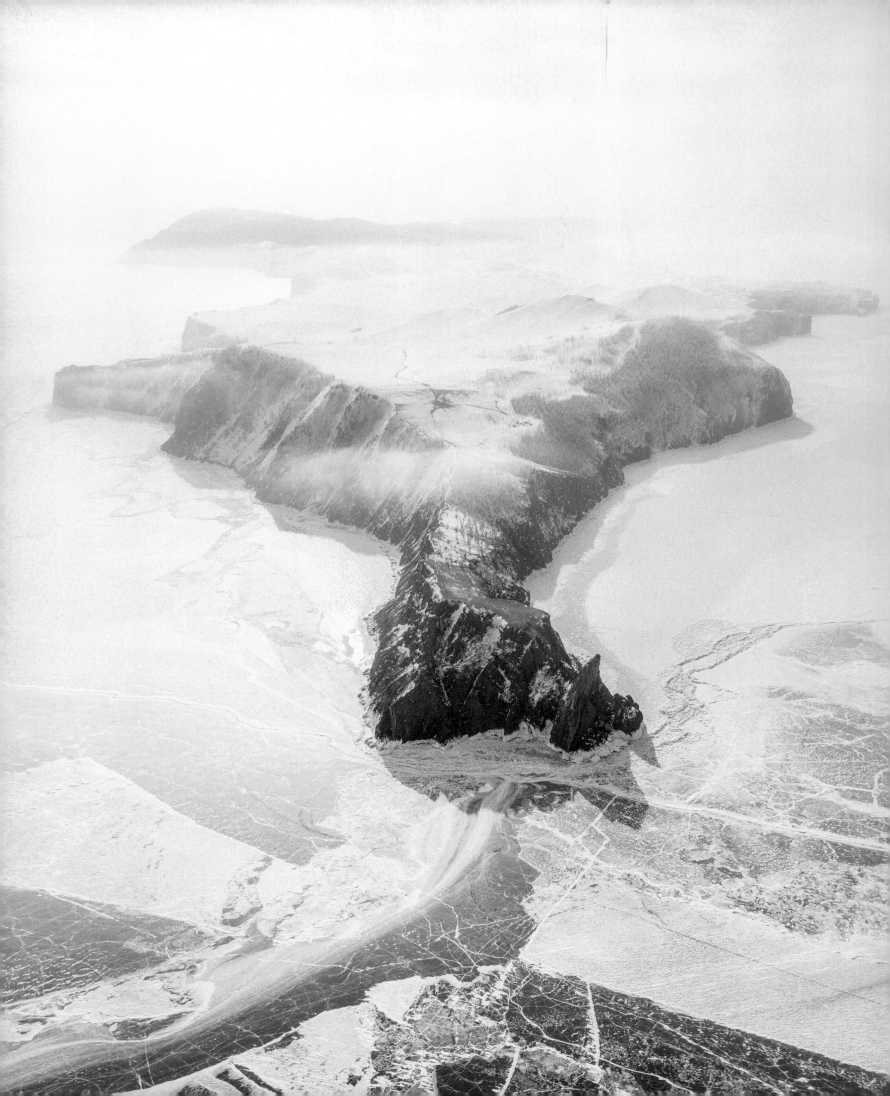

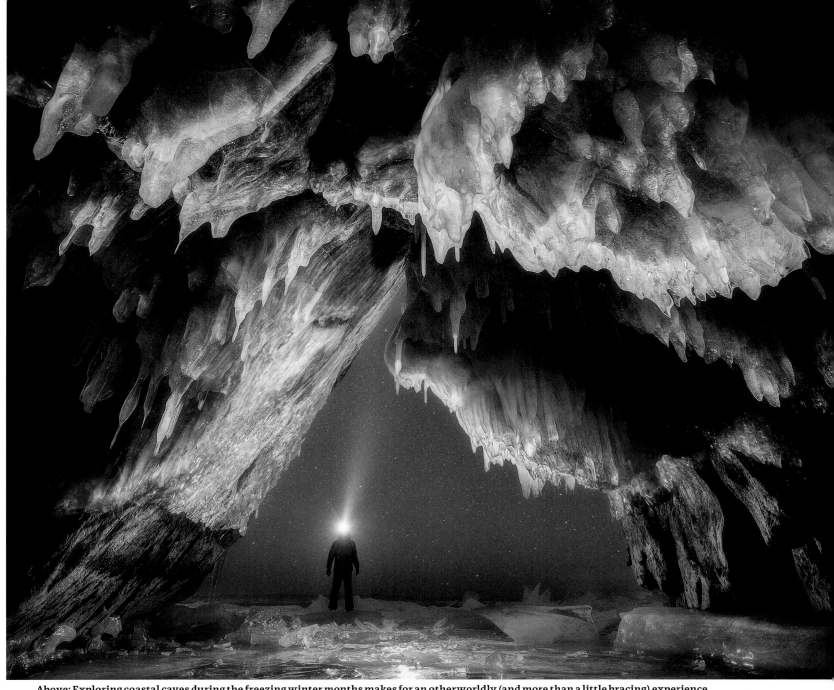

Above: Exploring coastal caves during the freezing winter months makes for an otherworldly (and more than a little bracing) experience.
Left: The frozen waters around Cape Khoboy. For almost five months a year, Lake Baikal is covered with ice.

Winter temperatures on Olkhon Island can drop below -25 °C (-13 °F).

As deep as an ocean and as large as a sea, this 30-million-year-old body of water is guaranteed to take even the most seasoned wayfarer's breath away.

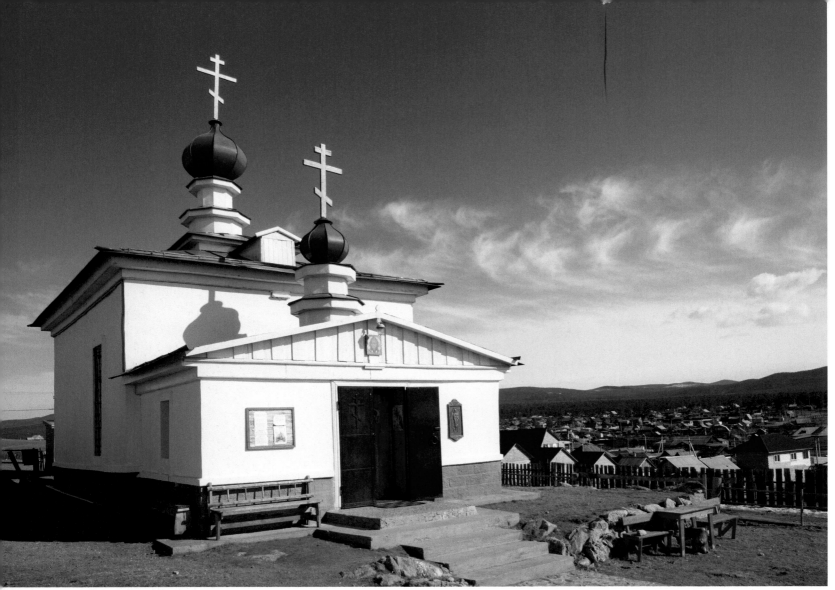

Orthodox church in the town of Khuzir.

The island is considered a sacred center of shamanism.

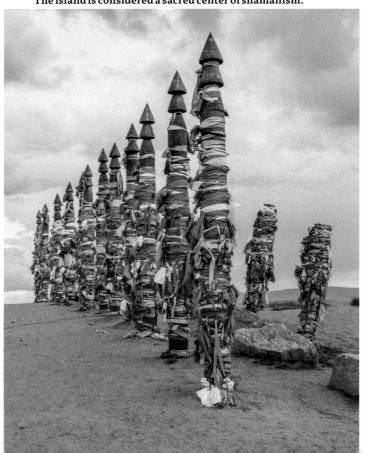

centuries. Known for their adherence to shamanism, the Buryats have traditionally been fisherman and farmers. But in recent years, tourism has played an increasing role in the local economy. For the most part, visitors to Olkhon base themselves in the main village of Khuzir, and from there explore the island by way of four-wheel drive, bicycles, or kayak. However, for those that come equipped with backpacking gear, it is also possible to experience the island on foot, with camping free and legal almost anywhere along the island's spectacular coastline.

The featured hike begins at Cape Khoboy, the northernmost part of the island. Regular tours from Khuzir visit this scenic, rocky outcrop, and they have no problem dropping you off so that you can return on foot. Before beginning the trek, be sure to make the short walk out to the tip of the cape. Marked by a large cairn and totem pole, and with dramatic red cliffs on three sides, the sweeping views from this lookout are among the best on the island. If you are lucky, you may even spot a nerpa, the world's only freshwater seal.

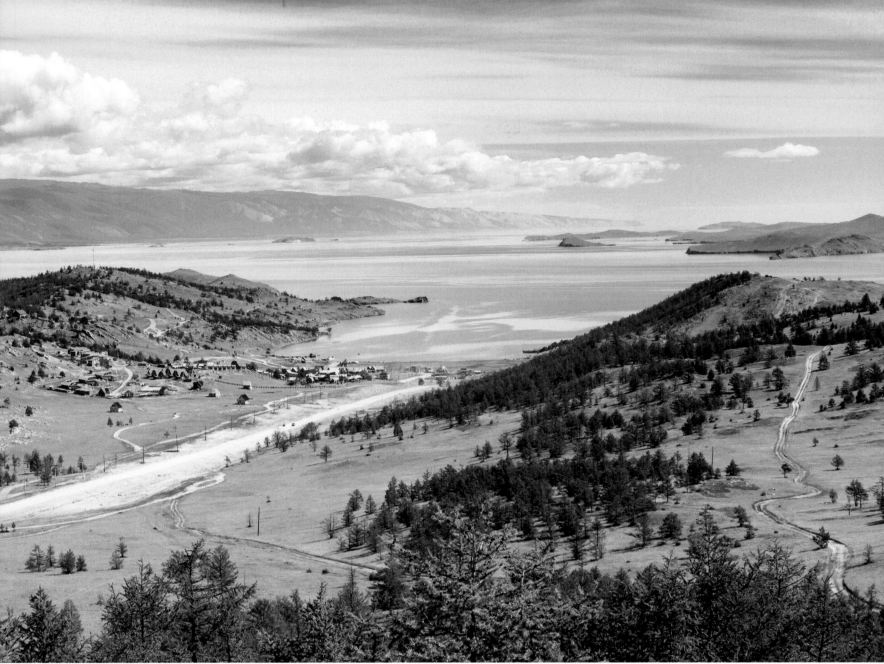

Less than 1,500 people live on Olkhon. The population consists primarily of Buryats, the island's aboriginal people.

The trek from Khoboy back to Khuzir is not an established trail. That said, the terrain is relatively gentle and open, and navigating is simply a matter of heading southwest in close proximity to the coast; it would be very difficult to get lost on this hike. After leaving the cape, the first notable feature you will encounter is the "Three Brothers" rock formation. According to Buryatian legend, this trio of outthrust blocks represents three brothers who were turned to stone for disobeying their father. Considering that they were eagles beforehand, it was a significant demotion, and the tale has no doubt featured in many a warning to children of the island as to the consequences of disobeying their parents.

From the Three Brothers, the route continues hugging the island's western coastline. Along the way, hikers are gifted a bird's-eye view of the color metamorphoses for which the lake is renowned. Clouds drift, winds rise, the angle of the sun changes ever so subtly, and each meteorological variance is mirrored by a corresponding alteration in the water below. It is a riveting interplay between the elements of air and water, and there is no better way to watch it unfold than from the terra firma of Olkhon Island.

Approximately 20 km (12 mi) after leaving the cape, you will arrive at a mysterious place by the name of Peschanaya. During Soviet times, this was a correctional facility that was part of the infamous Gulag system, forced labor camps that housed prisoners from the 1920s through to the mid-1950s. For the most part, detainees at Peschanaya worked at an on-site fish factory and sawmill. Nowadays, ▶

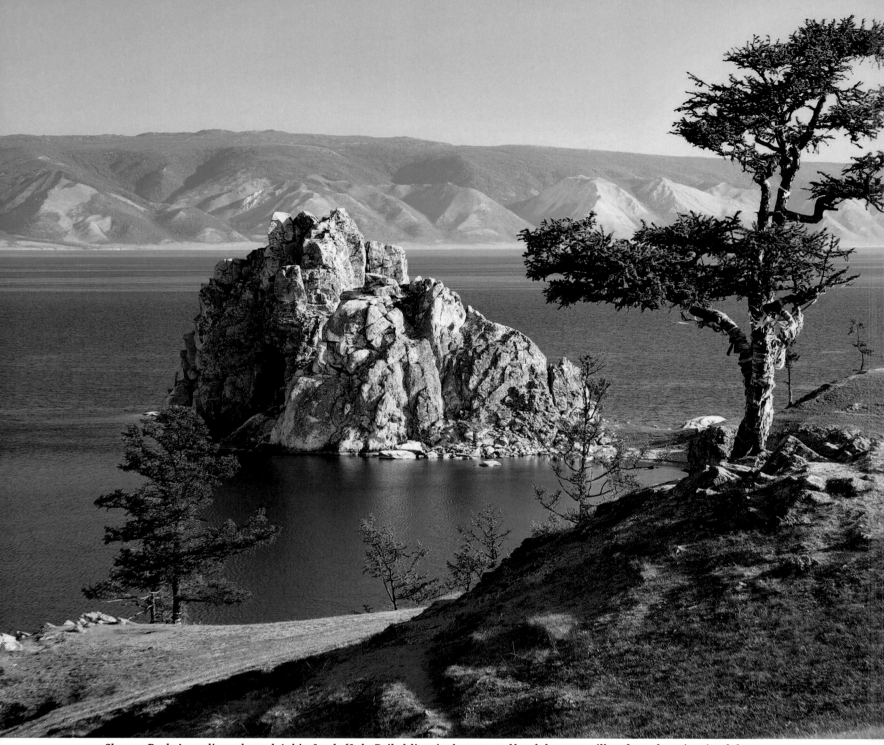

Shaman Rock. According to legend, Azhin, Lord of Lake Baikal, lives in the cave, and local shamans still perform cleansing rituals here.

most of the long-abandoned buildings have been covered by sand, and all that remains visible are a couple of houses and a broken-down bridge.

Not long after departing Peschanaya, you will reach a series of beaches perfect for camping. By this time, it will likely be late afternoon, and all that is left to do is find a nice spot to pitch your tent and prepare to watch the sunset over Lake Baikal. As you sit outside your shelter listening to the rhythmic sound of the waves lapping upon the shore, it is impossible not to be blown away by the sheer immensity of the jewel of Siberia. As deep as an ocean and as large as a sea, this 30-million-year-old body of water is guaranteed to take even the most seasoned wayfarer's breath away. ◆

Situated in the heart of Siberia, Lake Baikal contains a mind-boggling 22 % – 23 % of the planet's fresh water—more than all five of North America's Great Lakes combined.

GOOD TO KNOW

About the Trail
/ <u>DISTANCE</u> 37 km (23 mi) approx.
/ <u>DURATION</u> 2 days
/ <u>LEVEL</u> Easy

Start / Finish
🏁 Cape Khoboy
🏁 Khuzir

Season
June to October

Accommodation
Accommodation options are limited in the northern part of the island, so you will need to bring a tent. Finding places to camp, a non-issue: camping is legal and free practically anywhere along the island's beautiful coastline.

Highlights
Cape Khoboy, Three Brothers rocks, secluded coves, Shaman Rock, watching sunsets over Lake Baikal

Food and Water
During the hike, water can be obtained from the lake, though filtering or purifying is recommended. With regard to supplies, bring all that you need from the island's main village of Khuzir, which will act as your base during your time on Olkhon.

Banya
A *banya* is a traditional Russian steam sauna. Dating back centuries, this popular pastime makes for a great way to relax post-hike. Be warned—the temperatures can be extreme, often exceeding 93 °C (199 °F). One way locals have of mitigating the heat is by wearing funny-looking felt hats, which help keep your head cooler. You will look like you're wearing a tea cozy, but it really does work.

FLORA & FAUNA

Freshwater Seal Lake Baikal is home to the nerpa, one of the world's most unique aquatic animals. One of the smallest of its kind, this earless animal owes its singularity to being the planet's only completely freshwater species of seal. Which begs the still definitively unanswered question: how did the nerpa originally get to Lake Baikal, which is situated thousands of kilometers away from both the Pacific Ocean to the west and the Arctic Ocean to the north?

BACKGROUND

Shamanism For centuries, Olkhon Island has been home to the Buryats, a northern subgroup of the Mongols, who are adherents of shamanism. The island is considered to be one of the centers of the practice, and the Buryats believe that it represents one of five global poles of shamanic energy. Of the many sacred sites on Olkhon, the most famous is that of Shamanka, or Shaman Rock, situated a short walk from Khuzir. Shaman priests still perform rituals in the cave—a sacred place that is believed to possess the power to aid cleansing ancestral karma and remove curses.

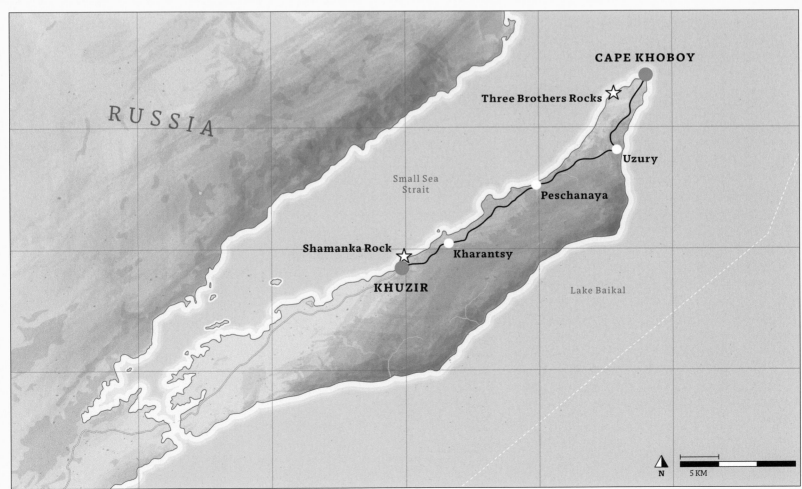

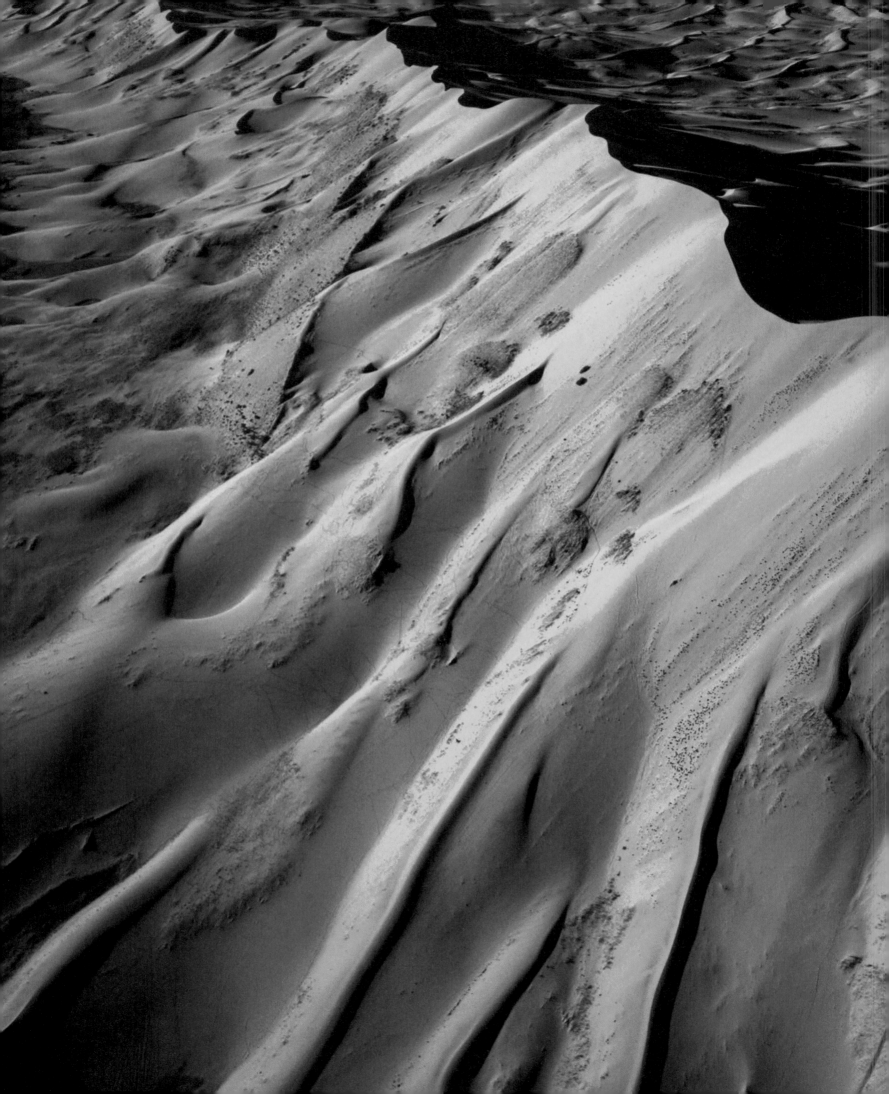

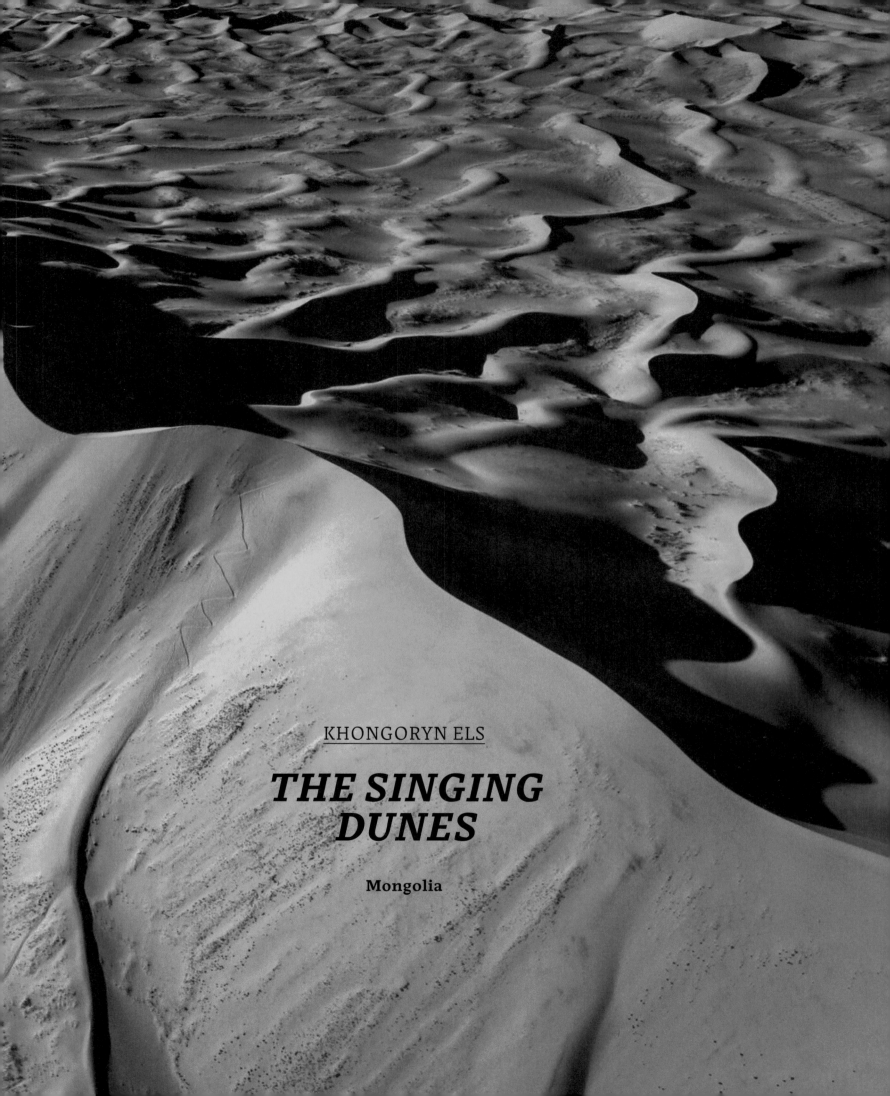

KHONGORYN ELS

THE SINGING DUNES

Mongolia

Sand dunes are the most malleable structures on Earth. Their size and shape are constantly changing as they are sculpted and re-sculpted by the elements. For hikers, this variable character is both a curse and a blessing—a curse while ascending steep, loose terrain, where every step forward equates to half a step back, and a blessing when descending that same forgiving surface, usually in leaps and bounds accompanied by lots of hooting and hollering. The bigger the sand dunes, the harder the climb and the more joyous the descent, with few dunes more beautifully encapsulating this extreme effort-to-reward ratio than the mighty Khongoryn Els.

Situated in the Gobi Desert in the far south of Mongolia, Khongoryn Els measures approximately 100 km (62.1 mi) long, 12 km (7.5 mi) wide, and up to 300 m (984 ft) high. Commonly known as Duut Mankhan (singing sands) due to the sound the dunes make when being buffeted by howling winds, Khongoryn Els forms part of Gobi Gurvansaikhan National Park. The park

While there is no established trek in Khongoryn Els, it isn't too difficult to piece together a multi-hour loop or out-and-back hike.

Mongolia is home to the world's largest population of two-humped Bactrian camels.

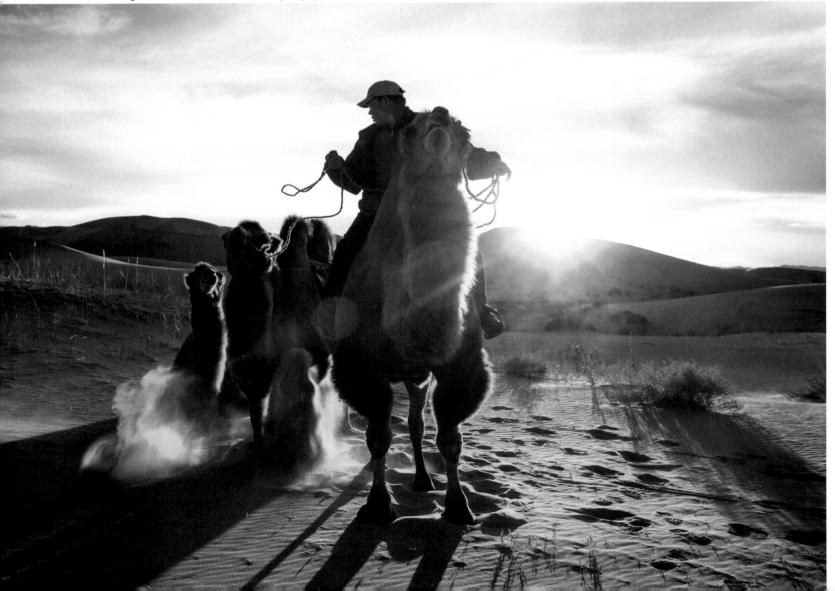

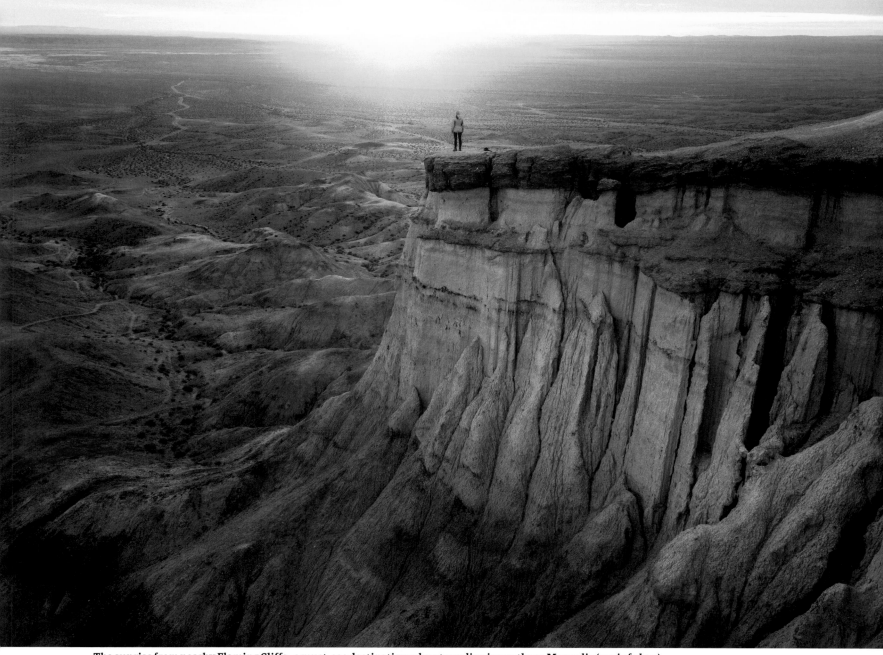

The sunrise from nearby Flaming Cliffs–a must-see destination when traveling in southern Mongolia (see info box).

Dung-fired iron stove in a traditional Mongolian *ger* (yurt).

is the country's largest, and within its boundaries lie over 20,000 sq km (7,722 sq mi) of diverse landscapes, including lonely steppes, majestic mountains, saline wetlands, barren gravel plains, and, of course, giant sand dunes.

Visitors to Khongoryn Els overnight at the *ger* (yurt) camps situated on the north side of the dunes. Staying at these nomadic abodes offers a fascinating insight into the Mongols and their traditions; the dung-fired iron stove, the handmade carpets, and the customary post-dinner game of *Shagai* (sheep ankle bones). What these simple establishments may lack in Western luxuries (showers are a rarity and bathroom facilities may be "rustic"), they more than make up for with their incredible location and the legendary hospitality of the nomads themselves. Before going to bed, be sure to step outside and admire the night sky; Mongolia has the lowest ►

253

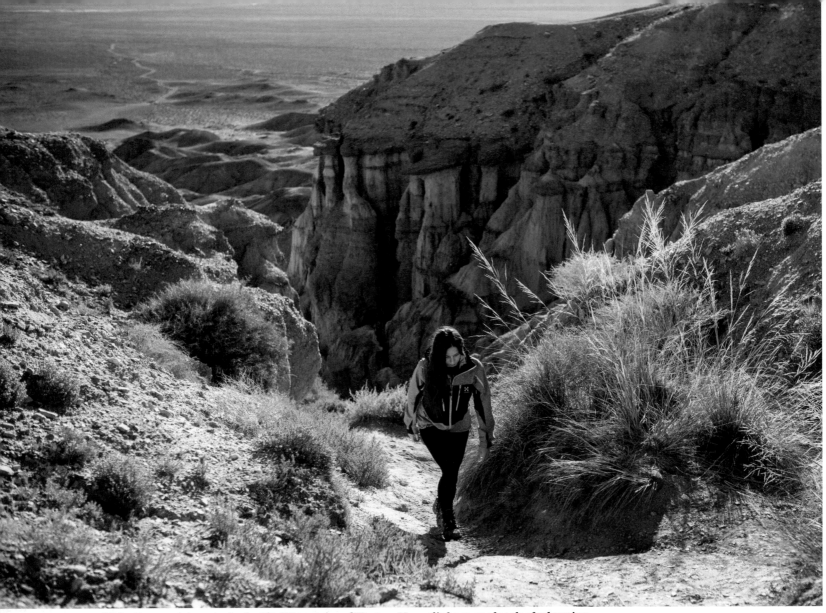

Right: For centuries, men in the Altai Mountains of Western Mongolia have used eagles for hunting.
Above: Ascending the Flaming Cliffs.

Starry night in the desert.

population density of any country on Earth, and away from the country's capital and only big city Ulaanbaatar, the stars shine with a brightness that must be seen to be believed.

Standard tourist activities at Khongoryn Els include an afternoon hike to the nearby ridge tops and a multi-hour camel ride along the outskirts of the dunes. However, for those intrepid souls who wish to venture off the beaten track, it is possible to set off on foot into the heart of the dunes, and, in doing so, have one of Central Asia's most remarkable natural wonders all to yourself.

While there is no established trek in Khongoryn Els, it isn't too difficult to piece together a multi-hour loop or out-and-back hike. Beginning from the *ger* camps, head in a southwest direction toward the tallest dunes (note: be sure to bring a compass and/or GPS). Once you have scaled these, drop down the other side and start exploring. From this point until you return to the highest dune, chances are it will be just you, a vast sea of sand, and the sound of ▶

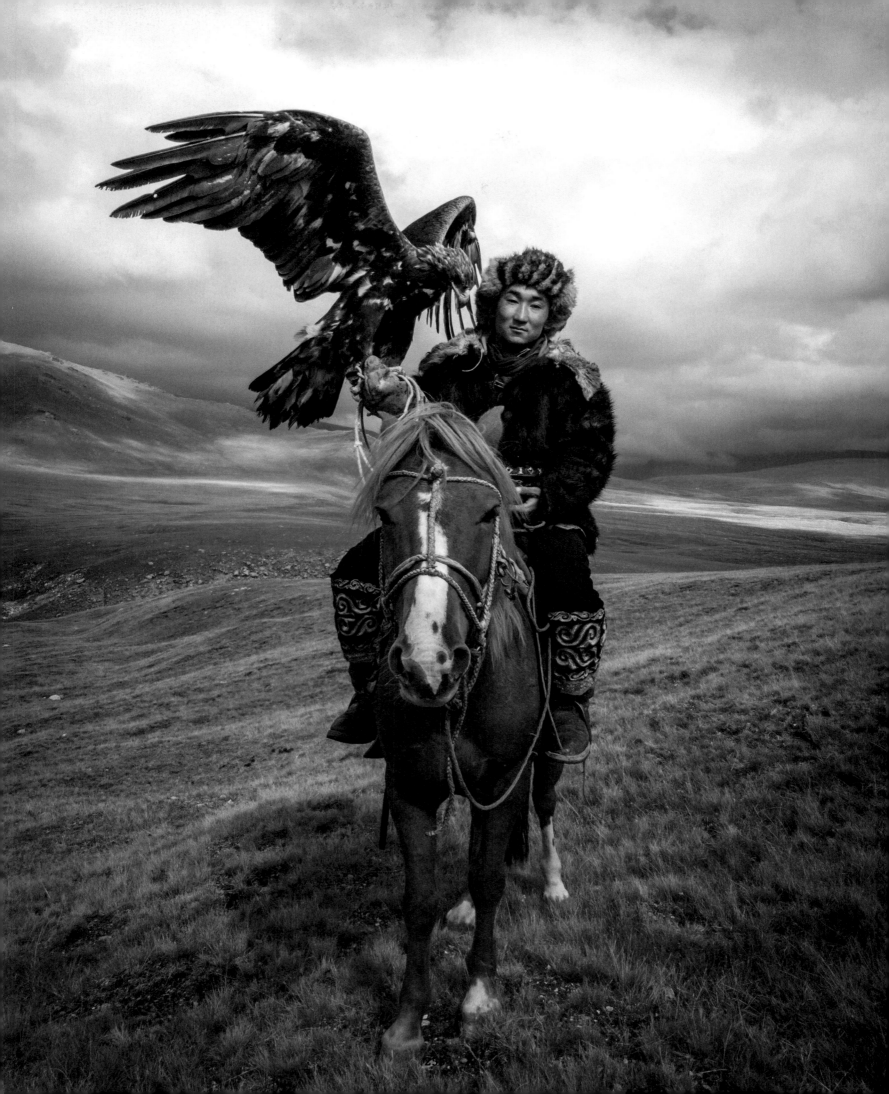

Before going to bed, be sure to step outside and admire the night sky; Mongolia has the lowest population density of any country on Earth, and away from the country's capital Ulaanbaatar, the stars shine with a brightness that must be seen to be believed.

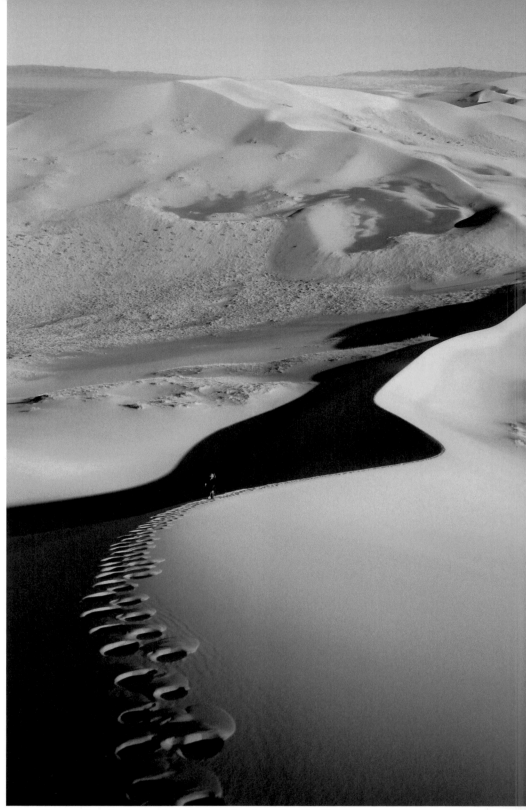

When scaling the dunes, the going is easier along the ridge lines.

the wind. If there happens to be no breeze at all, you will instead be enveloped by a silence and stillness that can only exist in a remote desert environment such as this.

From a practical point of view, always be cognizant of your location in relation to the highest dune while you are walking among the sands. This will act as your primary geographical reference point when you eventually turn back toward camp. Make sure you leave yourself plenty of time

in order to return before dark; this means you should aim at being back on top of the highest dune by sunset at the very latest. (Tip: always carry a headlamp just in case.)

As you stand there on the rooftop of Khongoryn Els, before making that final plunge down the steep slopes, take a moment to wholeheartedly embrace the fading light and distant horizon. The desert is a place like nowhere else. Unforgiving, yet serene. Timeless, yet constantly changing. ◆

About the Trail
/ <u>DURATION</u> 4 to 8 hours
/ <u>LEVEL</u> Moderate to challenging

Start / Finish
The *ger* camps on the northern side
of the dunes

Season
May to October

Permits
Entry permits for Gobi Gurvansaikhan
National Park can be attained at the park
office in Dalanzadgad, the entrance to Yolyn
Am, or from the ranger at Khongoryn Els.

HELPFUL HINTS

Equipment A broad-brimmed or
beekeeper-style hat, long-sleeve shirt
and pants, a buff or bandana to wear
over your face when the wind picks up,
sunglasses, lightweight running shoes,
and a compass and/or GPS.

Itinerary Be sure to advise your
driver, guide, and/or tour group
of your hiking plans before setting off.
Give them a description of your proposed
route as well as an estimate of what
time you will return.

Water Once you leave the *ger* camps, there
are no water sources. If you plan on hiking
for six-plus hours, be sure to bring at least
three to four liters per person.

FLORA & FAUNA

Bactrian Camels Mongolia is home to the
world's largest population of two-humped
Bactrian camels. Commonly known as the
"ships of the desert," these beasts of burden
can carry up to 270 kg (595 lb), almost twice
as much as their one-humped dromedary
brethren. Depending on temperature and
activity level, Bactrian camels can go for a
week without water and more than a month
without food. When they do eventually take
a drink, they are capable of drinking more
than 100 liters in less than 10 minutes.

BACKGROUND

Narrow Gorges & Flaming Cliffs Apart
from the dunes of Khongoryn Els, two other
must-see natural attractions in southern
Mongolia are Yolyn Am (Valley of the Eagles)
and the Flaming Cliffs. The former is a
dramatic canyon whose narrowest sections
are covered for most of the year by a thick
layer of ice, and which offers visitors the
chance to spot vultures, wild argali sheep
(the largest sheep in the world), and the golden
eagles after which its name derives. To the
northwest of Yolyn Am are the Flaming Cliffs
(also known as Bayanzag), a collection of
splendid red rock formations that are best
appreciated at sunrise and sunset, when they
light up with an ethereal orange-and-red
glow. Apart from their stunning beauty, the
cliffs are most known for being the site where
the first officially recognized dinosaur egg
fossils were discovered in the 1920s. The man
in charge of that historic excavation was
American paleontologist Roy Chapman
Andrews, who is said to have inspired the
character of Indiana Jones.

Golden Eagle Festival Every October,
the western Mongolian province of Bayan-
Ölgii plays host to one of Asia's most unique
celebrations, the Golden Eagle Festival.
The two-day gathering brings together some
of the country's finest hunters and their
magnificent eagles to compete in tests of
speed, agility, and accuracy.

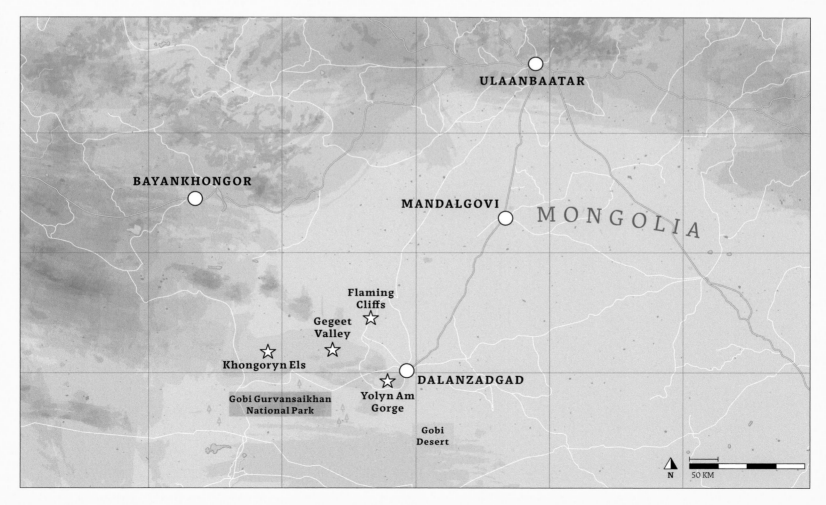

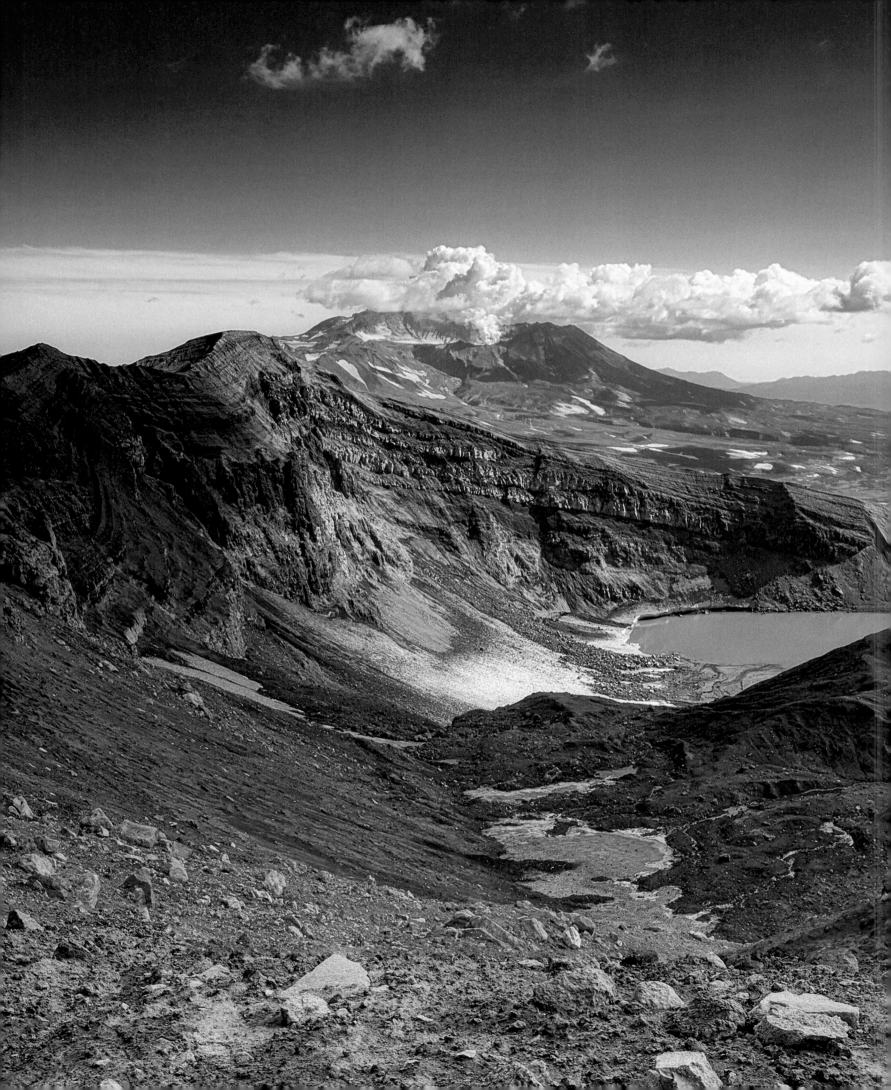

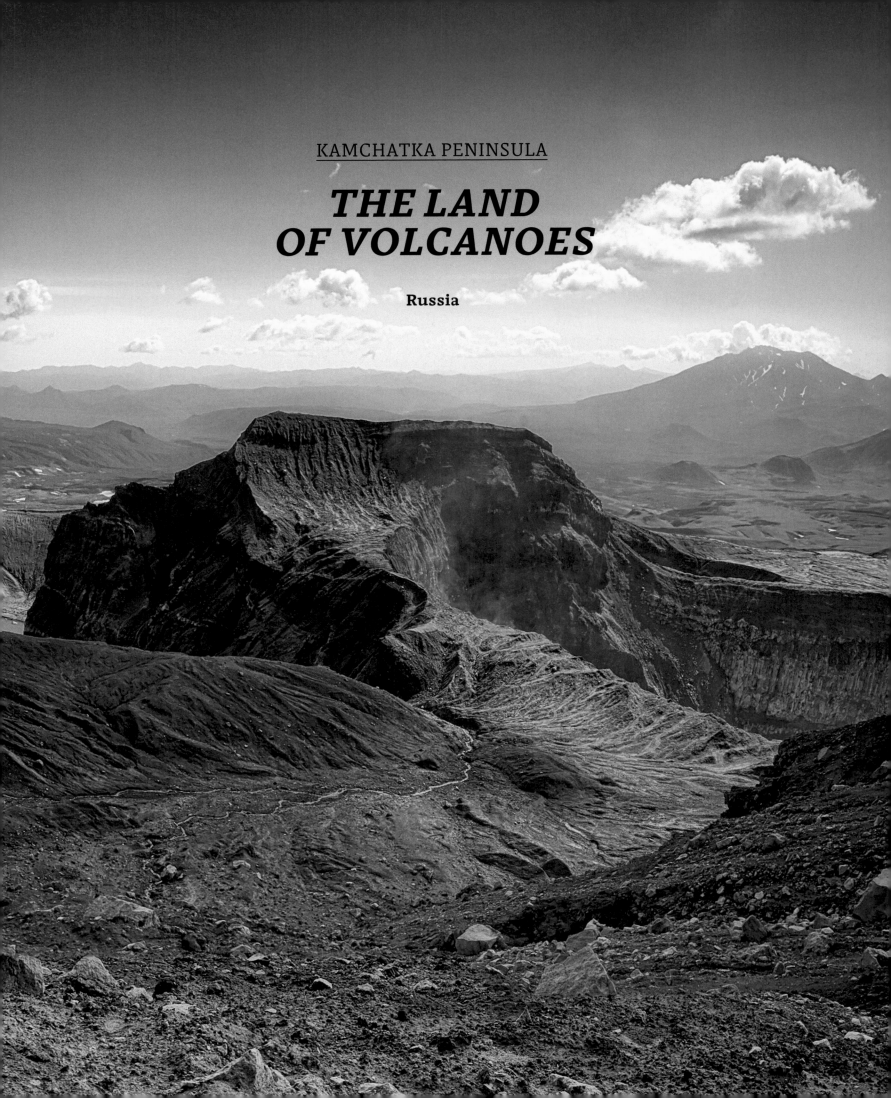

KAMCHATKA PENINSULA

THE LAND OF VOLCANOES

Russia

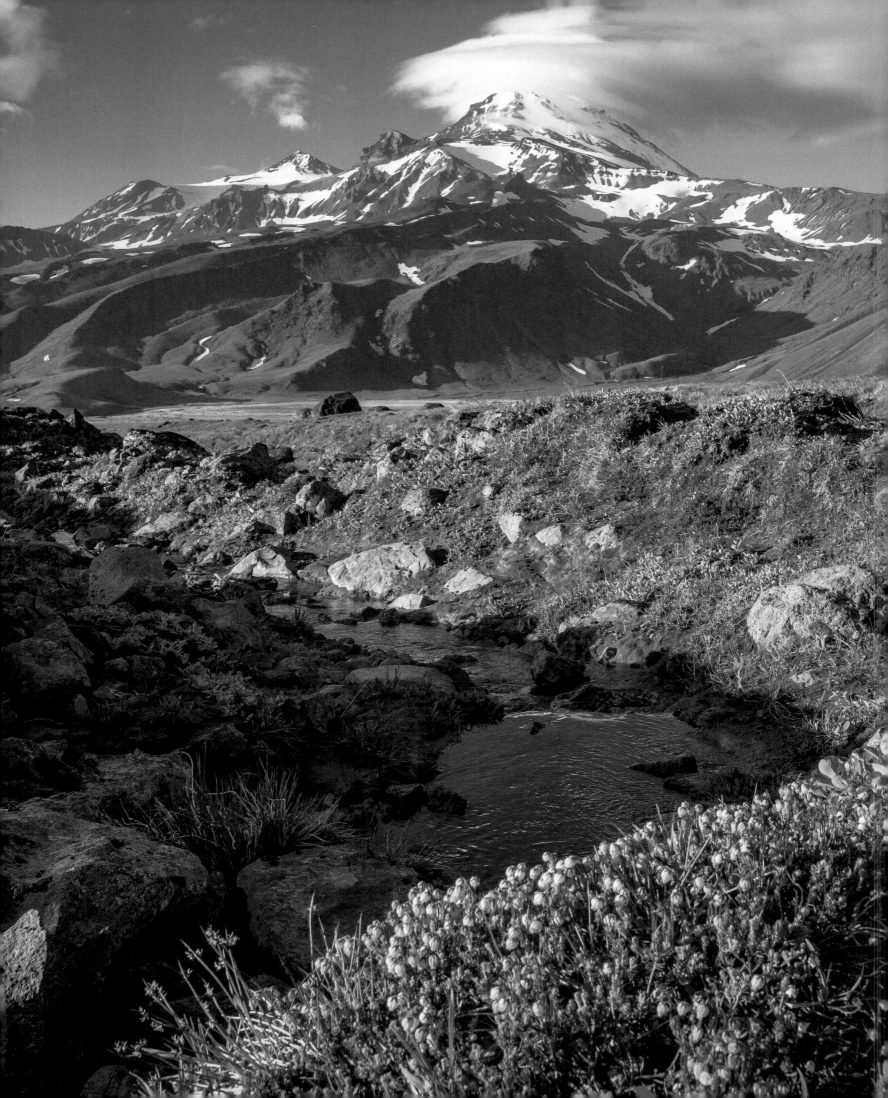

Left: In Kamchatka there are very few trails, but hiking possibilities abound.
Above: Kamchatka's bears profit from the high concentration of Pacific salmon that live around the peninsula.

I magine a place with the geysers of Yellowstone, the volcanoes of Hawaii, and the untamed landscapes and abundant wildlife of Alaska. Then imagine that place was virtually tourist-free and not connected to any other country by rail or road. In a nutshell, that's the Kamchatka Peninsula.

Long shrouded in mystery and mythology, the Kamchatka is an untamed land in the far east of Russia. Due to its frontier location, it was considered of strategic importance during the Cold War years, and thus remained isolated from the rest of the world until the fall of the Soviet Union between 1990 and 1991 (see info box).

The 1,250 km (780 mi) long Kamchatka Peninsula forms part of the Pacific Rim's Ring of Fire and contains 160 volcanoes, 29 of which are still active. According to the NASA Earth Observatory, Kamchatka has the "highest concentration of active volcanoes on Earth." When combined with its more than 150 hot springs, as well as with its countless fumaroles, mud pots, and geysers, the Kamchatka represents a geothermal wonderland only rivaled by Iceland.

The peninsula's volcanoes dominate not only its landscape, but also the legends of its indigenous peoples. Perhaps the most famous of these myths is from the Koryak tribe, who believe that Kamchatka was brought into being when the great raven god Kutkh dropped a feather from the heavens. He then sent ▶

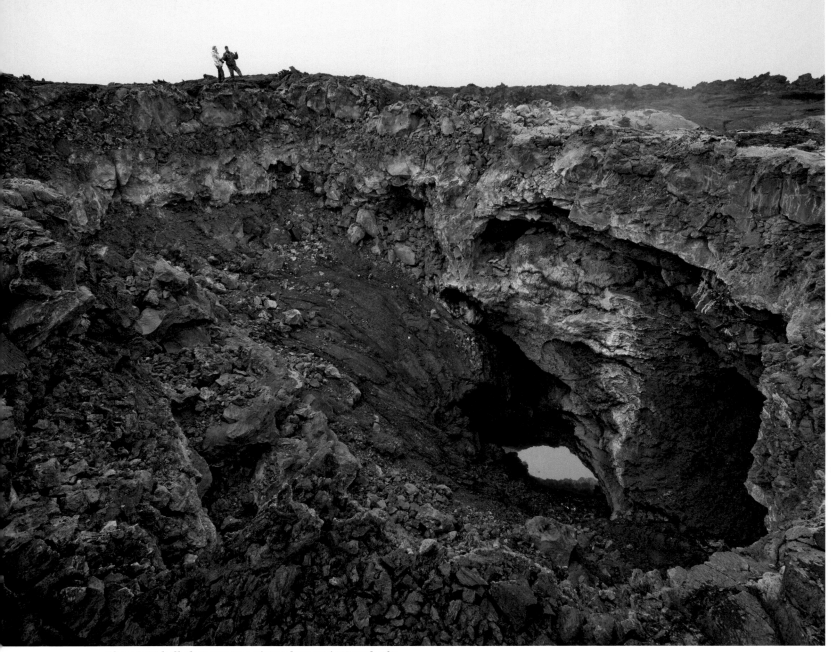

The gate to hell, there are 29 active volcanoes in Kamchatka.

A hungry *Evrazhka* (a local rodent).

men, and later a beautiful woman, to inhabit his creation. Not surprisingly, all the men fell for the lone woman. But as they passed away one by one, they transformed into volcanoes, their passion for the unattainable beauty forever destined to burn brightly. And that is how, according to the Koryaks, the Kamchatka Peninsula became the "land of fire" that it is today.

Most of the trekking options in Kamchatka take hikers up close and personal with these explosive—and if you believe the Koryak legend, somewhat melancholy—natural phenomena. One of the most popular hiking choices is Nalychevo Nature Park. Readily accessible from the capital city of Petropavlovsk-Kamchatsky, this 2,872 sq km (1,109 sq mi) protected area boasts a combination of volcanic and coastal landscapes, more than 100 thermal

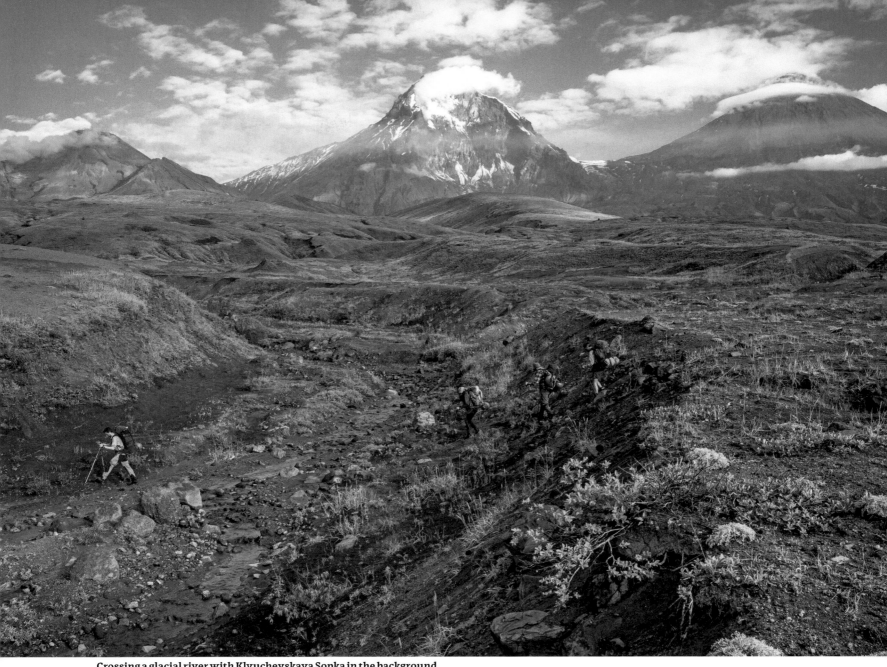

Crossing a glacial river with Klyuchevskaya Sopka in the background.

springs, and a well-marked trail network dotted with comfortable mountain huts. It is possible to reach the park via a 40 km (25 mi) trail that runs north from Mount Avachinsky (2,741 m [9,000 ft]), which is one of Kamchatka's smaller and easier to climb volcanoes. Avachinsky can be summited as a day trip (four to five hours from the base to the top) from Petropavlovsk-Kamchatsky.

For those looking for a more challenging and remote proposition, the Klyuchevskaya massif is an excellent choice. Consisting of a group of 14 volcanoes, the standout (and namesake of the region) is Klyuchevskaya Sopka (4,750 m [15,584 ft])—the highest active volcano in Eurasia and the highest and most sacred peak on the Kamchatka Peninsula. Treks through this isolated region, located approximately 354 km (220 mi) north of Petropavlovsk-Kamchatsky,

are a serious proposition: no trails, no villages, and one of the most active volcanic areas on the planet. Any hiking itinerary planned in the Klyuchevskaya, including a summiting of the eponymous peak, is subject to change depending on the daily conditions, and anyone considering a trip in this area should be fit, experienced, and capable of carrying most of their own equipment.

A third trekking option is Bystrinsky Nature Park, near the village of Esso in the central part of Kamchatka. Reachable via a six- to eight-hour bus journey from Petropavlovsk-Kamchatsky, Bystrinsky is located in the Sredinny Range and has a system of well-mapped pathways ranging from 2 to 42 km (1.2 to 26 mi) in length. In addition to its volcanoes, what sets Bystrinsky apart from other nature reserves on the peninsula is that its indigenous ▶

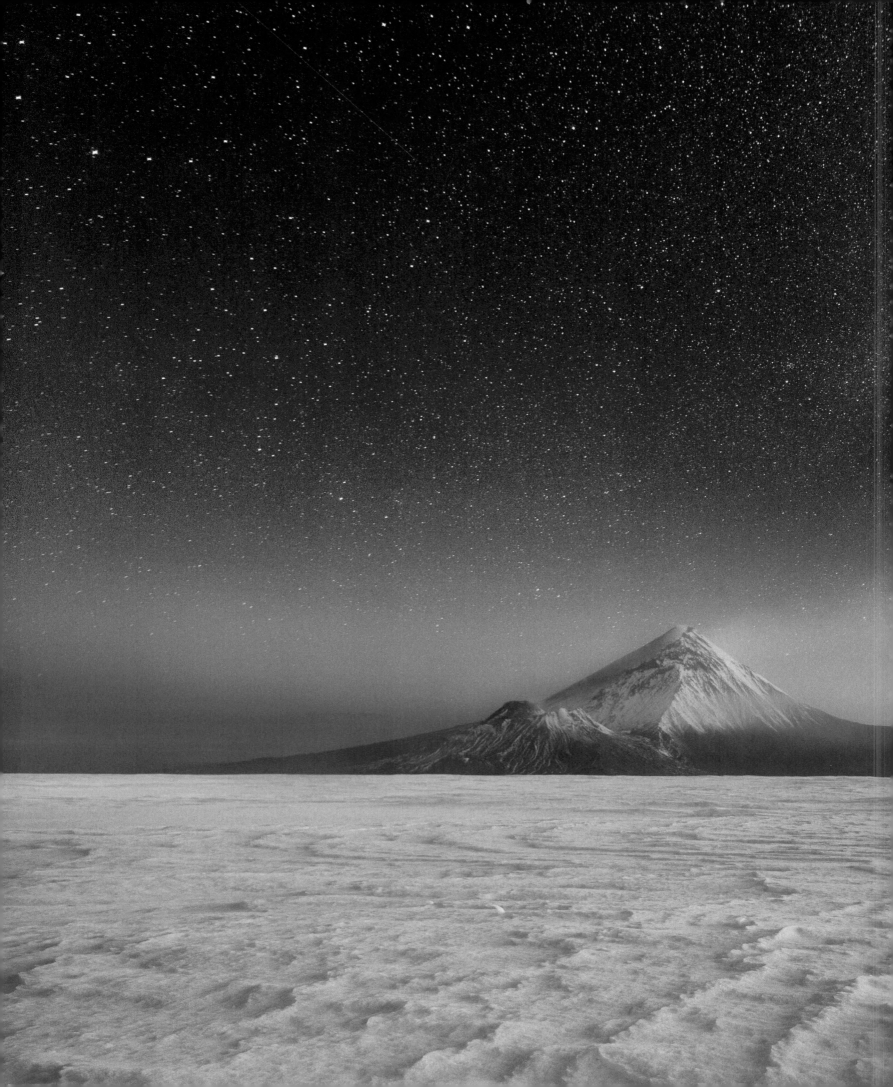

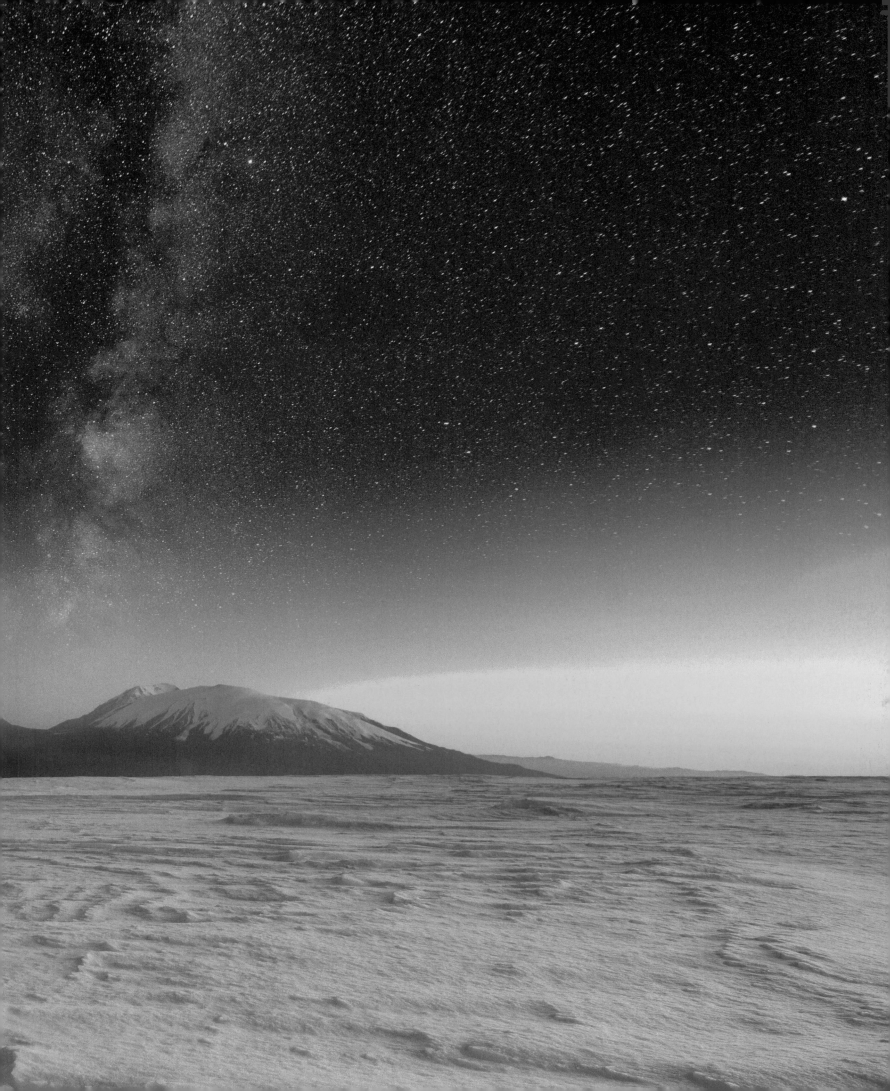

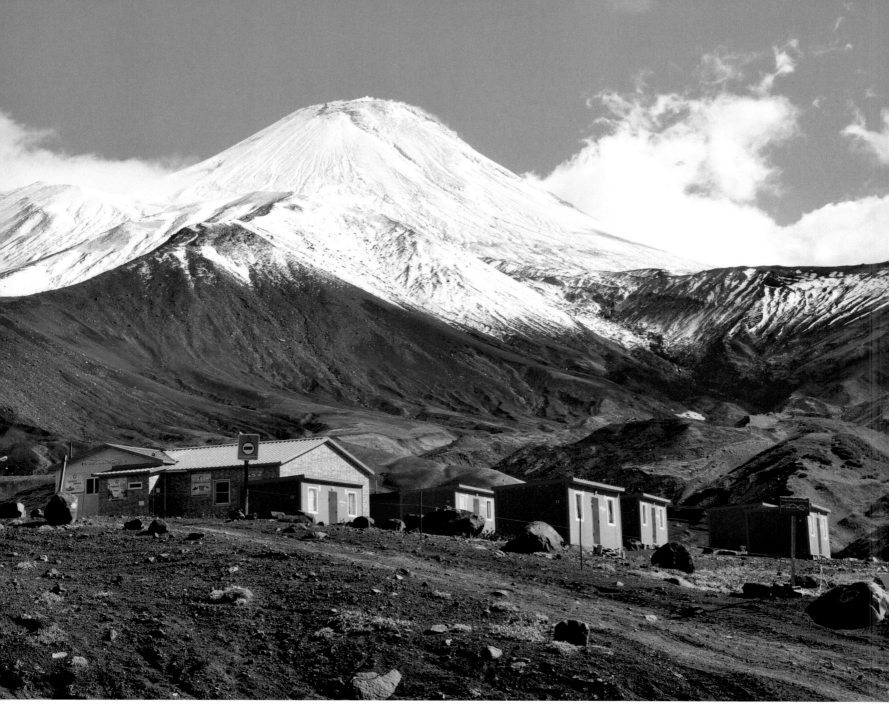

A snow-capped Avachinsky volcano.

inhabitants—the Koryaks, Itelmens, and Evenks—still maintain their traditional livelihoods of reindeer herding, hunting, fishing, and trapping.

In addition to the incredible geothermal landscape, a highlight of trekking in the Kamchatka is the diversity of wildlife. There are wolverine, moose, lynx, Arctic fox, and Steller's sea eagles (see info box). Notably, the Kamchatka Peninsula is also home to the world's highest concentration of brown bears (more than 15,000 in total). And thanks to the fact that approximately 20 percent of all Pacific salmon originate in the peninsula, Kamchatka's bears rate among the best-fed on the planet. For a front row seat to what may well be the world's biggest seafood buffet,

consider visiting the southern part of the peninsula in August, where every year hundreds of bears congregate at Kurile Lake in anticipation of the Earth's largest salmon run.

Getting to the Kamchatka takes time and effort, and as of 2018, the peninsula plays host to only a few thousand visitors per year. (Its trans-Bering Strait cousin, Alaska, receives more than two million visitors per year.) But for those curious souls that make the journey, this remote finger of land in Russia's far east rarely fails to impress. The World Heritage-listed volcanoes and abundant wildlife are nothing less than awe-inspiring, and when combined with its untamed, frontier-esque character, Kamchatka is an adventure destination like no other on the planet. ◆

GOOD TO KNOW

About the Trail
/ <u>DURATION</u> 1 to 10 days
/ <u>LEVEL</u> Moderate

Suggested Trekking Locations
Nalychevo Nature Park, Klyuchevskaya massif, and Bystrinsky Nature Park

Season
June to October. Generally speaking, the Kamchatka Peninsula has a cool maritime climate on the coastal regions, and a cold continental climate in the mountainous interior.

Soviet Influence in Kamchatka
Due to its frontier location on the Pacific Rim, the Kamchatka Peninsula was considered to be of high strategic importance during the Cold War years. As a result, it essentially remained closed off from the outside world—not only to foreigners, but to most Russians as well—until the fall of the Soviet Union between 1990 and 1991. To this day, Russia continues to maintain a strong military presence in Kamchatka—the peninsula is the headquarters of its Pacific submarine fleet and hosts several air force bases.

FLORA & FAUNA

Steller's Sea Eagle Native to Russia's far east and most common on the Kamchatka Peninsula, the Steller's sea eagle is one of the largest raptors in the world. With a wingspan of up to 2.4 m (8 ft), a striking black-and-white plumage, and an oversized yellow beak, this remarkable-looking bird was named after the famed botanist Georg Wilhelm Steller, a member of Vitus Bering's second expedition and the first European to set foot in Alaska.

HELPFUL HINTS

Valley of Geysers Apart from its volcanoes, perhaps the most famous natural wonder on the Kamchatka Peninsula is the Valley of Geysers. This remarkable area in the Kronotsky Nature Reserve has the second-highest concentration of geysers in the world after Yellowstone National Park (approximately 90 in total) and can only be accessed via helicopter as part of an organized tour.

BACKGROUND

Vitus Bering In the year 1740, famed explorer Vitus Bering is said to have founded the capital of the Kamchatka Peninsula, Petropavlovsk-Kamchatsky. He subsequently set off from the far-flung outpost on the second and final of his two Pacific voyages, during which he famously discovered the strait between Russia and Alaska (or Asia and North America) that now bears his name.

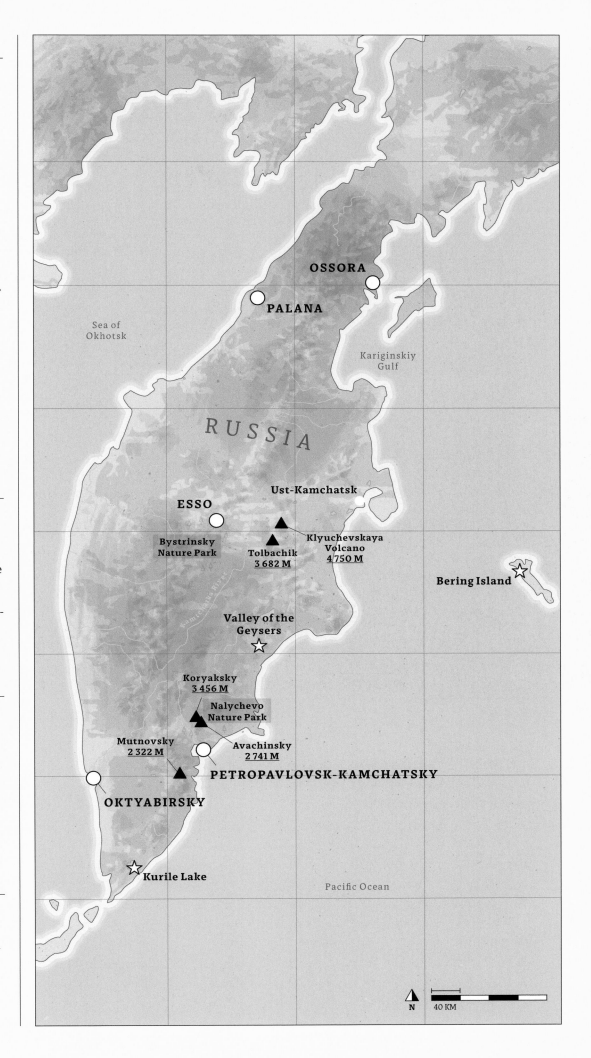

PEAKS OF THE BALKANS
Albania, Montenegro & Kosovo

JACK BRAUER
mountainphotography.com
pp. 6-8, 10 (top), 11-12

AUDREY SCOTT AND DANIEL NOLL
uncorneredmarket.com
pp. 9, 10 (bottom)

SVANETI
Georgia

MARGARITA SOLYANOVA
midoritai.livejournal.com
pp. 14-22

PYRENEAN HAUTE ROUTE
France & Spain

JACK BRAUER
mountainphotography.com
pp. 24-25, 26 (bottom)

ALEX RODDIE
alexroddie.com
pp. 26 (top), 27, 28 (bottom), 29-30

GETTY IMAGES / MICHEL GOUNOT
p. 28 (top)

JULIAN ALPS
Slovenia

TIBOR LELKES
flickr.com/people/140544530@N06/
pp. 32-33, 36 (bottom), 37

GETTY IMAGES / ENRIQUE UGARTE
p. 34

JACK BRAUER
mountainphotography.com
p. 35

**GETTY IMAGES /
WHITWORTH IMAGES**
p. 36 (top)

JACK HARDING
jackharding.photo
p. 38

SAREK NATIONAL PARK
Sweden

HANS STRAND
hansstrand.se
pp. 40-41, 46-47

ORSOLYA HAARBERG
haarbergphoto.com
pp. 42-43

ERIK LORENZ
erik-lorenz-autor.de
pp. 44-45

ERLEND HAARBERG
haarbergphoto.com
p. 48

CAUSEWAY COAST WAY
Northern Ireland

ALAN DIXON
adventurealan.com
pp. 50-53, 55

**GETTY IMAGES /
MARCO BOTTIGELLI**
p. 54 (top)

LUKAS PETEREIT
lukas-petereit.com
p. 54 (bottom)

JOHANNES HULSCH
500px.com/bokehm0n
pp. 56-58

SKYE TRAIL
Scotland

LUKAS PETEREIT
lukas-petereit.com
pp. 60-61, 62 (top), 64-65

SHAWN SMITH
nadacliche.com
pp. 62 (bottom), 63 (top)

TOBIAS WESSLING
photo-inspirator.com
p. 63 (bottom)

RYAN SHEPPECK
ryansheppeck.com
pp. 66 (top), 67-68

SARAH GREEN
sarahinthegreen.com
p. 66 (bottom)

LIESERPFAD
Germany

JANA ZIESENISS
sonne-wolken.de
pp. 70-76

HERMANNSDALSTINDEN PEAK
Norway

GENE WAHRLICH
genewahrlich.com
pp. 78-79, 81

CODY DUNCAN
68north.com
pp. 80, 82-83

BRENDAN LYNCH
youseethenew.com
p. 84

RWENZORI MOUNTAINS
Uganda

MATTEO LEONI
signalkuppe.com
pp. 86-87, 88 (bottom), 89

JAVIER AND MIGUEL BLANQUER
viajaporlibre.com
pp. 88 (top), 90-92

OTTER TRAIL
South Africa

JOSIE ACLAND
sixyeargapyear.com
pp. 94-102

AUSANGATE CIRCUIT
Peru

JACK BRAUER
mountainphotography.com
pp. 104-105, 111 (top)

ALEXANDER FUCHS
fuxografie.com
pp. 106-110, 111 (bottom), 112

CIUDAD PERDIDA
Colombia

AUDREY SCOTT AND DANIEL NOLL
uncorneredmarket.com
pp. 114-120

CORDILLERA HUAYHUASH CIRCUIT
Peru

DAN ARNOLD
darnoldhiking.com
pp. 122-123, 128-129

ALEXANDER FUCHS
fuxografie.com
p. 124 (top)

FERRAN ALTIMIRAS
altimiras.cat
pp. 124 (bottom), 125

JACK BRAUER
mountainphotography.com
pp. 126-127

EDDY GROUT PHOTOGRAPHY
breakingtrailsblog.com
p. 130

SALAR DE UYUNI
Bolivia

**GETTY IMAGES /
TRAUMLICHTFABRIK**
pp. 132-133

MATEUSZ WALIGÓRA
mateuszwaligora.com
pp. 134-135, 137 (top)

CAM HONAN
thehikinglife.com
pp. 136 (top), 137 (bottom)

**GETTY IMAGES /
ATLANTIDE PHOTOTRAVEL**
p. 136 (bottom)

MARTA KULESZA
inafarawayland.com
pp. 138-140

MOUNT ANNE CIRCUIT
Australia

VIKTOR POSNOV
viktorposnov.com
pp. 142-145, 146 (top), 147-148

MAX MUENCH
muenchmax.com
p. 146 (bottom)

AROUND THE MOUNTAIN CIRCUIT
New Zealand

JONAS VON ROTZ
letscapturetheworld.com
pp. 150-151

ELLEN RICHARDSON
ellen-richardson.com
pp. 152-155

DANIEL ERNST
danielernstphoto.com
p. 156

DUSKY TRACK
New Zealand

DANILO HEGG
southernalpsphotography.com
pp. 158-163, 164 (top)

MARTA KULESZA
inafarawayland.com
p. 164 (bottom)

CONTINENTAL DIVIDE TRAIL
U. S. A.

VIKTOR POSNOV
viktorposnov.com
pp. 166-167, 168 (top), 169 (bottom), 172-173

RYAN CHOI
pp. 168 (bottom), 169 (top), 170-171, 174

HAYDUKE TRAIL
U. S. A.

DAN ARNOLD
darnoldhiking.com
pp. 176-177, 179

RYAN CHOI
pp. 178, 180 (bottom), 181,
183 (bottom left), 184

ASHLEY HILL
sobohobo.com
pp. 180 (top), 186

RYAN "TUNA HELPER" WEIDERT
instagram.com/revelphotography
pp. 182, 185

JACK BRAUER
mountainphotography.com
p. 183 (top)

SARAH GREEN
sarahinthegreen.com
p. 183 (bottom right)

BIG CYPRESS NATIONAL PRESERVE
U. S. A.

PAUL MARCELLINI PHOTOGRAPHY
paulmarcellini.com
pp. 188-191, 192 (top), 193 (top)

CAM HONAN
thehikinglife.com
p. 192 (bottom)

MATT TILGHMAN
matttilghman.com
p. 193 (bottom)

SANDRA FRIEND AND JOHN KEATLEY
floridahikes.com
p. 194

KLUANE NATIONAL PARK
Canada

DAN ARNOLD
darnoldhiking.com
pp. 196-197, 200 (top)

SEAN JANSEN
jansenjournals.com
pp. 198-199, 200 (bottom)

JACK BRAUER
mountainphotography.com
pp. 201-202

JAMES IRVINE AND MINERS RIDGE LOOP
U. S. A.

ANDY TUPMAN
andytupman.com
pp. 204-205

GRACE HAVLAK CALLANDER
gracecallander.com
pp. 206-209, 212

STEVIN TUCHIWSKY
tuchiwsky.com
pp. 210-211

WONDERLAND TRAIL
U. S. A.

BEN BENVIE
atriacollective.com
pp. 214-216, 218 (bottom), 220

DAN ARNOLD
darnoldhiking.com
pp. 217, 219

**GETTY IMAGES /
DANITA DELIMONT**
p. 218 (top)

TIGER LEAPING GORGE
China

JONATHAN LOOK, JR.
travelphotos.lifepart2.com
pp. 222-223

JEREMY SCOTT FOSTER
travelfreak.net
p. 224

PAULA R. LABINE
paulalabine.com
pp. 225, 226 (top), 227

**GETTY IMAGES /
ALONGKOT SUMRITJEARAPOL**
p. 226 (bottom)

**GETTY IMAGES /
ANOTHERDAYATTHEOFFICE.ORG**
p. 228

SNOWMAN TREK
Bhutan

JONATHAN LOOK
travelphotos.lifepart2.com
pp. 230-231

MICHAEL MARQUAND
marquandphoto.com
pp. 232-233, 235-237

**GETTY IMAGES /
DE AGOSTINI/G. DE VECCHI**
pp. 234, 238

OLKHON ISLAND
Russia

ANTON AGARKOV
instagram.com/agarkov_foto
pp. 240-242, 244-245

**GETTY IMAGES /
KONRAD WOTHE/
MINDEN PICTURES**
p. 243

**GETTY IMAGES /
TUUL & BRUNO MORANDI**
p. 246 (top)

DMITRY NEVOZHAY
nevozhay.com
pp. 246 (bottom), 247

**GETTY IMAGES /
KLUG-PHOTO**
p. 248

KHONGORYN ELS
Mongolia

MAX MUENCH
muenchmax.com
pp. 250-255

CAM HONAN
thehikinglife.com
p. 256

KAMTCHATKA PENINSULA
Russia

VLADIMIR KIRILLOV
500px.com/vladimirkirillov
pp. 258-259, 262, 264-265

TOM KONTSON
91images.co.uk
pp. 260, 263

**GETTY IMAGES /
SERGEY GORSHKOV/
NATURE PICTURE LIBRARY**
p. 261

ANJA KOUZNETSOVA
p. 266

PREFACE
Colchuck Lake, U.S.A.

STEVIN TUCHIWSKY
tuchiwsky.com
p. 2

IMAGE CREDITS
Berg Lake Trail, Canada

ANDY TUPMAN
andytupman.com
p. 271

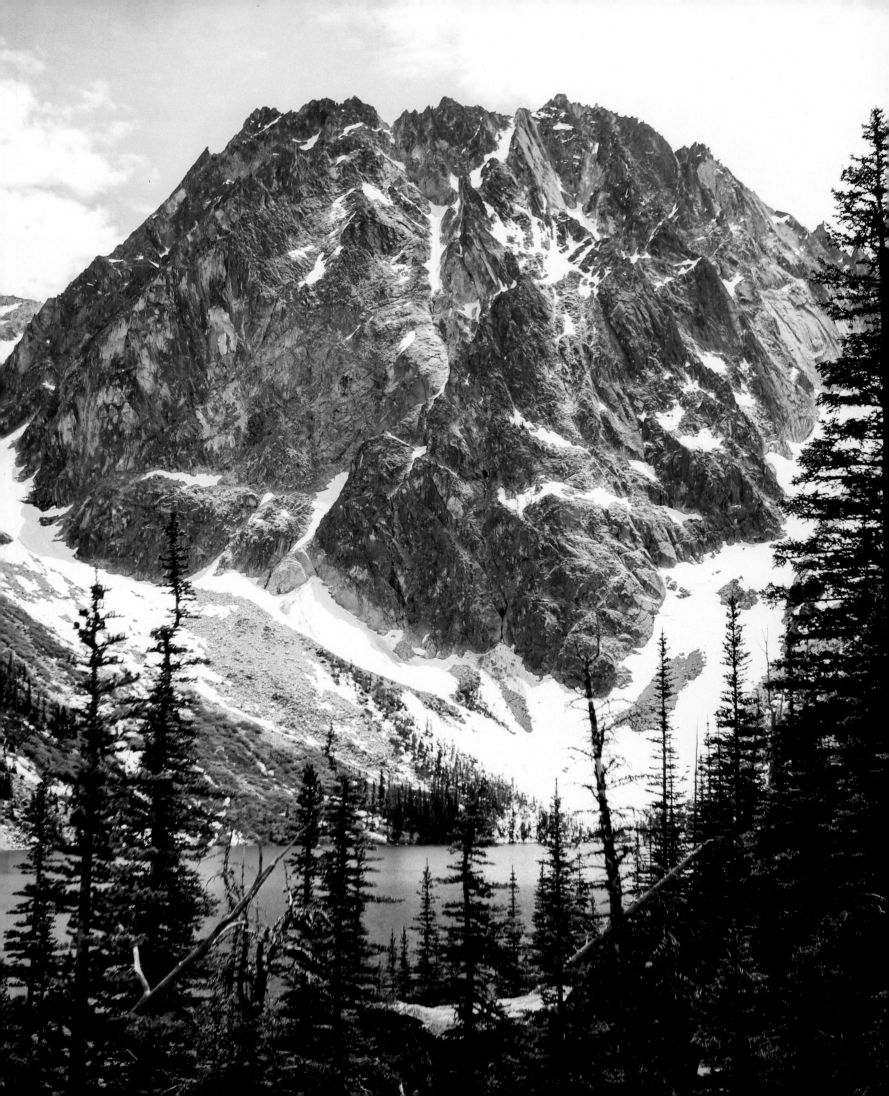

THE HIDDEN TRACKS

**Wanderlust off the Beaten Path
explored by Cam Honan**

This book was conceived, edited, and designed by **Gestalten**.

Edited by **Robert Klanten** and **Anja Kouznetsova**
Contributing Editor: **Cam Honan**

Texts by **Cam Honan**
Text editing by **Rachel Sampson**

Editorial Management by **Cyra Pfennings**

Design, layout, and cover by **Stefan Morgner**
Illustrations by **Florian Bayer**

Map research by **Cam Honan**
Map design by **Bureau Rabensteiner**

Typefaces: Pulitzer by **Olga Pankova**,
Arno by **Robert Slimbach**

Cover photography by **Kirstin Vang**
Back cover photography by **Johannes Hulsch**
Front endpaper by **Jan de Roos** and **Johannes Hulsch**
Endpaper by **Johannes Hulsch** and **Ben Benvie**

Printed by Printer Trento S.r.l., Trento, Italy
Made in Europe

Published by Gestalten, Berlin 2018
ISBN 978-3-89955-955-2

2nd printing, 2019

For more information, and to order books, please visit www.gestalten.com.

Bibliographic information published by the Deutsche Nationalbibliothek.
The Deutsche Nationalbibliothek lists this publication in the Deutsche Nationalbibliografie; detailed bibliographic data are available online at www.dnb.de.

None of the content in this book was published in exchange for payment by commercial parties or designers; Gestalten selected all included work based solely on its artistic merit.

This book was printed on paper certified according to the standards of the FSC®.

FSC
www.fsc.org
MIX
Paper from responsible sources
FSC® C015829

Described by *Backpacker Magazine* as the "most traveled hiker on Earth," **Cam Honan** has trekked more than 96,000 km (60,000 mi) over the last 25 years. He has hiked in over 50 countries, and documents his travels on his blog, *The Hiking Life*. He splits his time between Australia and his adopted homeland of Mexico.